MW00795886

80s

Image
of a
Decade

With 315 illustrations

The 1980s

Henry Carroll

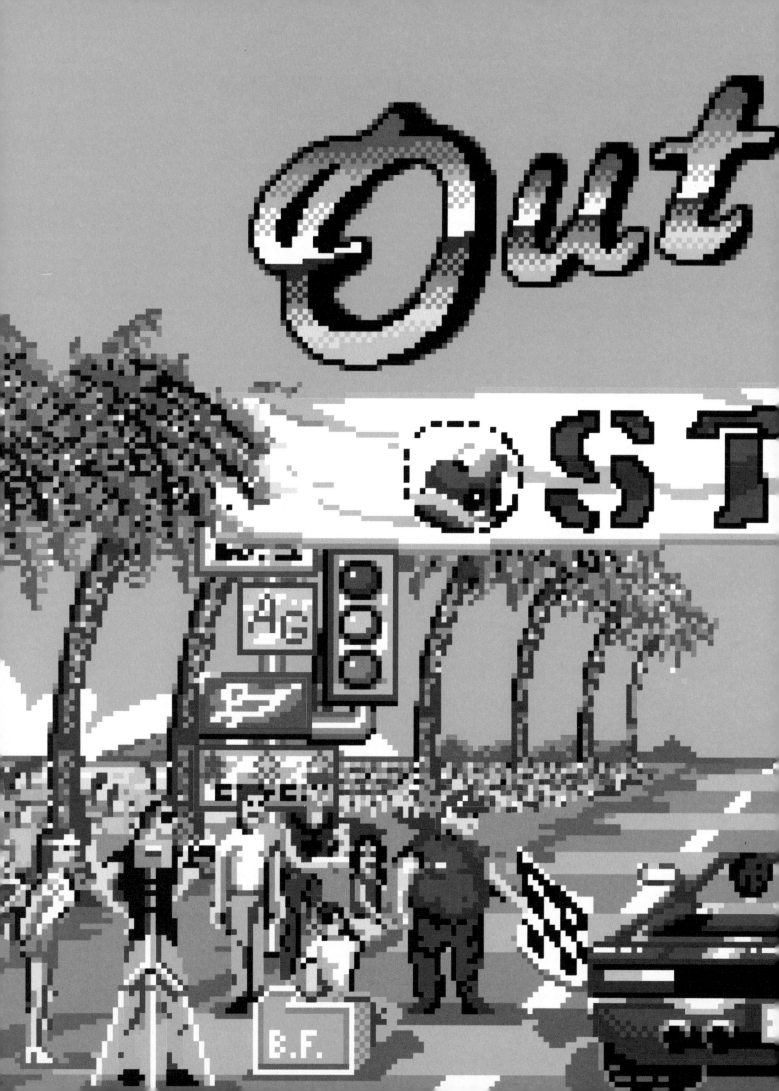

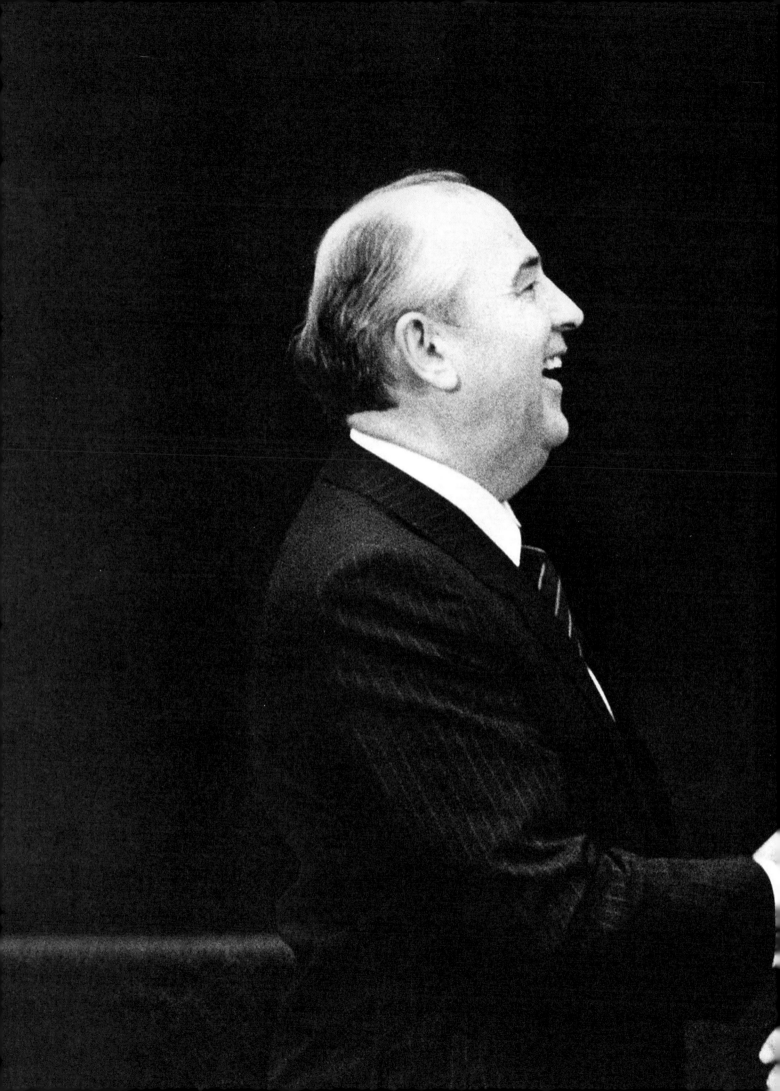

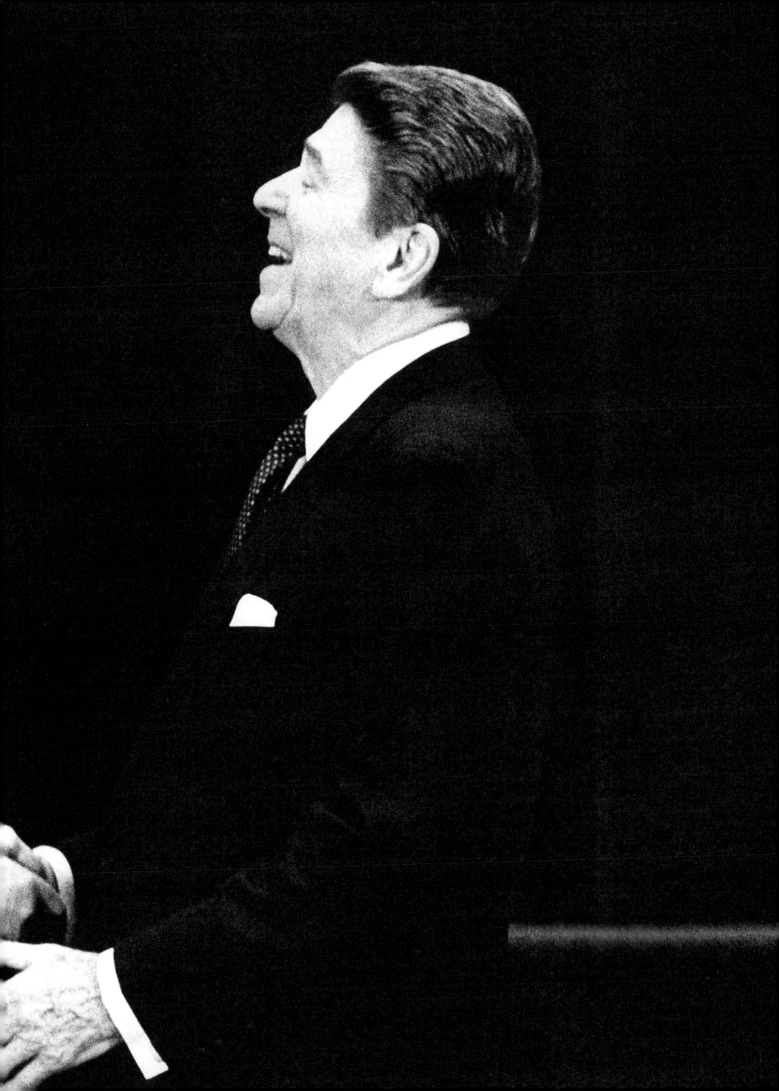

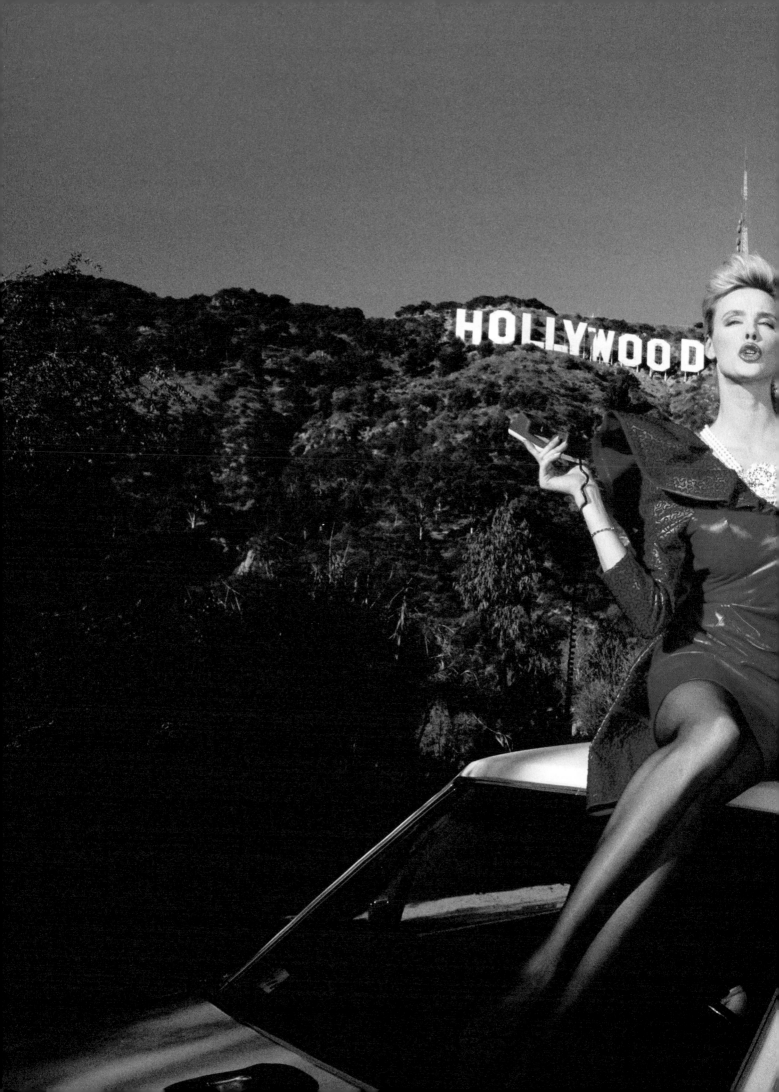

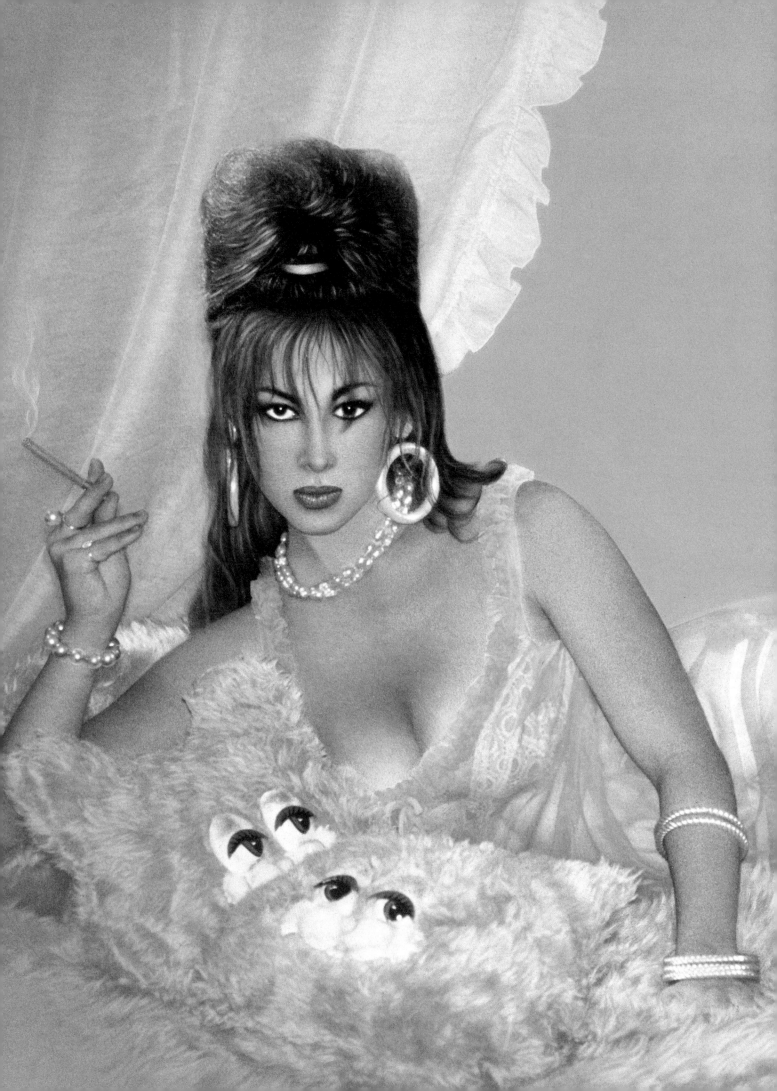

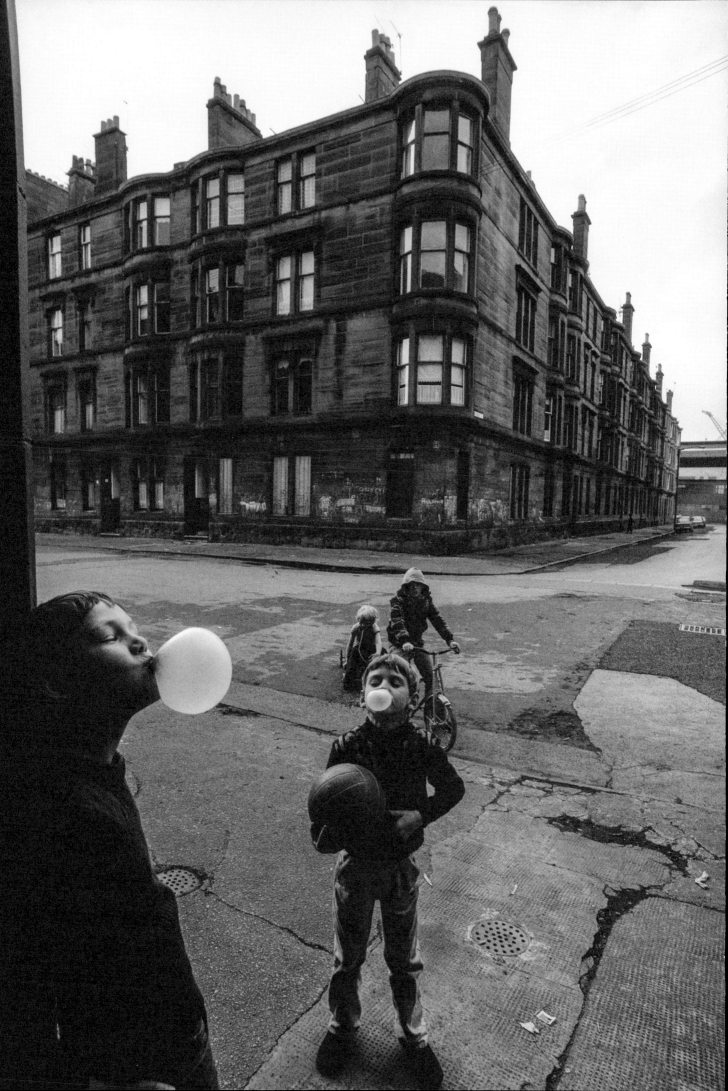

The tipping point.

(4–5) *OutRun*, **1986**
(6–7) Tom Wood, *Untitled Pink Lipstick*, **1984**
(8–9) US President Ronald Reagan and the new Soviet Premier Mikhail Gorbachev shaking hands after a summit meeting in Reykjavik, Iceland, **1986**
(10–11) Brigitte Nielsen modeling a Jean-Claude Jitrois leather dress in Hollywood, photo by Douglas Kirkland, **1986**

(12–13) A cut-out of Vladimir Lenin, founder of Soviet Russia, hanging in the editorial office of the weekly newspaper of the Solidarność (Solidarity) trade union, Krakow, Poland, photo by Bruno Barbey, **1981**
(14–15) Pierre et Gilles, *La petite Marceline*, Marceline, **1980**
(Opposite) Glasgow, photo by Raymond Depardon, **1980**
(Overleaf) Martin Parr, New Brighton, from the series *The Last Resort*, **1983–85**

The tipping point.

It was a time of bold exploration, bedazzling creativity, inspiring unity – and stark division. Technology, media, gender roles, race, sexuality, geopolitics, climate, our place in the universe, you name it: the 1980s saw almost all aspects of humanity challenged, upturned and reimagined.

New technology was the biggy. It changed the way we worked and communicated; it granted us more access to the world; it presented us with a different image of the future, one where the stuff of science fiction entered the realms of possibility. Cell phones made us ask, 'where are you *now*?' The way we listened to music changed – miniature devices like the Sony Walkman meant we could soundtrack our everyday lives, and the compact disk allowed us to skip instantaneously to our favourite tracks. Meanwhile, new television channels like MTV transformed music videos into a vibrant, experimental art form, and CNN started pumping out twenty-four-hour news. Screens entered our daily lives in the form of arcade-quality game consoles, and typewriters were replaced by Apple Macintoshes and PCs running on Microsoft Windows. For the first time, graphic designers used computers to manipulate type and create more complex layouts – a shift that was largely responsible for the zesty aesthetics of magazine and album covers of the 80s – and video game creators took advantage of greater processing power to build immersive worlds in 'platformers' like *Super Mario Bros.* Technology expanded the limits of our physical world, too. In space, the Voyager probes beamed back never-before-seen, close-up images of Saturn's rings and Uranus and its moons. By the end of the decade, these two pieces of human-made hardware passed Neptune and started their eternal glide into interstellar space.

As the world shifted from local to global, the influence of a few cultural epicentres reached out ever further. There was New York City with its street art and growing hip-hop scene. In Los Angeles, Hollywood perfected the blockbuster formula. London and Manchester gave rise to the New Romantics and, later, rave culture. Madrid emerged from the shackles of Fascism with La Movida Madrileña, an outpouring of creative and sexual expression. East Berlin youths embraced punk as communism in Europe teetered on the brink of collapse. And a tech-obsessed Tokyo breathed new life into a flailing video game industry.

In workplaces, women stepped out of administrative roles and slowly climbed the corporate ladders that led to corner offices and seats at boardroom tables. This jostling of the genders required a costume change, and women adopted a more androgynous style of cropped hair and power suits that gave them more physical presence alongside men in elevators and offices. Even though this was by no means a time of gender equality, a decisive shift was taking place that forced some men to fundamentally alter their view of women. At the end of the day, all that really mattered was making money, and boy-o-boy was there a lot of cash being splashed. It was a time of flamboyant furniture and extroverted fashion, big hair and small gadgets, snazzy cars and wide-tied traders barking 'Buy! Sell!' into brick-sized cell phones. The 80s was, undoubtedly, humanity's 'funniest' decade.

It was also a time of chronic injustice, social inequality, carnal greed, rampant homophobia and entrenched racism. It was a time of growing existential self-awareness, marked by inconvenient realizations of how our addictions to progress, consumption, convenience, and information overload were negatively impacting the planet. Millions were starving to death in Sudan and Ethiopia. Hundreds of thousands around the world were dying from HIV- and AIDS-related causes. Gay people were being ostracized. Residents of Black South African townships were beaten daily by agents of a racist government.

All this delight and all this despair illuminated TV screens and covered the pages of newspapers and full-colour magazines.

The real world was sliding into an image-based world, one where the pain and suffering of people on the other side of the globe was ever-present, yet also something packaged up and consumed in a new era of entertainment media. It's this tipping point in human history – this decade when compassion and consumption fought for a place in our hearts and minds – that makes the 80s such an appropriate time to kick off this series of books exploring the evolution of visual culture in recent history.

And this book is, I suppose, a little unusual. Rather than separate out the various facets of visual culture into neat boxes, I've tried to mirror our experience in the real world. You might, for example, go to a gallery because you want to see art. But art is not all you see. The other gallery-goers are dressed in a particular way, you arrive at the gallery via a specific mode of transport, on the way you see posters for movies, new architecture being built, an interesting use of type, someone's sunglasses remind you of that character in that TV show, and why can't you get that song out of your head? Your entire experience of the art is informed by time, by the here and now. Nothing is created or experienced in a vacuum. Nothing exists in isolation.

Like a game of mix and match, I've paired, grouped and sequenced imagery to reveal intriguing visual and thematic connections between art, pop culture, design, architecture, fashion, film and photography of the 80s. You'll see how politics, technology, unexpected global events and a palpable desire for change impacted the things we created and what they looked like. It will, I hope, make a visually chaotic time seem a little more coherent – maybe even logical.

That might all sound quite highfalutin, but it's not. In fact, this book places the lofty heights of fine art and the down and dirty depths of mass media on the same level. It unearths an ecosystem of influence and exposes the conscious and unconscious ripples of cause and effect that run through everything.

The shoulder pads of a power suit can influence the rear profile of a Ferrari, and a Ferrari the speaker of a boom box.

An iconic photograph of a royal wedding can spark a pop culture obsession with virgin brides and gothic romance. The brushstrokes of Willem de Kooning can influence the lines in a magazine advert for perfume.

Or maybe not.

That's the joy of visual culture. It's hard to pinpoint the exact influences that feed into a piece of creative work. It's often impossible to know where the line is between conscious choice and coincidence. The connections you draw, or dismiss, are entirely up to you.

Compiling this book has been a ride. Rather than map out any preconceived ideas I may have had about the 80s, I've let the content tell the story. Some of my image groupings are socially and politically pointed and others are purely playful. Some images I use as metaphors — as factual and emotive signs of the times — while in other groupings you might not see anything at all. The story is largely chronological with a few exceptions here and there that I couldn't resist. This is also a story that includes uplifting and painful moments. There are examples of cultural appropriation, there are some deeply uncomfortable images of suffering, and occasionally there are people who have since been exposed as sexual predators and abusers. What to do about these painful moments, these abusive individuals? I could ignore them for the sake of keeping things upbeat and inoffensive, but their influence on culture cannot be ignored and it cannot be unpicked. That's just not how creative influence works. By including these moments, I am not celebrating them or trying to be needlessly insensitive. I am simply acknowledging their place in the ecosystem of cultural influence.

On a lighter note, no doubt there will be, for you, references missing – things you love, things that define *your* 80s. Sorry about that. In my defence, this isn't supposed to be an all-encompassing encyclopaedia of the decade. It is, admittedly, a highly selective history, an entertaining source book of themes, ideas and events that help to make sense of the visual twists and turns of a vibrant and varied time in history. Our triumphs sit alongside our tragedies, and I try to find reason behind the creative ebbs and flows. And while the decade may have ended long ago, the story is ongoing. Because the ripples of influence of what occurred back then continue to shape visual culture today. The 1980s was one of our most innovative and divisive decades. A time when we solved some problems and created others. A time when bold ideas became infrastructure, ushering in a new vision for the future. A future that we live in today.

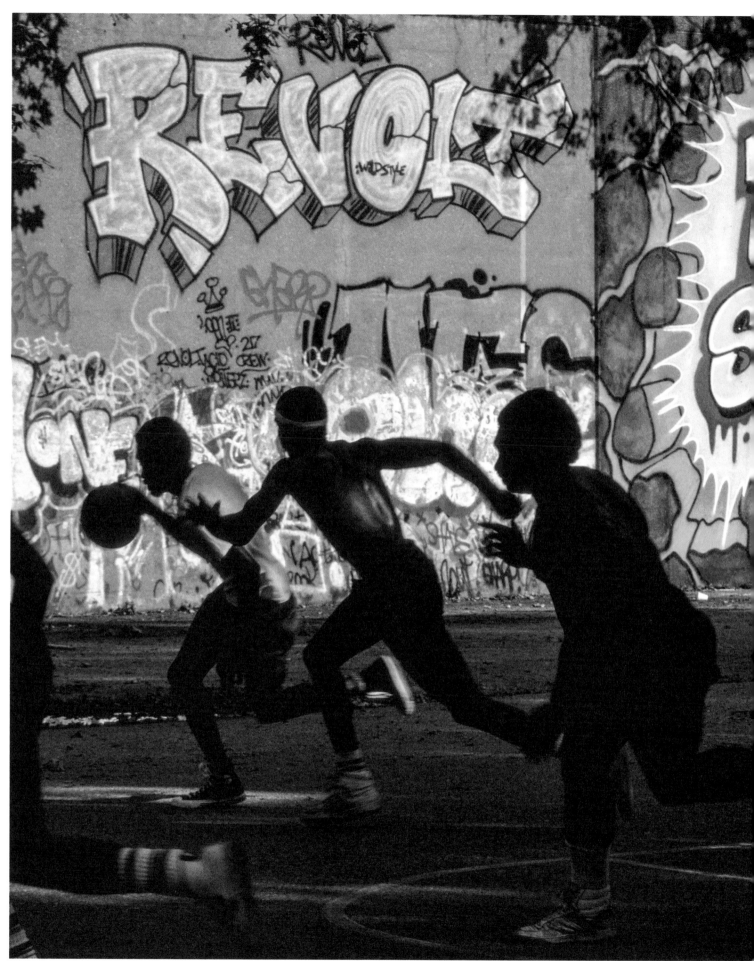

Martha Cooper, *Freshly Painted Wild Style Wall in Riverside Park, Manhattan, NYC*, **1983**

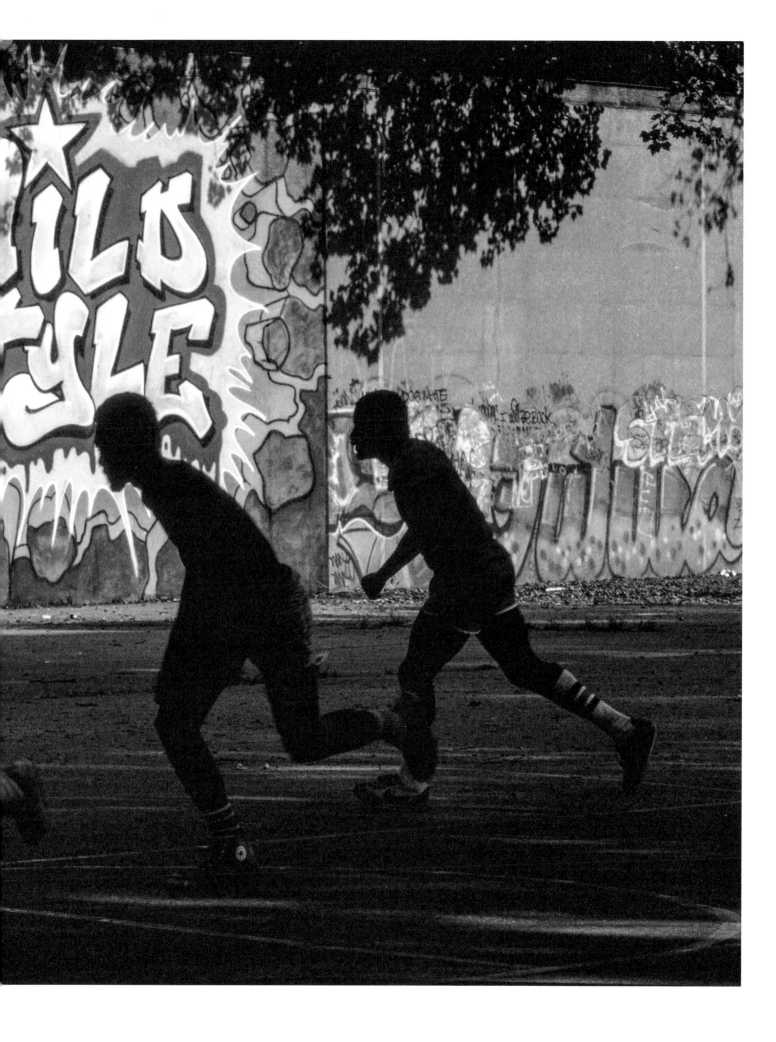

c.1980–83

It started with a bang. Several, in fact.

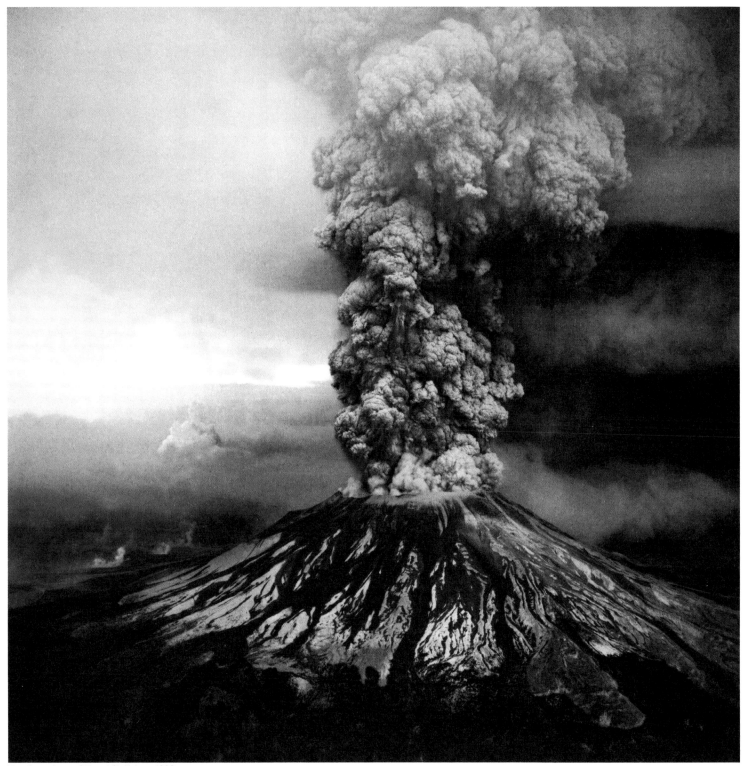

Eruption column of Mount St. Helens, **1980**

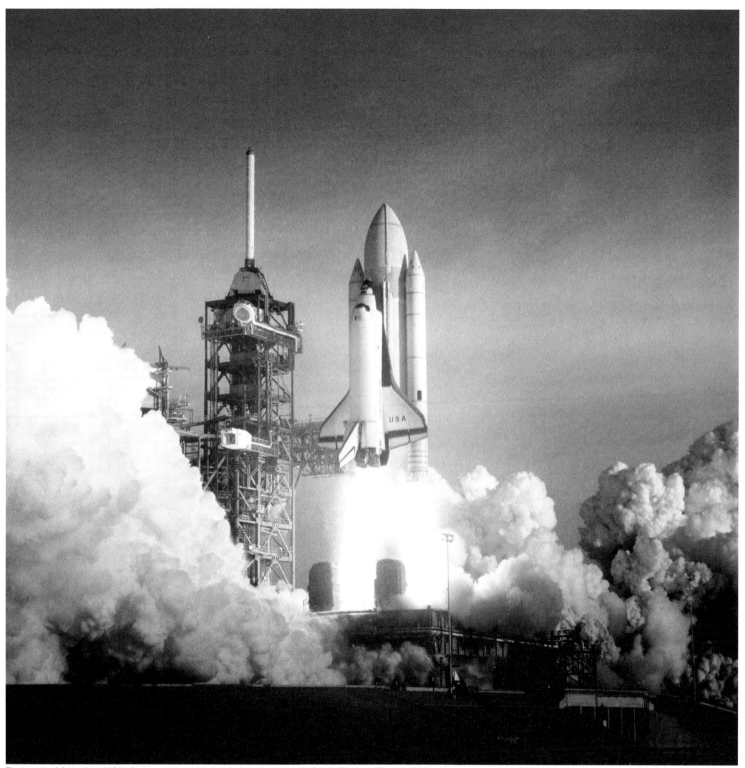

The launch of Columbia, NASA's first reusable space shuttle, from the Kennedy Space Center in Florida, **1981**

Around the world, gunshots rang out like starter pistols to a new decade of discontent. In New York City, John Lennon was killed outside his apartment building by Mark David Chapman (**80**). In Rome, Pope John Paul II was shot and wounded by Mehmet Ali Ağca (**81**). In Washington D.C., the newly elected President, Ronald Reagan, narrowly escaped death after being targeted by John Hinckley Jr. (**81**). In Cairo, President Anwar Sadat died in a hail of militant gunfire (**81**). And in the Philippines, a pig farmer named Rolando Galman shot to death Benigno Aquino Jr., the leader of the opposition against President Ferdinand Marcos, on the tarmac of Manila International Airport (**83**). But it was the assassination attempt of one Texan oil baron, on the evening of 21 March 1980, that attracted record audiences and birthed a phrase that would prove to be immortal: 'Who shot JR?'

Mother Nature was also restless. When Mount St. Helens in Washington state blew its top (**80**), the eruption was the deadliest in US history. And then, of course, there was a relatively new theory, circulating around offices and dinner parties, relating to CO_2 levels in the atmosphere. But 'global warming', as it was referred to back then, was considered a little far-fetched by the public and for world leaders it wasn't a priority – maybe, perhaps, sometime in the future it might be something to worry about, but not now. Far more concerning was the discovery of an ever-widening hole in the ozone layer above the South Pole. The culprit, it turned out, was us. Chlorofluorocarbons, or CFCs – chemical compounds used in refrigerators and aerosol cans – were poisoning the atmosphere at a potentially catastrophic rate.

Another threat, this one microscopic, also came into focus. In New York City, Los Angeles, San Francisco and London, men, specifically gay men, were falling ill and dying from a virus previously only known to be an issue in Africa. For conservative politicians like Reagan, what was then termed GRID (Gay-Related Immune Deficiency), wasn't even a passing concern, let alone something to mention in public.

When it came to the end of the world, the smart money was on nuclear Armageddon.

The US and the USSR had amassed fully stocked arsenals of humanity-ending weapons that could be unleashed at a push of a button. The UK, which lay slap-bang in between these two superpowers, issued a leaflet titled *Protect and Survive* (**80**) which contained reassuring statements such as, 'Even the safest room in your home is not safe enough.' Thankfully, mushroom clouds only detonated throughout visual culture, and the closest the world came to annihilation was in the hit movie *WarGames* (**83**), in which a young gamer played by Matthew Broderick inadvertently hacks into a US military supercomputer and starts playing a 'game' called Global Thermonuclear War.

In 1981, NASA offered a little hope and distraction when the first reusable

space shuttle, Columbia, successfully blasted into orbit. That same year, TV screens were once more flooded with images of a man on the moon, only this astronaut was holding a flag reading 'MTV', marking another giant leap for mankind, into the era of 24/7 music content.

The newly released Sony Walkman allowed users to disconnect from a noisy world and lose themselves to the music inside their heads.

Their music of choice would likely have been 'Endless Love' by Lionel Richie (81), 'Ebony and Ivory' by Paul McCartney and Stevie Wonder (82), 'Tainted Love' by Soft Cell (81), or 'Girls Just Want to Have Fun' by Cyndi Lauper (83). In movie theaters, George Lucas pumped out two *Star Wars* sequels, Steven Spielberg perfected the high-concept blockbuster formula with *Raiders of the Lost Ark* (81) and *E.T.* (82), and Ridley Scott indulged audiences' dystopian desires with *Blade Runner* (82).

In China, the population hit one billion (82). In Japan, *Pac-Man* started munching his way around the world (80), and a pixelated plumber named Mario made his first appearance in *Donkey Kong* (81).

In the US, Microsoft launched Word (83), *Time* magazine substituted a human for hardware, awarding the personal computer 'Machine of the Year' (82) and graffiti found its way into swanky Manhattan galleries. In the UK, the royal wedding of Charles and Diana (81) captivated the world and a small Covent Garden club named Blitz birthed the New Romantics. With their androgynous styling and synthy sound, this post-punk movement would come to influence the pop culture aesthetics of the entire decade.

Elsewhere, young urban professionals, or 'yuppies', paraded around in big suits and flashy cars, their extreme hunger for money fuelled by years of belt-tightening following the worst recession since the Great Depression. As for the poor, they were expected to keep quiet and carry on digging up the coal. This increasing wealth divide inflamed social tensions but also stoked creative fires. Art, especially the text-based art of Barbara Kruger and Jenny Holzer, was a potent form of activism, while the flamboyant furniture of the Memphis Group, founded in Milan by Ettore Sottsass (80), encapsulated an 'anything goes' attitude. And in south London, racial tensions hit a riotous low after years of officially sanctioned police harassment of the local community and a bungled police response to the stabbing of the young Black man Michael Bailey (81).

In the first few years of the 1980s, existential dread escalated, confusion spread about a new deadly virus, and social and political divides widened. By 1984, when a band named 'Frankie Goes to Hollywood' released their debut single, its one word title became a necessary call to action: 'RELAX'.

(Overleaf) Memphis Milano designers with founder Ettore Sottsass (far right) in Tawaraya Ring bed, designed by Masanori Umeda, **1981**

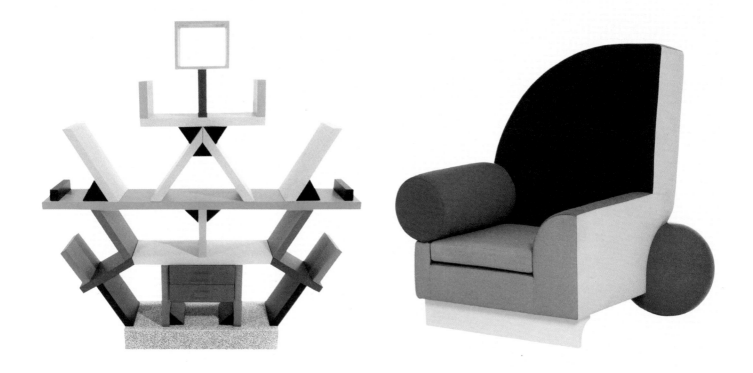

Ettore Sottsass, *Carlton* bookcase, **1981**

Peter Shire, *Bel Air* armchair, **1980**

The flamboyant furniture and interiors were a cacophony of colour. Curves, sharp angles and unclassifiable shapes coexisted like amoeba floating in a petri dish. It was the work of the Memphis Group, a Milan-based collective founded by Ettore Sottsass in 1980. While the group's designs might have appeared to come out of nowhere, to the discerning eye, they were the epitome of postmodernism. Look closely at a cup or a clock, and you'd likely see accents of art deco, Bauhaus or even traces of Native American or ancient Egyptian cultures. The choice of materials made the most of industrial techniques, sometimes combining wood, plastic, ceramics, metal and glass in a single object. It was playful and disruptive, an intentional assault on 'good taste'. This anything-goes attitude was also embraced, albeit with a bit more ponderousness, when architects like Frank Gehry, Rem Koolhaas and Ricardo Bofill exhibited their designs at the 1980 Venice Biennale, a postmodern frenzy of ideas cherry-picked from anywhere, any time, under the banner 'The Presence of the Past'.

Andrea Branzi, *Century* divan, **1982**

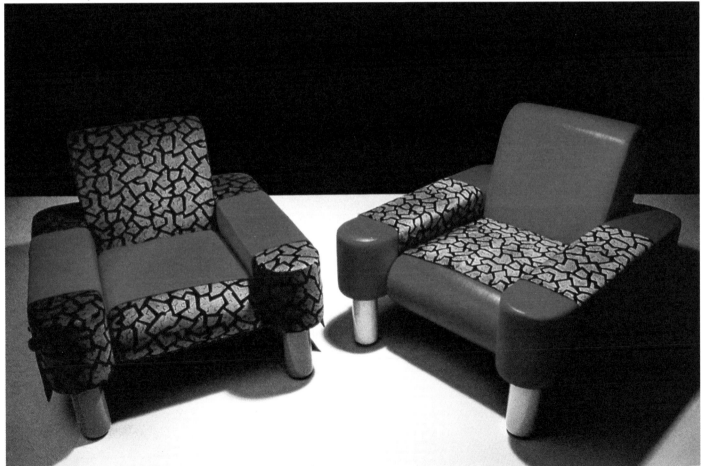

George Sowden, *Oberoi* armchairs, **1981**

Hans Hollein, *Strada Novissima* for 'The Presence of the Past' exhibition, 39th Venice Biennale, Italy, **1980**

Interior design of the Haçienda nightclub, Manchester, **1982**

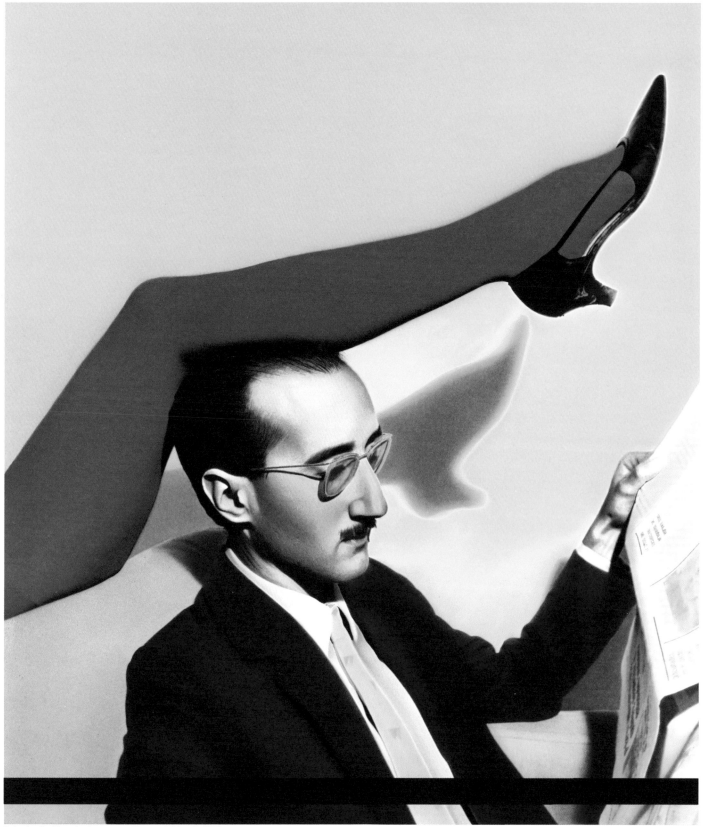

Ouka Leele, *Escuela de romanos* (Romans' School), **1980**

The Messiness of Freedom

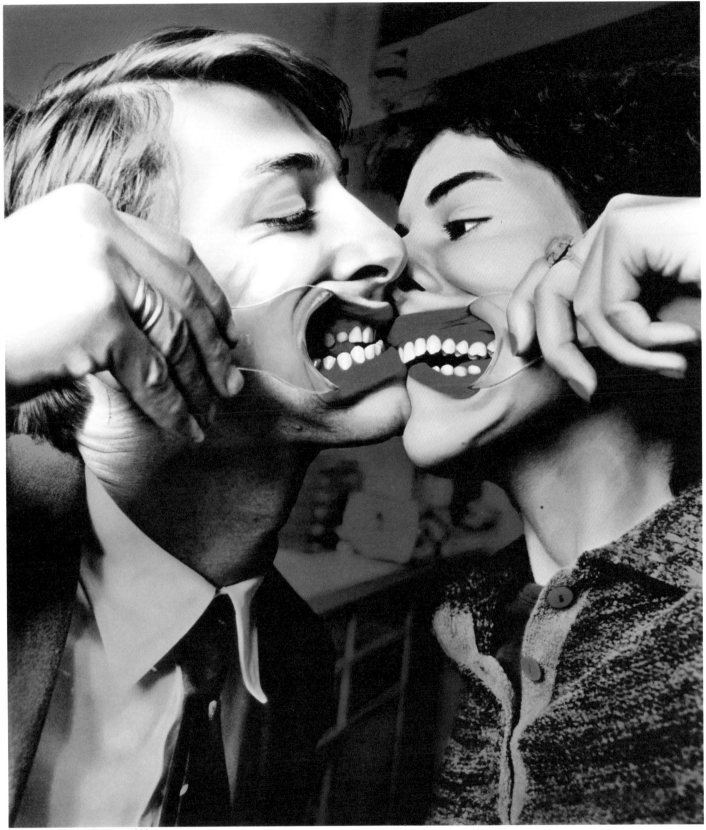

Ouka Leele, *El beso* (The Kiss), **1980**

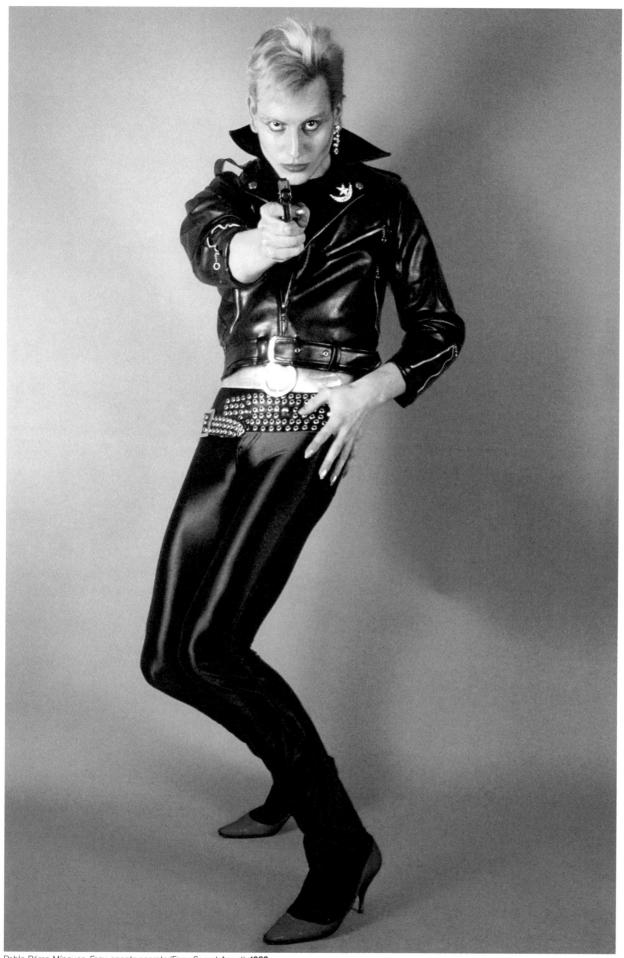

Pablo Pérez-Mínguez, *Fany, agente secreto* (Fany, Secret Agent), **1982**

The Messiness of Freedom

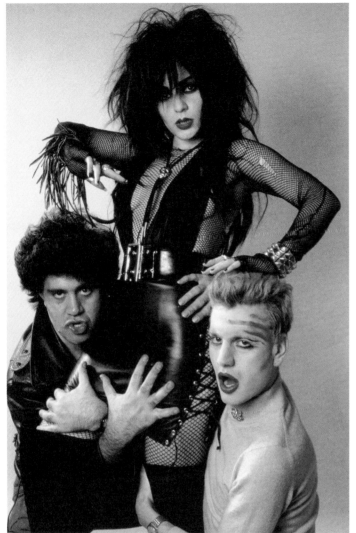

Pablo Pérez-Mínguez, *Trío Rock Ola*, **1983**

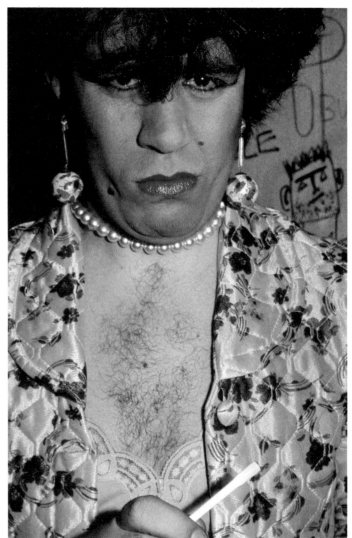

Pablo Pérez-Mínguez, *Pedro Almodóvar*, **1983**

Franco was dead, Spain was now a democracy and the 'messiness of freedom', as emerging filmmaker Pedro Almodóvar described it, was being fully embraced by a new generation of Spaniards. La Movida Madrileña – a style, an attitude, a movement, call it what you will – emerged in Madrid, a reaction against decades of oppression. Fuelled by a healthy dose of anti-Fascist sensibility, the young and newly free expressed themselves with fashion, music, graphic design and film that all incorporated aspects of 70s British punk rock and DADA, the anarchic art movement of the early 20th century. Gender was fluid, hair was explosive, makeup was everywhere. The focus was on fun, and if this counterculture movement did have a manifesto, it was most likely scrawled in lipstick and eyeliner on the walls of a backstreet bar in Madrid.

(Overleaf) New York City subway riders listening to Walkmans, **1981**

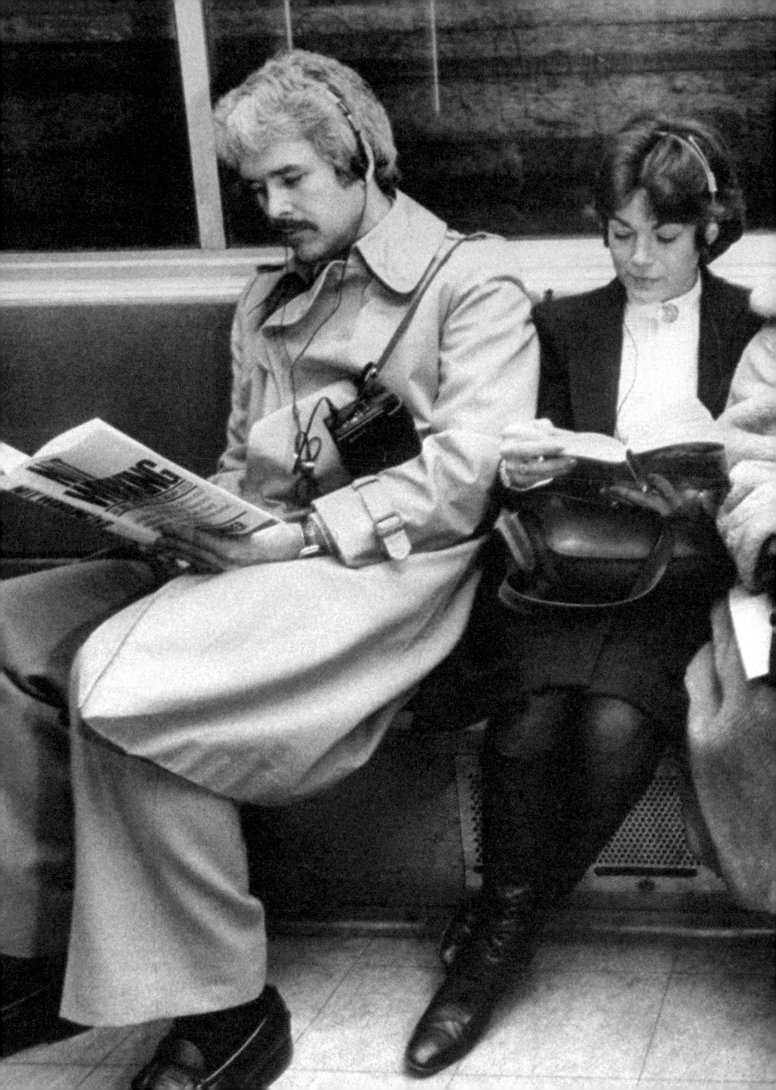

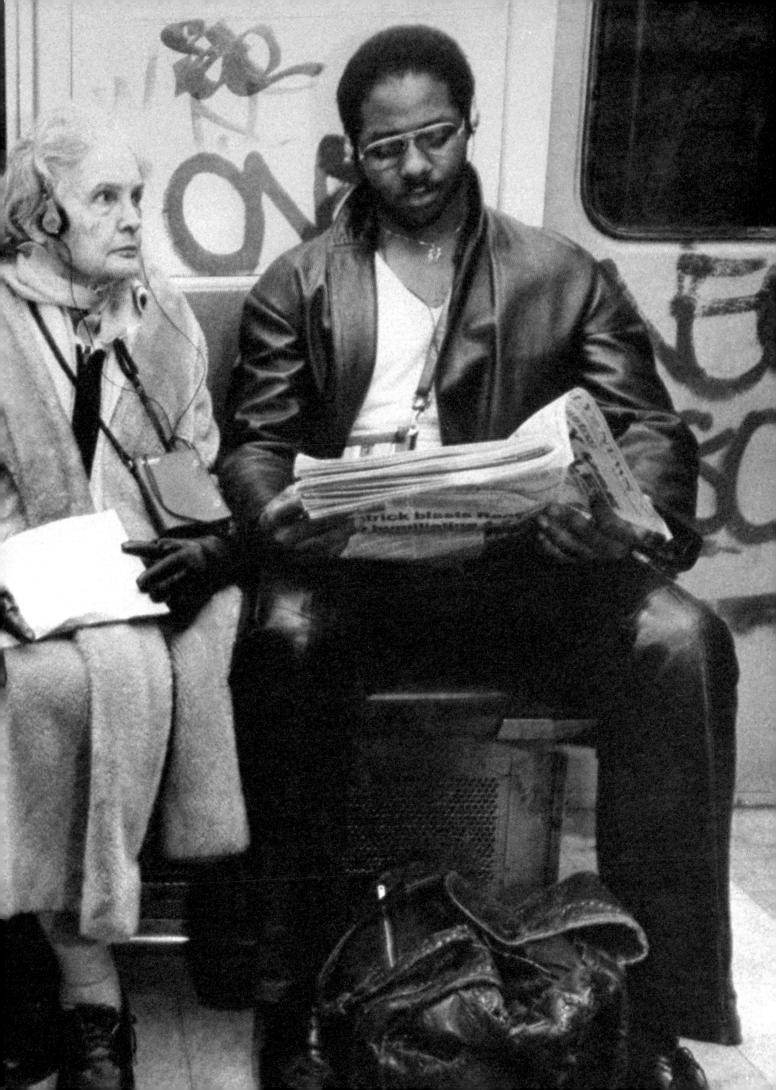

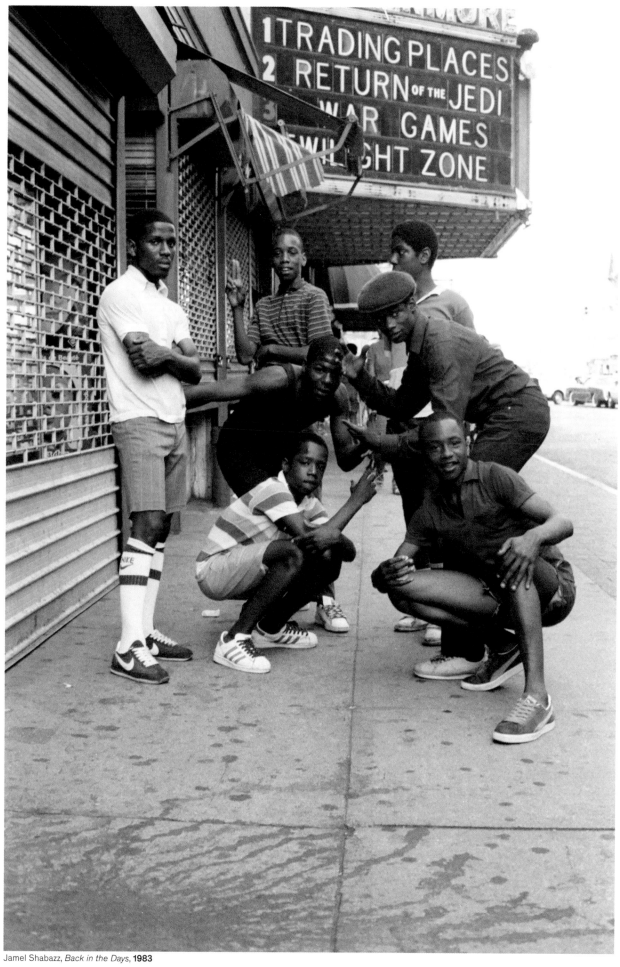

Jamel Shabazz, *Back in the Days*, 1983

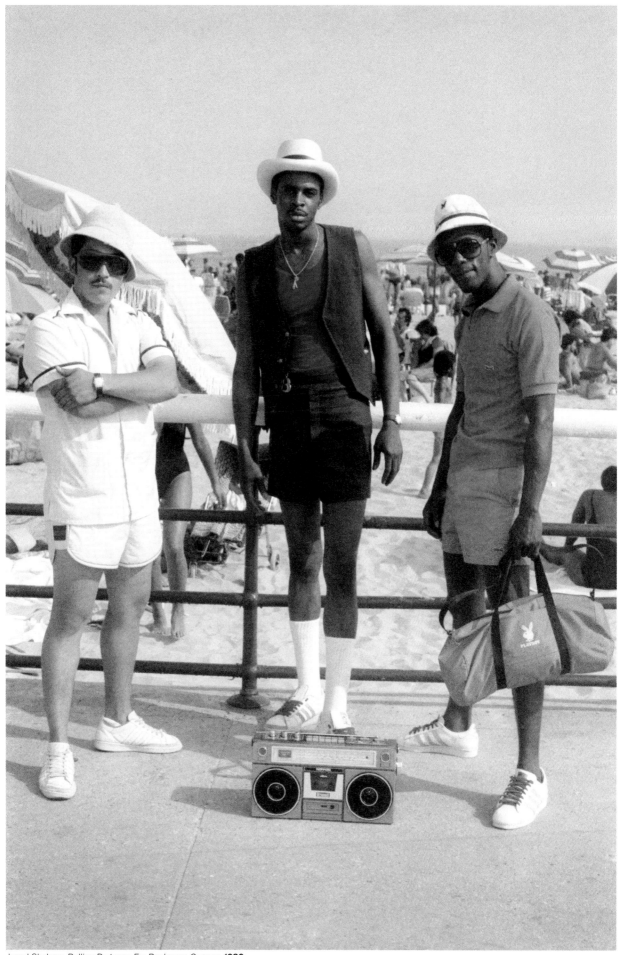

Jamel Shabazz, *Rolling Partners, Far Rockaway, Queens,* **1980**

New Look. New Sound. New York.

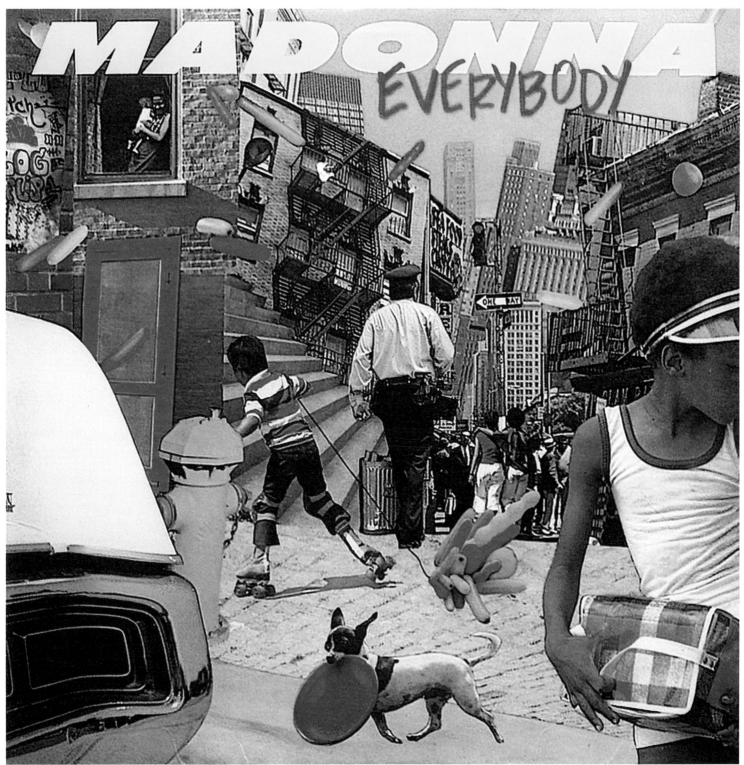

Cover of Madonna's debut single, 'Everybody', **1982**

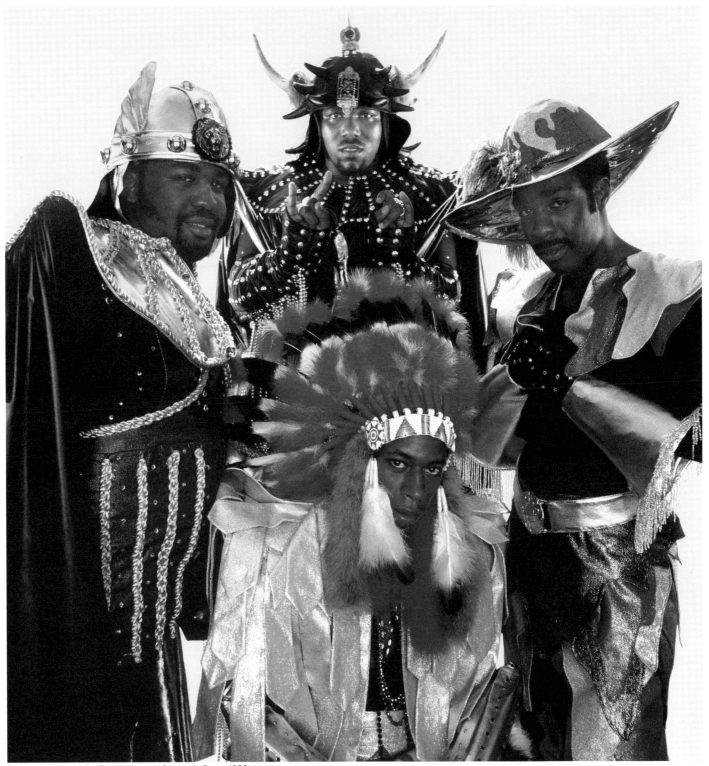

George DuBose, Afrika Bambaataa and Soulsonic Force, **1982**

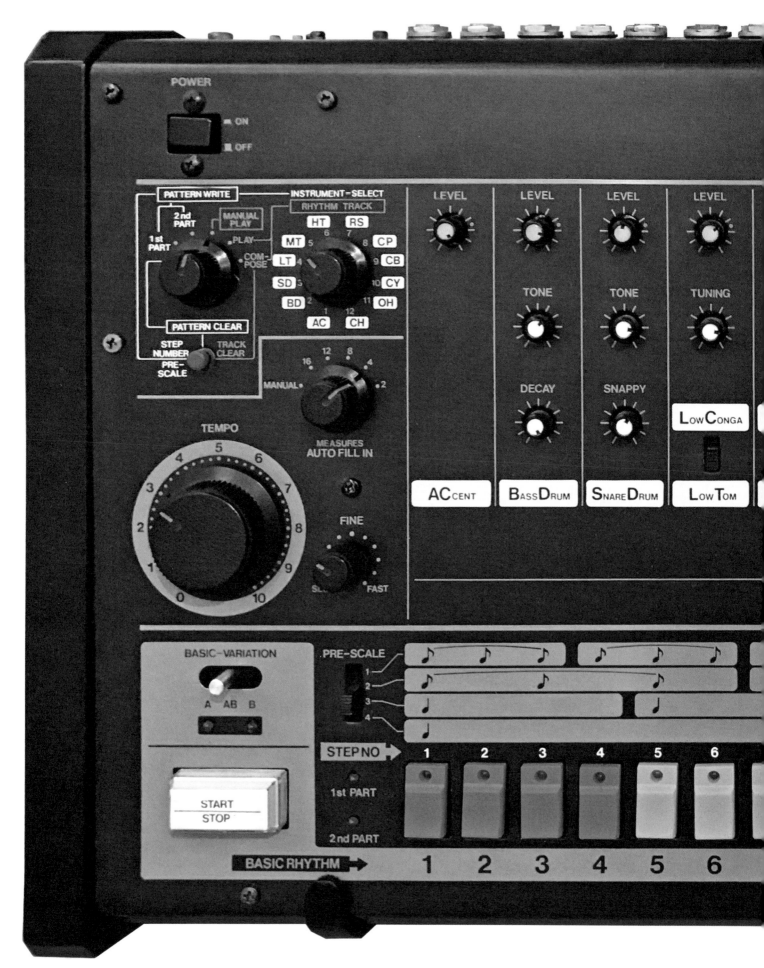

Roland, TR-808 Rhythm Composer, the first drum machine to allow users to program their own rhythms, **1980**

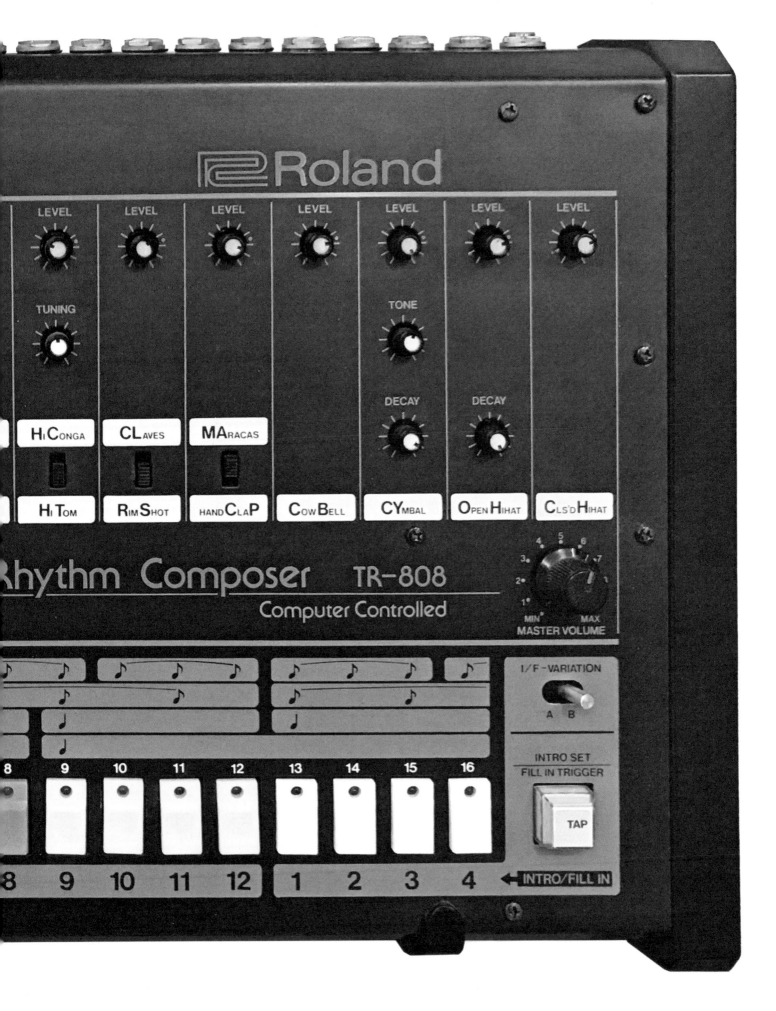

49

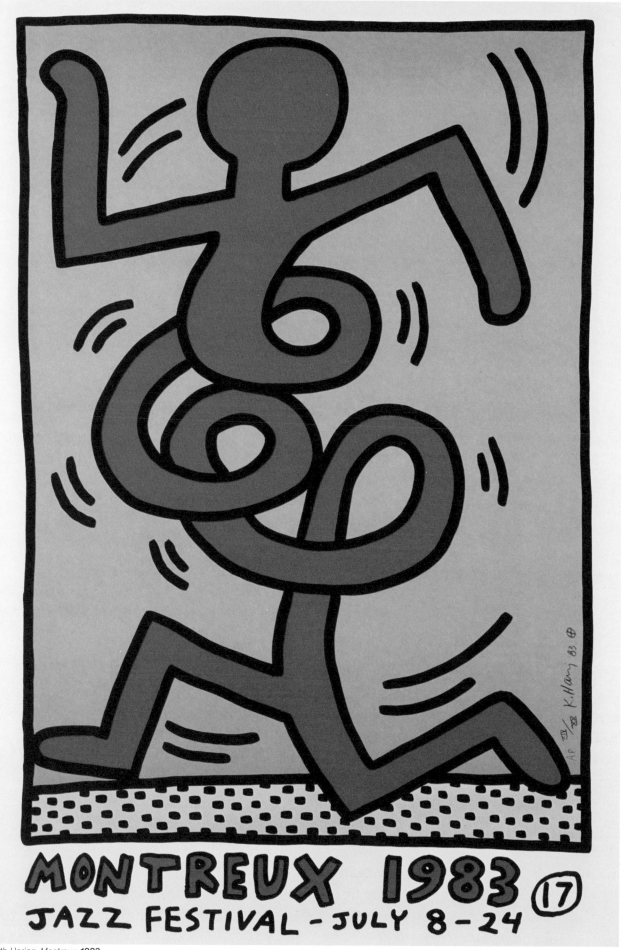

Keith Haring, *Montreux*, **1983**

New Look. New Sound. New York.

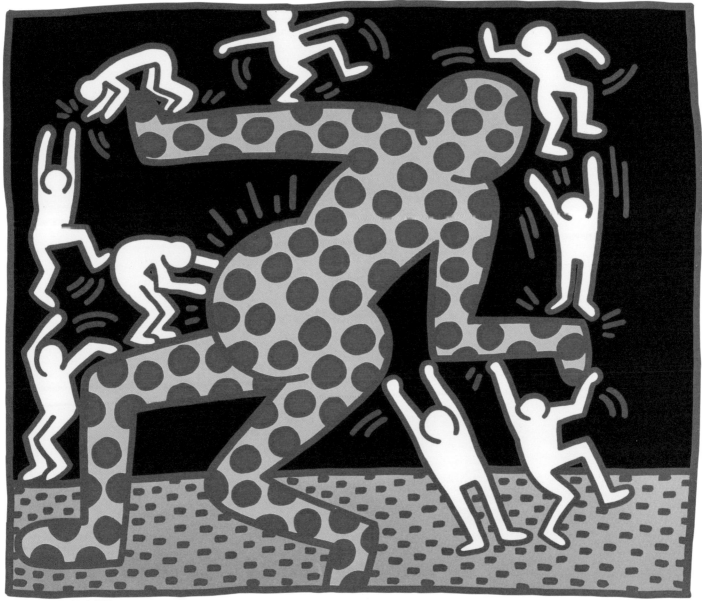

Keith Haring, *Untitled*, **1983**

It was a perfect storm. The art, music, dance and fashion that had, for a few years, been enlivening the streets of the Lower East Side and the Bronx in isolation converged. Now graffiti, breakdancing and hip-hop became inseparable, their relationship cemented by Charlie Ahearn's documentary film *Wild Style* (83). Photographers like Jamel Shabazz and Martha Cooper celebrated the scene on the streets with their cameras, while artists like Keith Haring and Jean-Michel Basquiat elevated the reputation (and price tag) of graffiti, an art form that was once regarded as vandalism. The artists themselves were objects of fascination, their life and works immortalized by photographer friends such as Tseng Kwong Chi. Hip-hop culture, with its socially and politically charged components, was a powerful alternative to the often blandly anodyne White-dominated pop industry. Emerging outsiders like Run-D.M.C. now fit into a 'category', or more widely understood genre, that was on the brink of becoming an almighty tour de force that would come to dominate mainstream music.

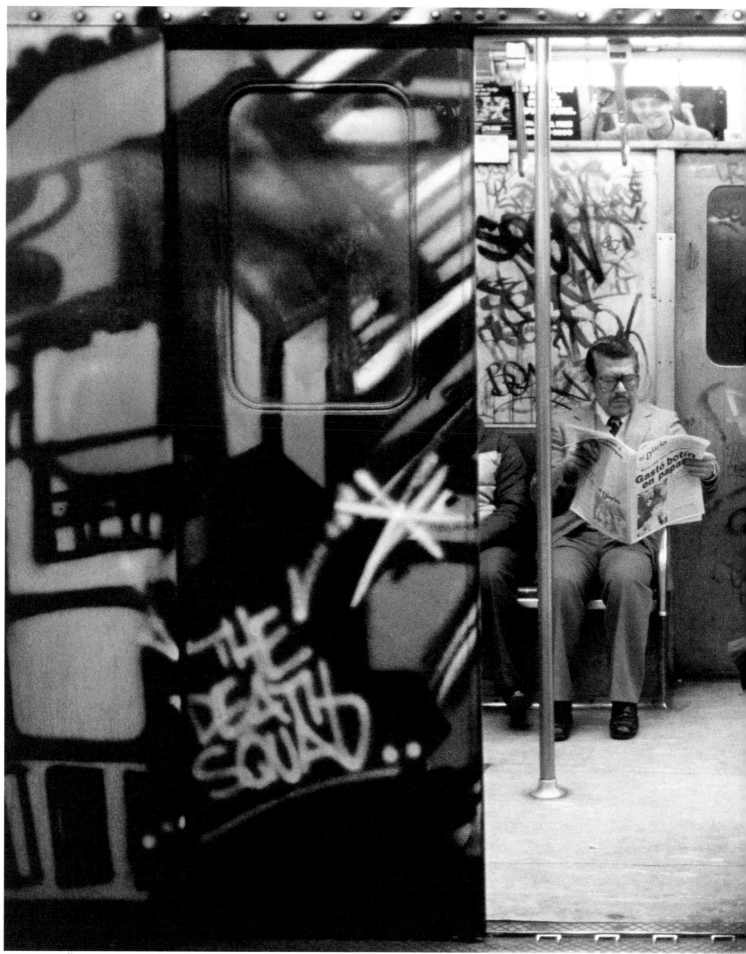

Martha Cooper, *Style Wars by NOC 167, Manhattan*, 1981

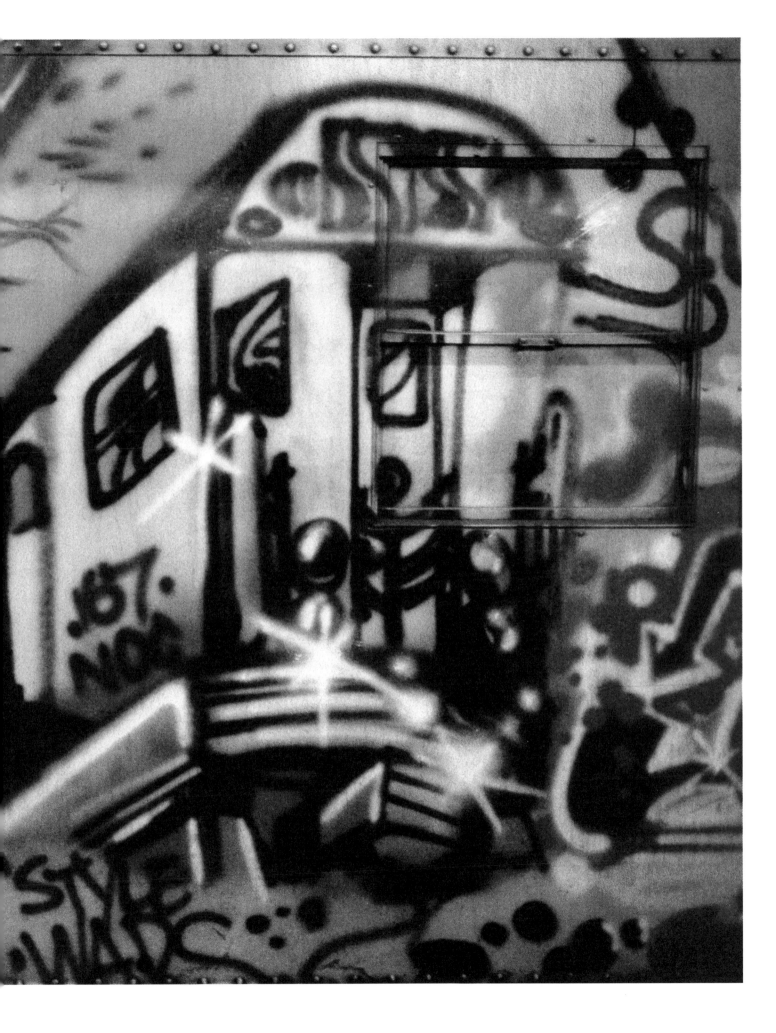

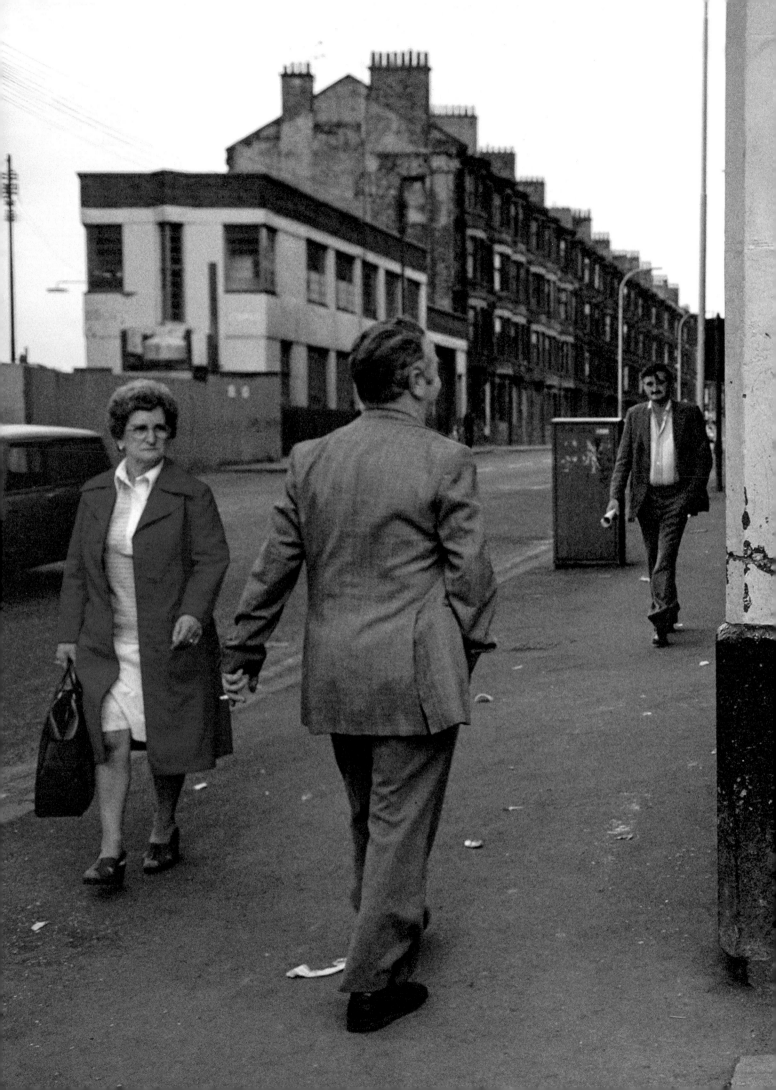

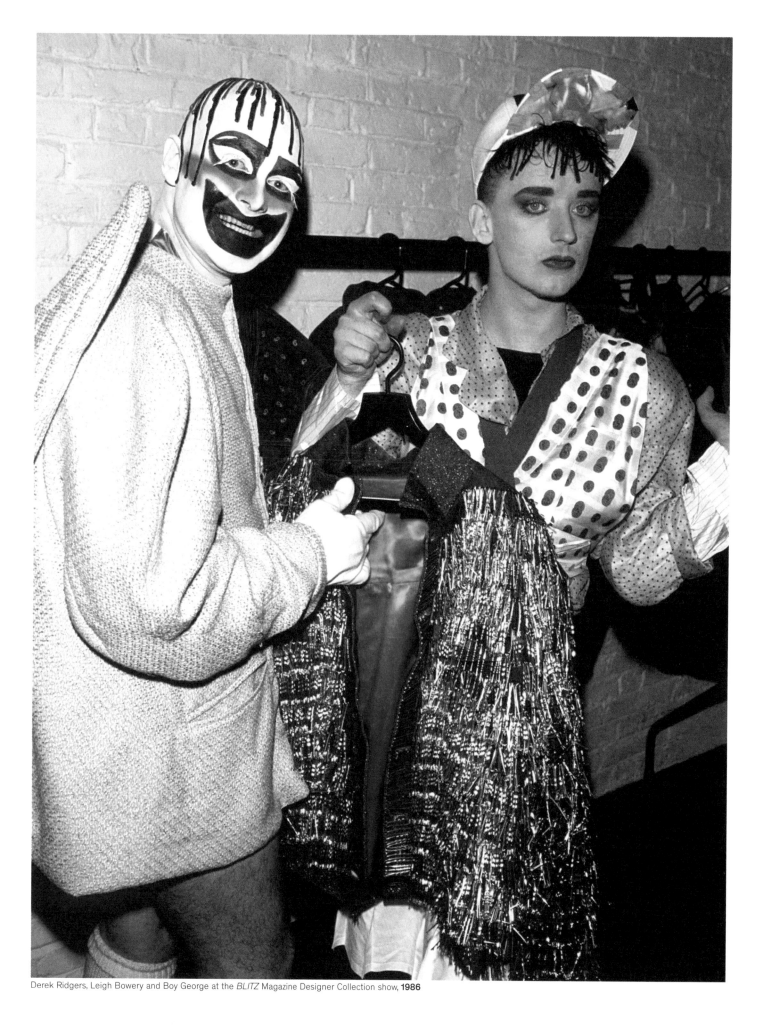

Derek Ridgers, Leigh Bowery and Boy George at the *BLITZ* Magazine Designer Collection show, **1986**

(Previous pages) Glasgow, photo by Raymond Depardon, **1980**

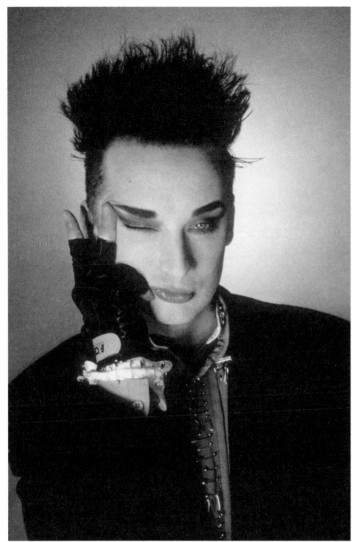

Boy George, **1985**

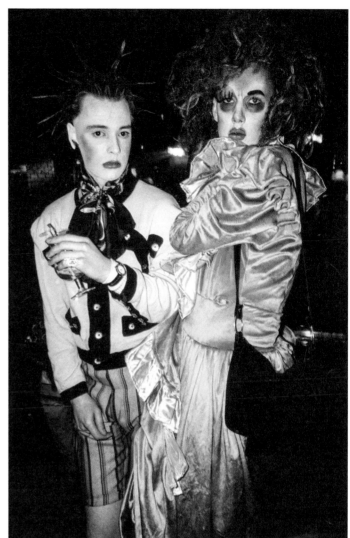

Derek Ridgers, *Trojan and Mark at Taboo*, London, **1985**

Things were far from rosy as the UK entered this new decade. Unemployment was the highest it had been since 1935, newly elected conservative Prime Minister Margaret Thatcher got tough on trade unions, and inflation was at 18 per cent. Late 70s punk had spurred a second wave of skinhead subculture that saw some members leaning heavily towards the violence of football hooliganism and the political right. Meanwhile, the looks and sensibilities of the New Romantic subculture that emerged from London clubs like Covent Garden's Blitz were the complete opposite. Synthpop was their music of choice and adherents like Boy George wore lavish makeup, had big hair, and wore outfits inspired by the Romantic period of the early 19th century. In the shadow of urban decay, underground hedonism was at its height. In London, the club scene erupted with Wag and Taboo, and in Manchester the legendary Haçienda opened its doors (82). Dress codes were strict, not just for reasons of sartorial snobbery, but also to protect patrons from rising thug violence against the gay community.

The (Un-)United Kingdom

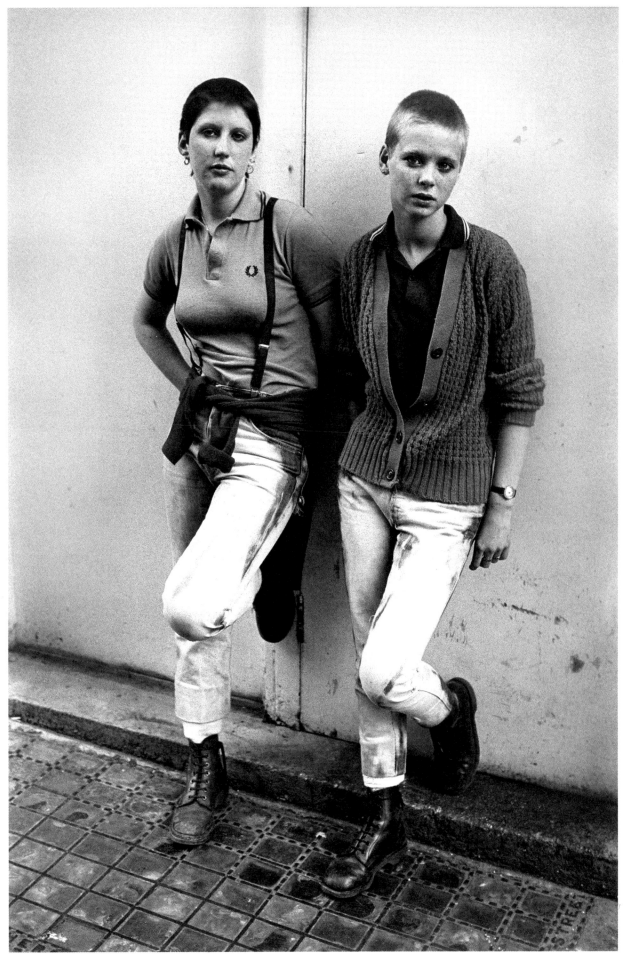

Derek Ridgers, *Skinhead Girls, Bank Holiday, Brighton 1980,* **1980**

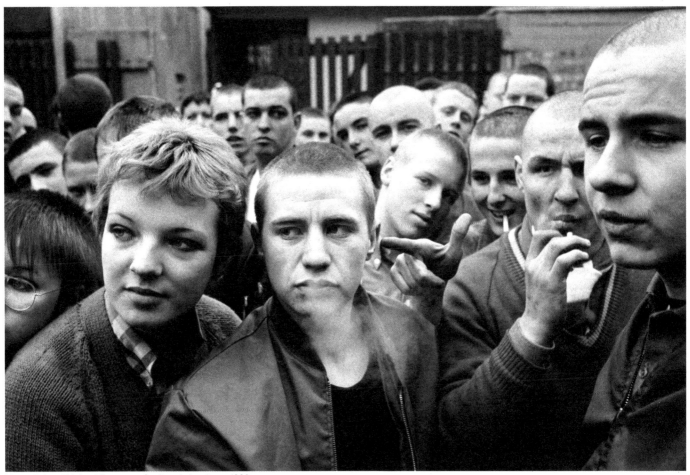

Homer Sykes, *Skinhead Teenagers, Southwark, London*, **c. 1980**

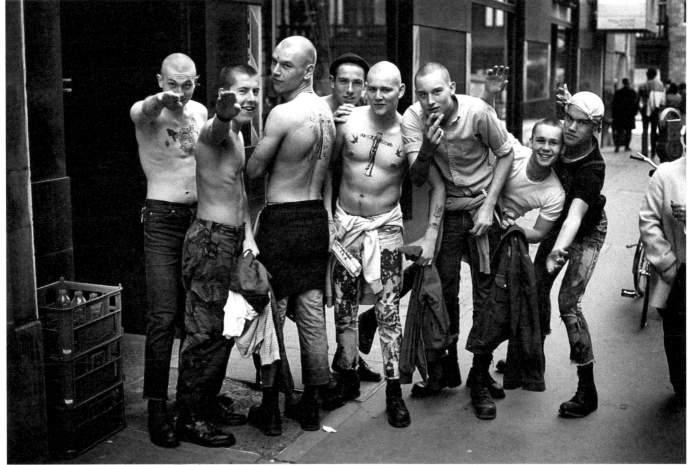

Derek Ridgers, *Chelsea*, **1982**

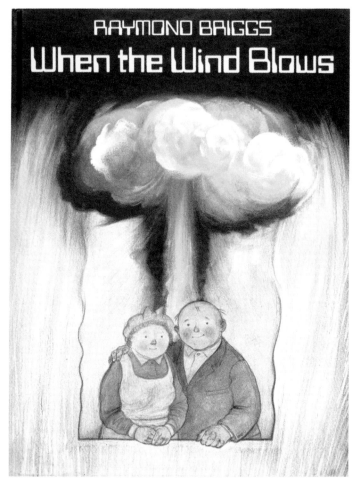

Cover of the graphic novel *When the Wind Blows* by Raymond Briggs, **1982**

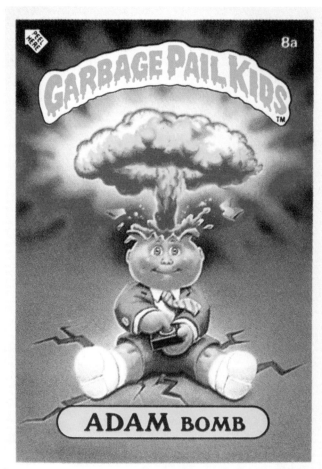

Adam Bomb, Garbage Pail Kids trading card, **1985**

When it came to relations between the US and the USSR, the early 80s was a match made in Armageddon. The USSR was, in Western eyes, a global force of evil. The US and its allies were, in the eyes of the USSR, about to launch a first-strike nuclear attack. And who could blame them for their suspicion? Intercontinental ballistic missiles (ICBMs) were in place in the US, and former-actor-turned-President Ronald Reagan announced plans for a 'Strategic Defense Initiative'. This elaborate and expensive concept would use laser beams to defend the US from incoming missile strikes, but it needed a catchy title. The administration looked to the movies for inspiration and landed on 'Star Wars'. After billions of dollars were spent, it became apparent that the technology needed for this cool idea was, in fact, the stuff of science fiction.

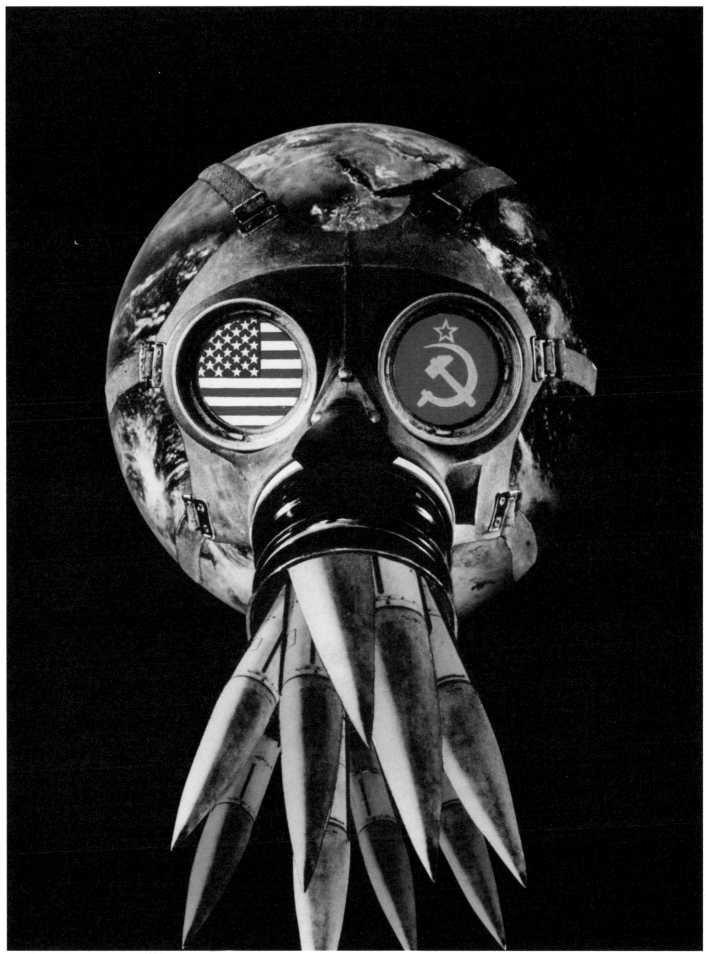

Peter Kennard, *Defended to Death*, **1983**

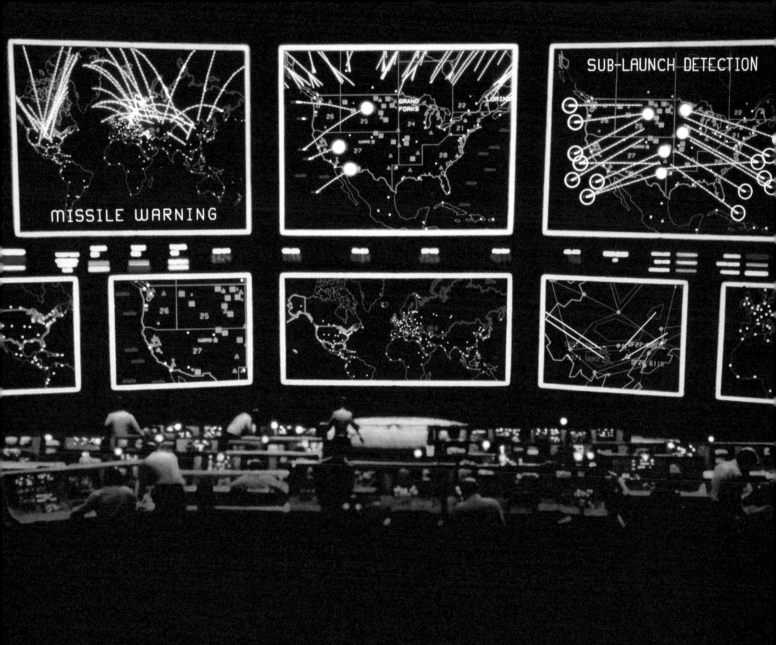

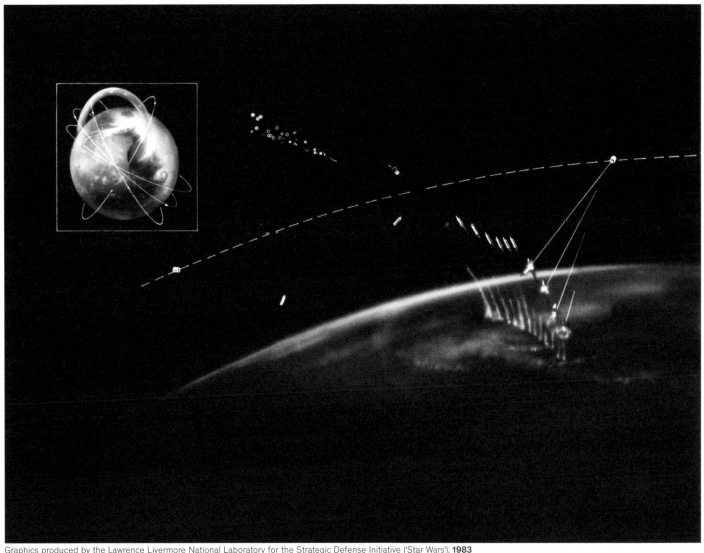

Graphics produced by the Lawrence Livermore National Laboratory for the Strategic Defense Initiative ('Star Wars'), **1983**

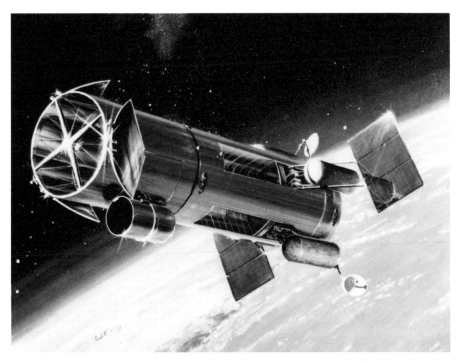

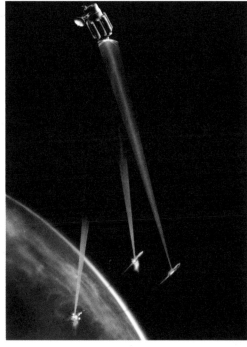

(Opposite) *WarGames*, **1983**
(Overleaf) Saturn, photographed by Voyager I, **1980**

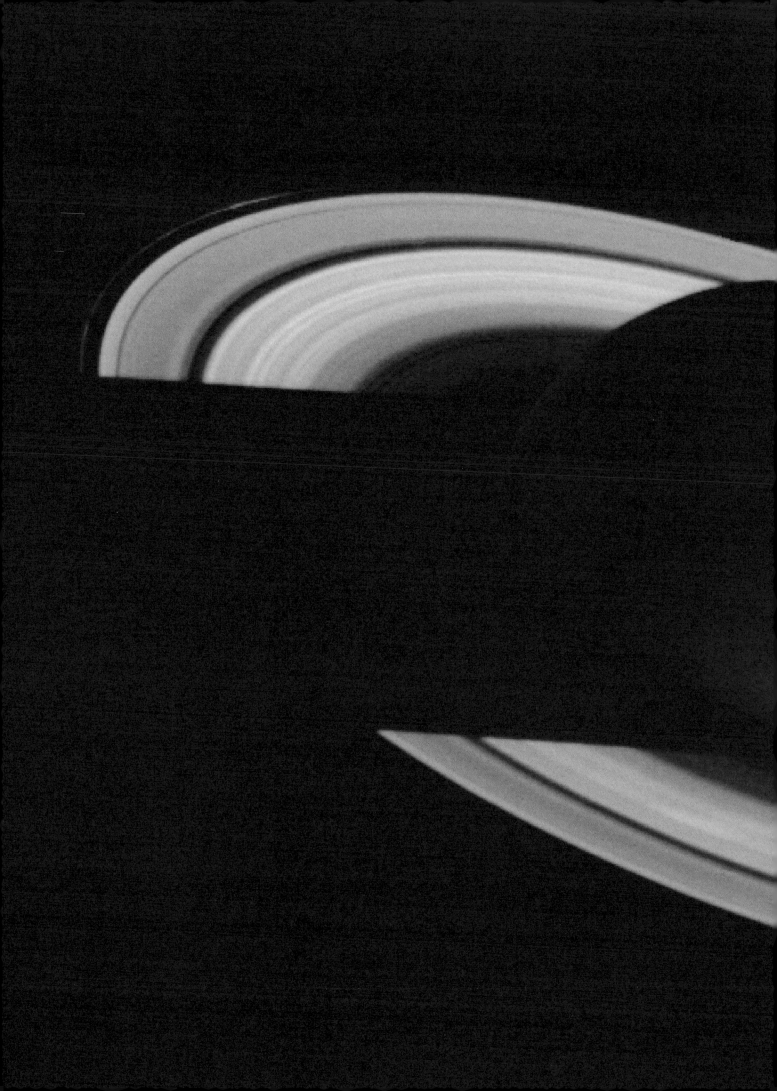

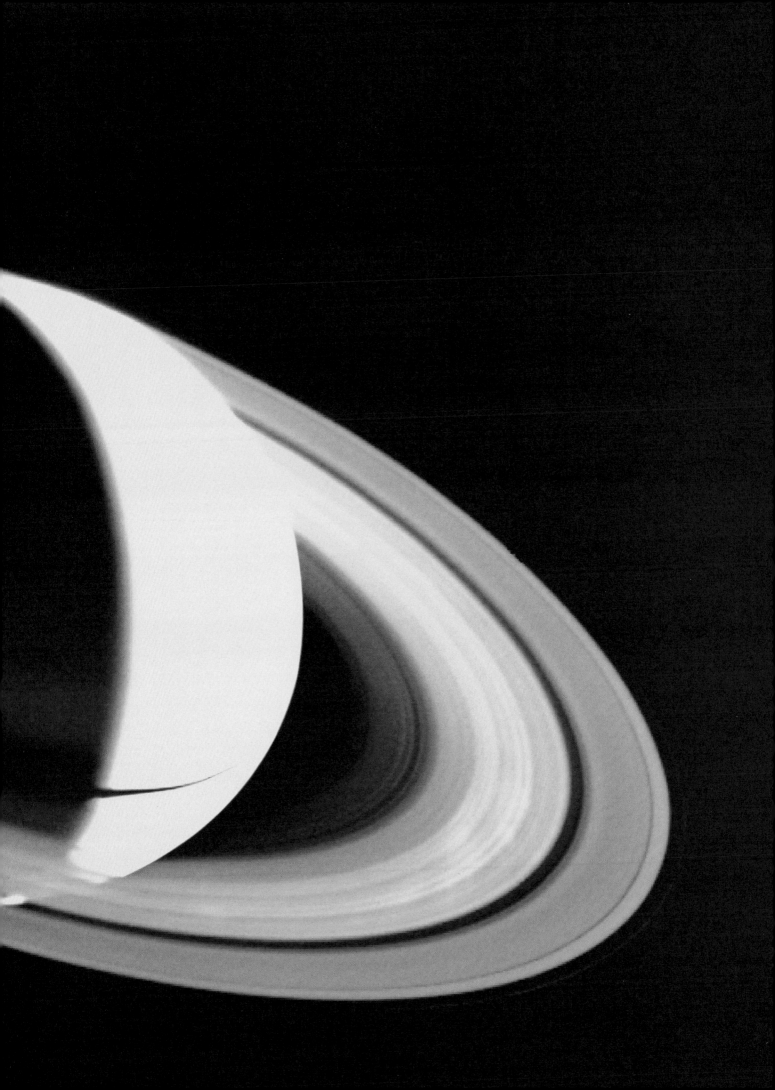

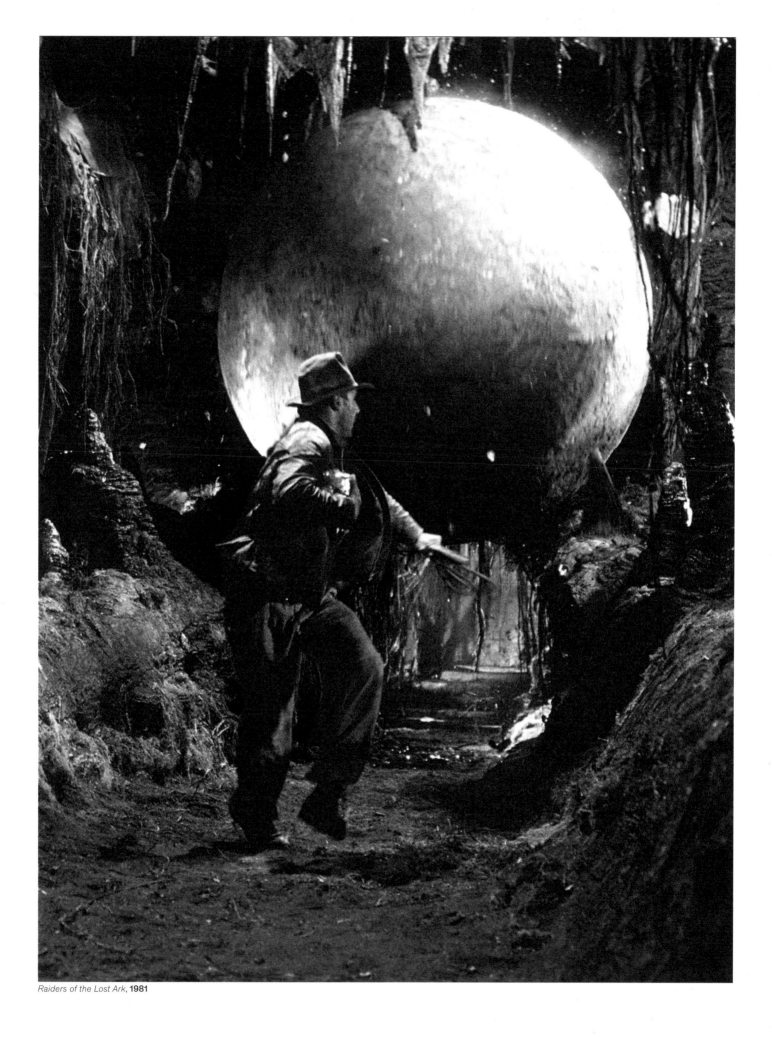

Raiders of the Lost Ark, **1981**

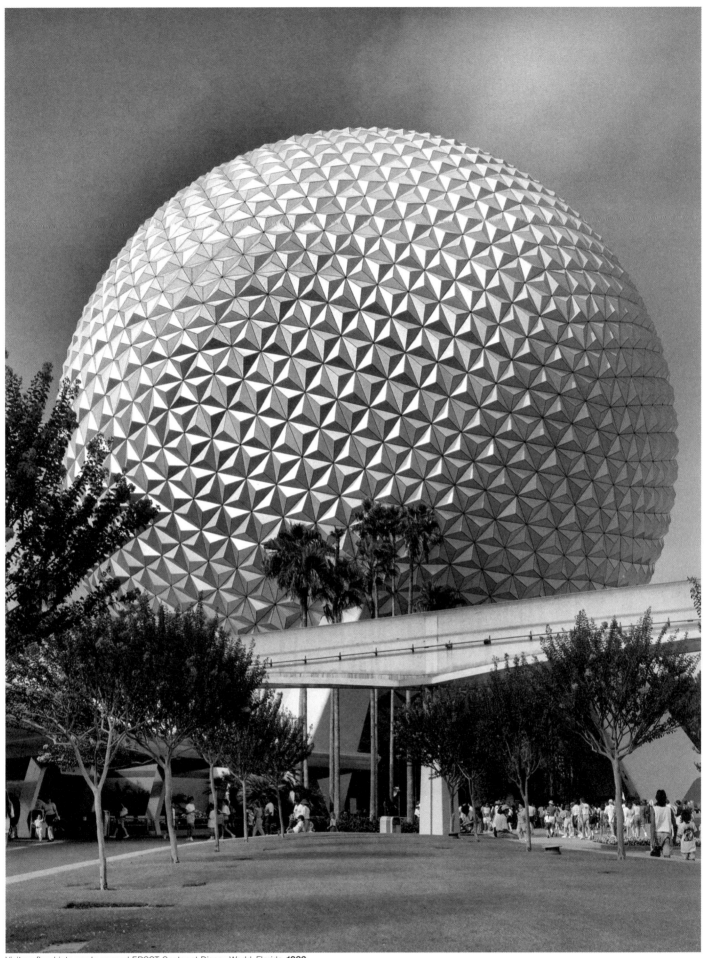

Visitors flood into newly opened EPCOT Center at Disney World, Florida, **1982**

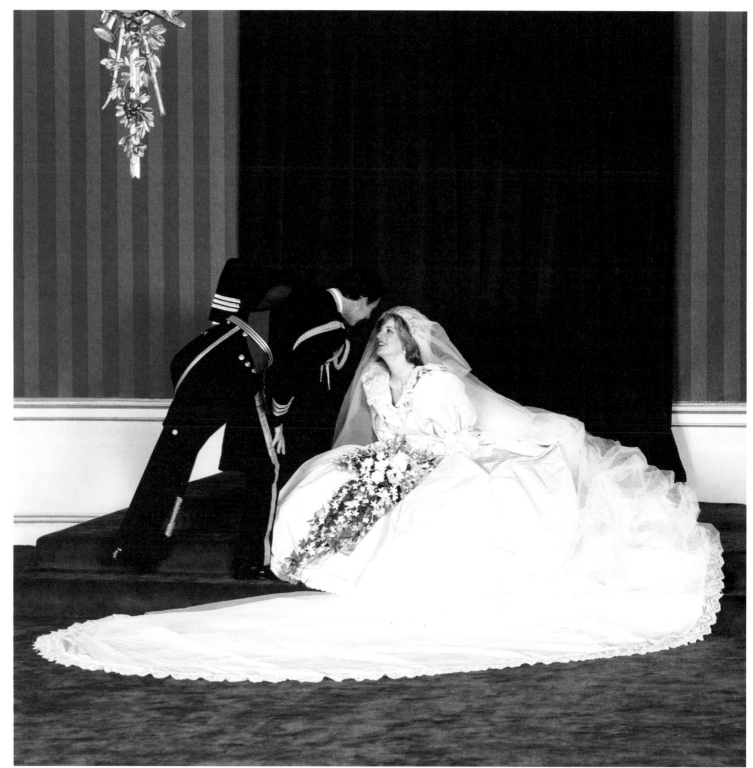

HRH The Prince of Wales and HRH The Princess of Wales on their wedding day, photo by Patrick Lichfield, **1981**

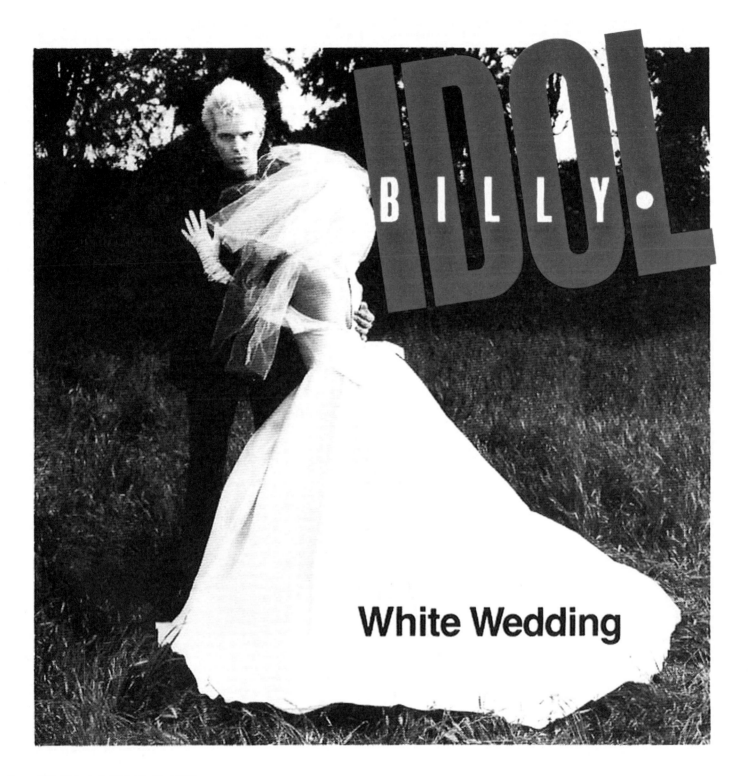

Cover of Billy Idol's single, 'White Wedding', **1982**

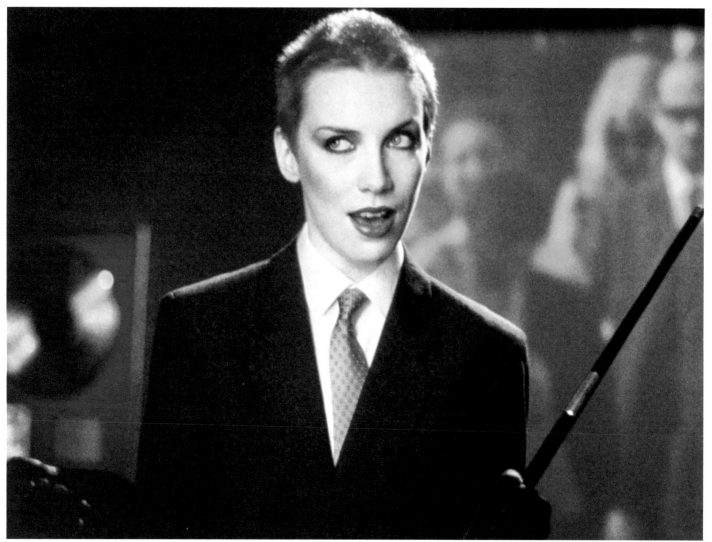

Annie Lennox of Eurythmics, 'Sweet Dreams (Are Made of This)', **1983**

Women were increasingly occupying positions of power across all areas of public life. Was it feminism in action? It wasn't always clear. Cyndi Lauper adopted a rebellious style and declared that 'girls just want to have fun'. Margaret Thatcher didn't seem to care about supporting women in the slightest, but her presence at the top was enough to normalize the idea of a female leader. Sisterhood was, however, a powerful force in what was still a deeply sexist world. Women used protest as an effective weapon to prompt change, relating not just to gender equality, but injustice in general. At the Royal Air Force station at Greenham Common in the UK 30,000 women joined hands around the base to protest nuclear weapons on the site (82). In art, Jenny Holzer eschewed the vagaries of visual language and adopted a more direct form of communication by installing Orwellian-esque statements in public spaces to challenge power structures and rabid consumerism.

Power Women

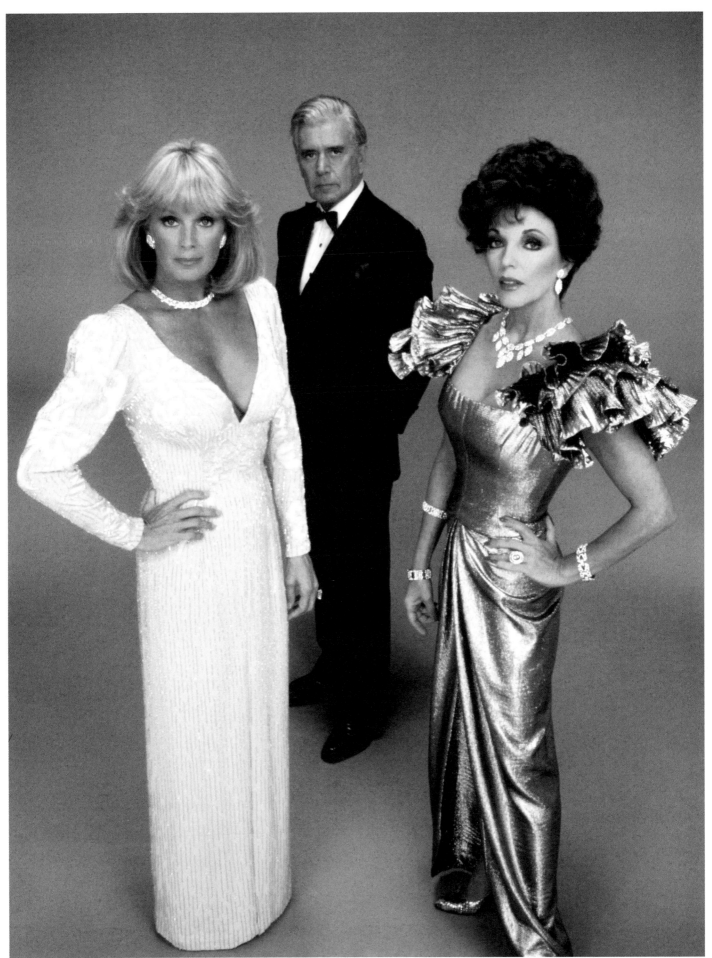

Cast members of *Dynasty*. From left: Linda Evans (Krystle Carrington), John Forsythe (Blake Carrington), Joan Collins (Alexis Colby), **1981**

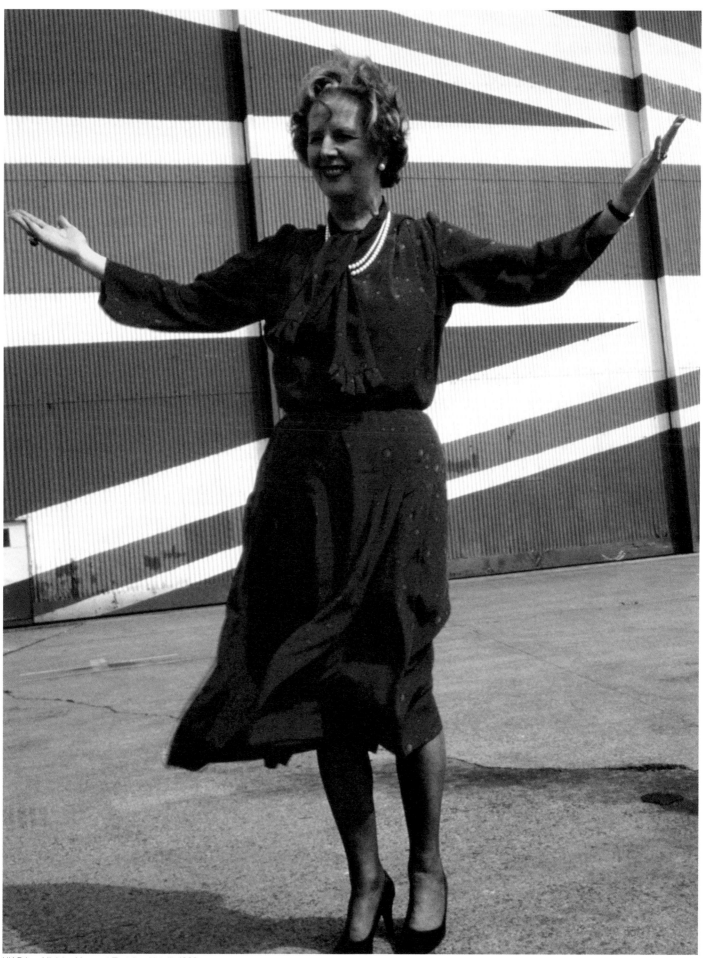

UK Prime Minister Margaret Thatcher (detail), **1983**

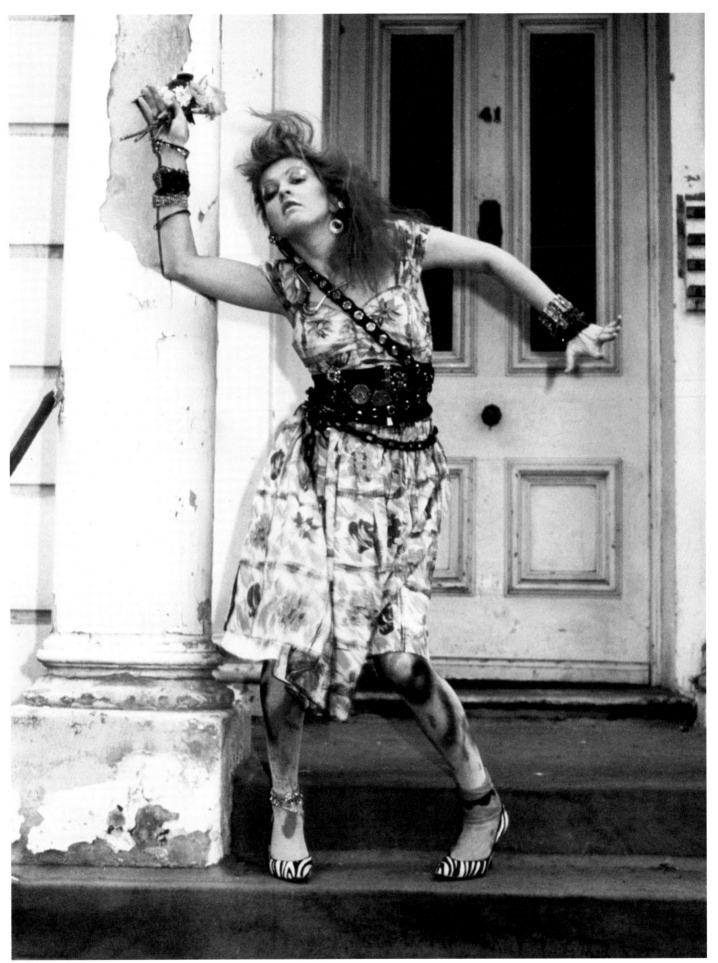

Cyndi Lauper, **1983**

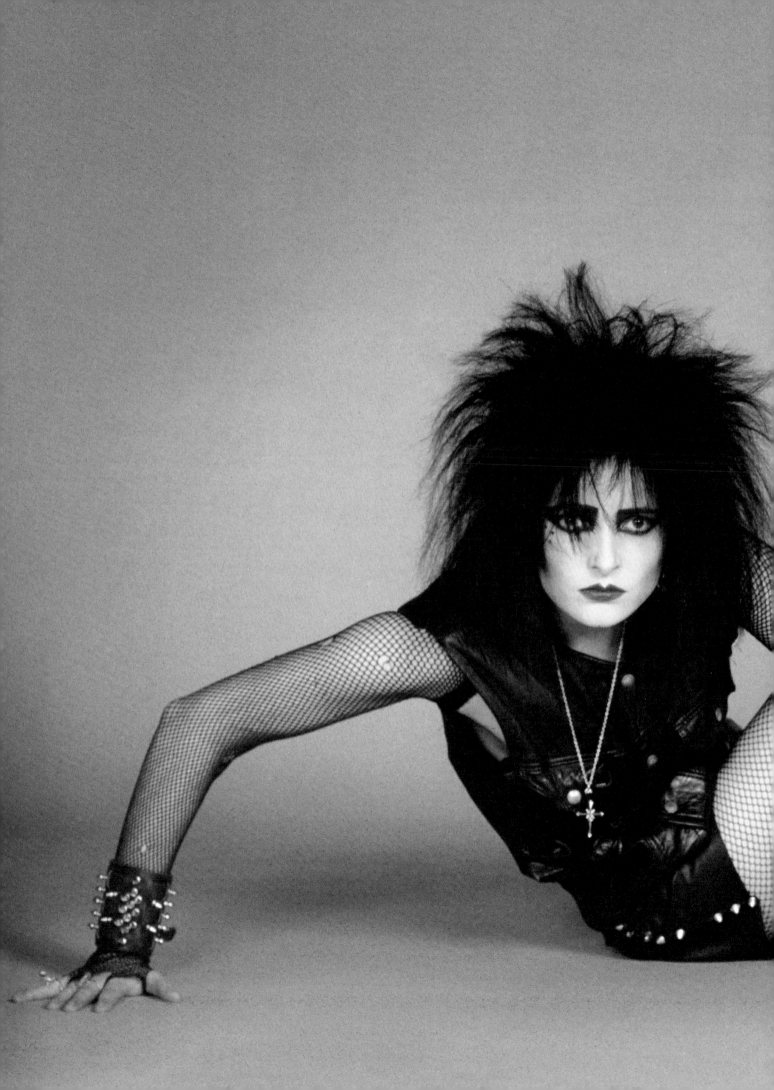

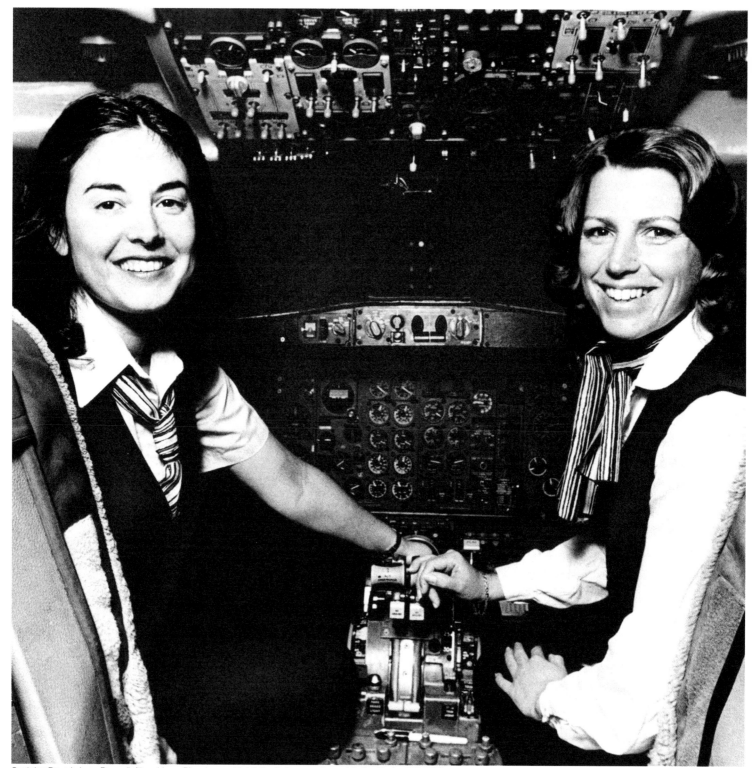

Captains Beverly Lynn Burns (left) and Lynn Rippelmeyer (right), the first women to captain the Boeing 747, **1983**

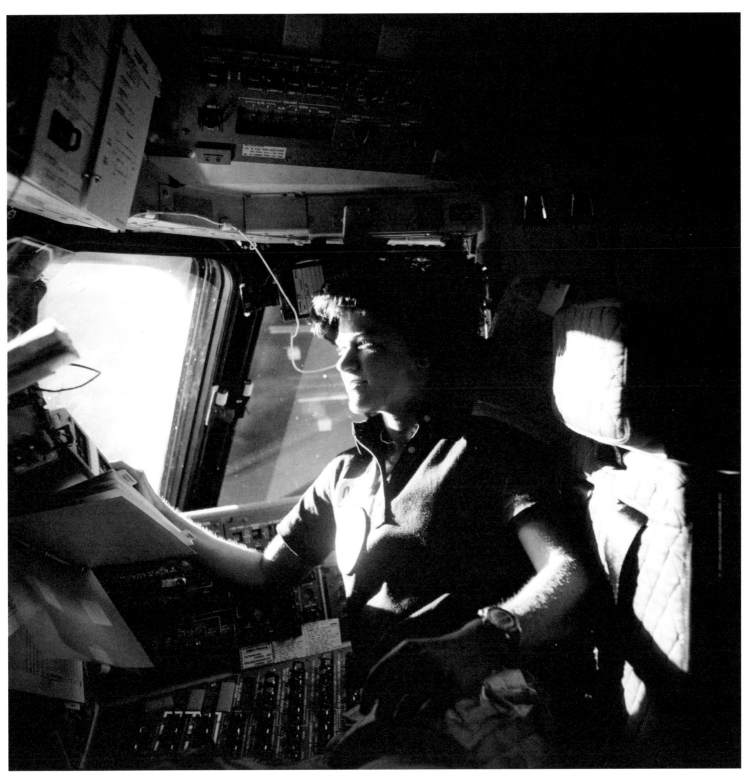

Astronaut Sally Ride, the first American woman to fly in space, orbiting Earth in the Challenger space shuttle, **1984**

(Overleaf) Some of the roughly 30,000 women linking hands around the six-mile (9.6 km) perimeter of
the Royal Air Force base at Greenham Common in protest of American cruise missiles held onsite, **1982**

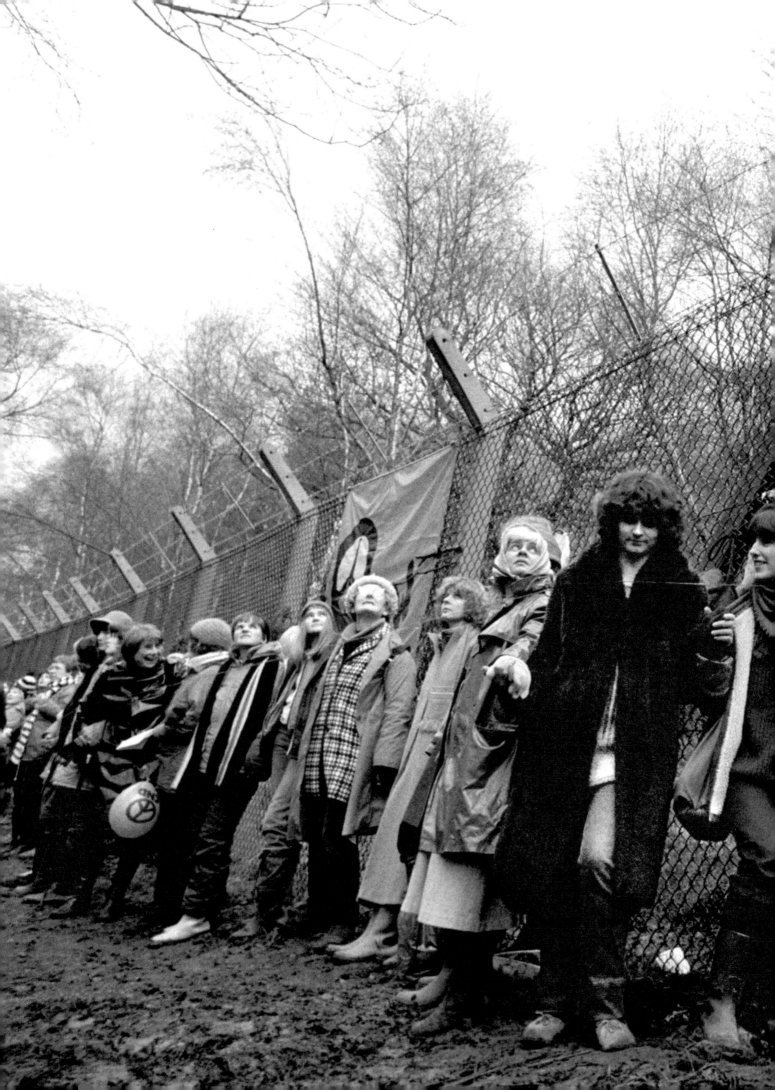

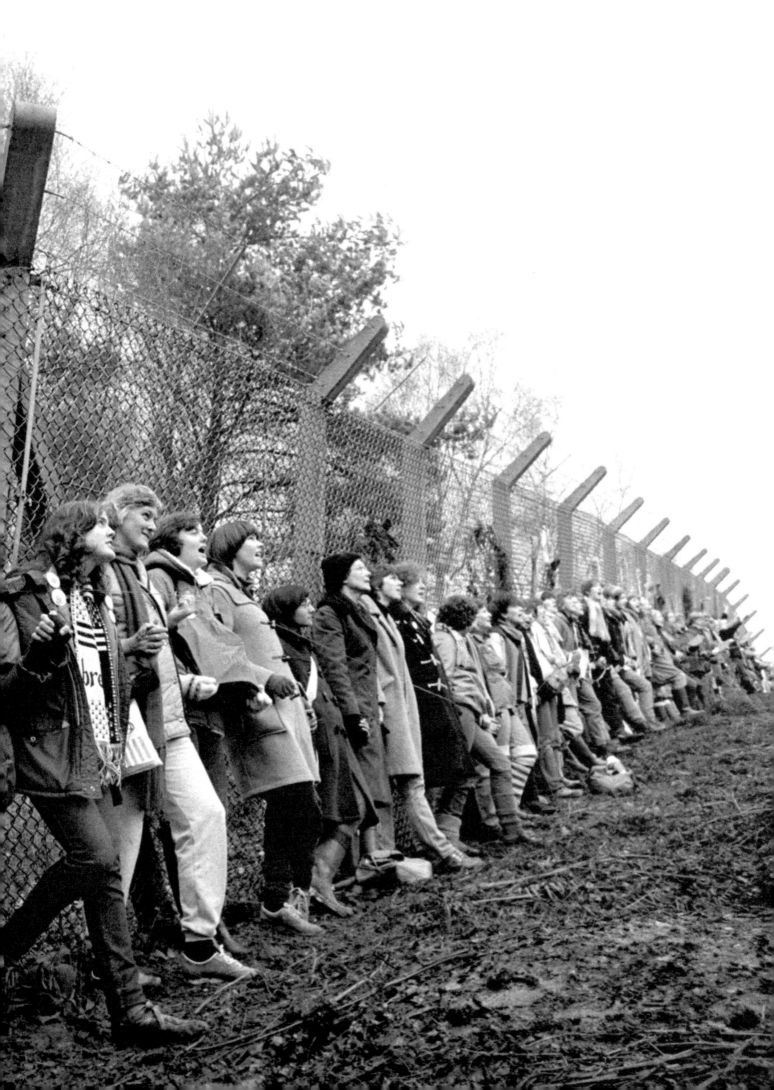

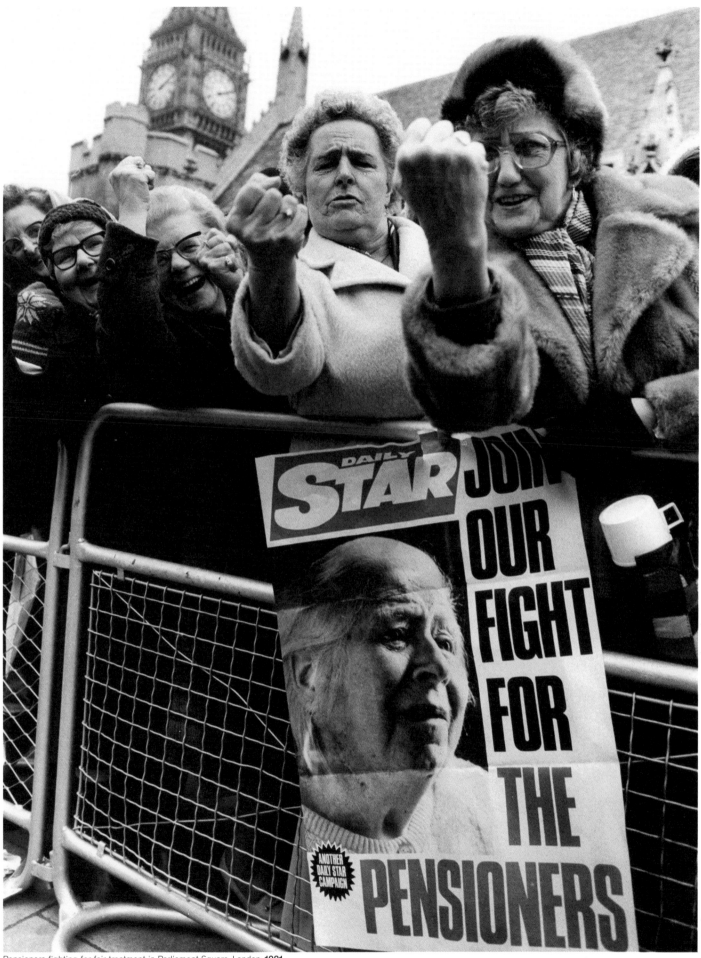

Pensioners fighting for fair treatment in Parliament Square, London, **1981**

Power Women

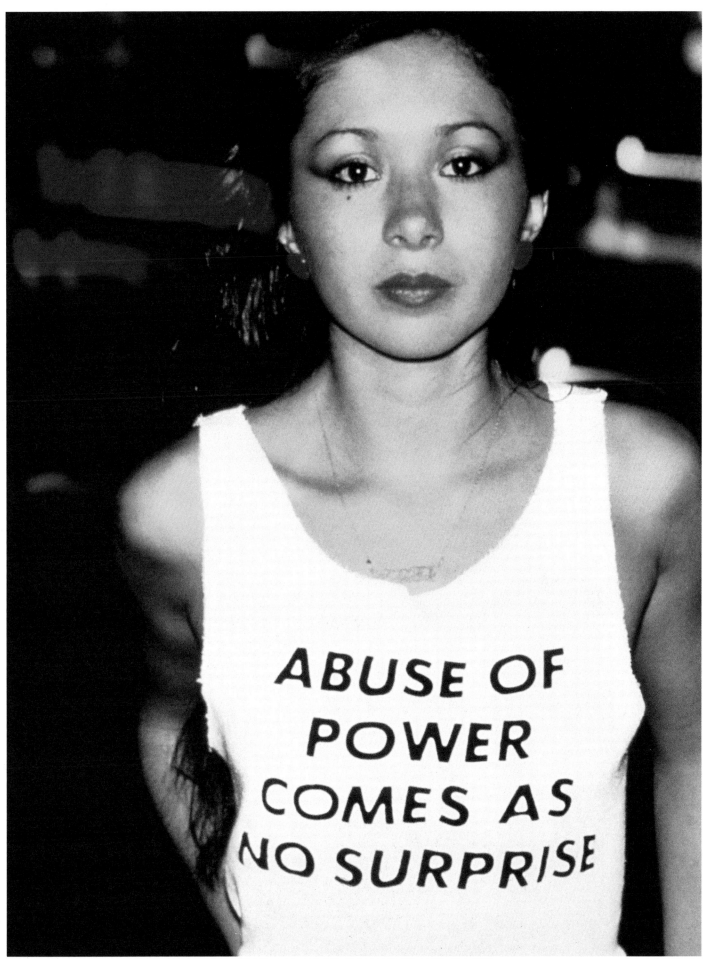

Jenny Holzer, *Abuse of Power Comes as No Surprise*, 'Truism' T-shirt worn by Lady Pink, photo by Lisa Kahane, New York, **1983**

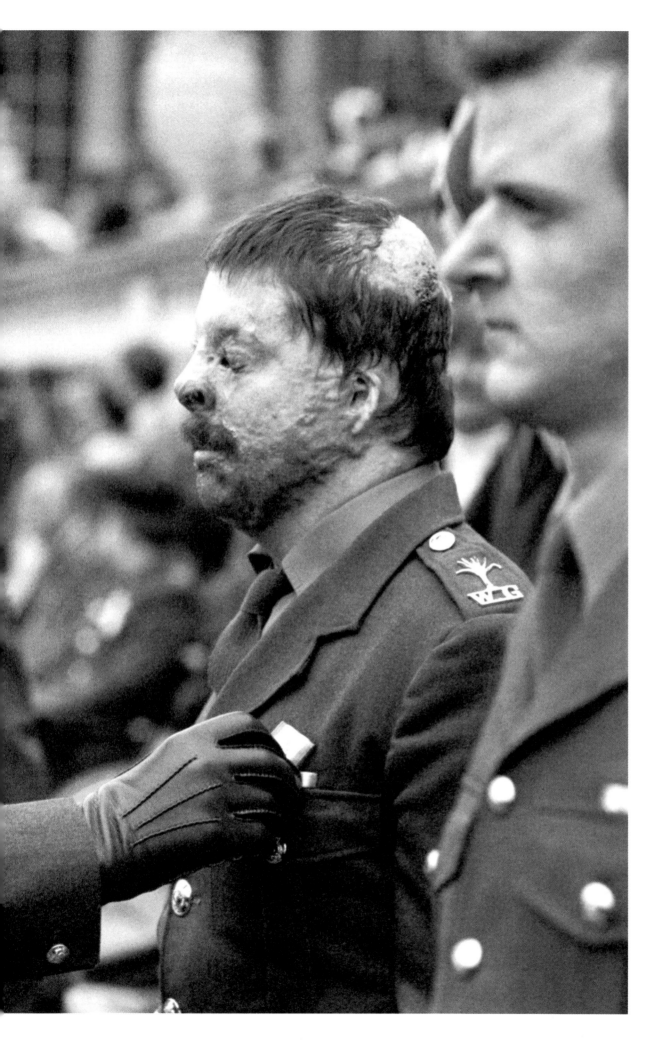

The Duke of Edinburgh pinning the South Atlantic Medal on Guardsman Simon Weston, who suffered severe burns during the Falklands War, **1982**

Gallipoli, **1981**

Flashdance, **1983**

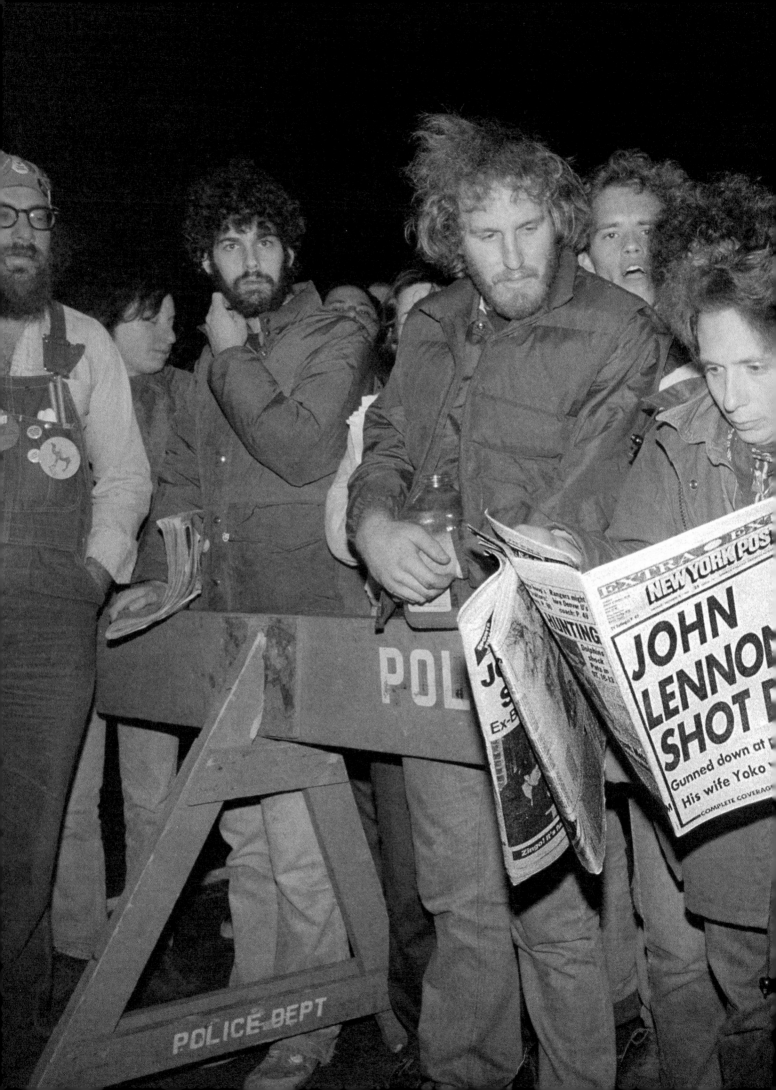

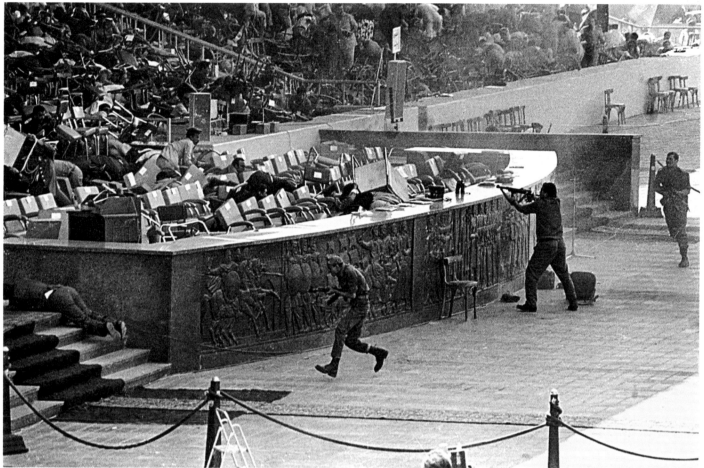

The assassination of President Anwar Sadat during the victory parade in Cairo, **1981**

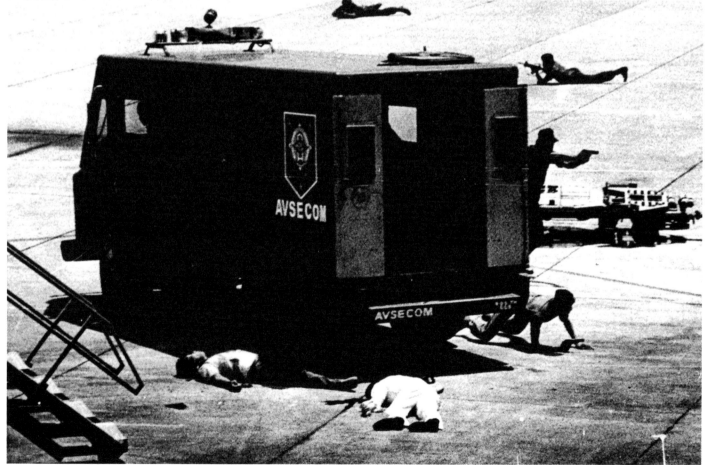

The assassination of Senator Benigno Aquino at Manila International Airport, Philippines, **1983**

Assassinations

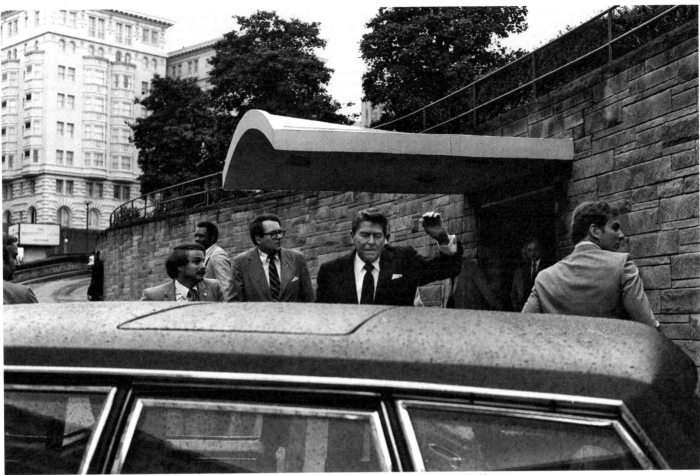

Newly elected President Ronald Reagan waving before he is shot and wounded by John Hinckley Jr. in Washington, D.C., **1981**

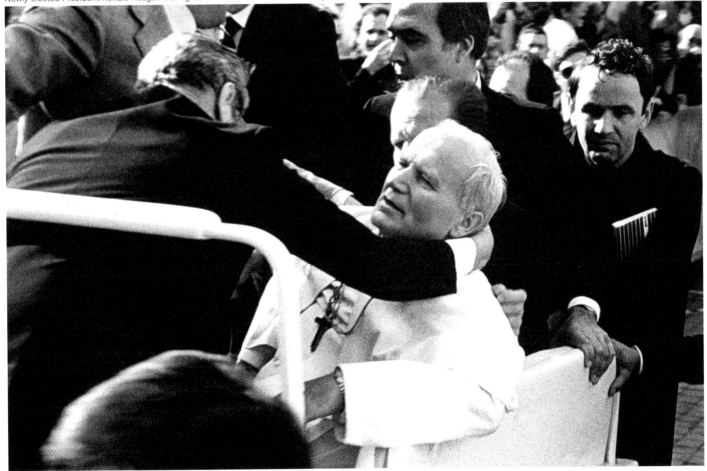

Pope John Paul shot and wounded in St. Peter's Square, Vatican City, **1981**

(Overleaf) The assassination attempt of Texan oil baron J.R. Ewing in the season 3 finale of *Dallas*, **1980**
(94–95) Magnified image of HIV-infected cells, **1984**

Who sl

not JR?

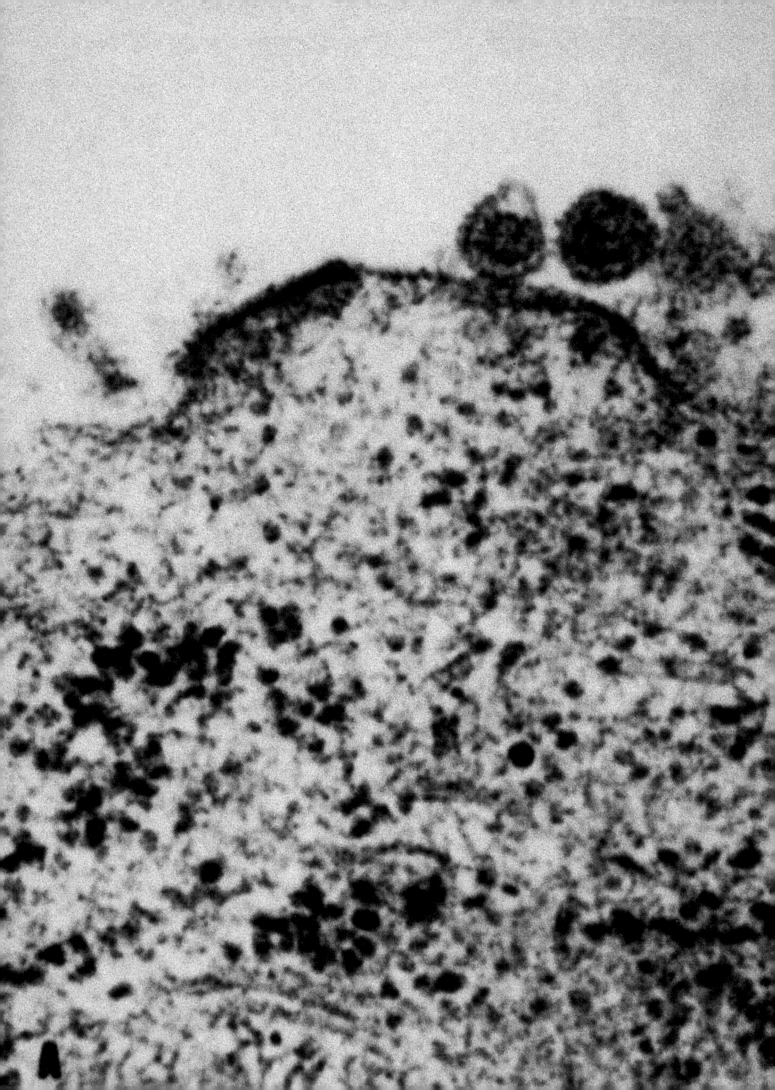

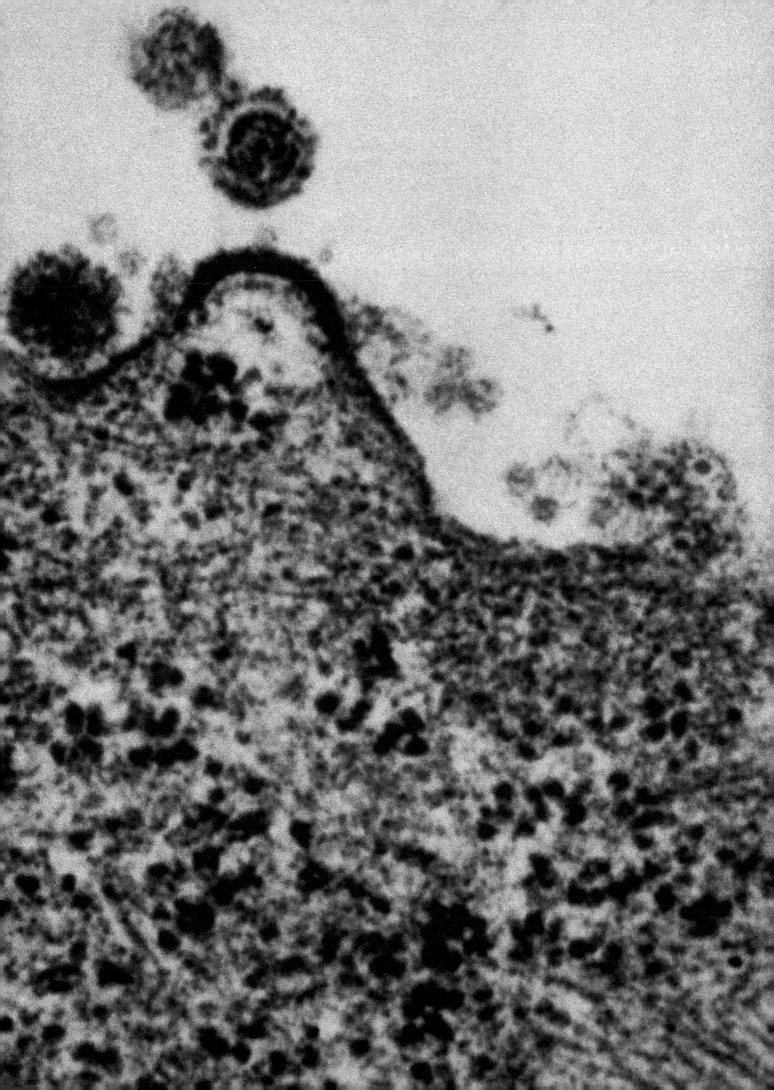

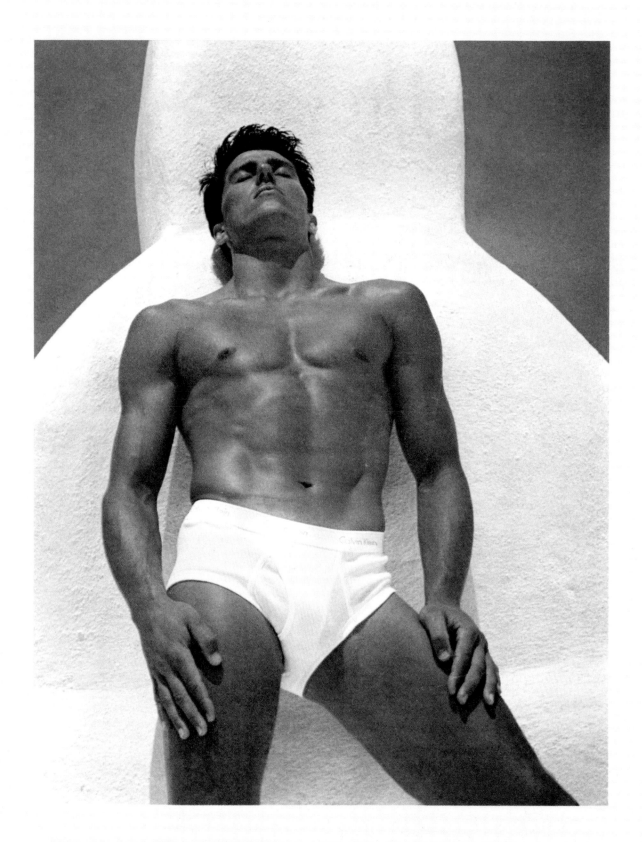

Calvin Klein Underwear

Advertisement for Calvin Klein featuring Tom Hintnaus, **1983**

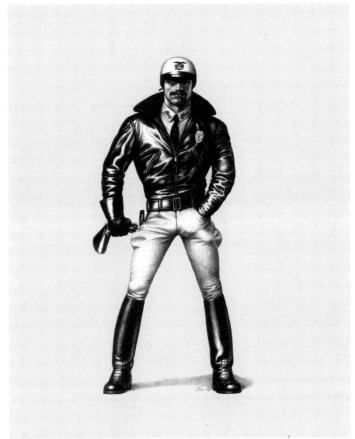

Tom of Finland, *Untitled*, **1981**

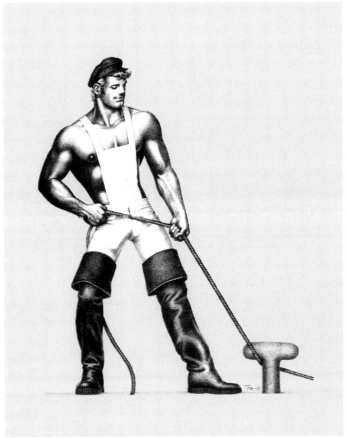

Tom of Finland, *Untitled*, **1981**

As attitudes around sexuality and gender were being challenged, a new image of
the male body emerged: impossibly powerful, tanned and toned. Calvin Klein's first
underwear ad (83) caused a sensation in magazines and on billboards. The drawings of
Tom of Finland were a homoerotic delight with their depictions of strong, well-endowed
men in uniform, and Robert Mapplethorpe's sensual photographs of muscular White
and Black men engaged in extreme BDSM acts confronted gallery-goers with a new
perspective on human intimacy. In a culture of fierce homophobia, these representations
of powerful, healthy gay men challenged notions that being homosexual meant being
weak and effeminate. But this buff body could also be a symbol of regressive politics:
the massive muscles of Sylvester Stallone as Rambo in *First Blood* (82) and Arnold
Schwarzenegger in *Conan the Barbarian* (82) symbolized male continuity and control in
a world where feminism, communism and gay rights all threatened the traditional order.

Macho Macho Men

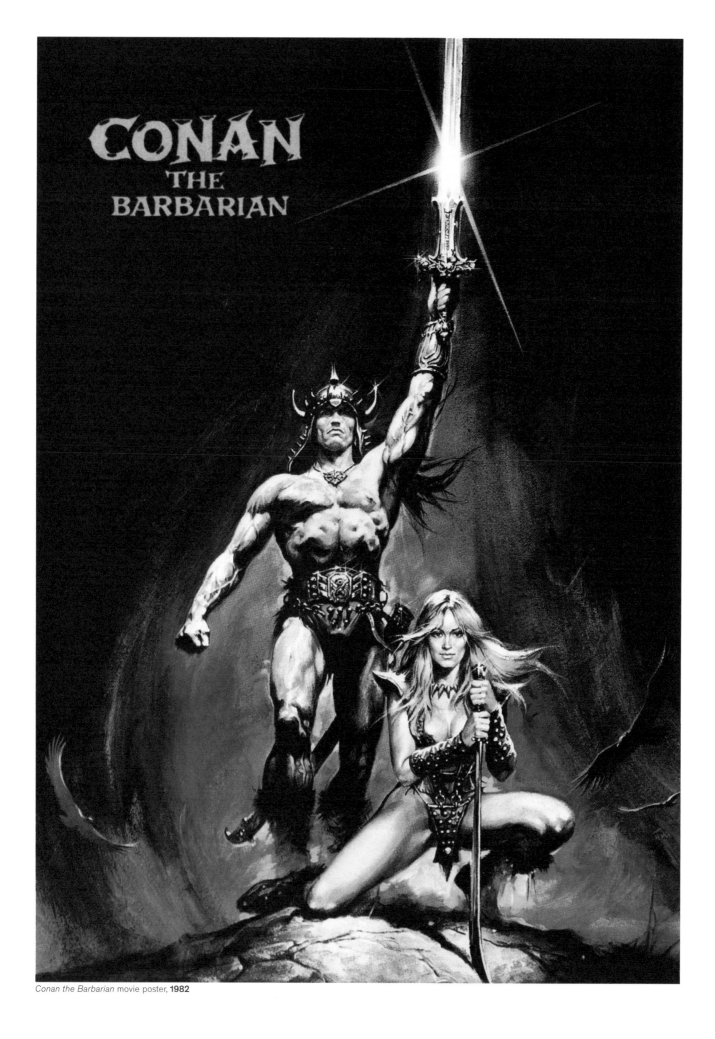

Conan the Barbarian movie poster, **1982**

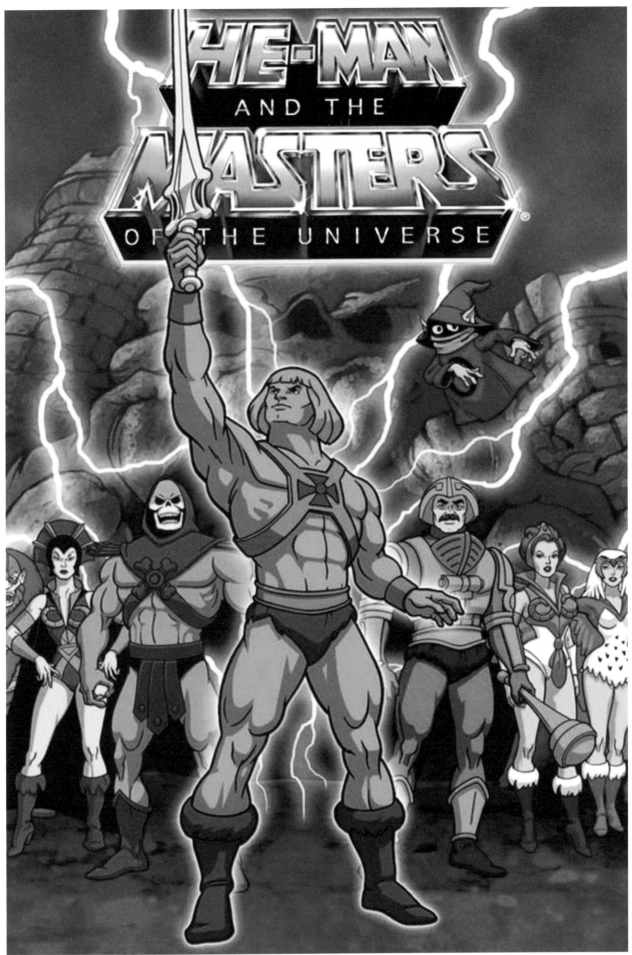

He-Man and the Masters of the Universe, **1983**

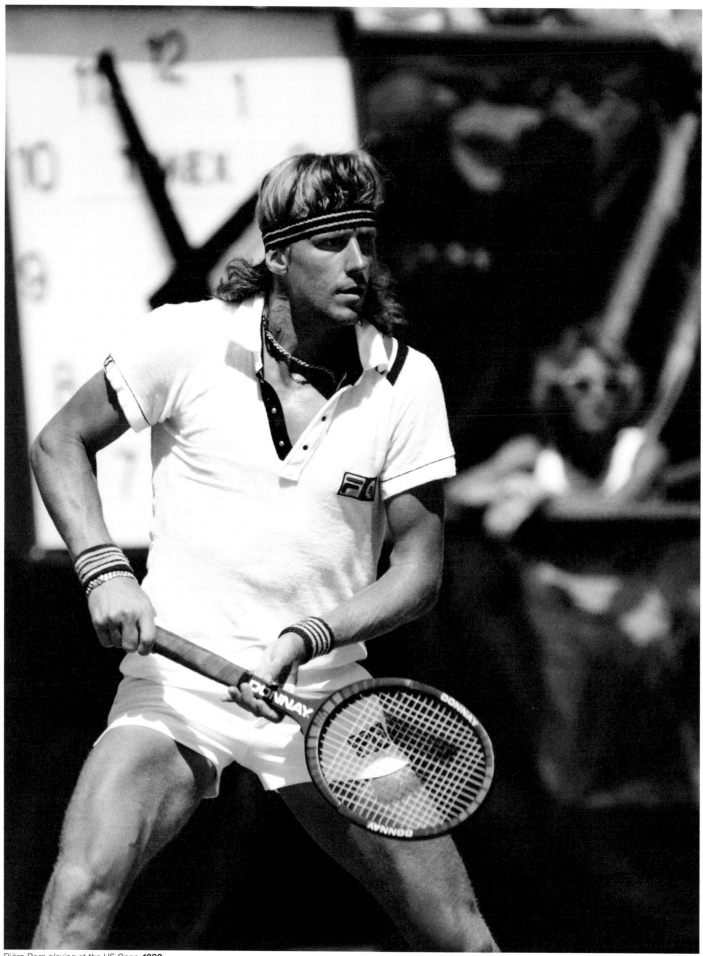

Björn Borg playing at the US Open, **1980**

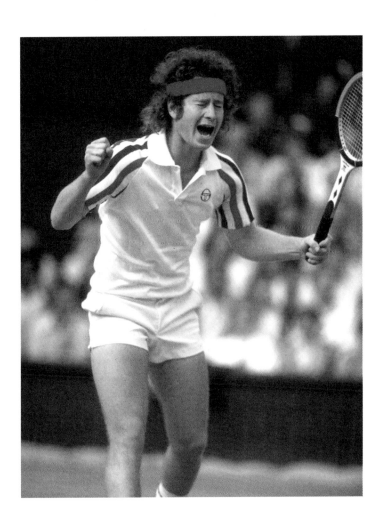

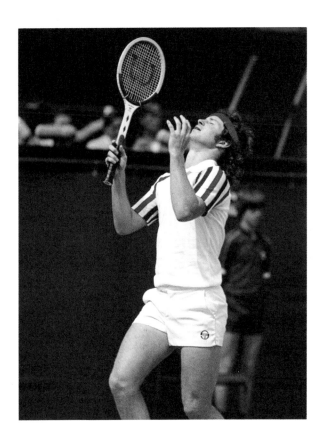

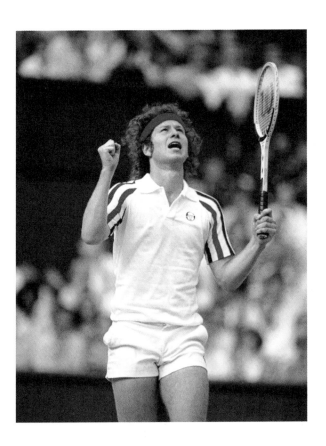

John McEnroe during the Wimbledon Men's Singles Final, which he lost in five sets to Björn Borg, **1980**

(Overleaf) Olivia Newton-John, 'Physical', **1981**

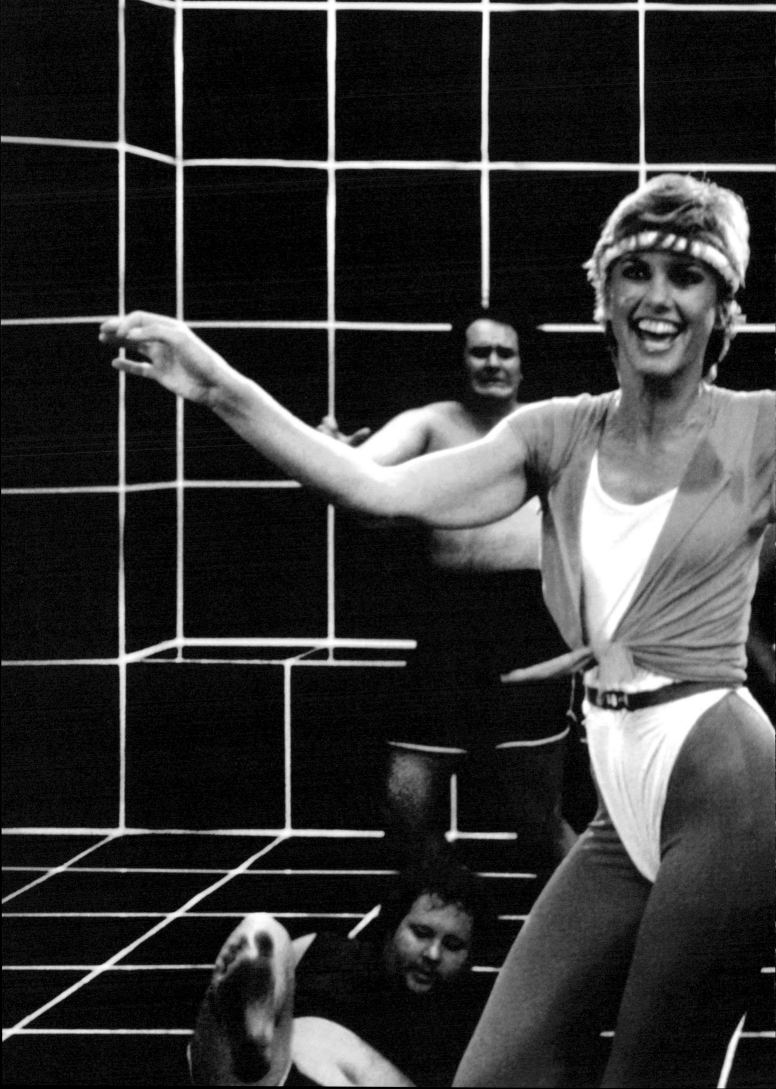

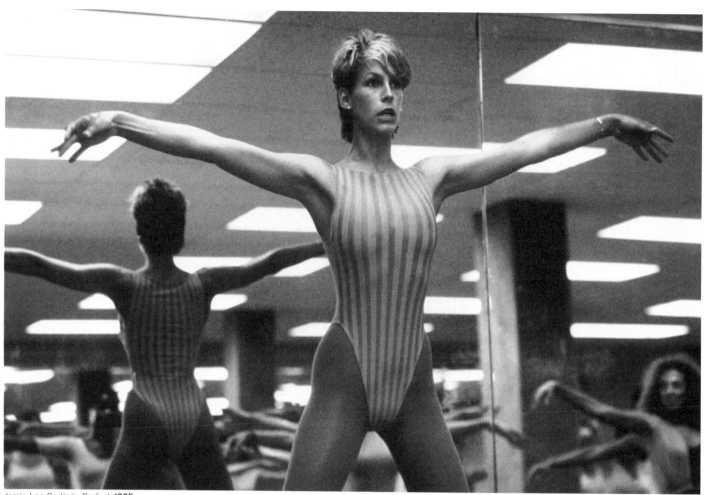

Jamie Lee Curtis in *Perfect*, **1985**

'Discipline is liberation', a phrase chanted by Jane Fonda in her workout videos, became a mantra for many 80s women. Aerobics wasn't simply about keeping fit. It was a way of taking control of one's time and body. Now that VHS players were commonplace, aerobics could be practised at home, in front of the TV, guided by instructors like Fonda, whose colour-coordinated, body-sculpting activewear sparked a new style that was sexy and powerful. Alongside fitness crazes like Jazzercise, dance and female empowerment became an ongoing theme in entertainment throughout the decade. In music, Olivia Newton-John out-danced men to near cardiac arrest in the music video for 'Physical' (81), and in movies like *Flashdance* (83), *Footloose* (84), *Perfect* (85) and *Dirty Dancing* (87), female leads used dance as a way to achieve professional ambitions, confront repression, challenge masculinity and escape patriarchal rule.

Getting Physical

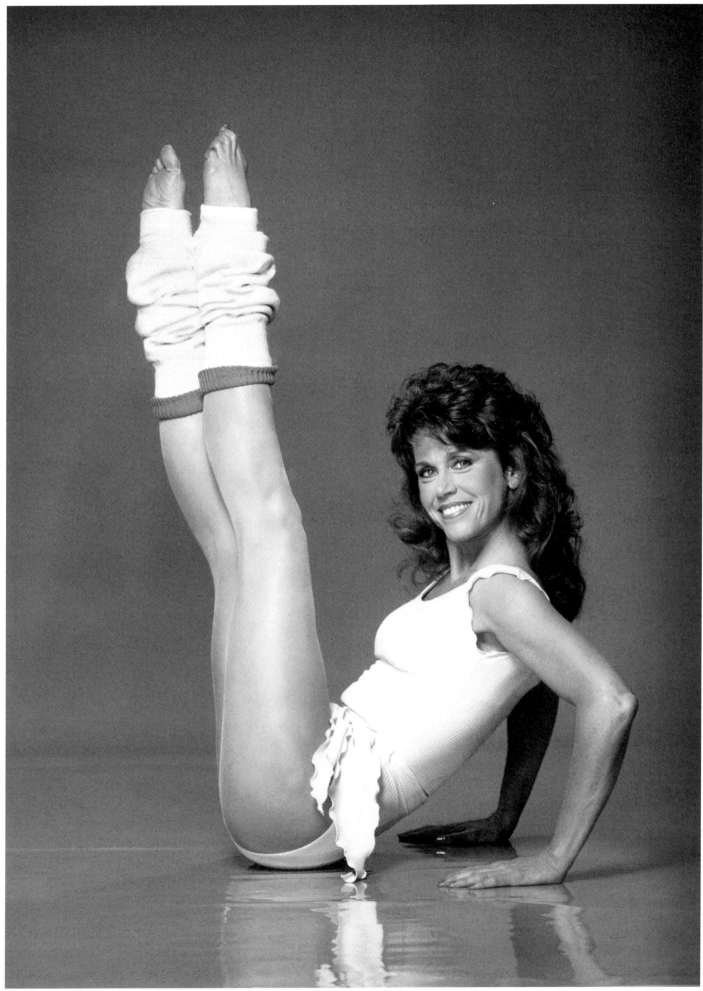

Jane Fonda, *c.* 1985

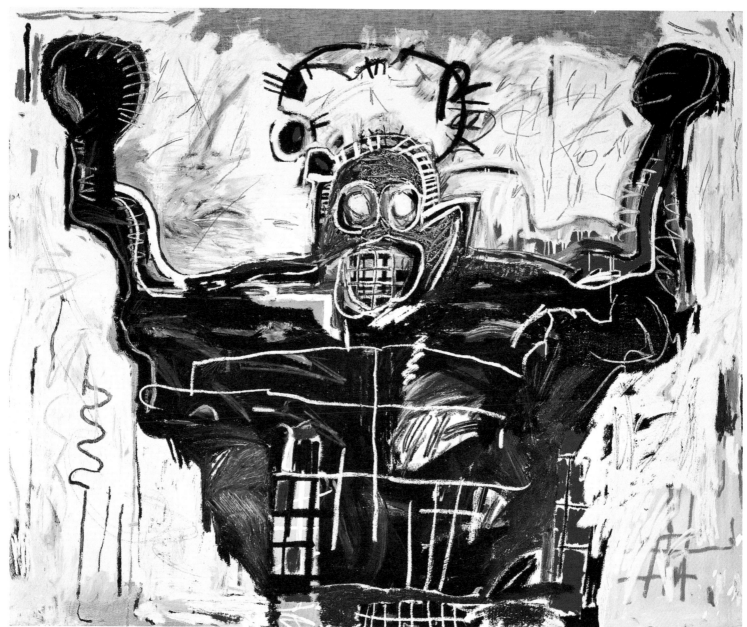

Jean-Michel Basquiat, *Untitled (Boxer)*, **1982**

Getting Physical

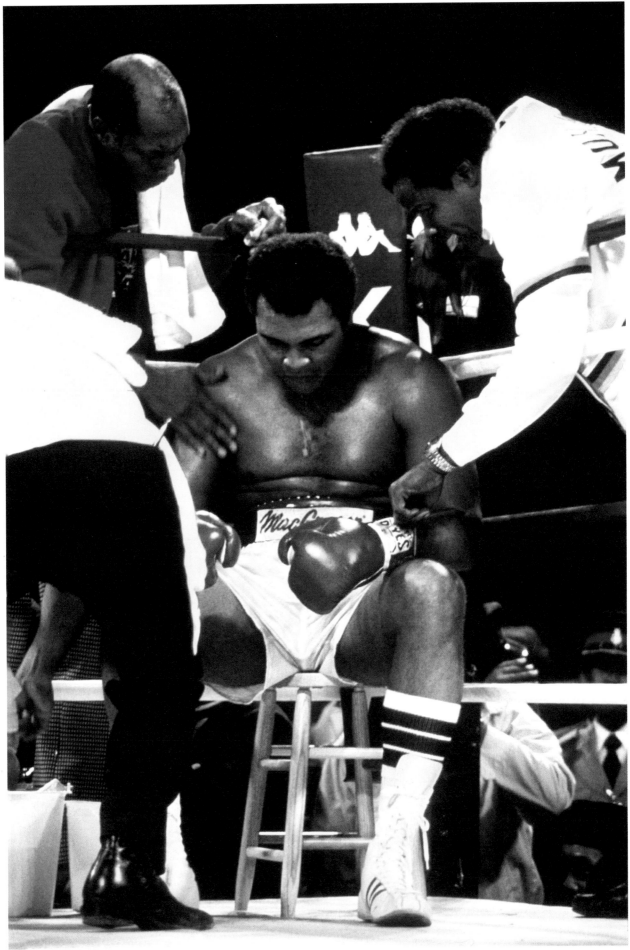

Muhammad Ali during his final fight, **1981**

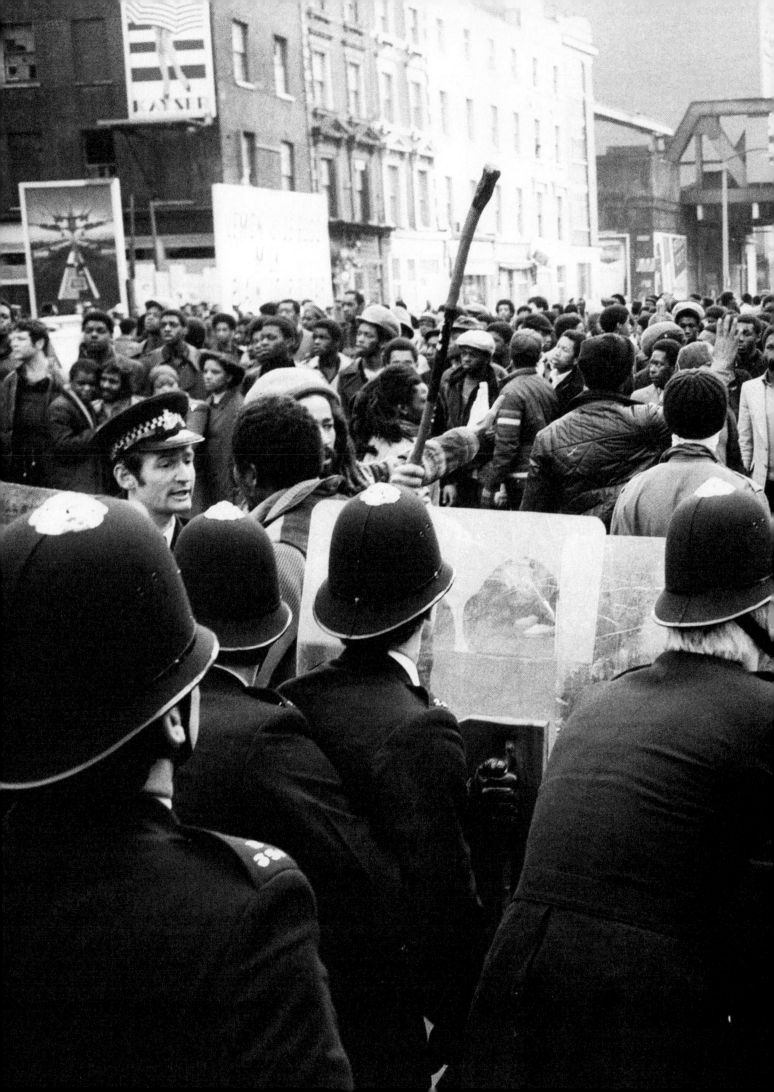

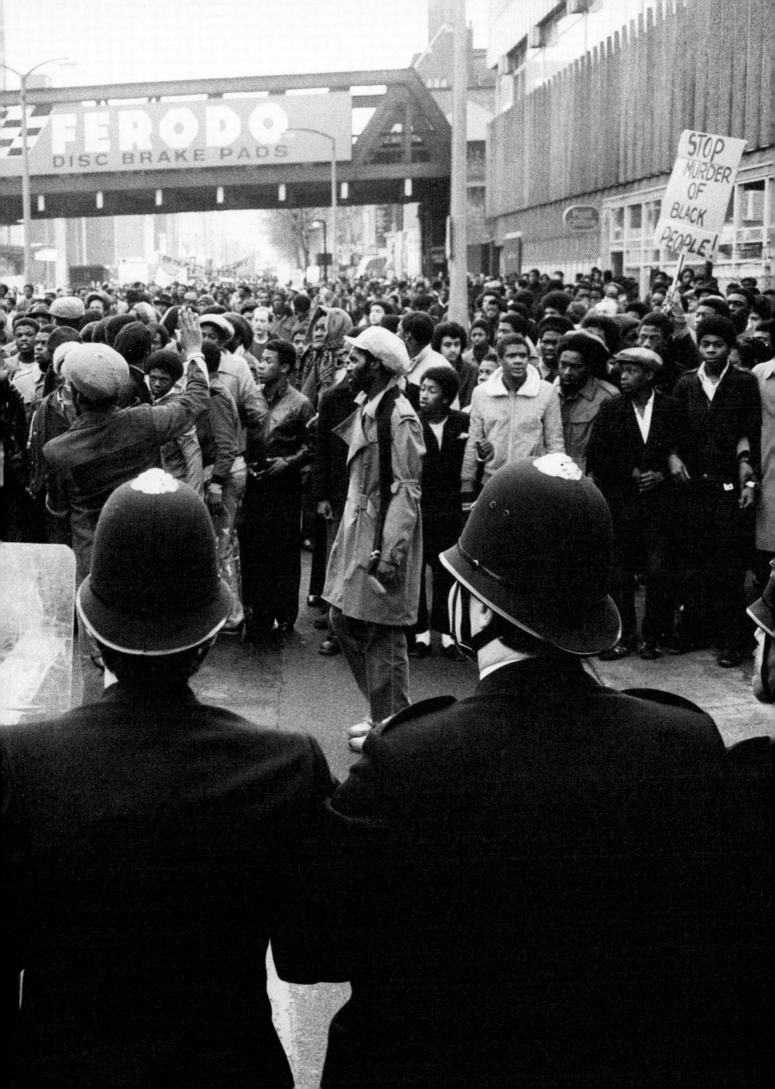

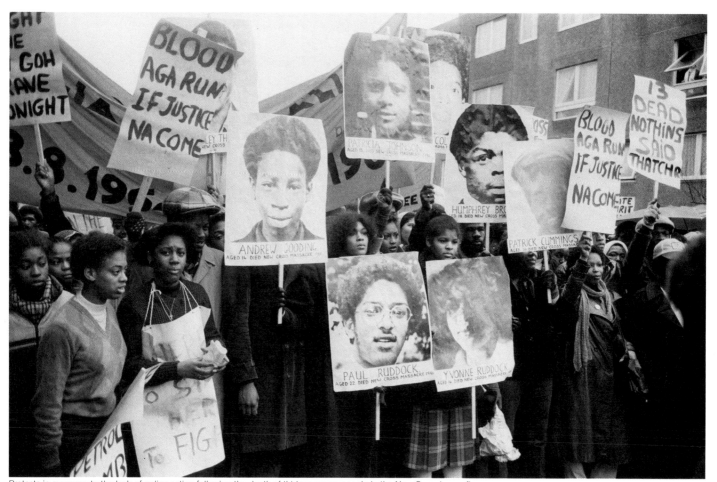

Protests in response to the lack of police action following the death of thirteen young people in the New Cross house fire, believed to have been racially motivated, Deptford, London, **1981**

Race riots ignited in Miami and London. Apartheid raged in South Africa. Meanwhile, movie makers, musicians and fashion brands took it upon themselves to try to set things straight. Paul McCartney and Stevie Wonder released 'Ebony and Ivory' (82), Hollywood leaned into the Black cop / White cop dynamic with films like *48 Hours* (82) and Benetton launched its 'All the Colours of the World' campaign. Perhaps these attempts to show how Blacks and Whites can work together in 'perfect harmony' were well-intentioned. Perhaps they were opportunistic and crass. Wherever you might land on that one, the 80s did provide a platform for more influential Black creatives across music, film and art to rise to the top. And while actors like Eddie Murphy often found themselves stuck playing stereotypical Black roles, *The Cosby Show* (84) was a pivotal moment in mainstream TV with its depiction of an upper-middle class family in Brooklyn who just so happened to be Black.

Race Relations

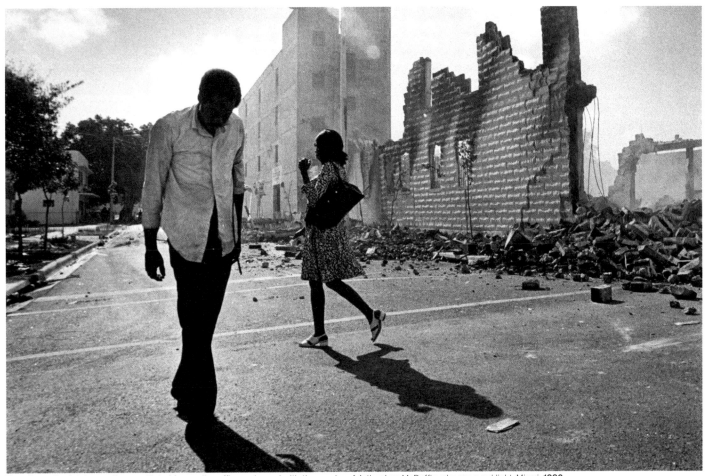
The aftermath of riots over the acquittal of four police officers charged with the murder of Arthur Lee McDuffie, who ran a red light, Miami, **1980**

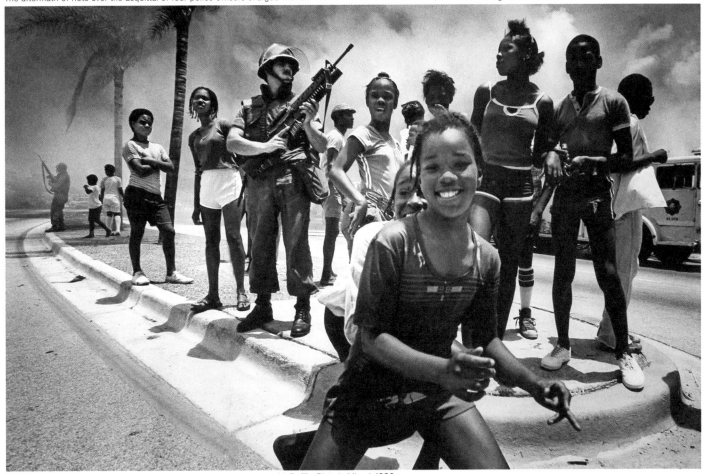
Children posing alongside a Florida National Guard soldier during the McDuffie Riots in Miami, **1980**

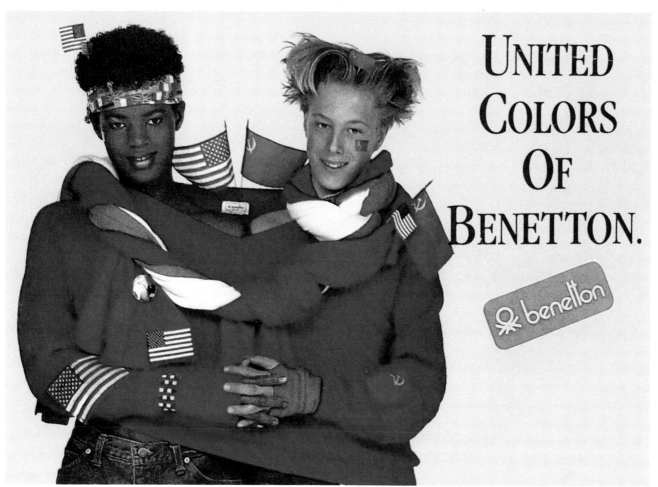

'Flags', Benetton advertisement, **1985**

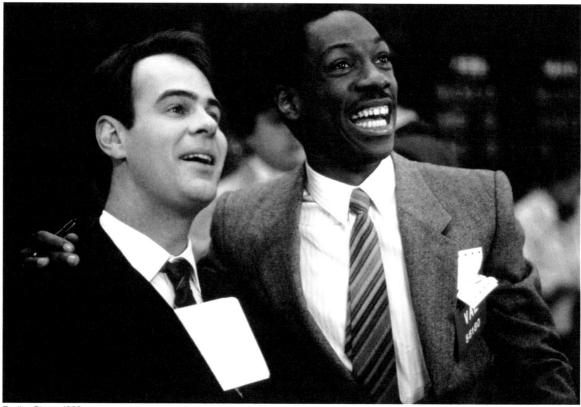

Trading Places, **1983**

Race Relations

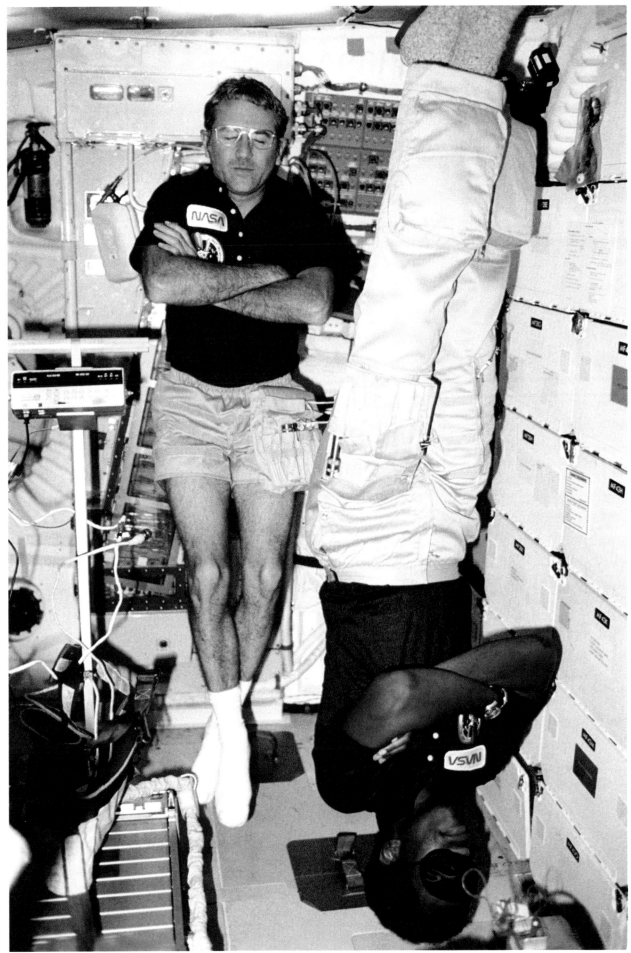

Commander Richard Truly (left) and Mission Specialist Guion Bluford (right), the first African American in space, taking a nap aboard the Challenger space shuttle, **1983**

(Overleaf) Eric Fischl, *Untitled*, **1984**

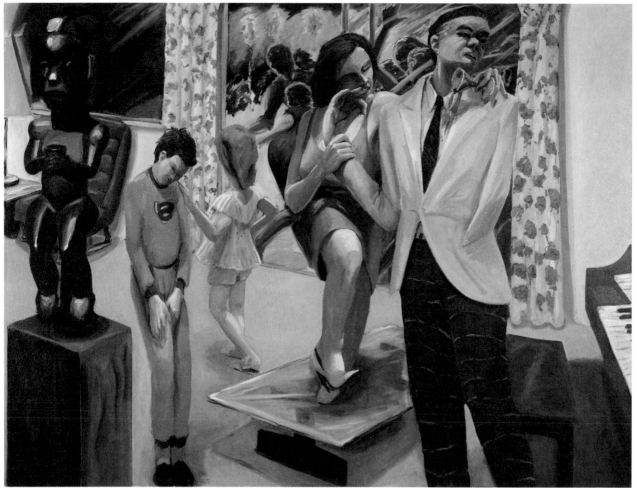

Eric Fischl, *Time for Bed*, **1981**

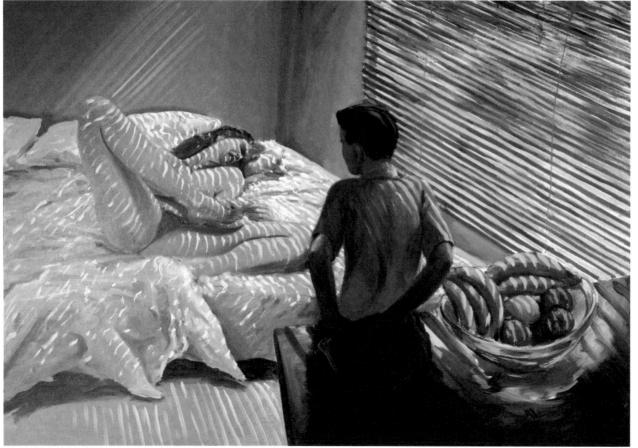

Eric Fischl, *Bad Boy*, **1981**

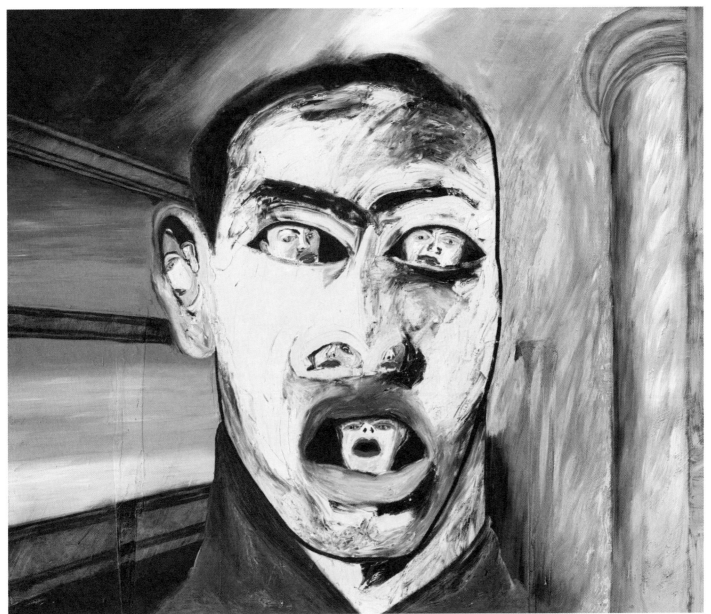

Francesco Clemente, *Name*, 1983

As audiences grew tired of the dry intellectualism of 70s conceptual art, a hunger grew for the raw viscerality of paint. Enter Neo-Expressionism (or *Transavanguardia* as it was known in Italy, along with *Neue Wilden* in Germany and *Figuration Libre* in France). Artists such as Anselm Kiefer, Eric Fischl and Francesco Clemente embraced the physicality of oil on canvas and favoured figurative works over abstract. There was a kind of catharsis to how the paint was getting pushed around: big gloopy gestures and an almost violent enthusiasm for mark making. Technique and subject matter came together to create emotional and disquieting images that commented on a spectrum of social issues, from war to race and sexual liberation.

The Painters Strike Back

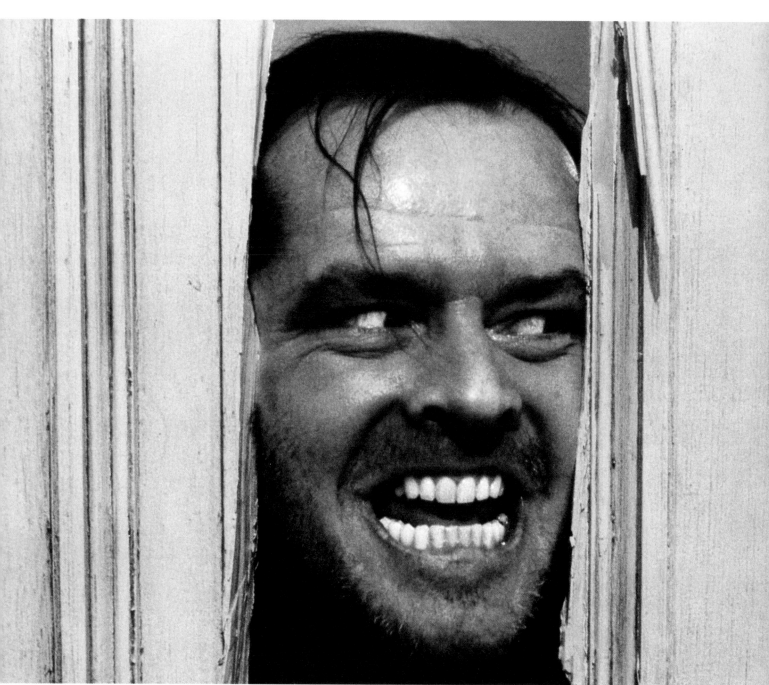

The Shining, **1980**

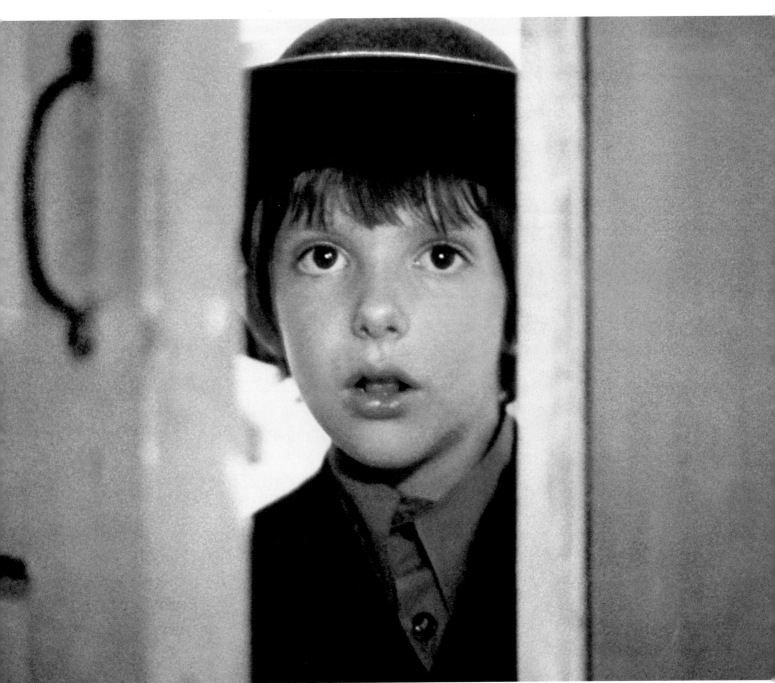

Witness, **1985**

Coming For Your Kids

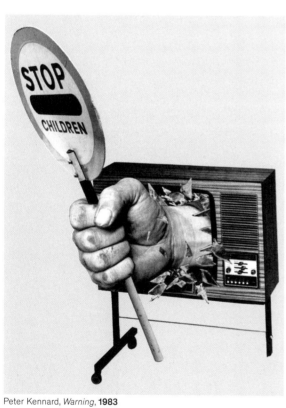

Peter Kennard, *Warning*, 1983

Videodrome, **1983**

Poltergeist movie poster, **1982**

Coming For Your Kids

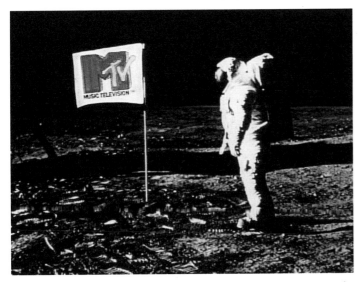

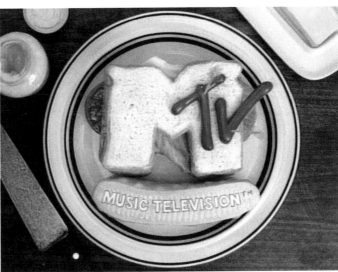

'We can't rewind, we've gone too far … Pictures came and broke your heart … Rewritten by machine on new technology…' The lyrics from the first music video aired on MTV say it all. 'Video Killed the Radio Star' by The Buggles blasted from TV sets one minute after midnight on 1 August 1981. Music's leap into the visual created a new, highly experimental arena for emerging directors to showcase their talents, and the release of videos like Michael Jackson's 'Thriller' (83) were nearly as hotly anticipated as blockbuster movies. And MTV wasn't the only new and disruptive channel to emerge in the early 80s. CNN started pumping out twenty-four-hour news the year before MTV's debut, and Channel 4, a left-leaning station championing youth culture, launched in the UK in 1982.

(Above) MTV logos. Used with permission. ©2023 Viacom International Inc. All Rights Reserved
(Overleaf) *The Thing*, 1982

Teen Wolf, **1985**

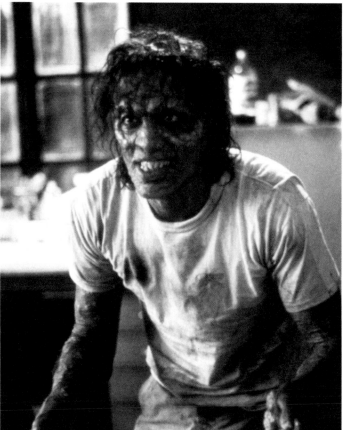

The Fly, **1986**

The unleashing of monsters was a recurring trope in B-movies, mainstream Hollywood fare and music videos alike. As new media, new technology, new holes in the ozone layer and a new deadly virus all added anxiety to everyday lives, audiences watched bodies being constrained, disfigured and morph into grotesque beings. The werewolf became a recurring inner demon in movies like *Teen Wolf* (85) and *An American Werewolf in London* (81) and in the music video for *Thriller* (83). In *The Fly* (86) technology gone wrong was the catalyst for monstrous change when an eccentric scientist endured a slow, Kafka-esque demise after testing his new teleportation device.

Fear of Change

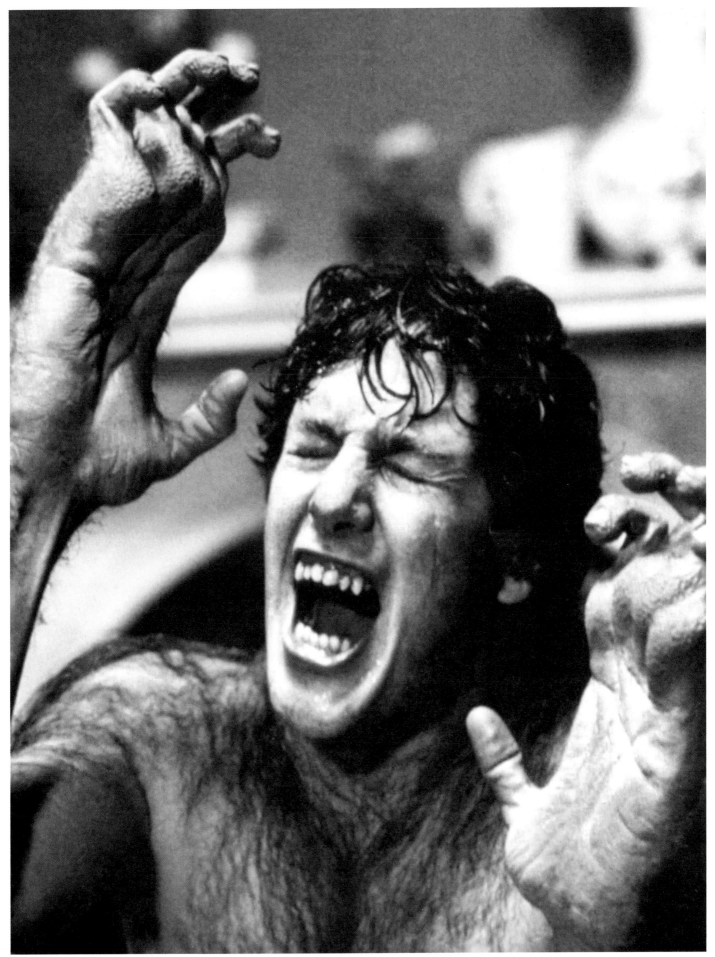

An American Werewolf in London, **1981**

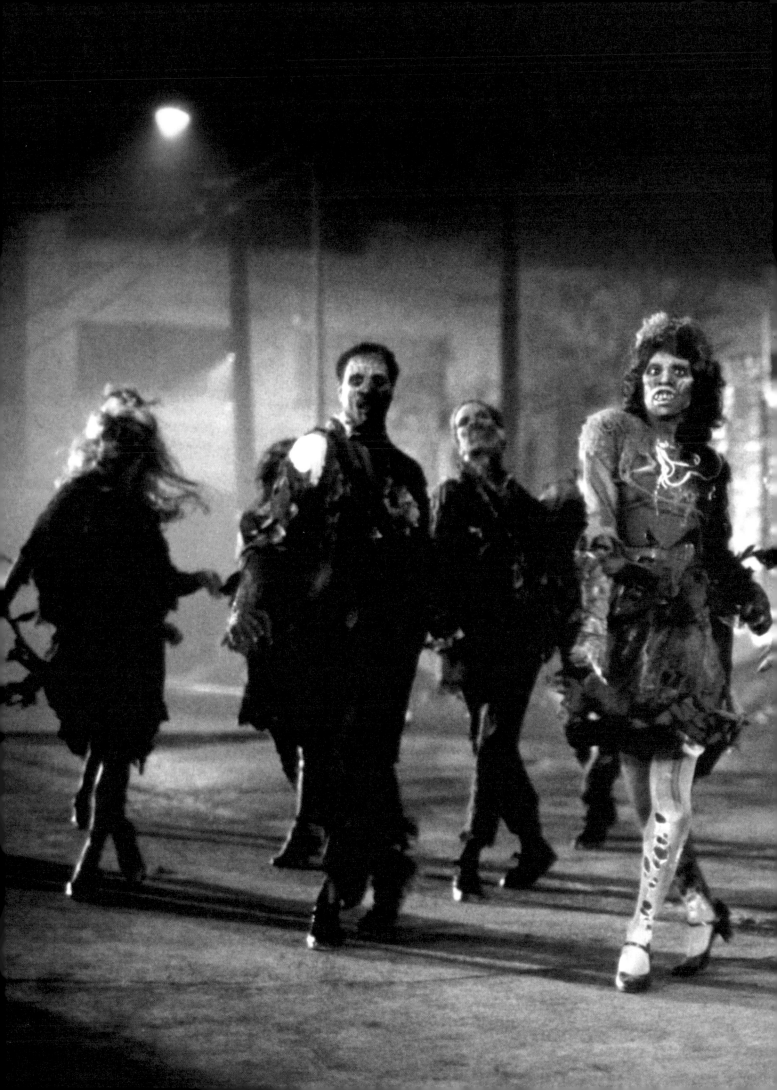

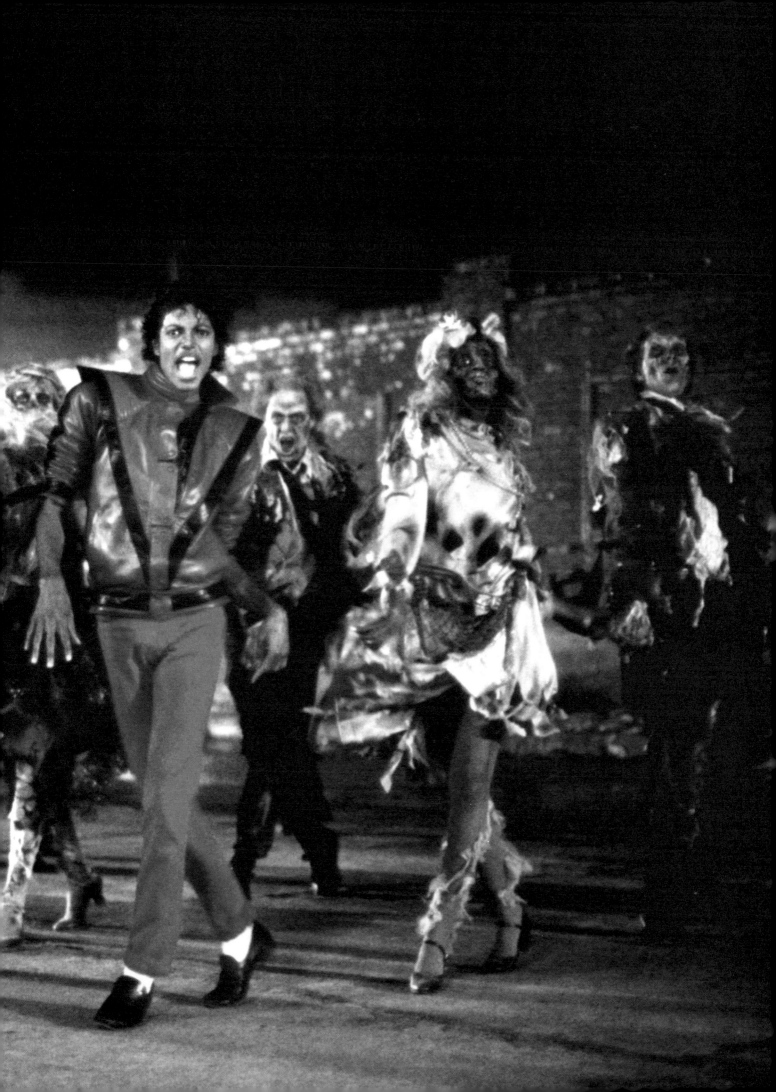

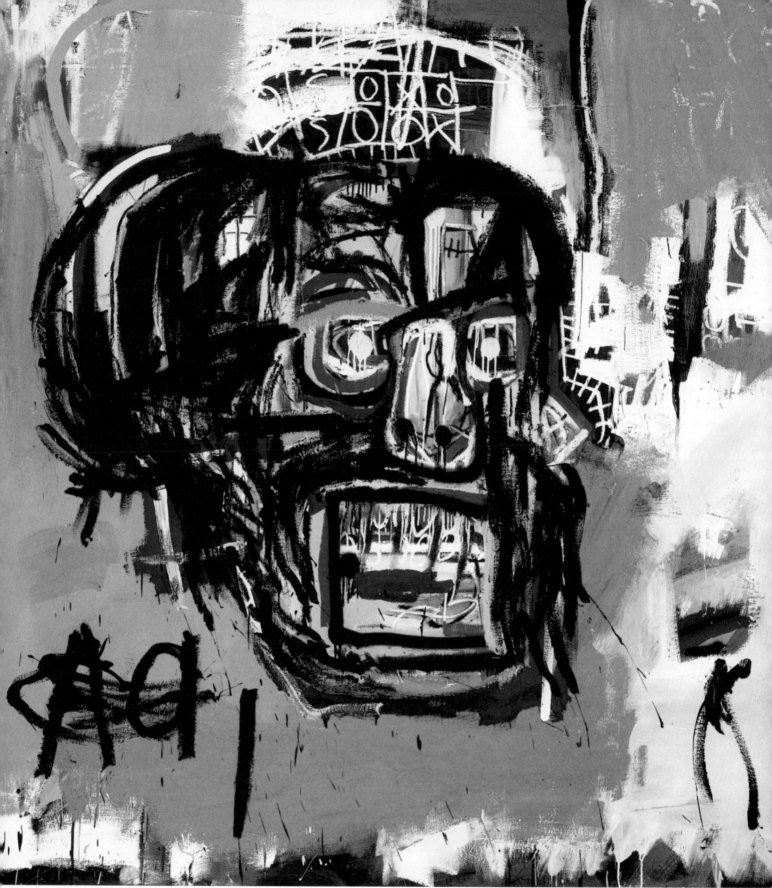

Jean Michel Basquiat, *Untitled*, **1982**

130

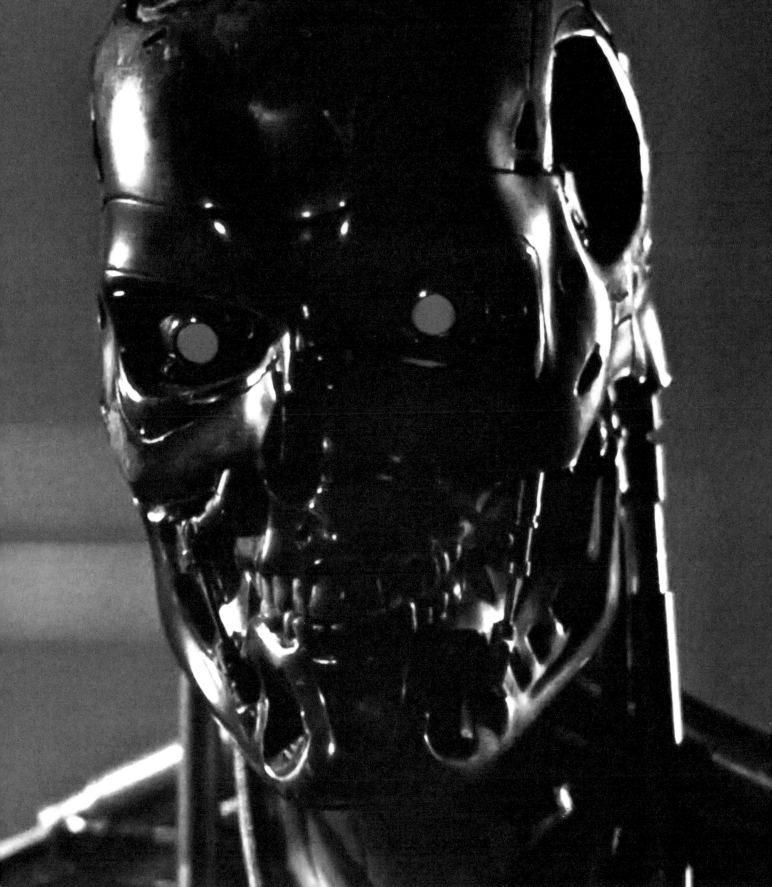

The Terminator, **1984**

KITT from *Knight Rider*, **1982**

In the early years of the decade, computers went from being room-sized abstractions to desktop-size boxes, commonplace in offices. At home, new gaming consoles like the Sega SG-1000 and the Nintendo NES revived a dying industry now that kids could play arcade-style games in their bedrooms. As the capabilities of computers and processing power increased, so did anxiety about a loss of control and existential fears about technology taking over. While the TV show *Knight Rider* (82) presented a harmonious relationship between a man and his artificially intelligent car named KITT, more dystopian visions of the future were seen in cyber punk and tech noir films. In *Blade Runner* (82) and *The Terminator* (84), cybernetic beings replaced humans and raised questions about transhumanism and the sentience of machines. While these preoccupations were not new, they did start to feel a little more real, and a little more urgent, now that computers were part of our daily lives.

Thief, **1981**

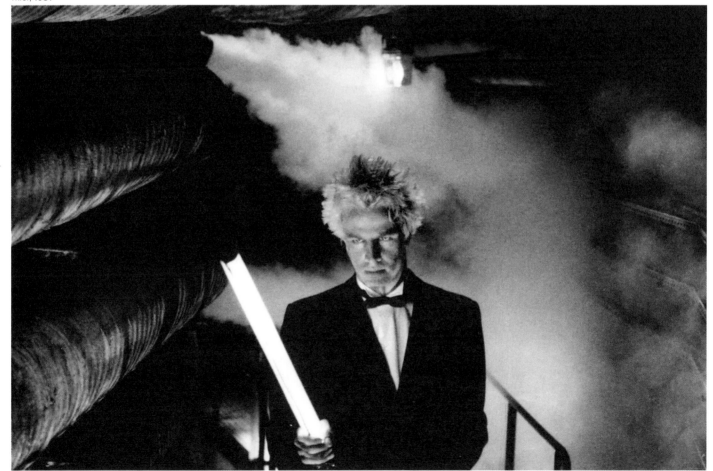

Subway, **1985**

Man vs. Machine

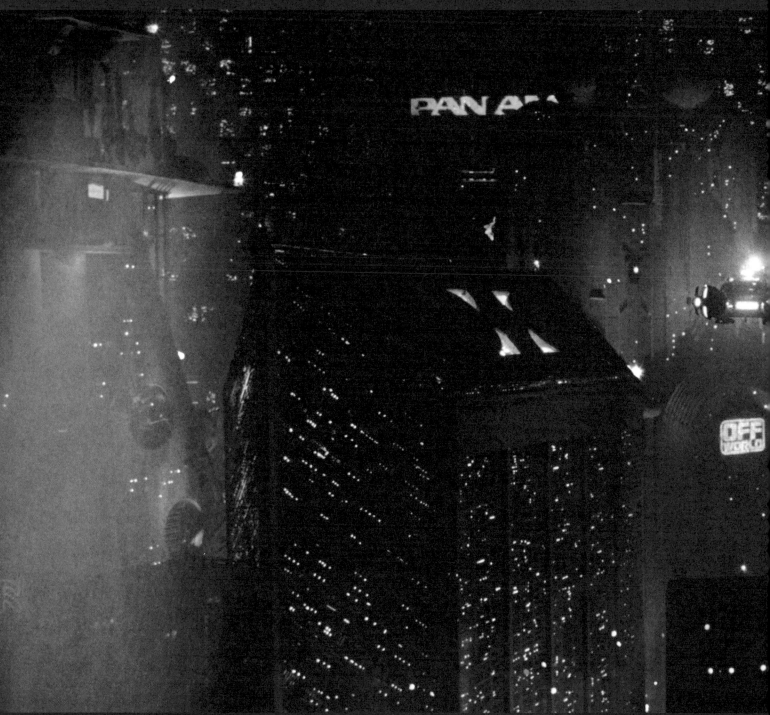

Blade Runner, 1982

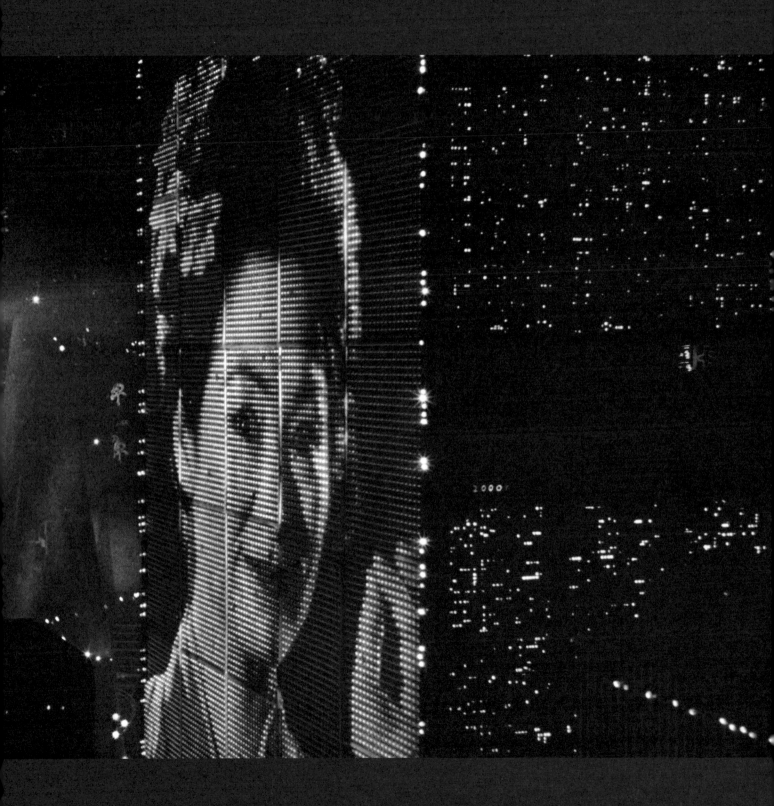

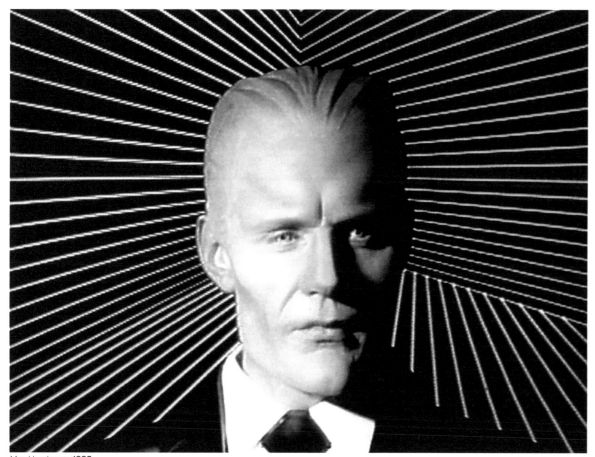

Max Headroom, **1985**

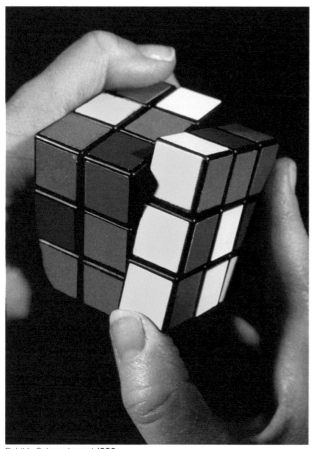

Rubik's Cube, released **1980**

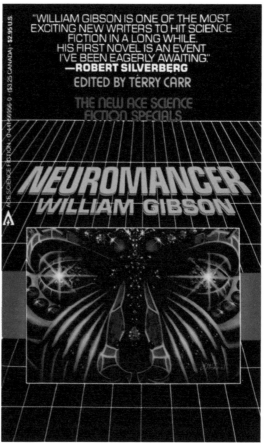

William Gibson, *Neuromancer,* **1984**

Grids and Lasers

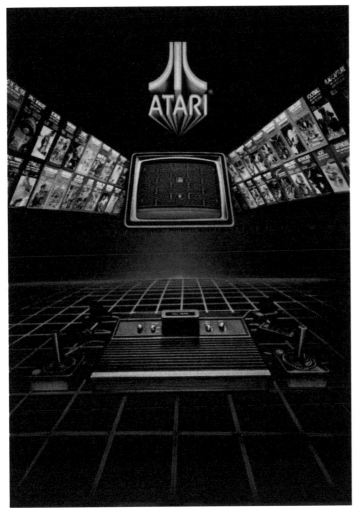

Atari advertisement, *c.* 1982

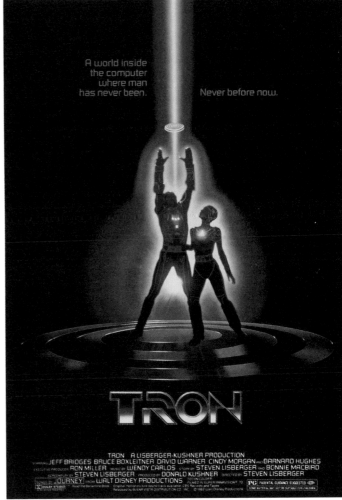

Tron, 1982

The rudimentary design software and limited computational power of the early 1980s meant that designers couldn't even approach the uncanny valley, much less cross it. And if you can't make it real, they thought, make it totally imaginary. The use of grids defined by 'lasers' was an achievable way to create the futuristic environments described in novels like William Gibson's *Neuromancer,* where technology both restricted and enabled movement through infinite space and time. Laser grids formed striking backgrounds that removed characters from reality and created imaginary landscapes in movies like *Tron* (82), and in video games like *Battlezone* (80), one of the first to feature 3D graphics, simple lines against a black background created the 'immersive' environment. Even the Rubik's Cube, with its analogue panels of squares deployed in a grid, represented a universe of unlimited options in your hands.

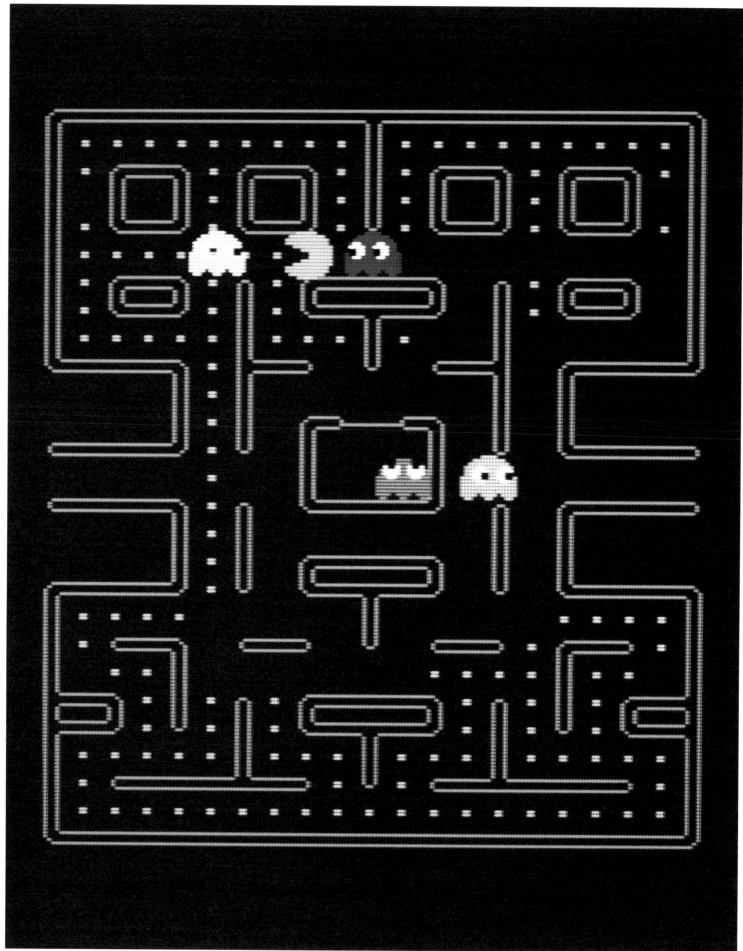

Pac-Man, **1980**

Greed and Hunger

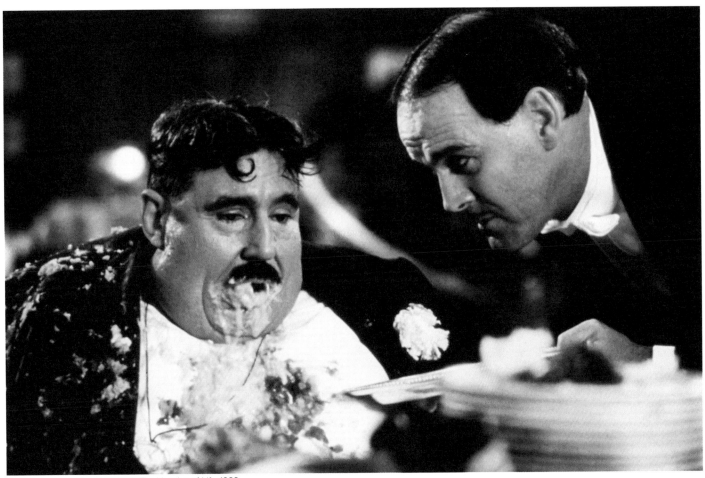

Mr Creosote from *Monty Python's The Meaning of Life*, **1983**

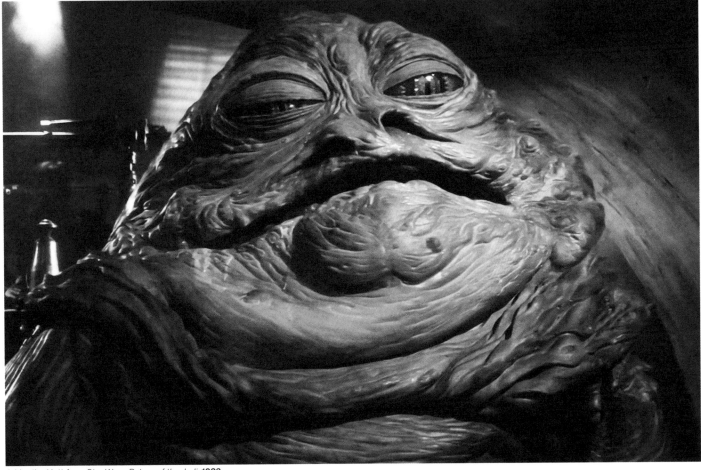

Jabba the Hutt from *Star Wars: Return of the Jedi*, **1983**

139

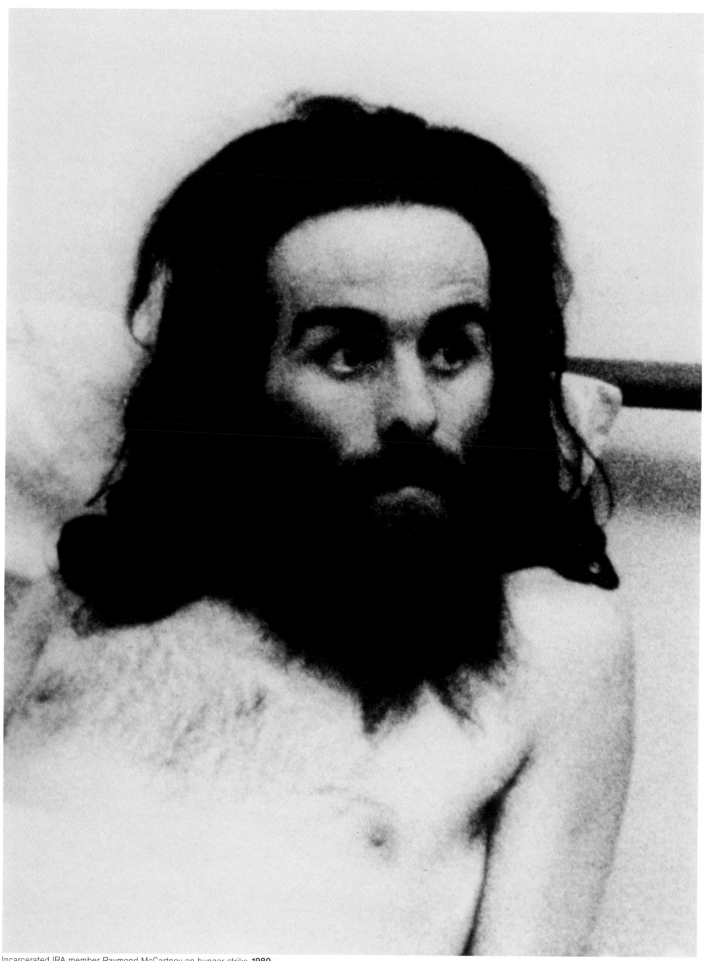

Incarcerated IRA member Raymond McCartney on hunger strike, **1980**

Greed and Hunger

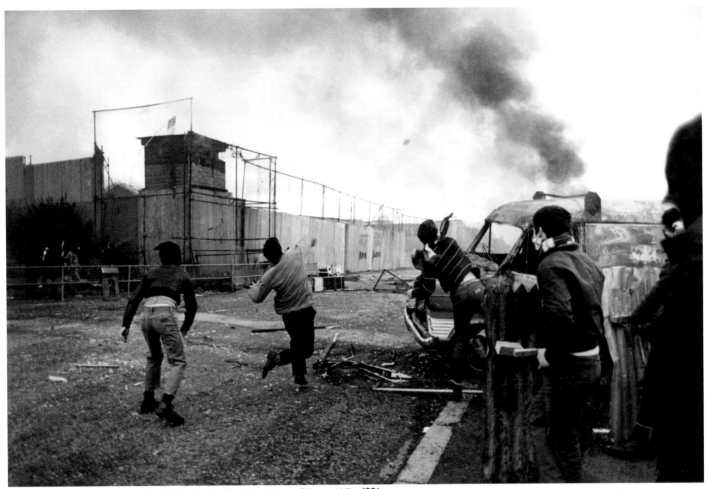

Rioters in Belfast, following the death of Bobby Sands after sixty-six days of hunger strike, **1981**

As yuppies in London and Wall Street traders in New York accumulated excessive personal wealth, gluttony and physical obesity represented the toxicity of power and money. This tendency was personified in characters like Mr. Creosote in *Monty Python's The Meaning of Life* (83), who exploded at the dining table after one last 'wafer-thin' mint, and the ever-multiplying *Pac-Man* family, including *Pac-Man* (80), *Ms. Pac-Man* (82), and *Jr. Pac-Man* (83), who all gobbled their way into gaming history by eating everything in sight. At the same time, newspaper images depicted starving men, women and children in famine-struck Uganda and Ethiopia. Food was also used as a means of protest. Incarcerated members of the IRA began widely televised hunger strikes that would claim the life of Bobby Sands in 1981, after sixty-six days, and further escalated the violence in Northern Ireland.

Members of the band Frankie Goes to Hollywood with actor Gene Kelly holding a 'Frankie Say Relax' t-shirt, **1984**

Relax

c.1984–86

The best of times. The worst of times.

Ostentation was in. Red Ferraris were a recurring motif in video games and media, encapsulating an attitude of speed, freedom and carnivorous wealth. Prices for contemporary art spiralled as gestural Neo-Expressionist works by David Salle, Eric Fischl and Francesco Clemente replaced the austere intellectualism of 70s conceptual art.

On the streets, people sported big hair, big suits and big ties.

In homes, the earthy hues of the previous decade were being replaced by brightly-coloured furniture, chrome detailing, glass block walls and banana leaf print on the bedspreads and the walls.

As the West enjoyed its boom, distressing images began appearing on BBC news in late 1984. The images showed shockingly emaciated men, women and children starving to death in Ethiopia. The human suffering in eastern Africa prompted singer and activist, Bob Geldof, to call a ragtag group of forty famous friends to gather in a recording studio in Notting Hill in London. While the lyrics of 'Do They Know It's Christmas?' (84) were a little bizarre, over 100 million dollars were raised by the single and two proceeding Live Aid concerts in the UK and US (85).

The kids played video games with increasingly sophisticated graphics on consoles like the Nintendo NES (83),

and in the workplace, adults started embracing Microsoft Windows (85) and other conveniences such as the first cellular phone (83). Meanwhile, everyone was dazzled by the convenience of compact discs and the digitization of music. Technology was the alchemy of the age and along with all the excitement grew fears about dehumanization and the abuse of power. In a cinematic advert directed by *Blade Runner*'s Ridley Scott, Apple leaned into the Orwellian anxieties with a spot narrated by John Hurt, who had starred in *Alien*. Audiences were told that, with the new Macintosh, 'You'll see why 1984 won't be like 1984' – and where better to make such a pronouncement than during a timeout in the third quarter of the Super Bowl, with its 77 million viewers? That same year, figure skating duo Torvill and Dean won gold at the Olympics, becoming the highest-scoring figure skaters of all-time, and a gravity-defying Michael Jordan turned pro, part of a wave of young, record-breaking athletes that helped fuel the sports obsession of the mid-80s. A 17-year-old Boris Becker won Wimbledon (85), Mike Tyson became the youngest ever person to win the world heavyweight title (86), and Diego Maradona reignited Argentinean–British tensions with his infamous 'hand of God' World Cup goal against England (86).

At a summit in Iceland, US President Ronald Reagan and Mikhail Gorbachev, the new reformist leader of the USSR, shook hands and helped ease the tensions between the two countries (86). In South Africa, a State of Emergency was declared in 1985 and expanded nationwide in 1986 by President P.W. Botha and his apartheid government, in response to increasingly

organized anti-apartheid resistance in Black townships. The UK public largely lead the international response to end apartheid and free Nelson Mandela. But after her bloody win in the Falklands (82), Margaret Thatcher was more concerned with battles at home than with justice in South Africa. Pit closures triggered a bitter, year-long miners' strike (84–85), and she did little to address systemic racism following the police shooting of Dorothy Groce that reignited civil unrest on the streets of Brixton (85).

While Thatcher was regarded as the most powerful woman in the world, three other women were in the early phases of cultivating their longstanding cultural legacies. *The Oprah Winfrey Show* (86) aired nationally in the US, attracting audience numbers that would see it become the highest ranked daytime talk show in the country's history. Madonna smashed down sexual boundaries, both with provocative outfits featuring lace and crucifixes, and with her lyrics about virgin sex, teenage pregnancy and the benefits of having a sugar daddy. Princess Diana outgrew her 'shy Di' nickname to become a fashion icon and powerhouse campaigner for humanitarian causes including HIV and AIDS. Despite this, fear and misconception about AIDS continued to spread as the virus ripped through major cities in the West and Africa alike. By 1986, 81 per cent of sex workers in Nairobi were infected with HIV. The response of governments, particularly in the US, was slow, but the release of AZT, a new antiviral drug, in 1987 gave hope. Meanwhile, people in the UK and Europe were growing nervous about another deadly disease. Bovine spongiform encephalopathy or BSE – better known as mad cow disease (86) – would eventually necessitate the slaughter of over 4 million animals and spread to humans.

As the global population hit 5 billion and the hole in the ozone layer galvanized urgent international action, two explosions rocked the world.

In January 1986, 73 seconds after lift-off, the Space Shuttle Challenger exploded, killing all seven of its crew members, including Christa McAuliffe, a schoolteacher from New Hampshire. Three months later, a nuclear reactor at Chernobyl went into meltdown, contaminating 60,000 square miles (155,400 square km) of Ukraine, Belarus and Russia, and stoking fears that the whole of Eastern Europe and parts of Scandinavia would be irradiated.

In a period when the human species moved through extremes of abundance and want, achievement and crises of our own making, it fell to a fictional trader named Gordon Gekko to sum up, in Oliver Stone's *Wall Street* (87), an attitude that would, for many baby boomers, become a mantra that helps explain the crippling inequalities we face today. 'Greed', he said, 'is good.'

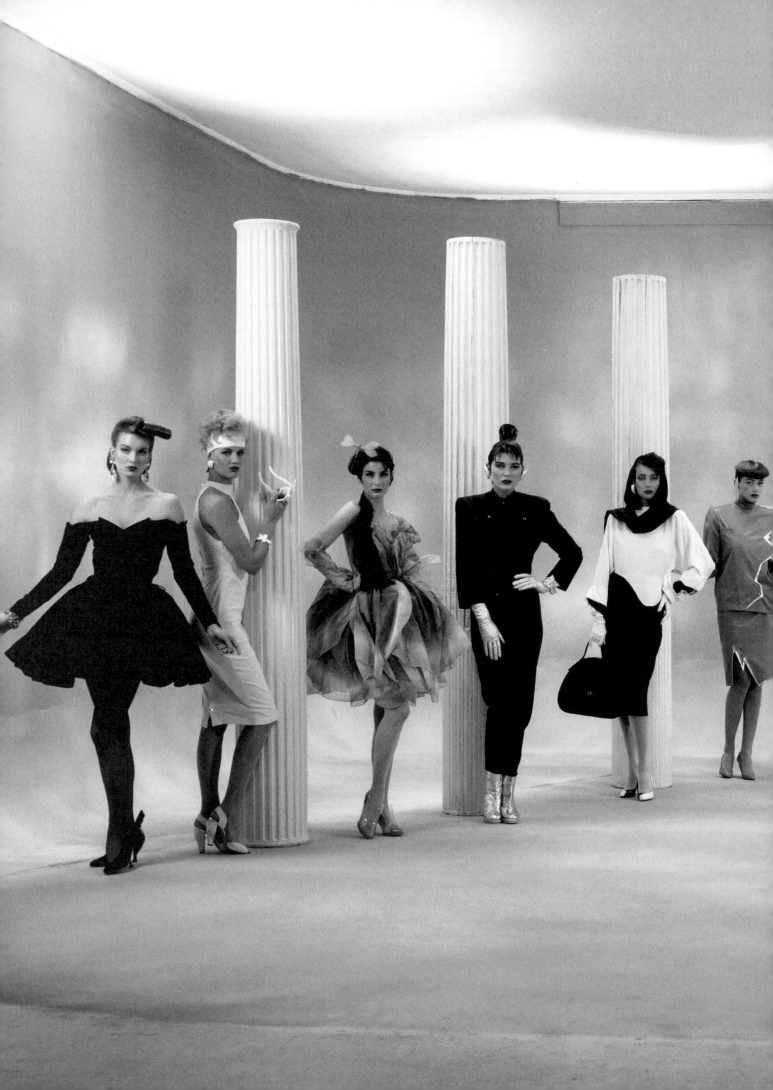

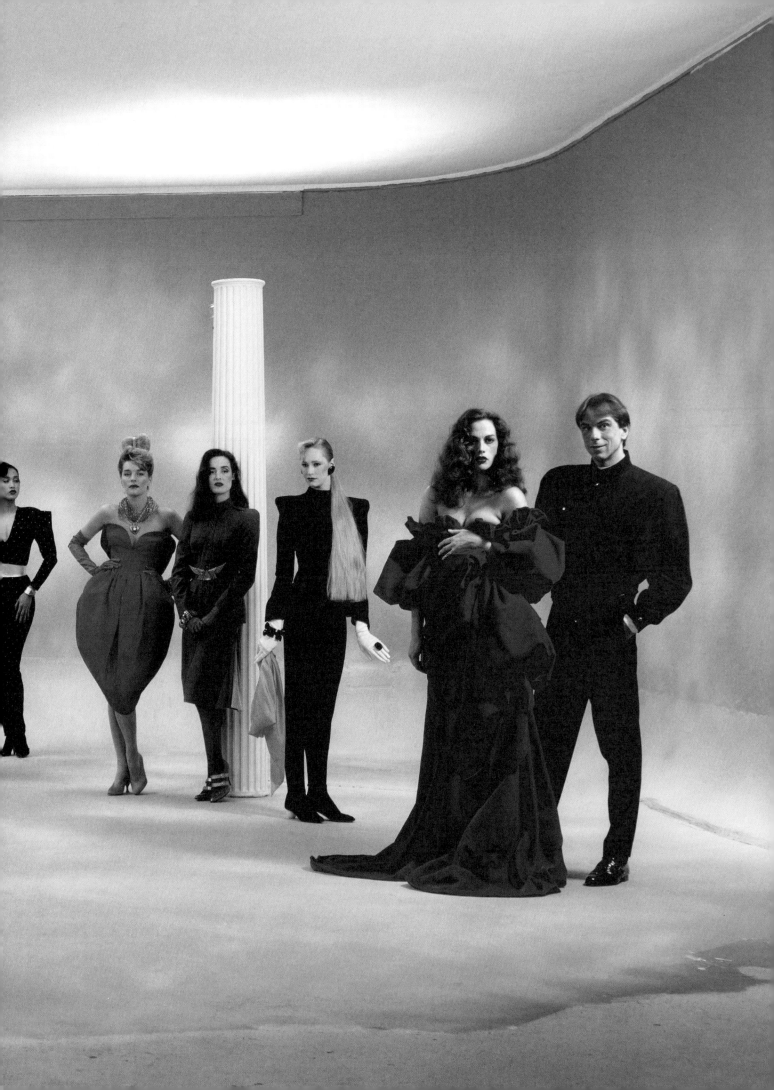

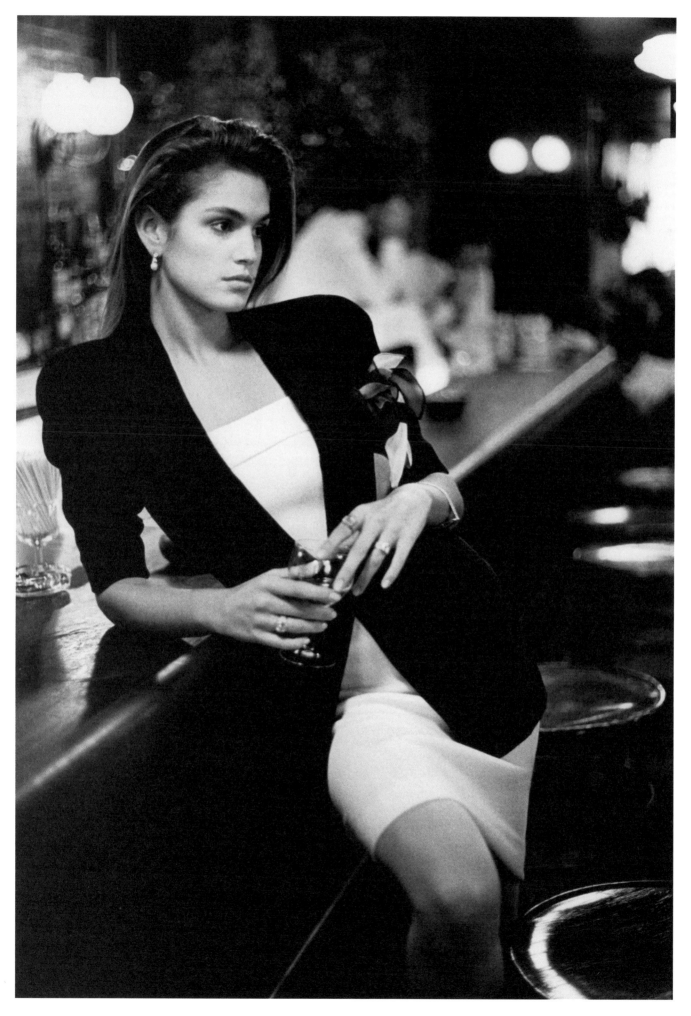

Cindy Crawford modelling for the February issue of *Vogue*, photo by Richard Avedon, **1988**

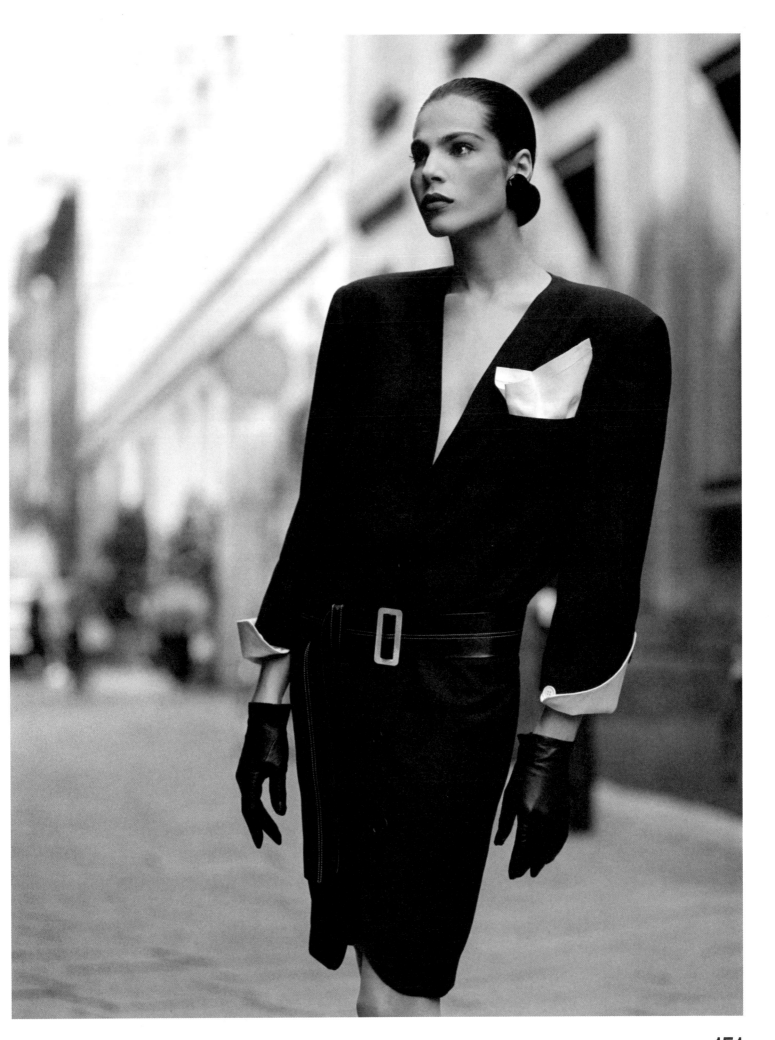

Gianfranco Ferré, Spring **1987**

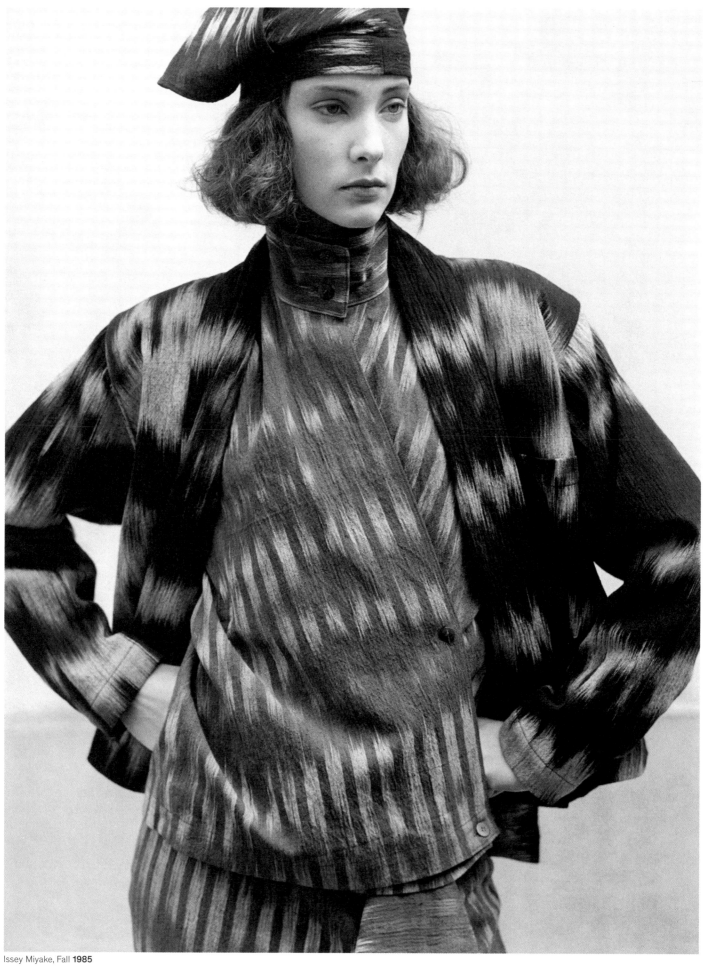

Issey Miyake, Fall **1985**

Fashion Statements

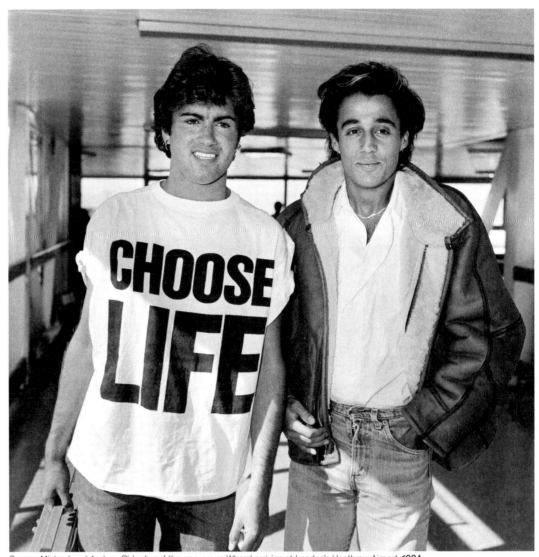

George Michael and Andrew Ridgeley of the pop group Wham! arriving at London's Heathrow Airport, **1984**

Fashion became a direct form of communication when Katharine Hamnett revived the slogan tee with her 'Choose Life' shirt (83). In the workplace, women abandoned 70s frills in favour of imposing power suits designed by Anne Klein and Donna Karan. The wide shoulders and angular silhouettes, reminiscent of battle armour, looked like they were designed to intimidate male colleagues. Meanwhile, Giorgio Armani reinvented the men's suit. Moving away from the uptight pinstripe uniform of the old boys club, Armani's relaxed, oversized tailoring, with earthy hues and textured fabrics, gave men something that could be worn for both work and play. Japanese designers like Issey Miyake and Rei Kawakubo had a deconstructive approach to fashion that turned clothes into sculpture. This approach was totally different to Western houses, and it elevated Tokyo to a fashion capital alongside Paris, Milan, London and New York City.

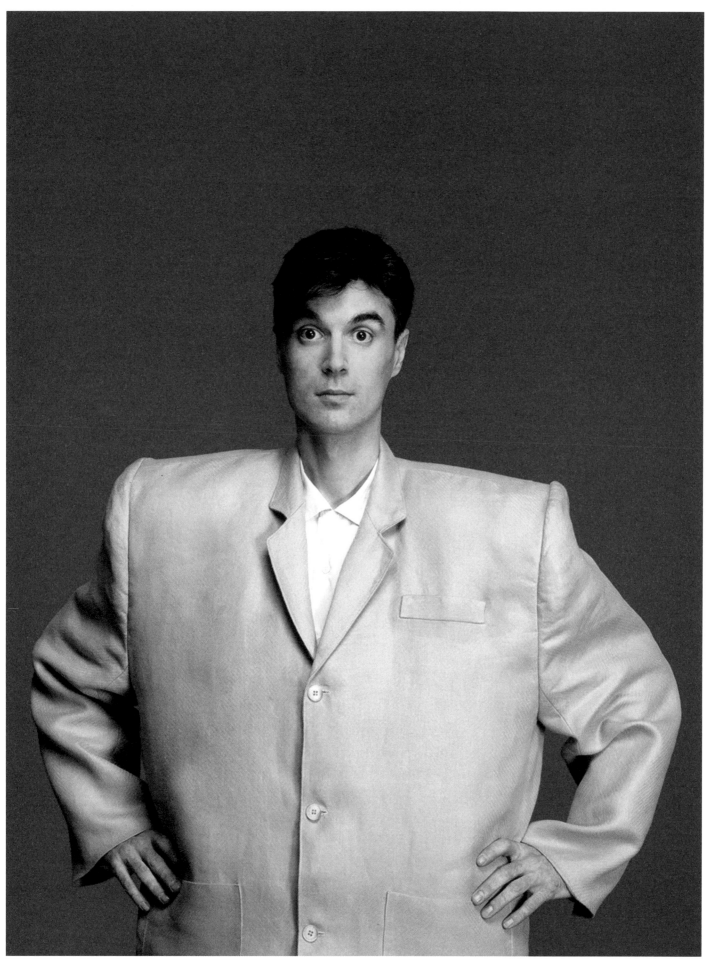

David Byrne in an oversized suit, **1983**

Fashion Statements

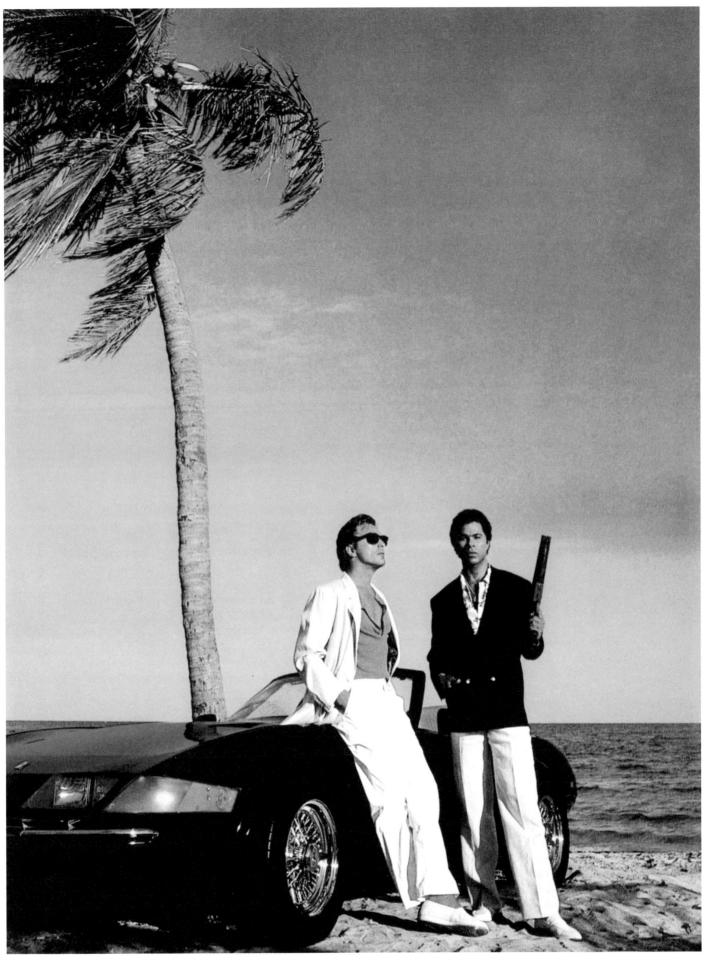

Miami Vice, **1984**

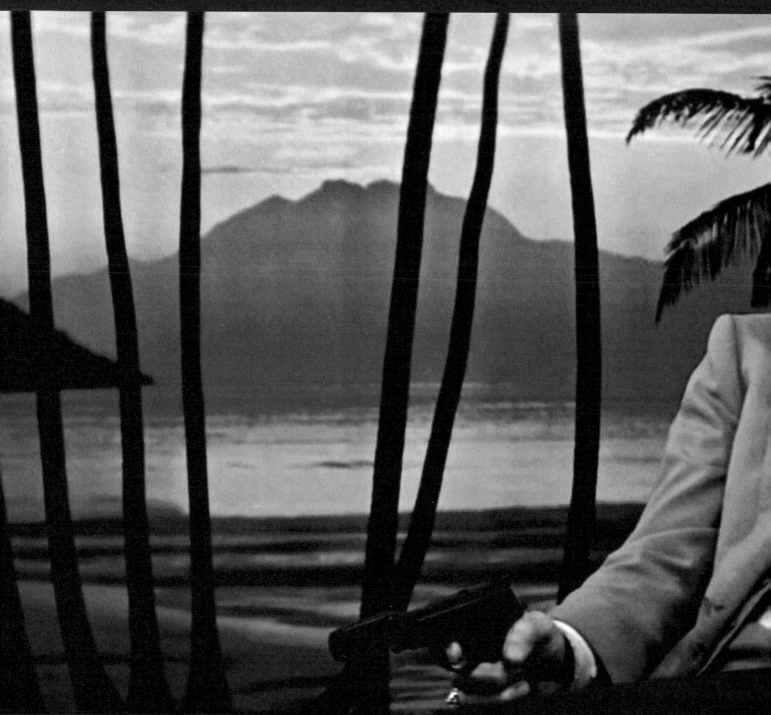

Scarface, 1983

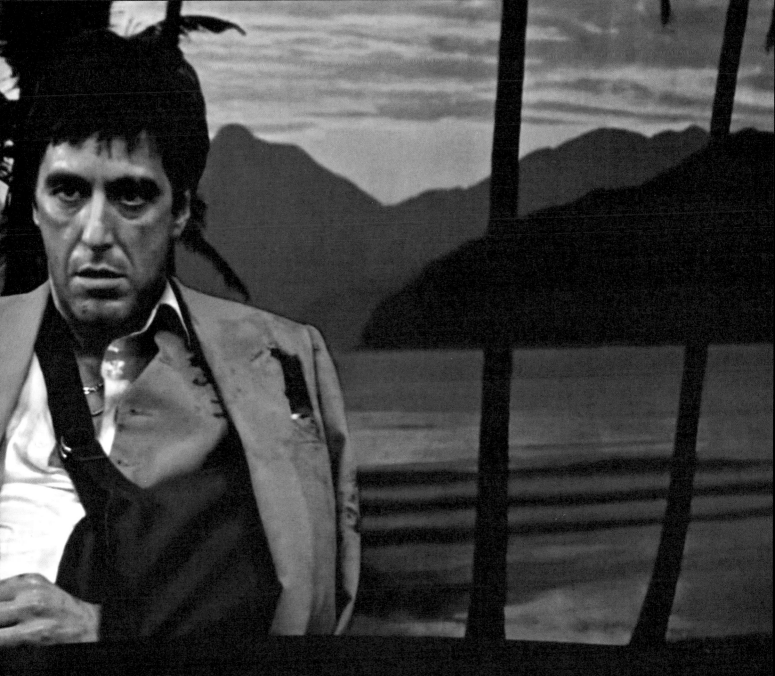

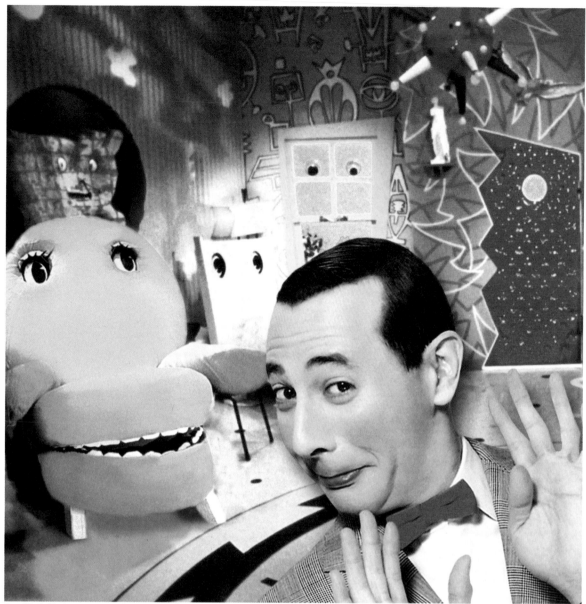

Pee-Wee's Playhouse, starring Pee-Wee Herman, **1986**

As the world emerged from global recession, green shoots started sprouting in affluent homes and exclusive restaurants. 'Martinique', the banana leaf wallpaper first popular in the 1940s during the postwar boom, covered the walls of the new and notorious New York restaurant Indochine (84). The lush design captured a sense of abundance and new beginnings, and was just one element of a mid-80s obsession with tropical escapism. There were TV hits like *Miami Vice* (84–89) and *Magnum P.I.* (80–88), and a thriving market for exotic pets, the most famous of which was Michael Jackson's monkey, Bubbles. Billboards around cities showing sunsets, piña coladas and pink flamingos became windows providing glimpses of a lush utopia against the backdrop of urban decay.

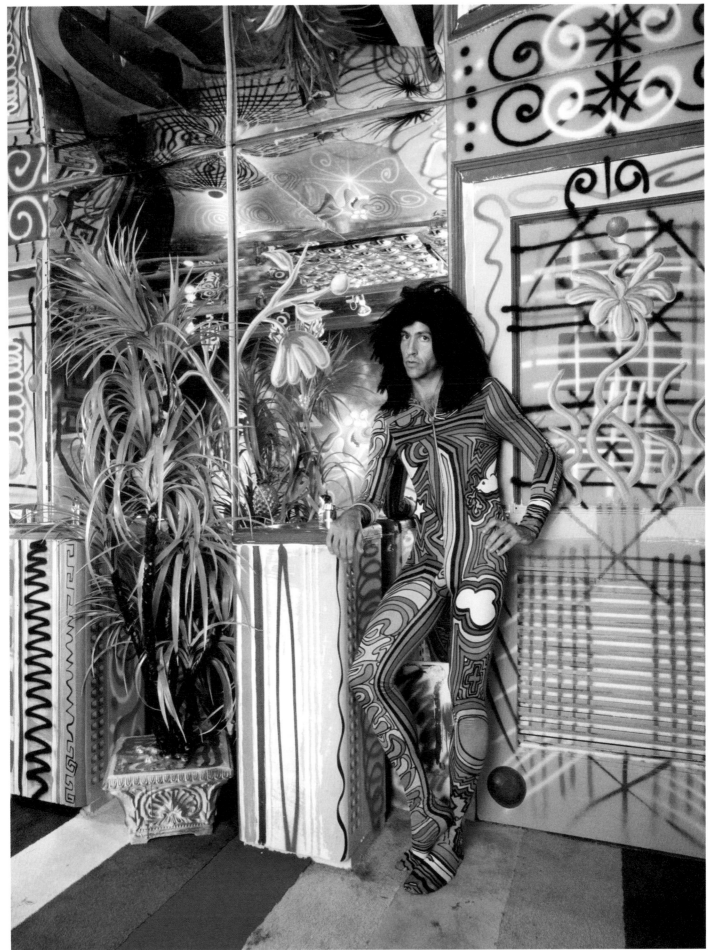

Kenny Scharf with his art installation at the Palladium, New York City, **1985** Photograph by Tseng Kwong Chi © Muna Tseng Dance Projects, Inc. New York

(Overleaf) Famine in Ethiopia, **1984**

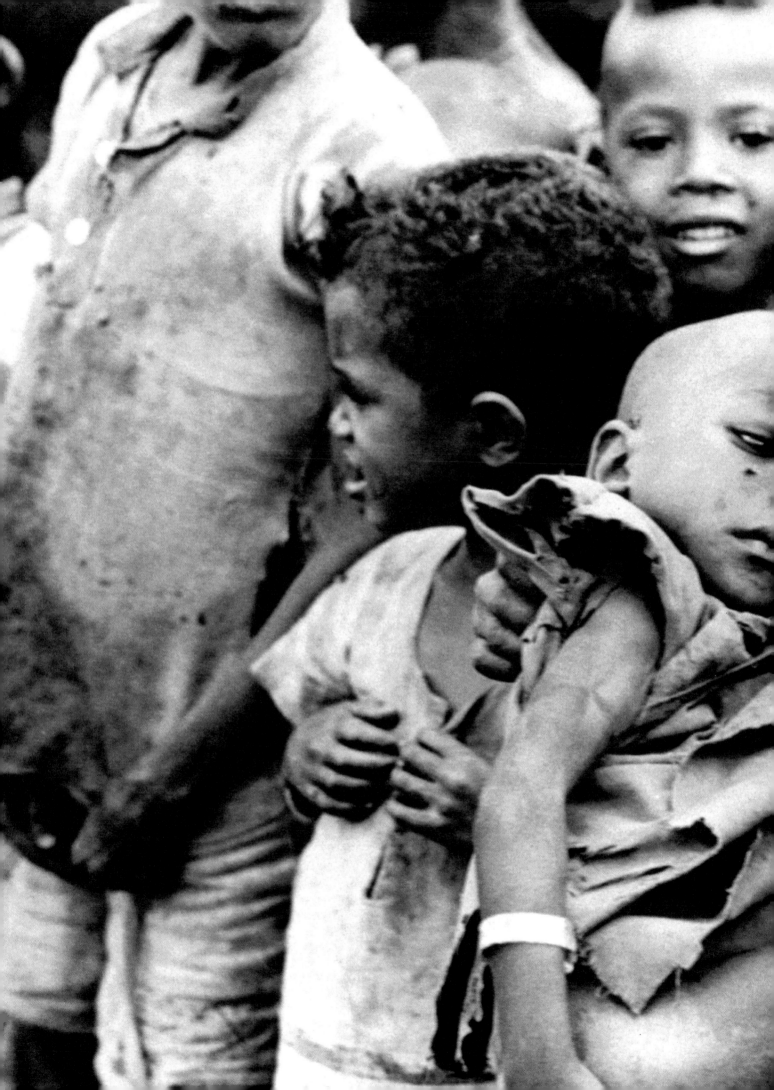

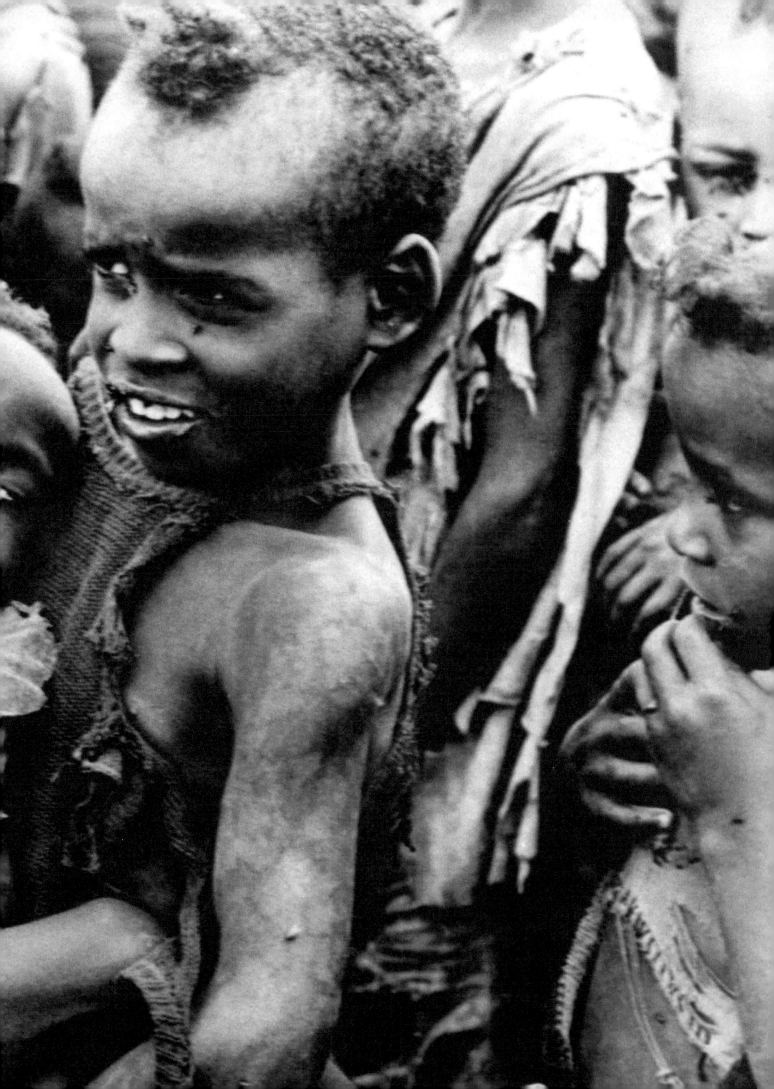

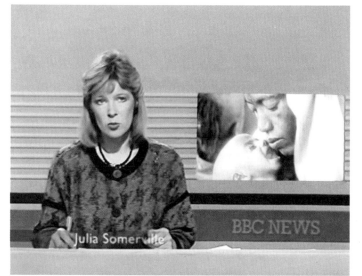
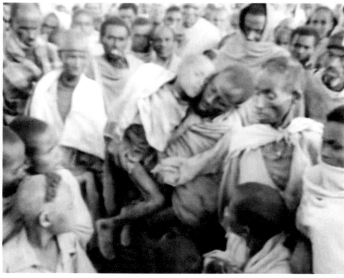
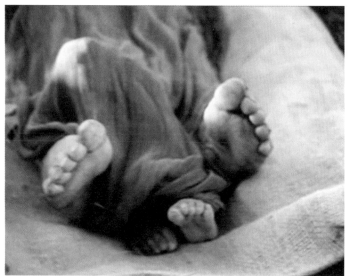
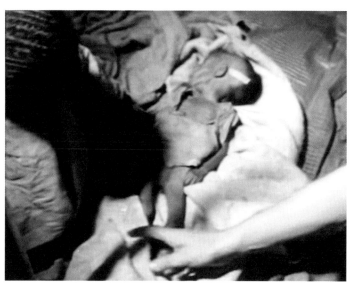

BBC News report on famine in Ethiopia, **1984**

It was one of the most catastrophic humanitarian disasters of the century. Years of conflicts, recurring droughts and failed harvests led to over one million people in Ethiopia dying of starvation. When Michael Buerk's BBC News report aired in October 1984, the world witnessed harrowing images of a 'biblical' famine, the scale of which had never been captured on video before. The seven-minute broadcast forever changed the West's relationship and response to distant suffering, even if increased awareness didn't change the facts on the ground. The coverage brought the cries of the dying into living rooms. The unflinching footage zoomed in on emaciated limbs and showed the wilted bodies of newborn babies who had starved to death in their mothers' arms. In a new era of constant TV content, these were scenes that couldn't be forgotten – or solved – by simply changing the channel.

Famine

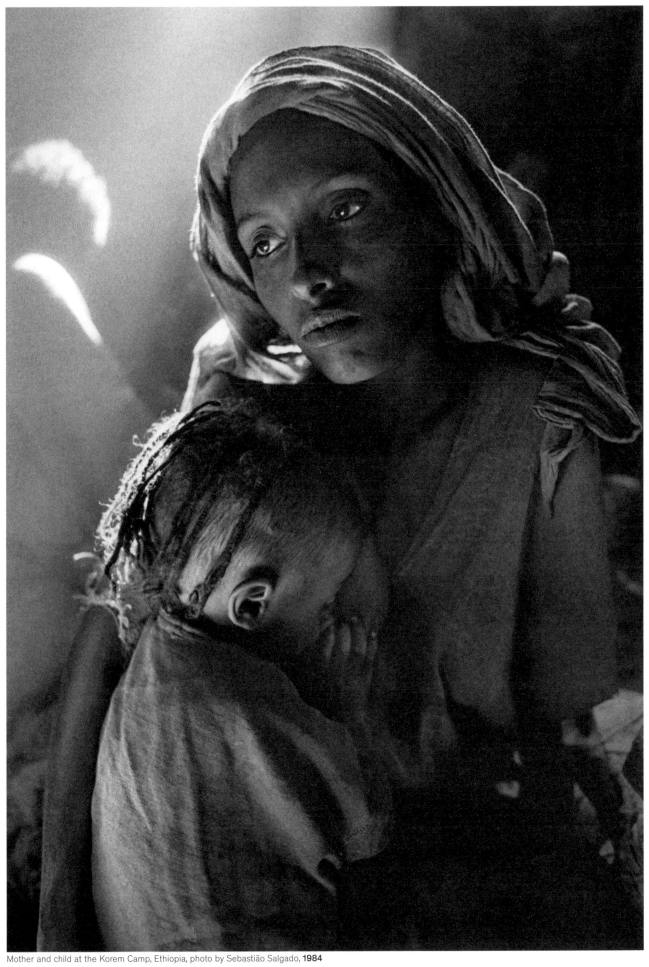

Mother and child at the Korem Camp, Ethiopia, photo by Sebastião Salgado, **1984**

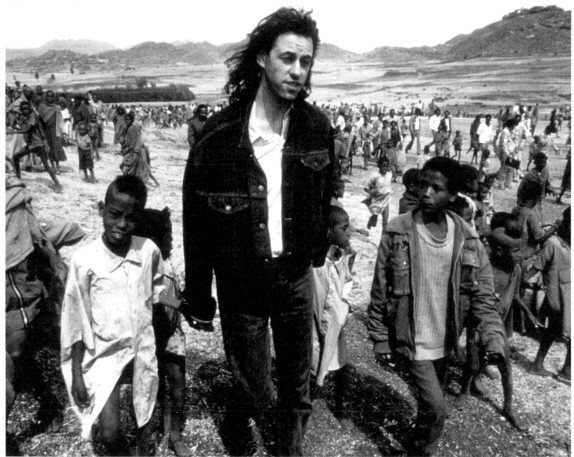

Bob Geldof in Africa, **1985**

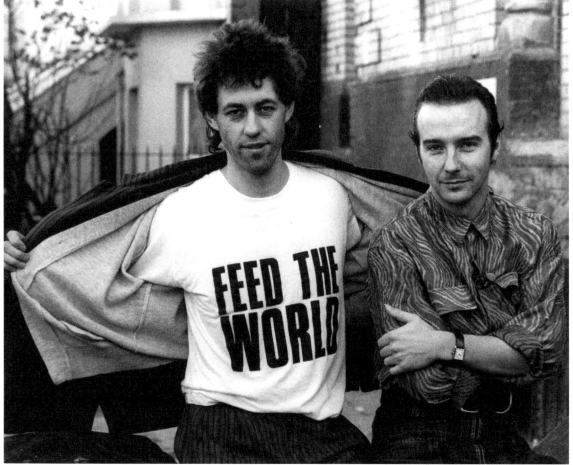

Bob Geldof and Midge Ure, **1984**

Food of Life

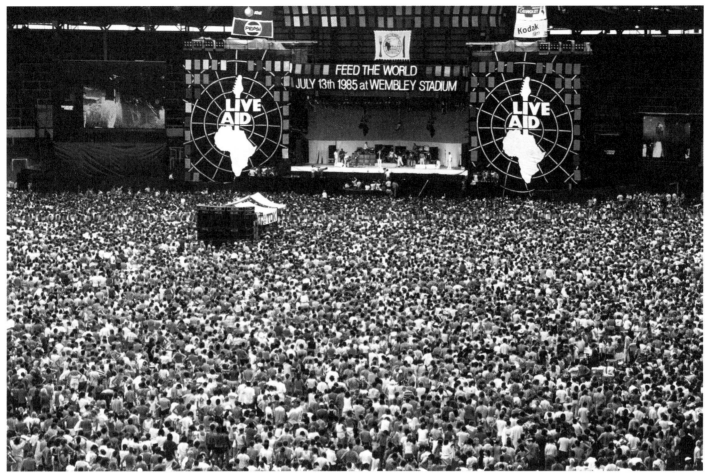

Live Aid, Wembley Stadium, London, **1985**

In response to news images coming out of Ethiopia, the singers and songwriters Bob Geldof and Midge Ure wrote and recorded the charity single 'Do They Know It's Christmas?' (84), which featured vocals by George Michael, Bono, Boy George and others. Geldof and Ure went on to organized two simultaneous, star-studded concerts in summer 1985, one in London and the other in Philadelphia. It wasn't the first benefit concert, but the sheer scale of Live Aid made all previous efforts seem a little parochial. Viewed by around 1.5 billion people, Live Aid raised approximately $120 million for Ethiopia and ultimately saved thousands of lives. It also set in motion a very 80s form of altruism, something that grew out of the increasing influence of celebrity, media broadcasting, globalization and the profitable power of positive PR. Audiences did, indeed, donate more than ever before, but only on one condition – they expected to be entertained.

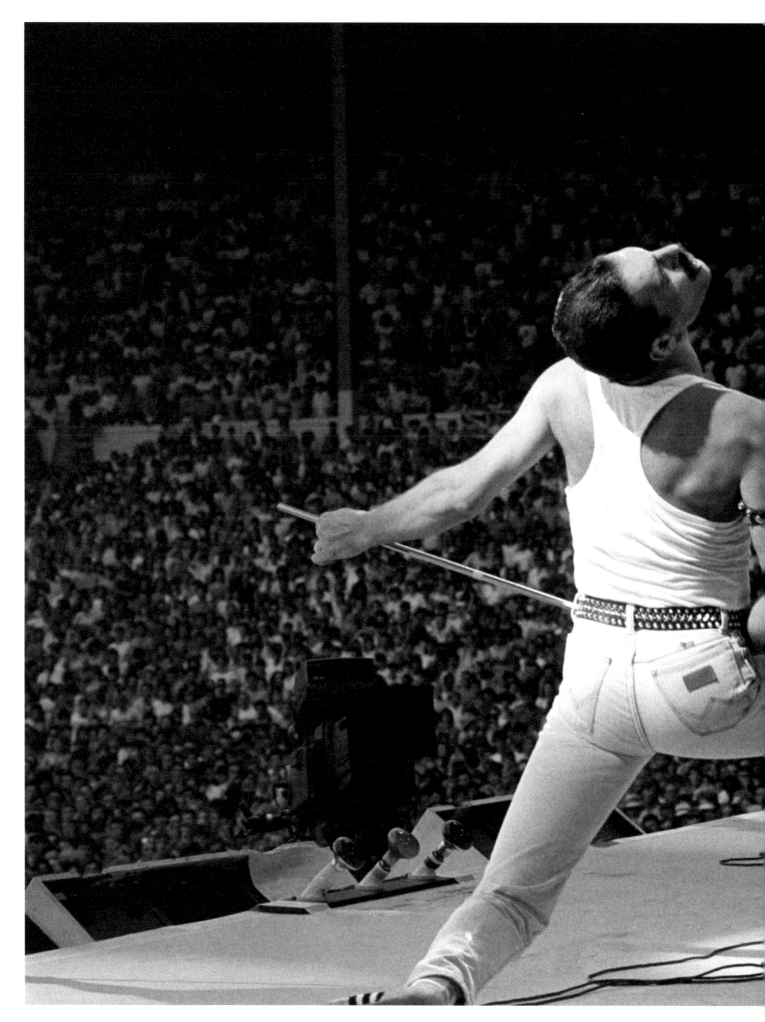

Queen on stage at Live Aid, Wembley Stadium, London, photo by Neal Preston, **1985**

Peter Gabriel, 'Sledgehammer', **1986**

A-ha, 'Take on Me', **1985**

Dire Straits, 'Money for Nothing', **1985**

MTV, with its twenty-four-hour content, created a platform for the music video art form to thrive. Michael Jackson's narrative-based 'Beat It' (82), directed by Bob Giraldi, and 'Thriller' (83), directed by John Landis, were regarded as short films, and the medium got the validation to match when MTV's Video Music Awards started handing out 'moonman' statues in 1984. Music videos increasingly became a space to showcase new special effects and animation styles that wouldn't necessarily lend themselves full-length feature films. There was Peter Gabriel's 'Sledgehammer' (86), which used stop-motion animation, Dire Straits' 'Money for Nothing' (85), which featured one of the first computer-generated human characters, and A-ha's 'Take on Me' (85), which used rotoscoping to combine live action and pencil sketches.

(Overleaf) Kate Bush, 'Running Up That Hill', **1985**

The first genetic fingerprint, 1984

Tetris, graphics from the original game, **1985**

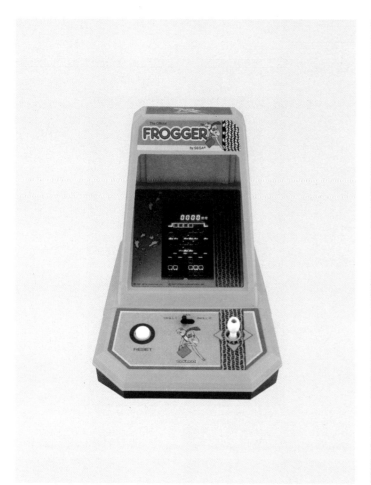

Frogger, **1981**

Donkey Kong, **1982**

Fights of the Titan, **1983**

Pocket Simon, **1980**

Digital Worlds

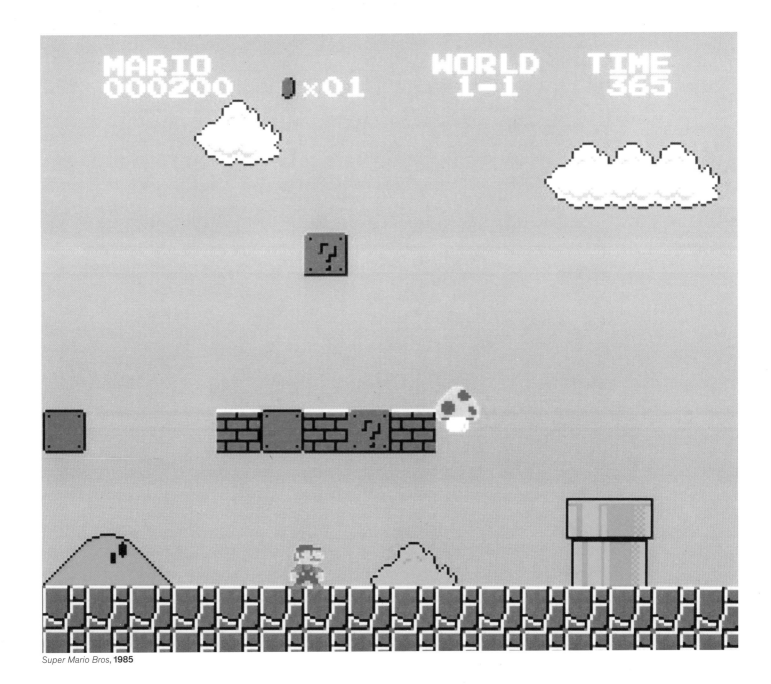

Super Mario Bros, **1985**

He was, and still is, a plumber – an Italian plumber – whose ability to jump on command over rolling barrels in the video game *Donkey Kong* earned him the nickname 'Jumpman'. Created by Shigeru Miyamoto, this collection of coloured blocks, 16 pixels high by 12 pixels wide, became Mario, the most successful video game character of all time. First released in arcade format in 1983, and then on the new Nintendo NES console in 1985, *Super Mario Bros* presented gamers with something new. Rather than the fixed, finite worlds of *Space Invaders*, the left-to-right moving platform format gave players the chance to navigate seemingly infinite worlds, levels and pathways. With Mario, Miyamoto ushered in a new era of gaming that placed the emphasis on exploration, not just high scores.

(Overleaf) Andy Warhol and Debbie Harry demonstrating the new Amiga computer at Lincoln Center, New York, **1985**

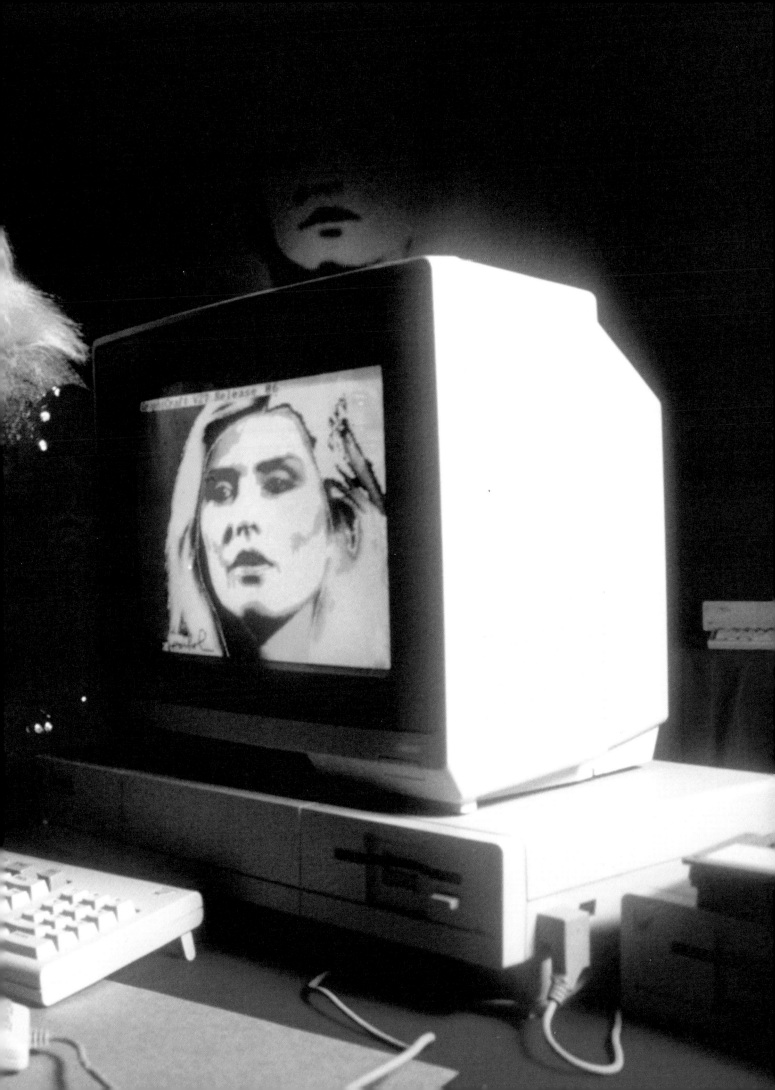

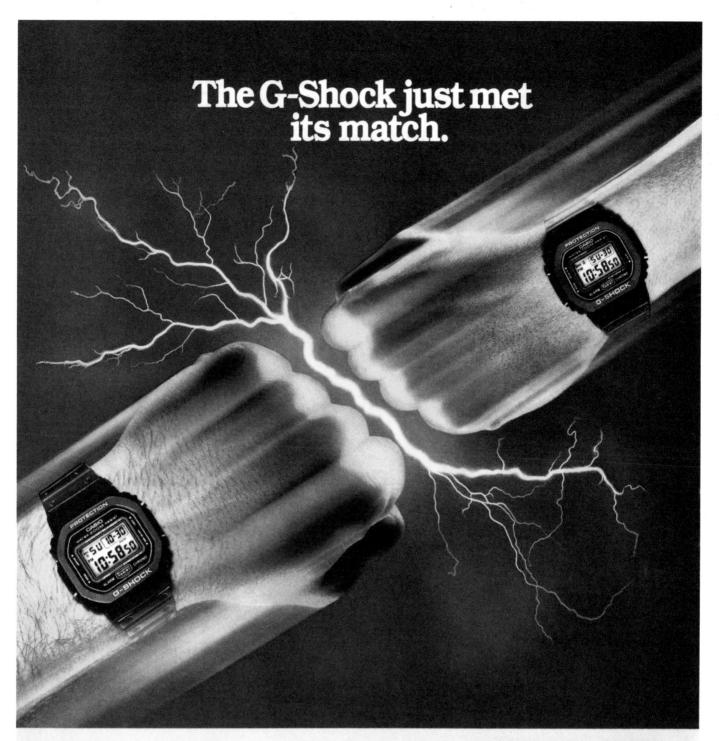

The G-Shock just met its match.

Talk about a tough act to follow. Consider the Casio G-Shock and its hard-earned reputation as the world's toughest watch.

Now it's met its match. Our new G-Shock. Slightly smaller but just as tough, the new G-Shock's water resistant case can also withstand life's harder knocks. As well as hundreds of feet in depth.

And the G-Shocks do more than just soak up a lot of abuse. With their daily and monthly alarms, 1/100 second stopwatch and countdown timer, they give you a lot more than just the time.

Whether you're working on the ocean floor or scaling a rock wall, things are tough all over. Don't take a chance—be prepared for a shock. With a Casio G-Shock.

DW-5600C DW-500C DW-500C

Casio, Inc. Timepiece Division: 570 Mt. Pleasant Avenue, Dover, NJ 07801
Casio Canada Ltd., 2100 Ellesmere Road, Suite 240, Scarborough, Ontario M1H3B7

CASIO®
Where miracles never cease

Casio G-Shock watch advertisement, **1988**

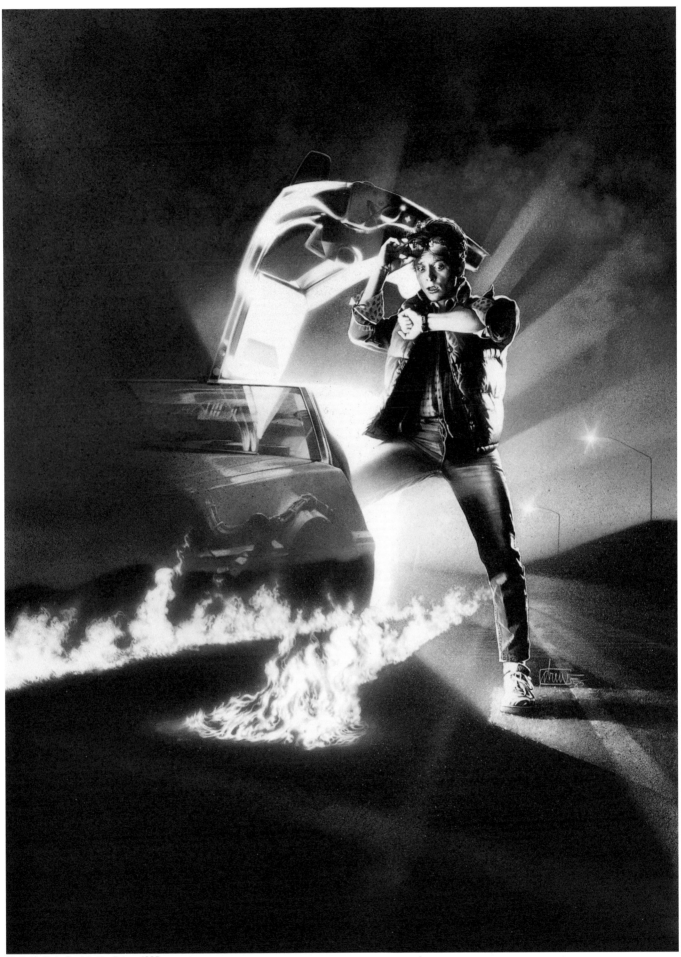

Marty McFly in *Back to the Future*, **1985**

Where

Gordon Gekko in *Wall Street*, **1987**

you

Sigue Sigue Sputnik bassist Tony James and girlfriend Janet Street-Porter, **1986**

are

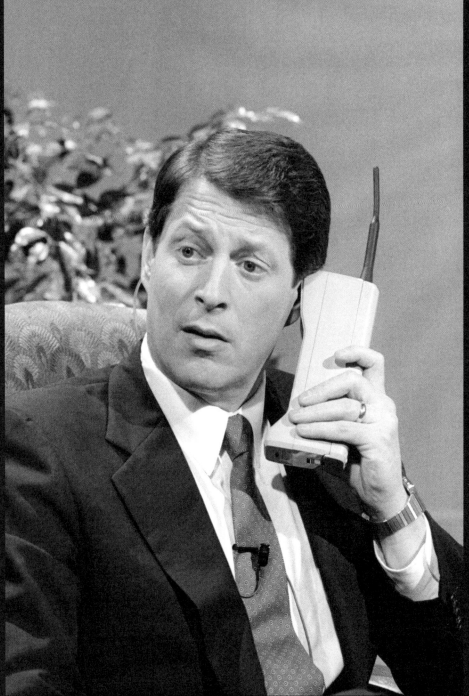

Senator Al Gore on 'Super Tuesday', New Hampshire, **1986**

now?

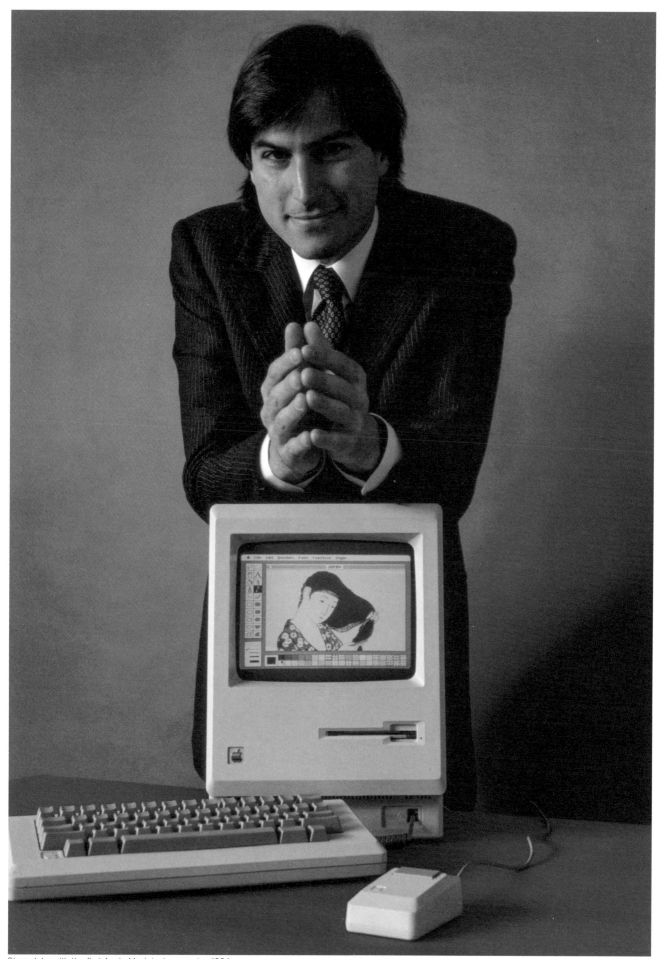

Steve Jobs with the first Apple Macintosh computer, **1984**

Advancing Technology

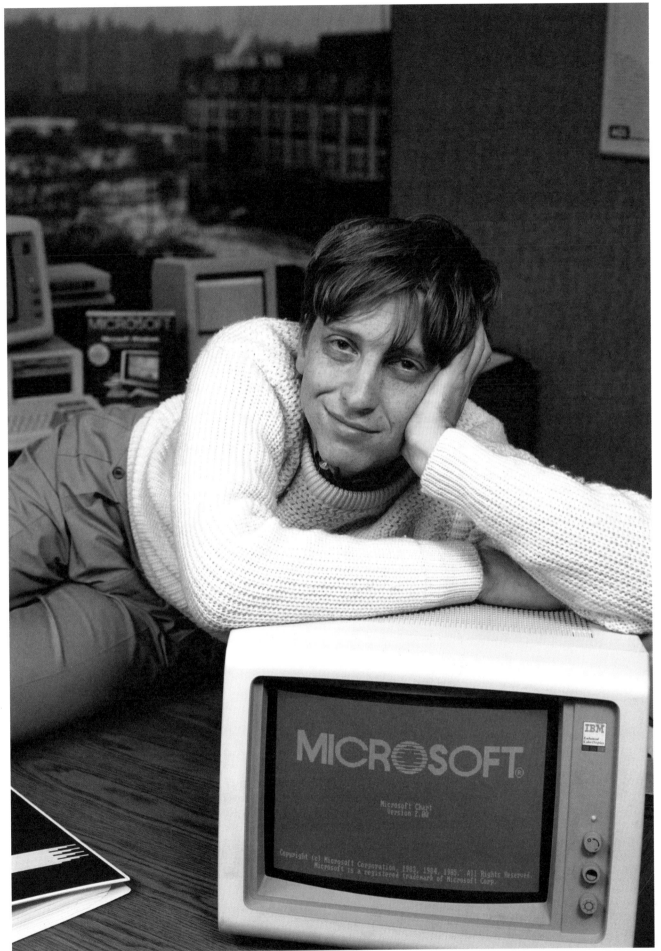

Bill Gates after the release of Windows 1.0, *c.* **1983**

(Overleaf) Superman attacked by a supercomputer in *Superman III*, **1983**

Apple Macintosh advertisement, directed by Ridley Scott, screened during the Super Bowl, **1984**

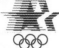 *Los Angeles 1984 Olympic Games*

April Greiman and Jayme Odgers, poster for the Summer Olympics in Los Angeles, **1984**

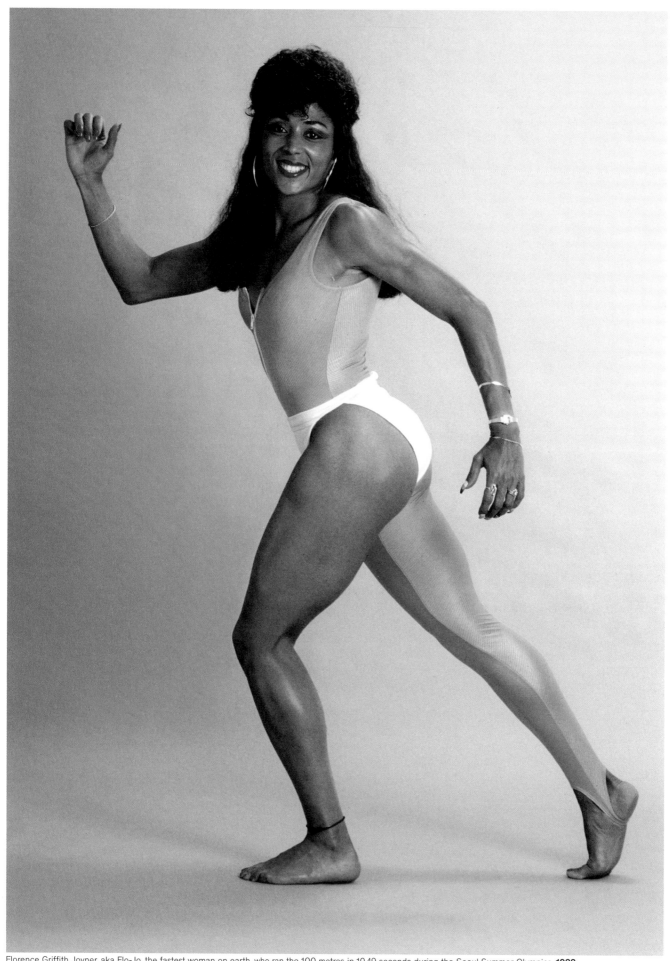

Florence Griffith Joyner, aka Flo-Jo, the fastest woman on earth, who ran the 100 metres in 10.49 seconds during the Seoul Summer Olympics, **1988**

Jayne Torvill and Christopher Dean at the Sarajevo Olympics where they became
the highest-scoring figure skaters of all time, **1984**

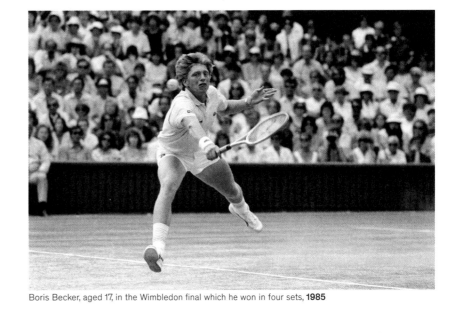

Boris Becker, aged 17, in the Wimbledon final which he won in four sets, **1985**

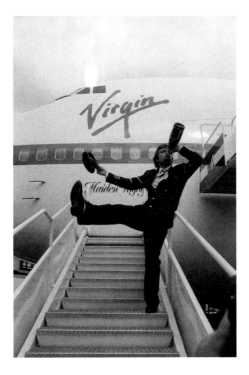

Richard Branson inaugurating his new airline, Virgin Atlantic Airways,
on the steps of the Boeing 747-200 'Maiden Voyager', **1984**

High Achievers

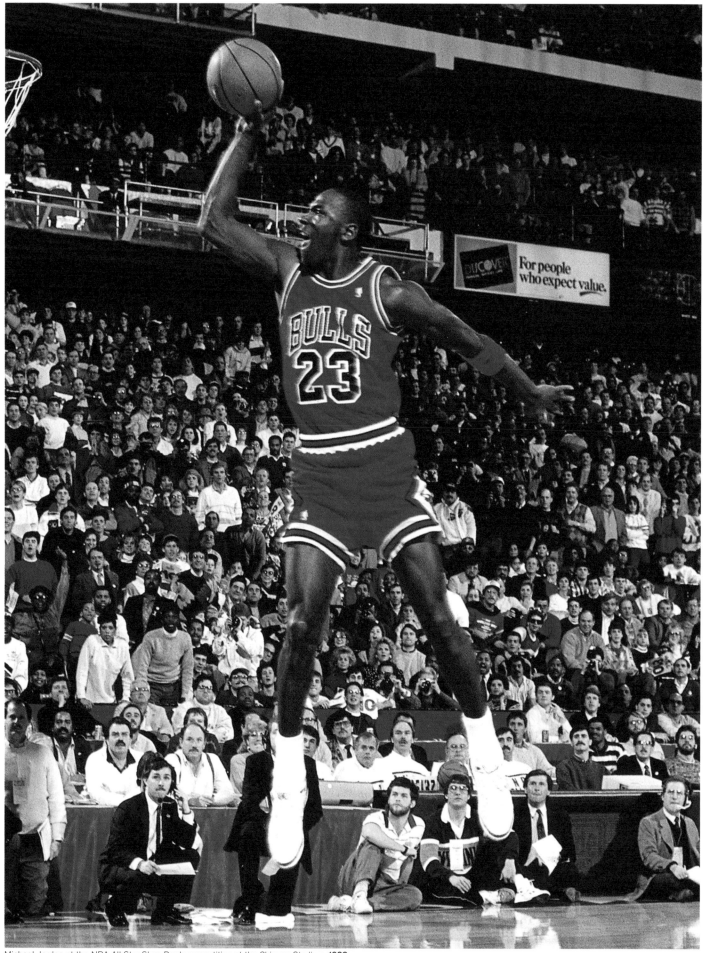

Michael Jordan at the NBA All Star Slam Dunk competition at the Chicago Stadium, **1988**

High Achievers

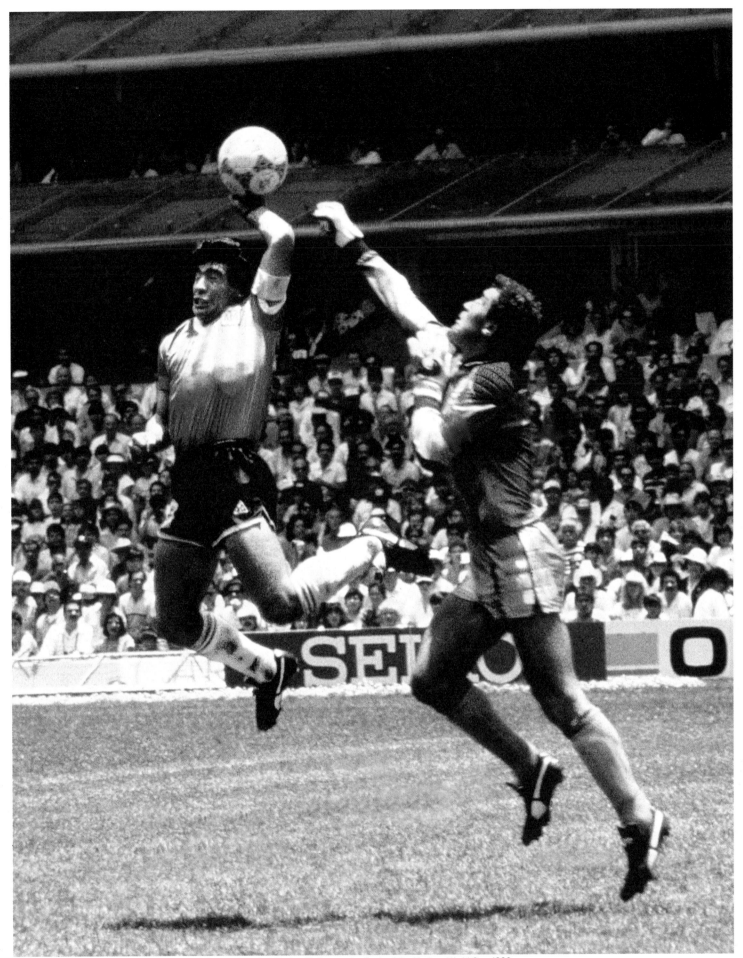

Argentinian footballer Diego Maradona's 'hand of God' goal against England in the quarter finals of the Mexican World Cup, **1986**

(Overleaf) Mike Tyson defeats Trevor Berbick to become the youngest Heavyweight World Champion in history, Las Vegas, **1986**

191

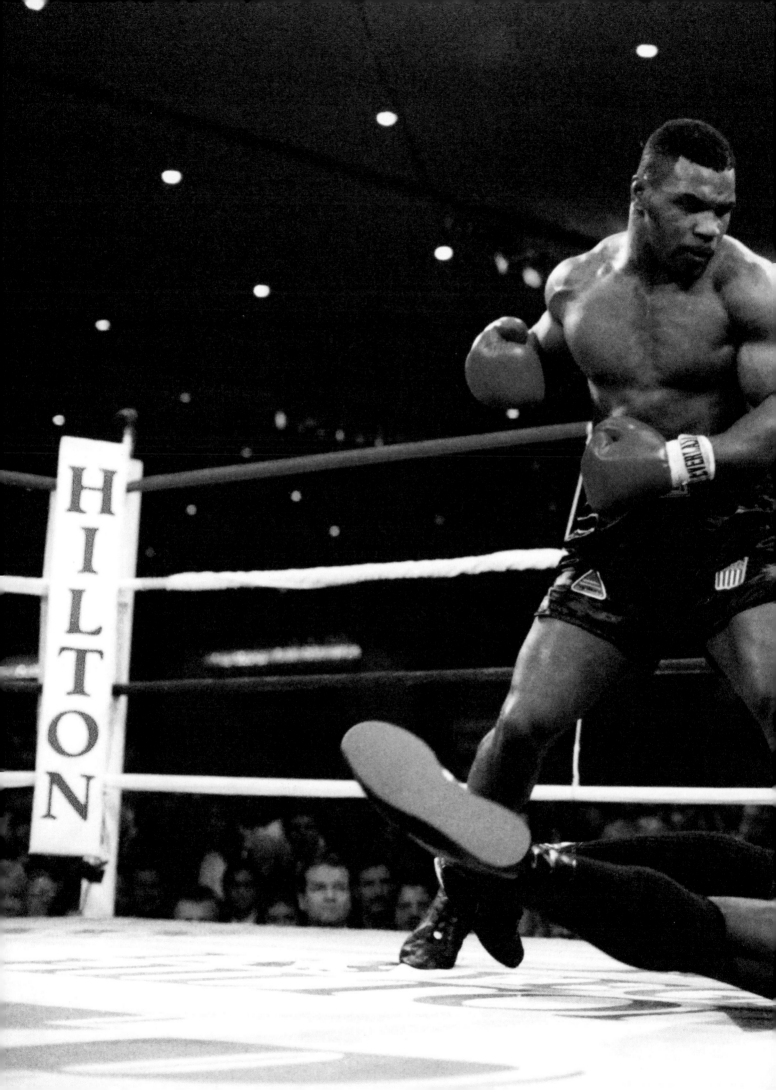

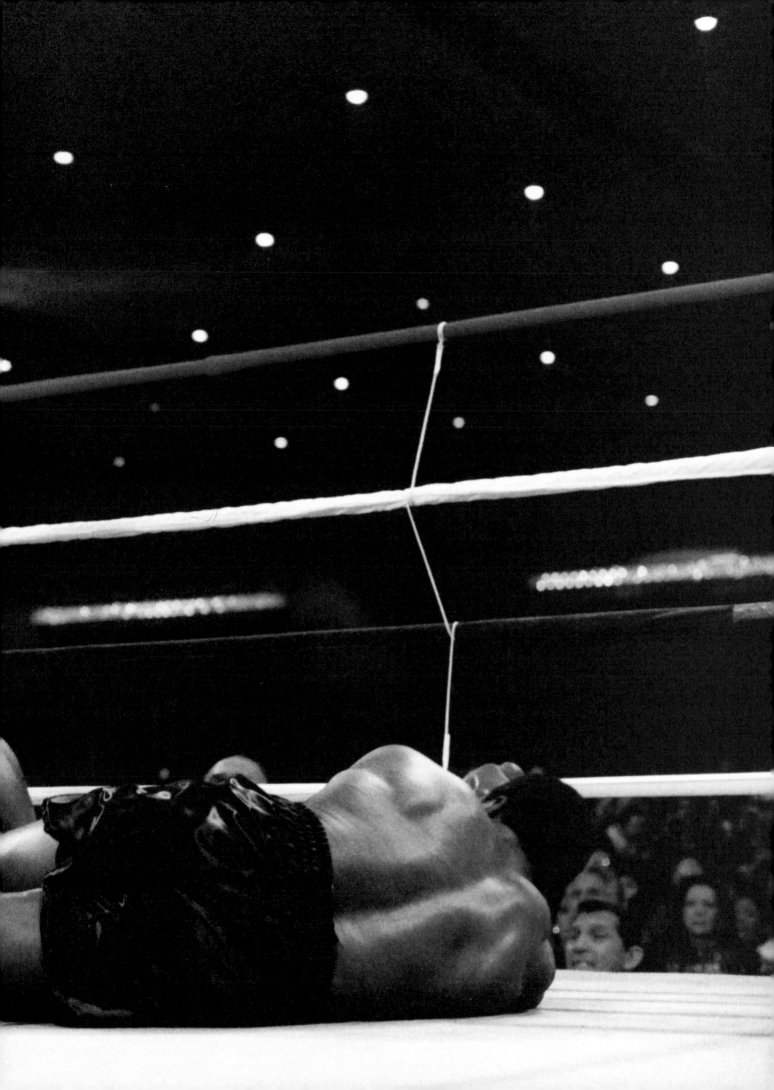

Tina Turner, 'What's Love Got to Do With It', **1984**

In the US, inspiring and influential Black voices rose to the top of music, film, TV, literature and sport. Black women, especially, commanded attention. Gwendolyn Brooks was named US Poet Laureate (85–86) and Alice Walker's novel *The Color Purple* won the Pulitzer Prize (83) and was adapted into a hit film of the same name (85). This literary sensation sparked a passion for purple among Black women, who used the colour as a symbol of strength and power on their rise to the top. In music, Whitney Houston's eponymous debut album (85) topped the charts for fourteen weeks, Janet Jackson's *Control* (86) was an instant number one, and Tina Turner was crowned the comeback queen of pop with *Private Dancer* (84). On TV, Oprah went from local morning show in Chicago to national phenomenon (86), while Phylicia Rashad's role as Clair Huxtable in *The Cosby Show* (84) elevated her into a figurehead for working moms. In sport, Florence Griffith Joyner became the fastest woman on earth at the 1988 Olympics. Meanwhile, race riots intermittently broke out across the US and Europe, and in South Africa the apartheid government led by newly elected P.W. Botha unleashed a new wave of repression against Black citizens in response to anti-apartheid protests.

The Colour Purple

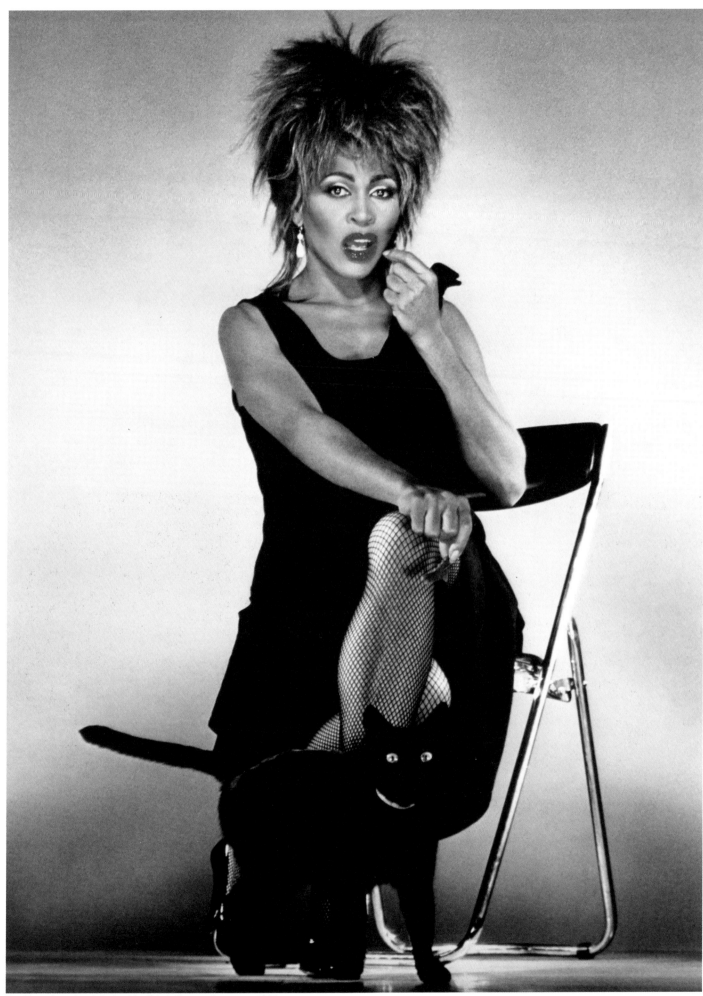

Tina Turner from the photoshoot for *Private Dancer* album cover, **1984**

Janet Jackson, **1986**

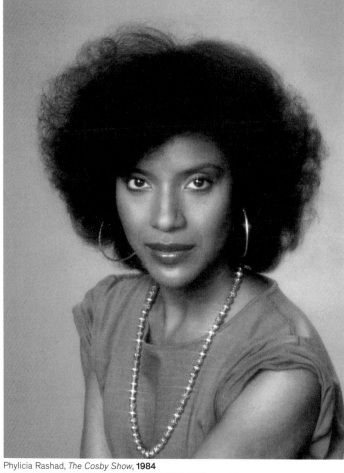
Phylicia Rashad, *The Cosby Show*, **1984**

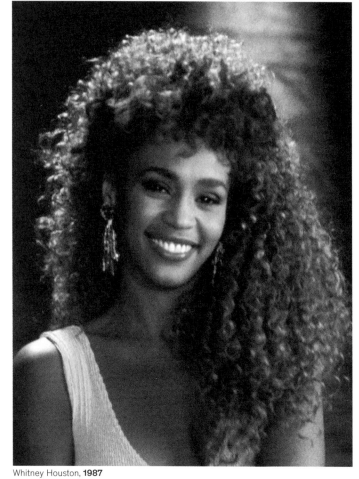
Whitney Houston, **1987**

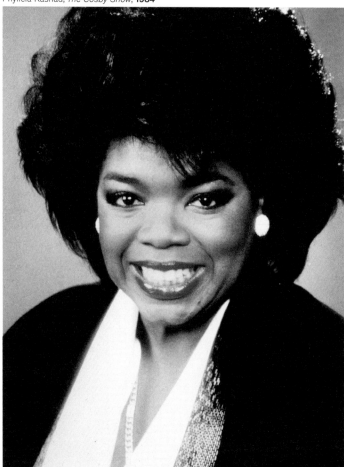
Oprah Winfrey, **1986**

The Colour Purple

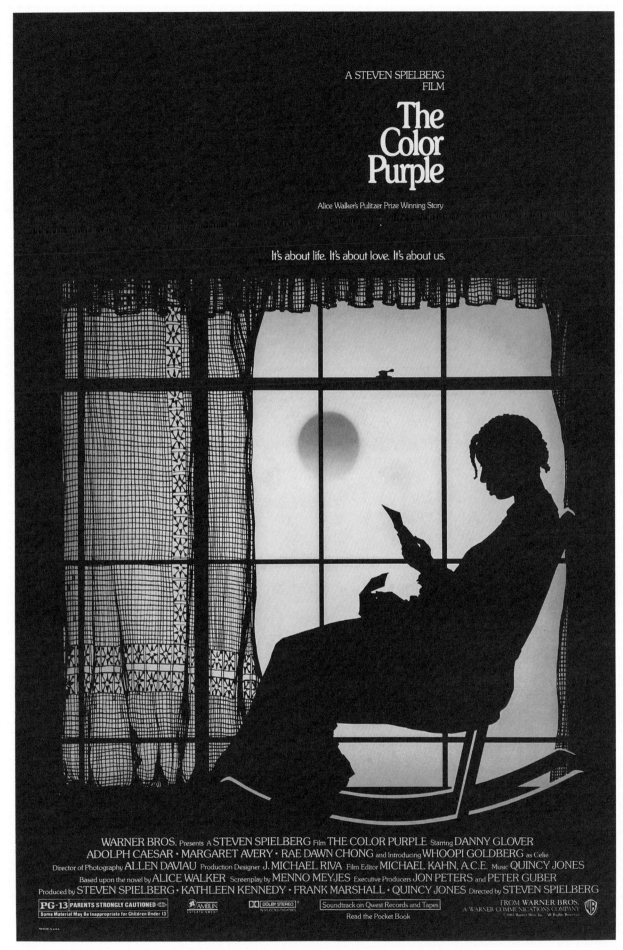

The Color Purple movie poster, **1985**

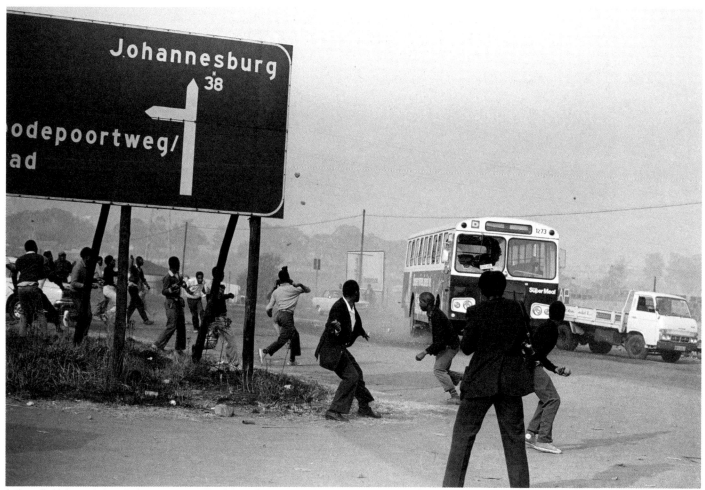
Anti-apartheid demonstrators stoning a government bus interrupting prayer services to commemorate the 1976 riots, Soweto, photo by Alf Kumalo, **1982**

By the mid-80s, anti-apartheid movements, especially in Britain, began to make a difference. While calls to impose sanctions on South Africa were ignored by Margaret Thatcher's Conservative government, public pressure prompted many companies to cancel contracts with South Africa, including the Co-op supermarket (85). By 1986, Barclays Bank pulled out of South Africa, and over a quarter of Britons said they were boycotting South African products. In 1988, the prominent anti-apartheid activist Dulcie September was shot dead in Paris, her death sparking further action in France. In the US, student protests led to most major universities divesting from South Africa. While many governments were hesitant about taking a stance against apartheid, mostly due to financial ties with South Africa, the public's opinion was unequivocal – apartheid must end, and it must end now.

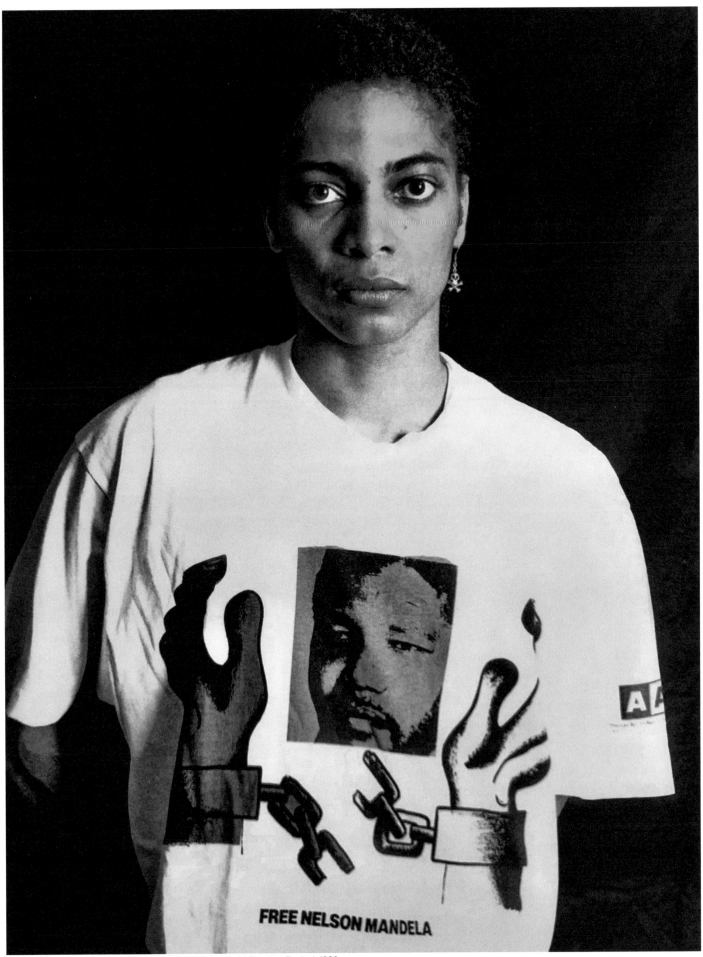

Musician Terence Trent D'Arby at the Artists Against Apartheid Freedom Festival, **1986**

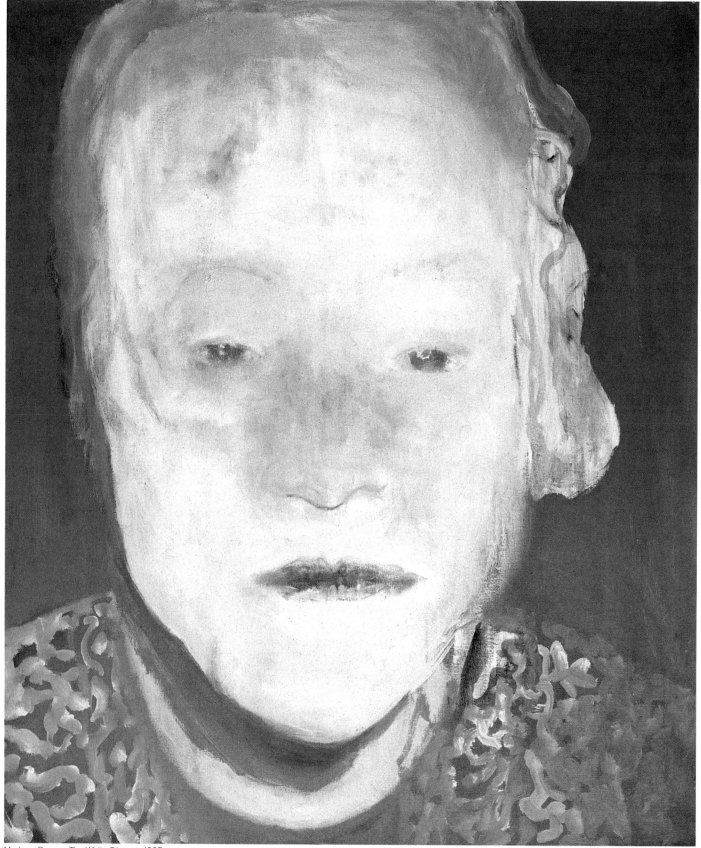

Marlene Dumas, *The White Disease*, 1985

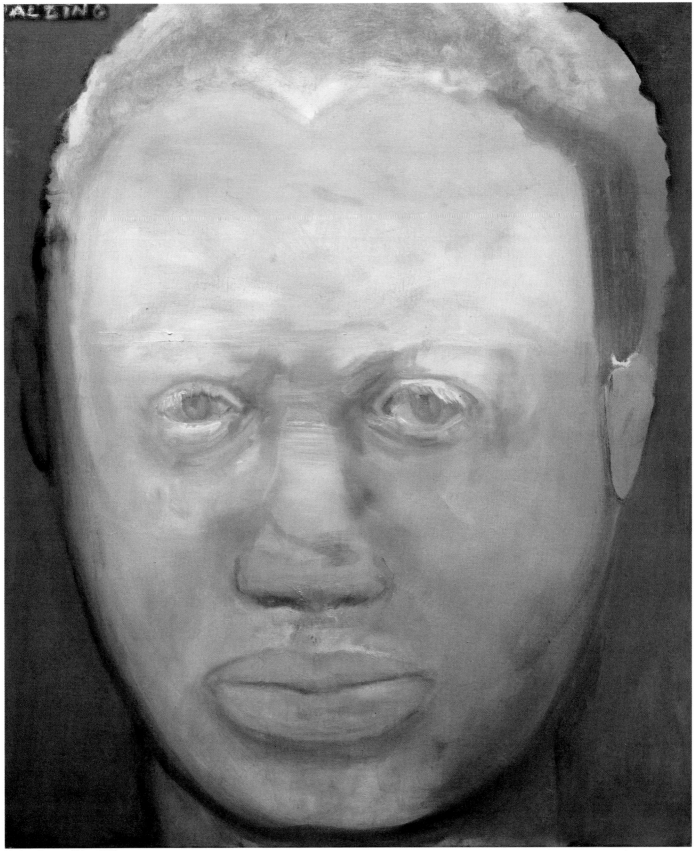

Marlene Dumas, *Albino*, **1986**

(Overleaf) Archbishop Desmond Tutu conducting a funeral service for a schoolgirl shot by police, photo by Ian Berry, **1985**
(204–205) The explosion of the Challenger space shuttle off the coast of Cape Canaveral, Florida, **1986**

201

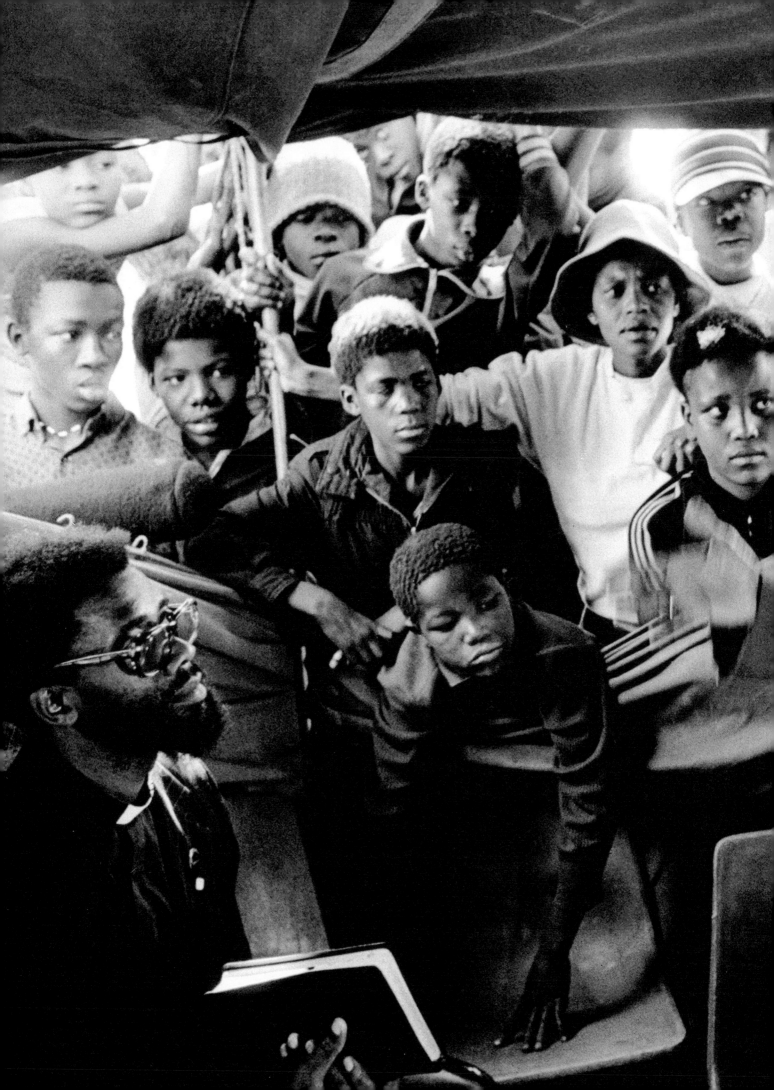

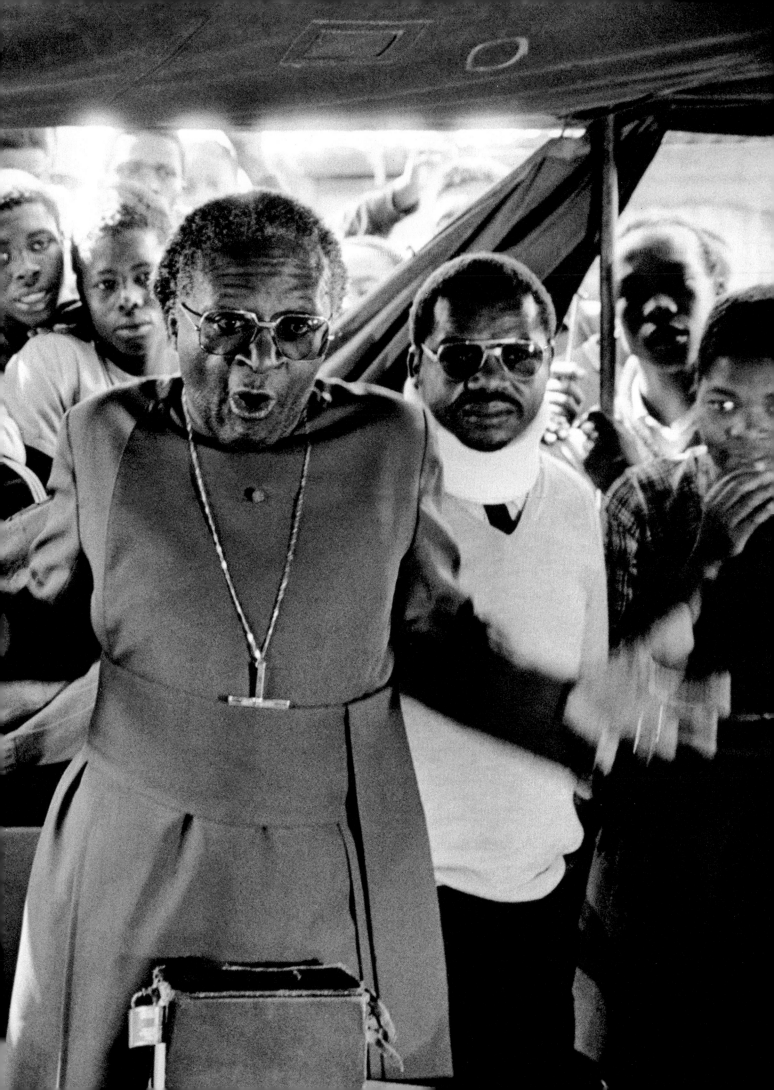

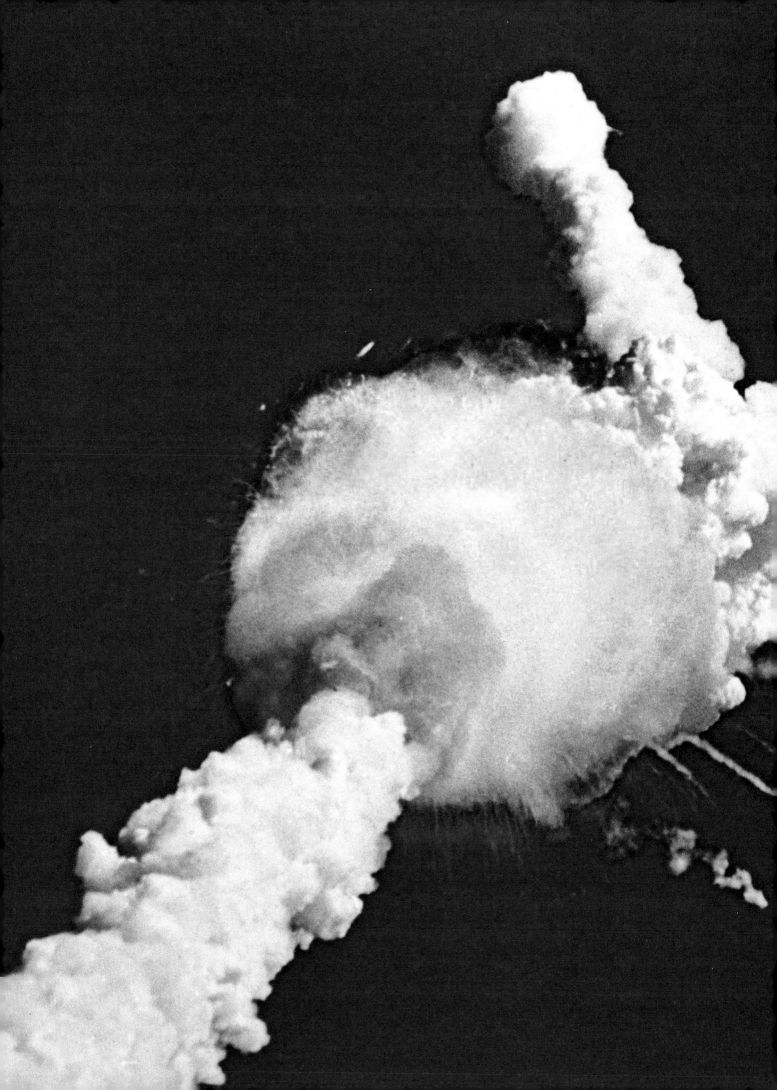

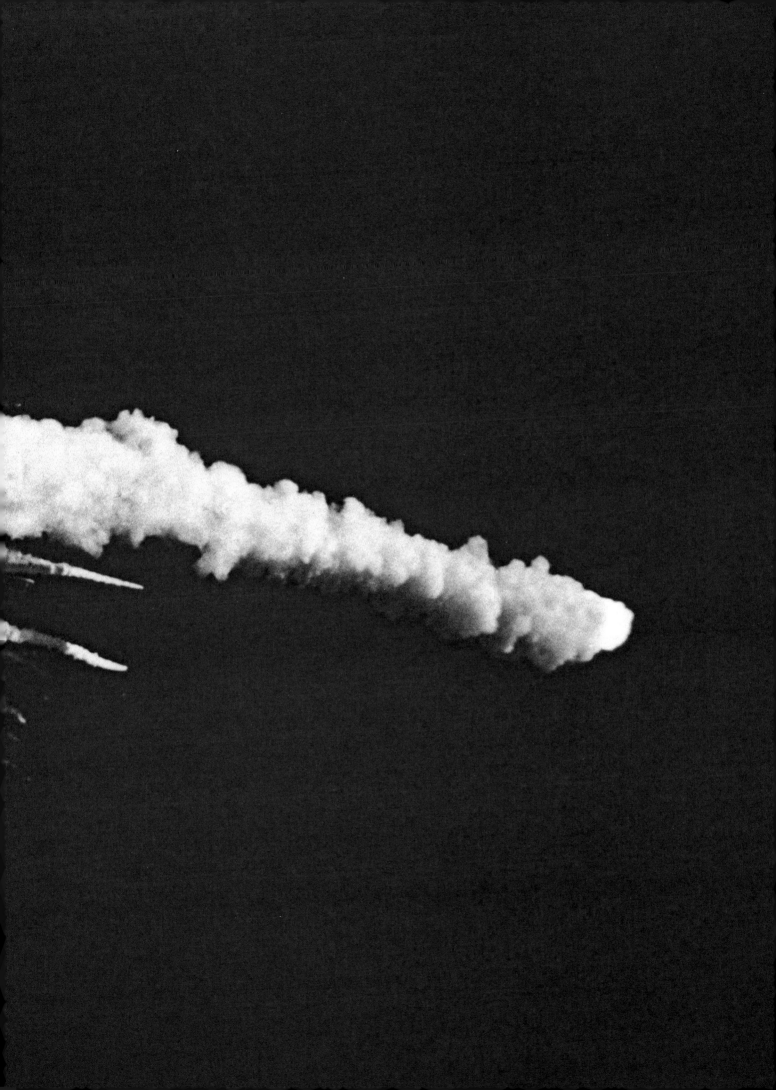

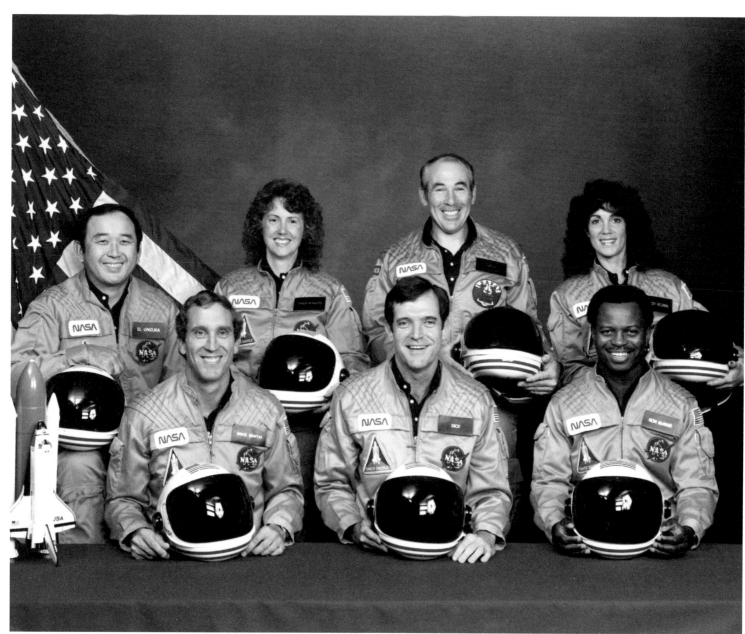

Challenger Mission STS-51L crew members, including schoolteacher Christa McAuliffe (back row, second), **1985**

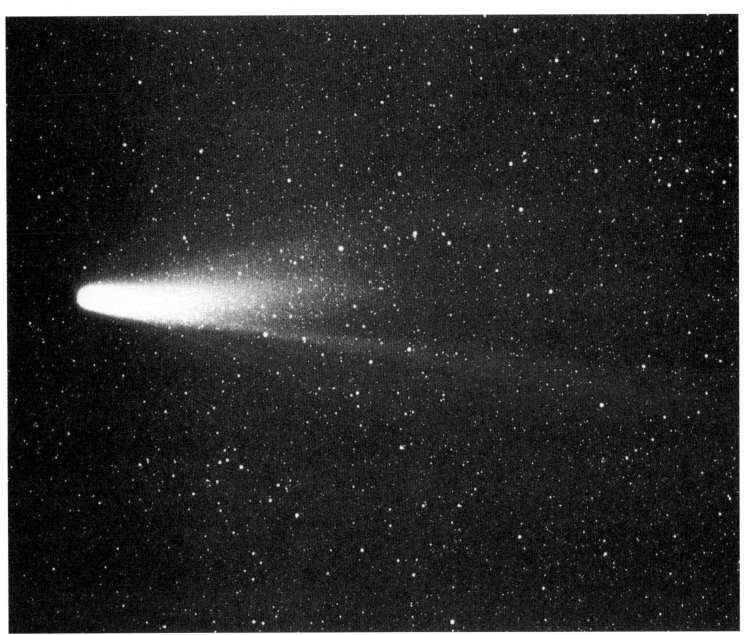

Halley's Comet, **1986**

(Overleaf) Astronaut Bruce McCandless on the first untethered spacewalk, outside the Challenger space shuttle, **1984**

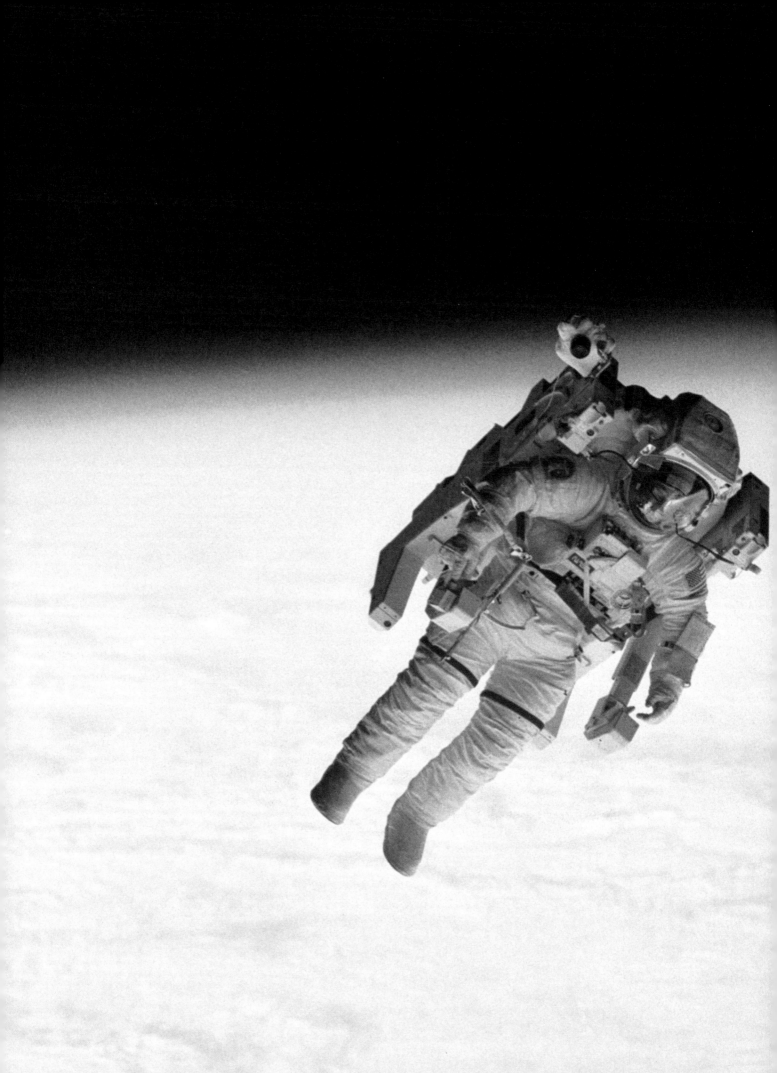

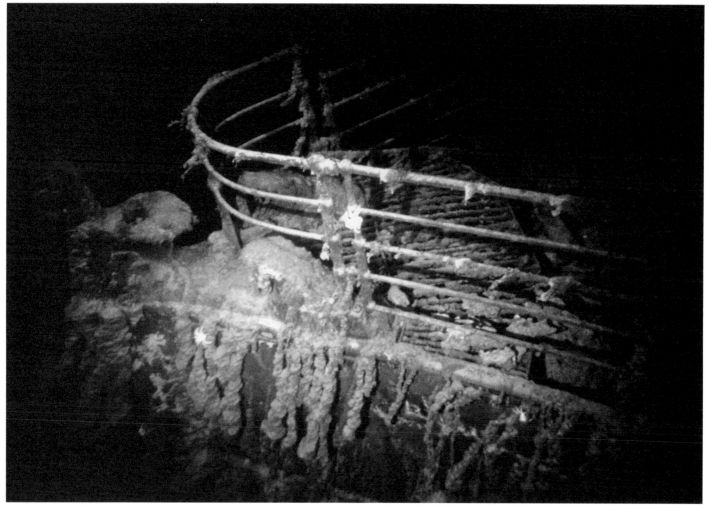

Titanic wreckage, **1986**

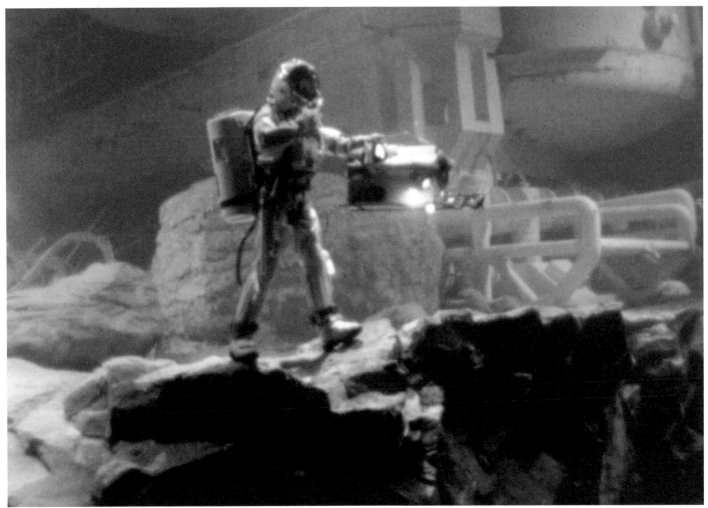
The Abyss, **1989**

It was an age of exploration in space and on Earth. The decade blasted off with Columbia, the first reusable space shuttle (81), and Bruce McCandless floated alone above the earth on the first untethered spacewalk (84). Meanwhile, the Voyager probes raced towards the outer solar system, sending back close-up images of Saturn (81), Uranus (86), and Neptune (89). Along with all this endeavour came tragedy, when the space shuttle Challenger exploded shortly after lift-off (86), an event witnessed in homes and classrooms live on CNN. The following month, in a kind of cosmic memorial, Halley's Comet (86) streamed through the night sky, an event that only occurs every seventy-six years. Ghosts of the deep also resurfaced: there was the raising of Henry VIII's warship, the *Mary Rose* (82), and the discovery of the *Titanic* (85), or the 'Mount Everest of shipwrecks', as director James Cameron later described it.

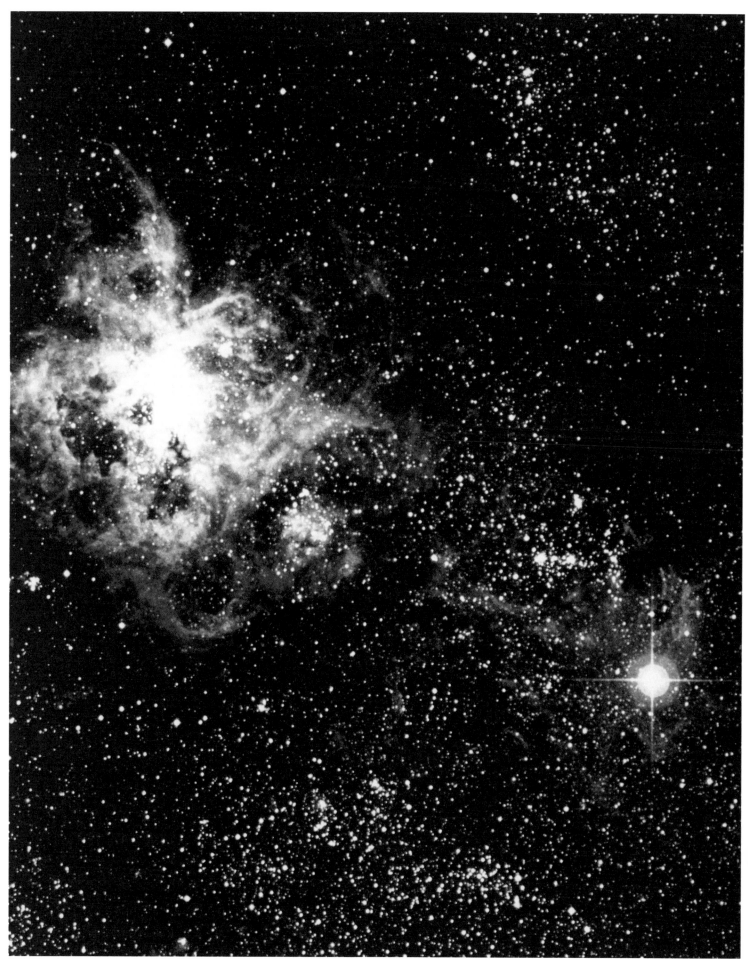

SN 1987A, a type II supernova (lower right), visible from earth with the naked eye, **1987**

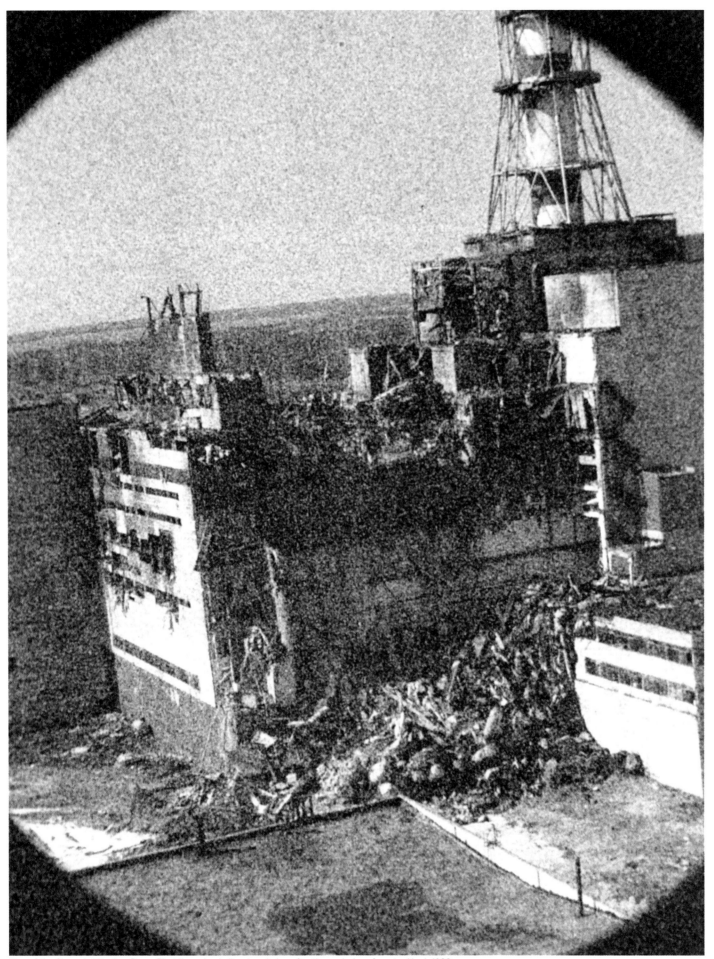

View of the Chernobyl Nuclear Power Plant through a helicopter window after the explosion of reactor No. 4, **1986**

Who Framed Roger Rabbit, **1988**

The Toxic Avenger Part III: The Last Temptation of Toxie, **1989**

Brazil, **1985**

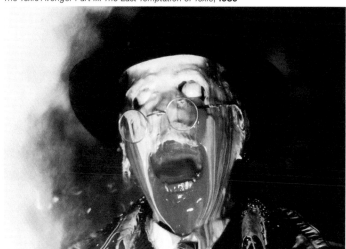
Raiders of Lost Ark, **1981**

An increasing awareness of environmental issues saw chemicals repeatedly dissolving flesh and bone. In movies like *The Toxic Avenger* (84) and *RoboCop* (87) heroes and villains fell into toxic waste. Even cartoon characters, such as the poor innocent shoe who got 'dipped' in *Who Framed Roger Rabbit* (88), were not safe from such an acidic end. Meanwhile, a real-life hero confronted the public with the realities of adapting to a life of disfigurement. Simon Weston, a British soldier whose boat was destroyed during the Falklands War (82), suffered burns over nearly half his body. His scarred face, shocking at first and hard to look at, gradually became one of the decade's most familiar and enduring emblems of strength and resilience due to his charity work and media appearances. Weston's was the face of accountability, a sobering reminder to politicians about the human cost of sending men to war.

Meltdown

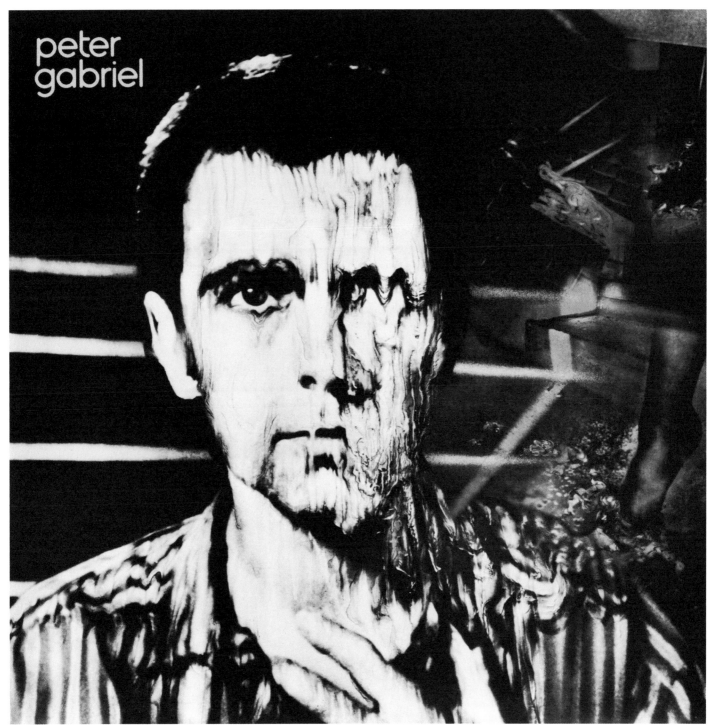

Cover of Peter Gabriel's self-titled studio album, released **1980**

The Goonies, **1985**

Lost Kids

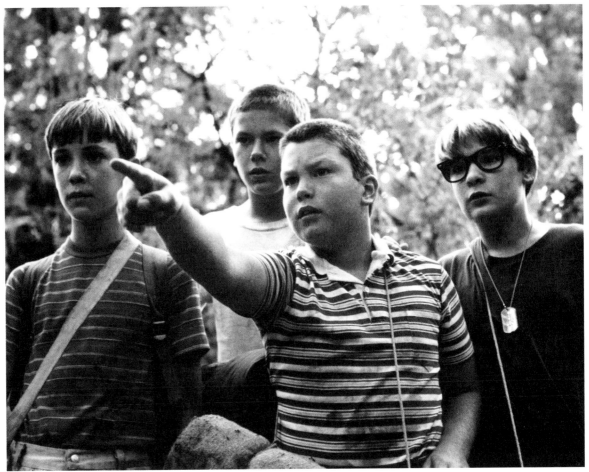
Stand By Me, **1986**

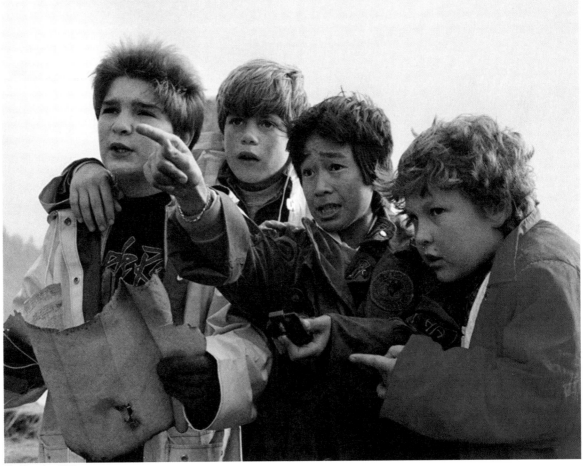
The Goonies, **1985**

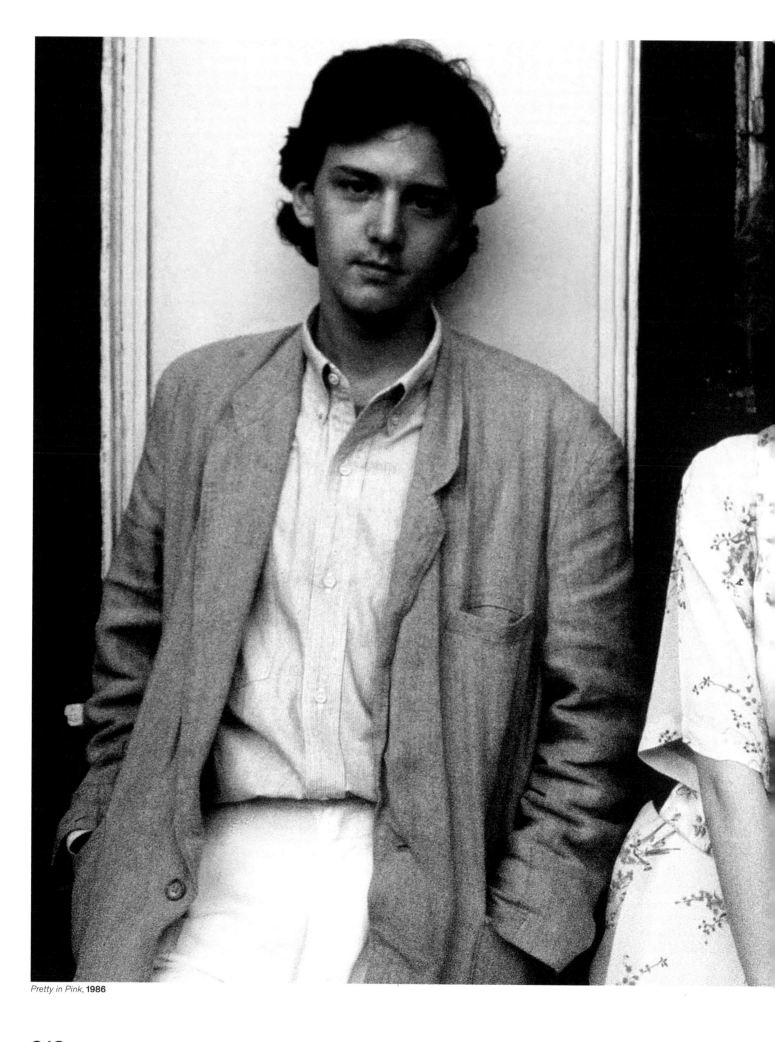

Pretty in Pink, **1986**

Lost Kids

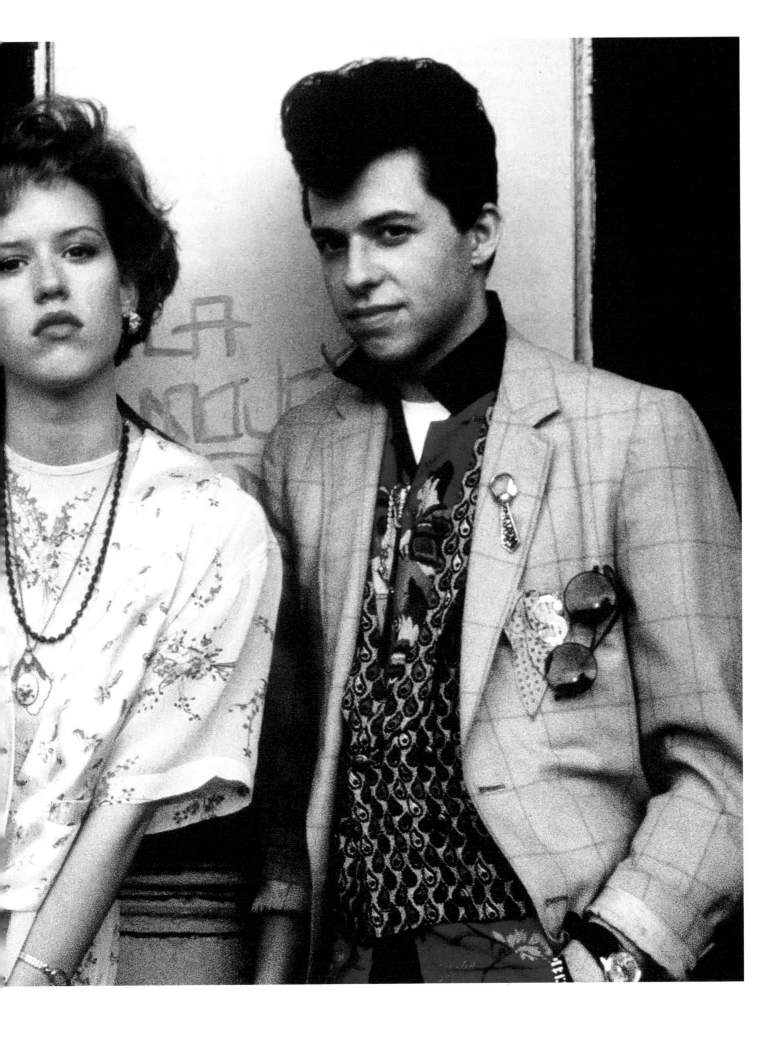

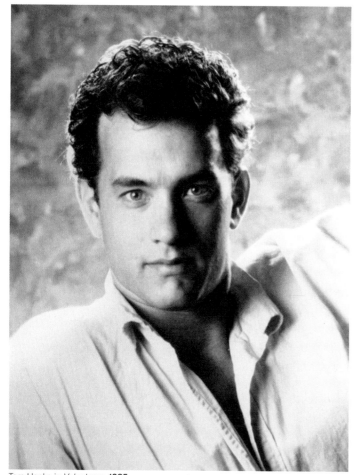

Tom Hanks in *Volunteers*, **1985**

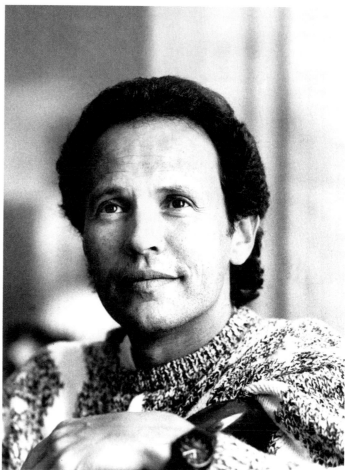

Billy Crystal, **1988**

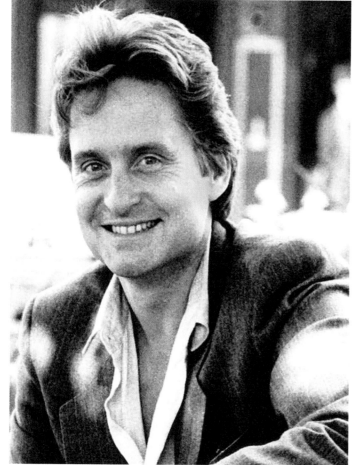

Michael Douglas, **1984**

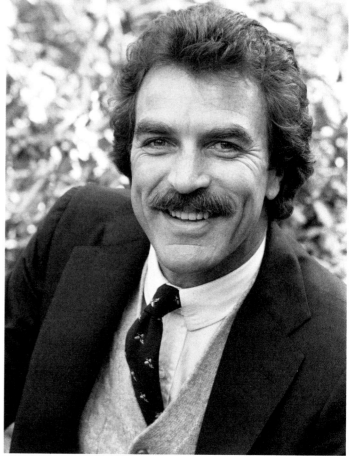

Tom Selleck, **1985**

Homogenous Heartthrobs

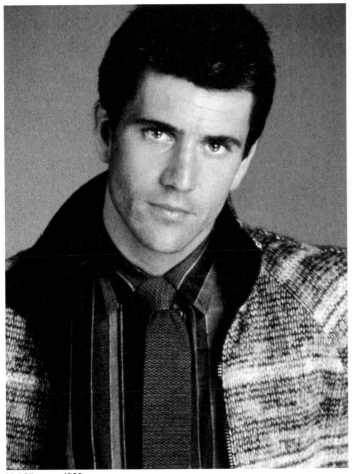

Mel Gibson, *c.* 1983

Harrison Ford, *c.* 1983

Steve Guttenberg in *Police Academy*, 1984

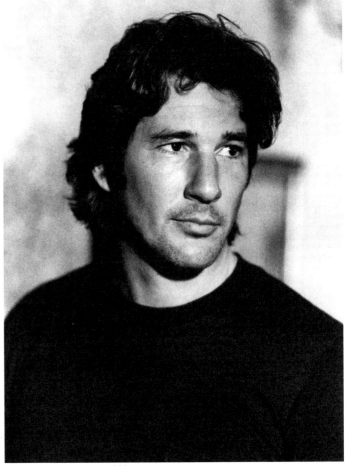

Richard Gere in *No Mercy*, 1986

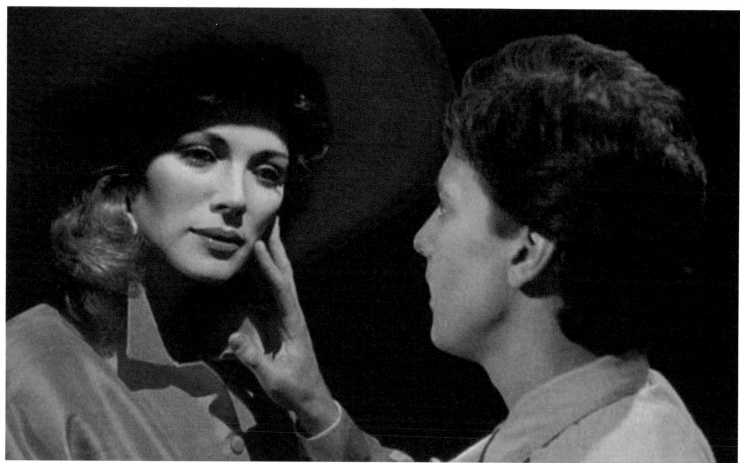

Mannequin, **1987**

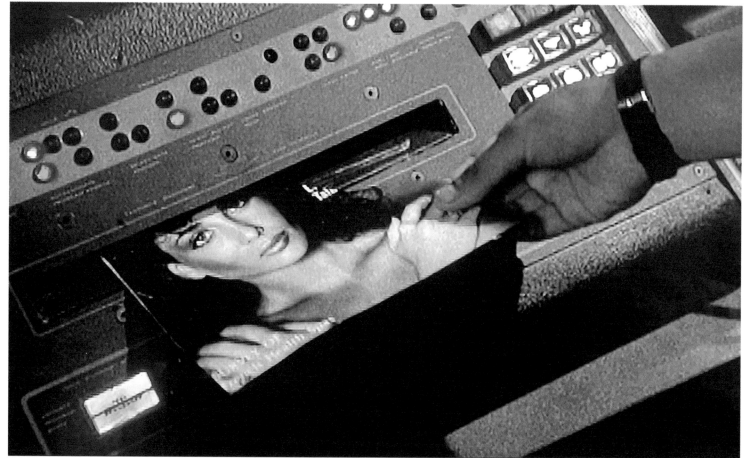

Weird Science, **1985**

Male Gaze

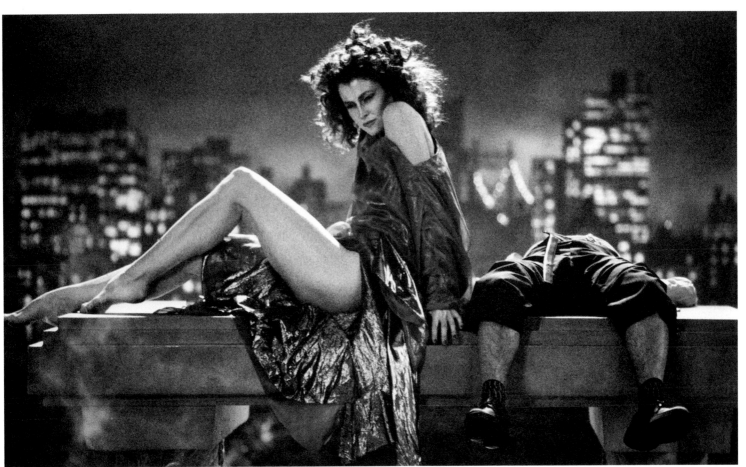

Ghostbusters, **1984**

Even after the sexual revolution of the 60s and 70s, the male gaze remained a powerful force in media, but the tactics were changing. Subterfuge was the name of the game as women rose through the ranks in the male-dominated industries that controlled representation. In film, television, advertising and publishing, attempts to reflect a woman's power and autonomy were sabotaged, consciously or unconsciously. Women were literally man-made in movies: in *Weird Science* (85), two teenage boys fed *Playboy* magazines into a computer to manufacture their perfect woman, and in *Mannequin* (87), a window dresser's creation came to life in a department store. Any influence or success a woman wielded at the cinema often resulted from her sexual confidence rather than her mind. But too much sexual confidence was depicted as unhinged. Glenn Close was the 'bunny boiler' in *Fatal Attraction* (87), and Sigourney Weaver went from being a self-assured cello player to a nymphomaniac after being possessed by demons in *Ghostbusters* (84).

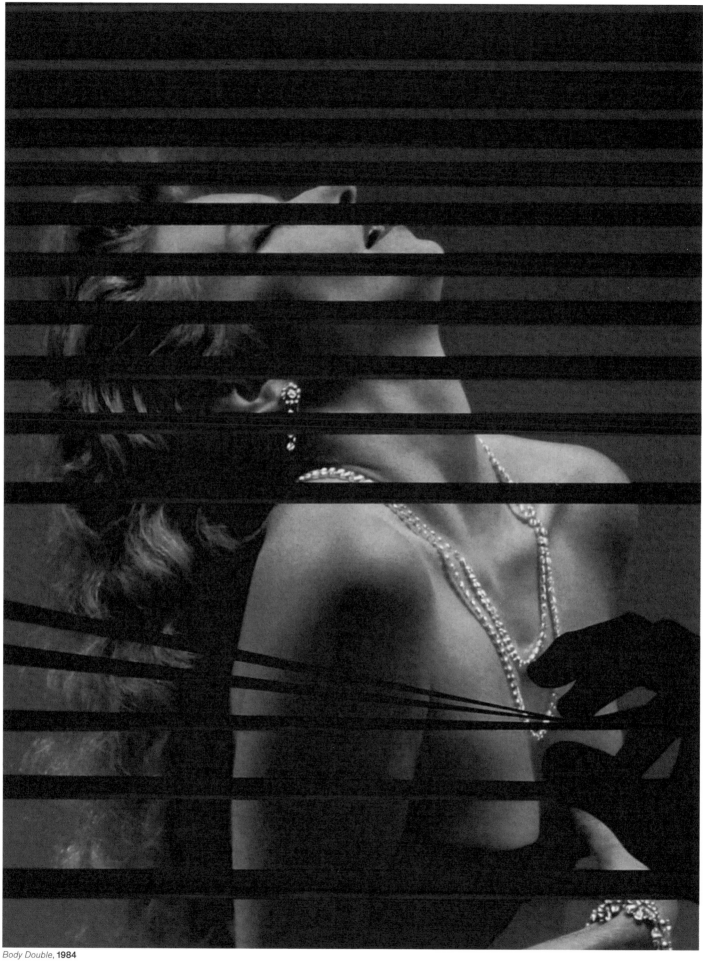

Body Double, **1984**

Male Gaze

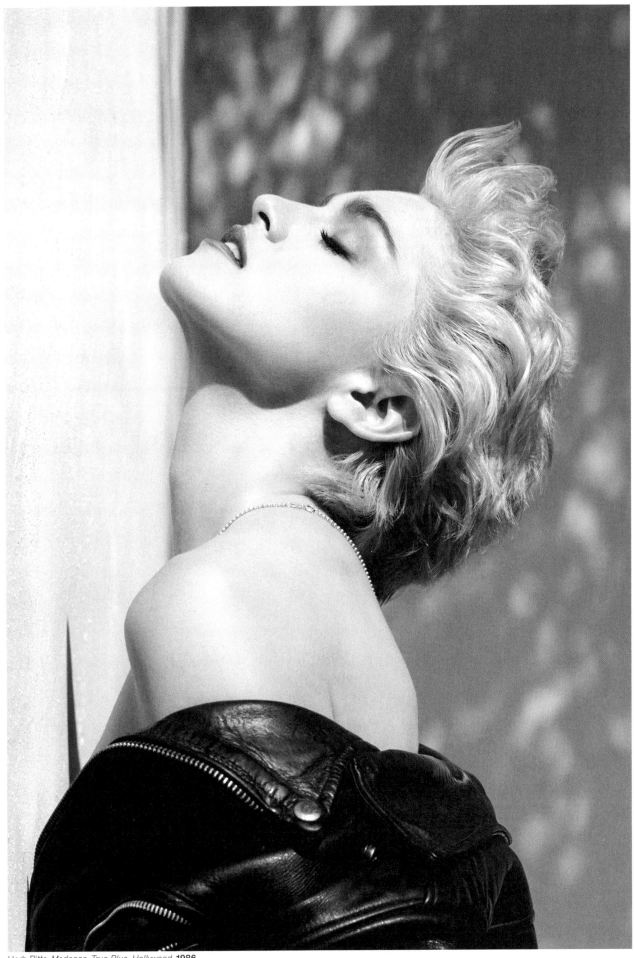

Herb Ritts, *Madonna, True Blue, Hollywood*, **1986**

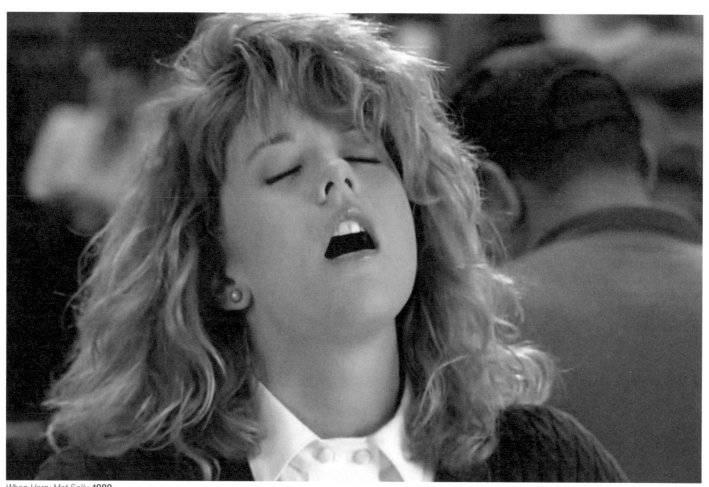

When Harry Met Sally, **1989**

226

Sex, Lies, and Videotape, **1989**

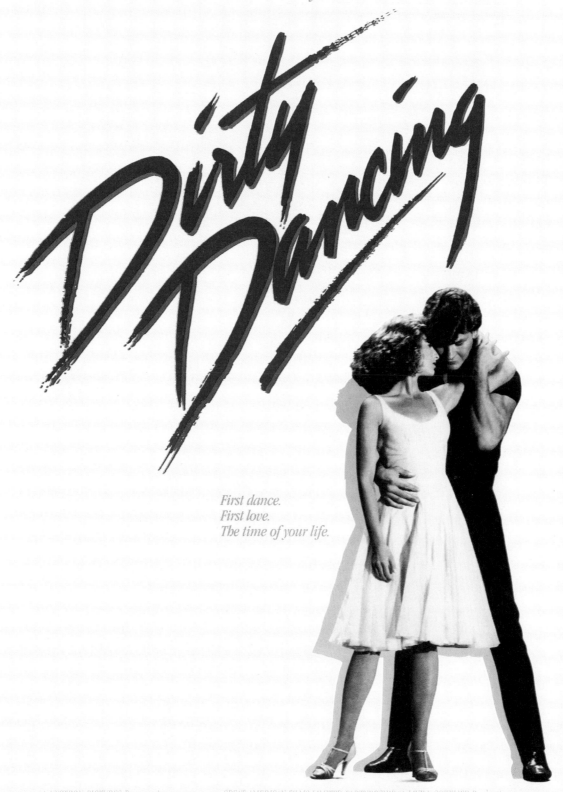

PATRICK SWAYZE · JENNIFER GREY

First dance.
First love.
The time of your life.

A VESTRON PICTURES Presentation In association with GREAT AMERICAN FILMS LIMITED PARTNERSHIP A LINDA GOTTLIEB Production
DIRTY DANCING Starring PATRICK SWAYZE · JENNIFER GREY · JERRY ORBACH · CYNTHIA RHODES Executive Producers MITCHELL CANNOLD and STEVEN REUTHER
Choreography KENNY ORTEGA Music Consultant JIMMY IENNER Music Score JOHN MORRIS Co-Producer ELEANOR BERGSTEIN Associate Producer DORO BACHRACH
Editor PETER C. FRANK Production Designer DAVID CHAPMAN Director of Photography JEFF JUR Written by ELEANOR BERGSTEIN
Produced by LINDA GOTTLIEB Directed by EMILE ARDOLINO

Dirty Dancing movie poster, **1987**

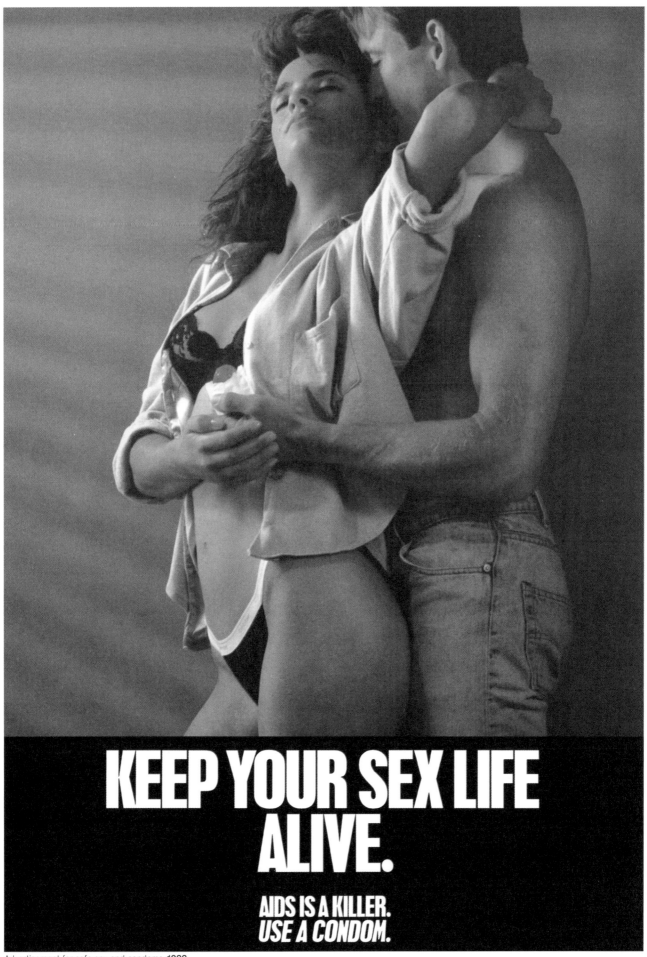

KEEP YOUR SEX LIFE ALIVE.

AIDS IS A KILLER.
USE A CONDOM.

Advertisement for safe sex and condoms, **1988**

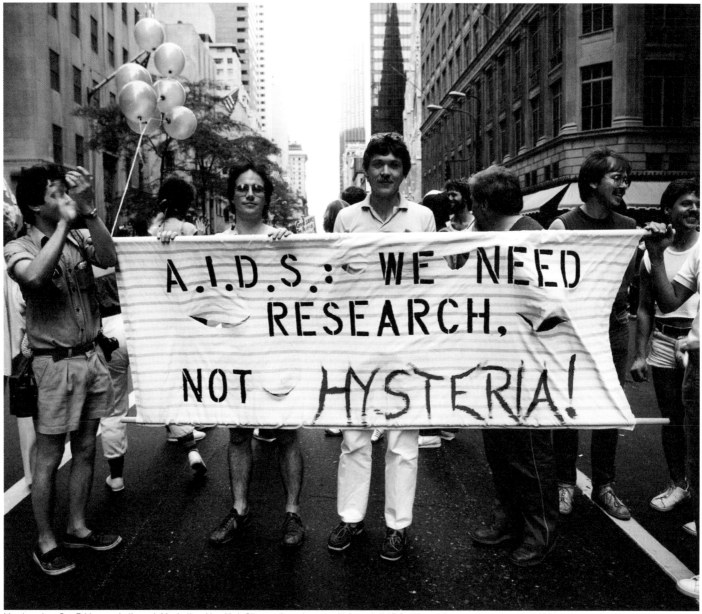

Marchers in a Gay Pride parade through Manhattan, New York City, carrying a banner which reads 'A.I.D.S.: We need research, not hysteria!', **1983**

David Wojnarowicz, *History Keeps Me Awake at Night*, **1986**

(Overleaf) John Sturrock, striking miners confronting police during the one-year miners' strike, Bilston Glen, Scotland, **1984**
(234–235) US President Ronald Reagan and newly elected General Secretary of the Communist Party of the Soviet Union
Mikhail Gorbachev at the Chateau Fleur d'Eau, Geneva, Switzerland, **1985**

231

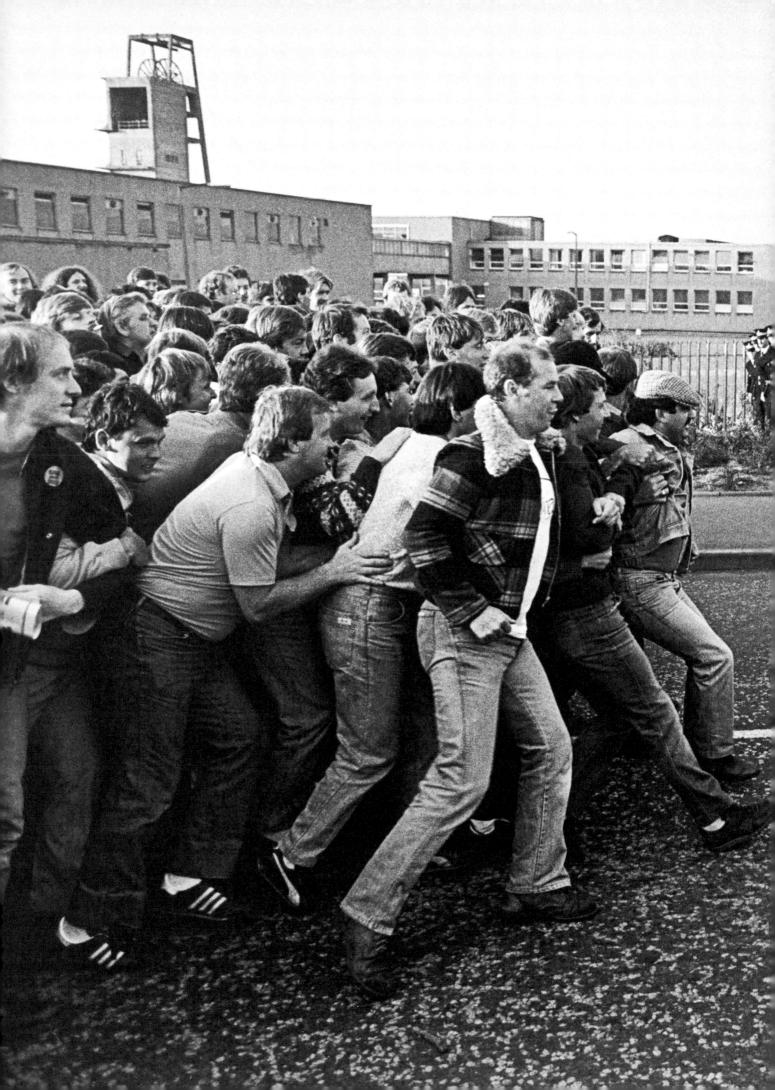

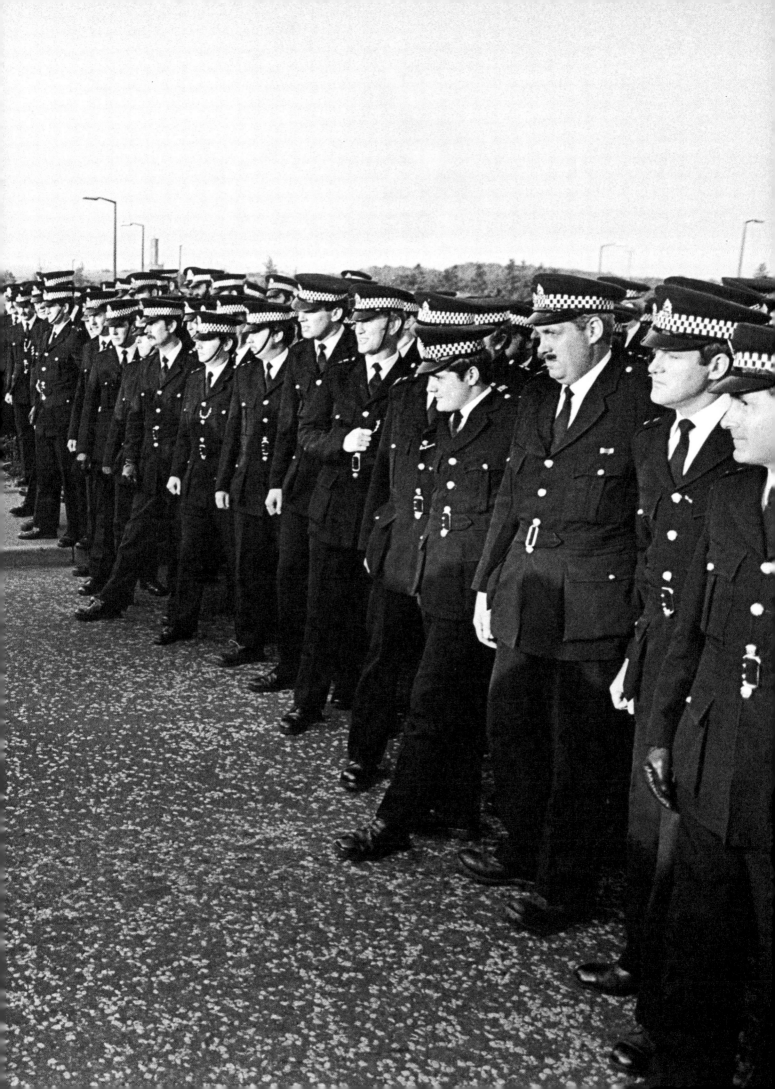

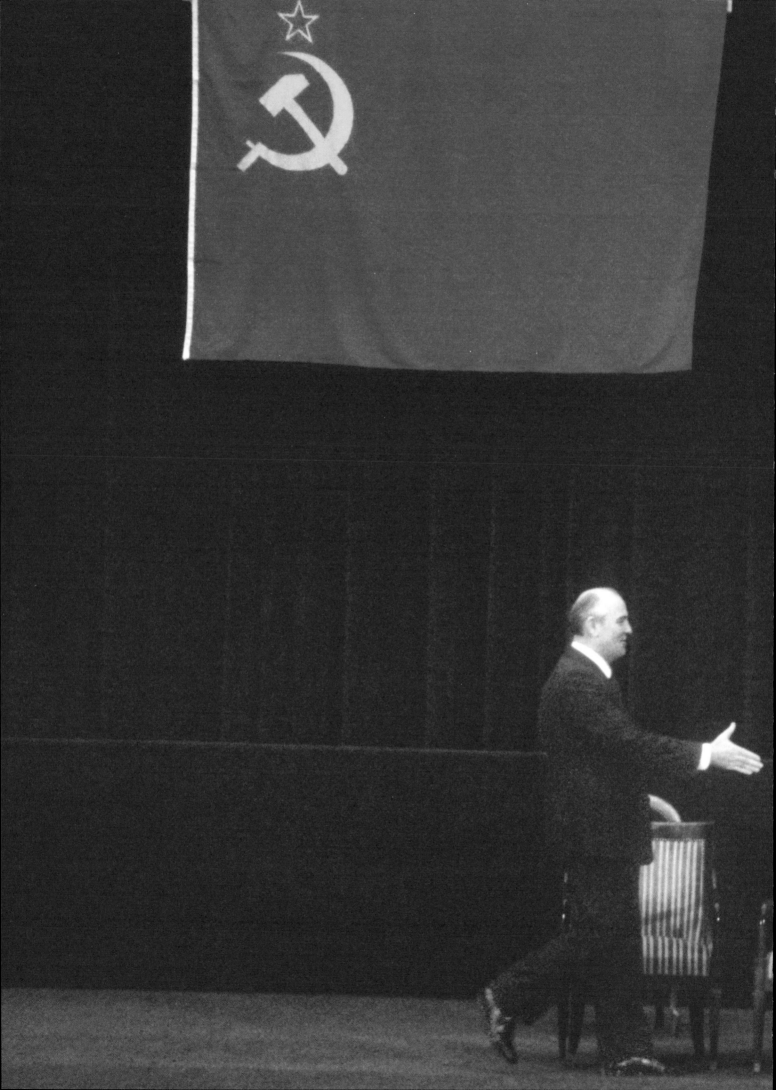

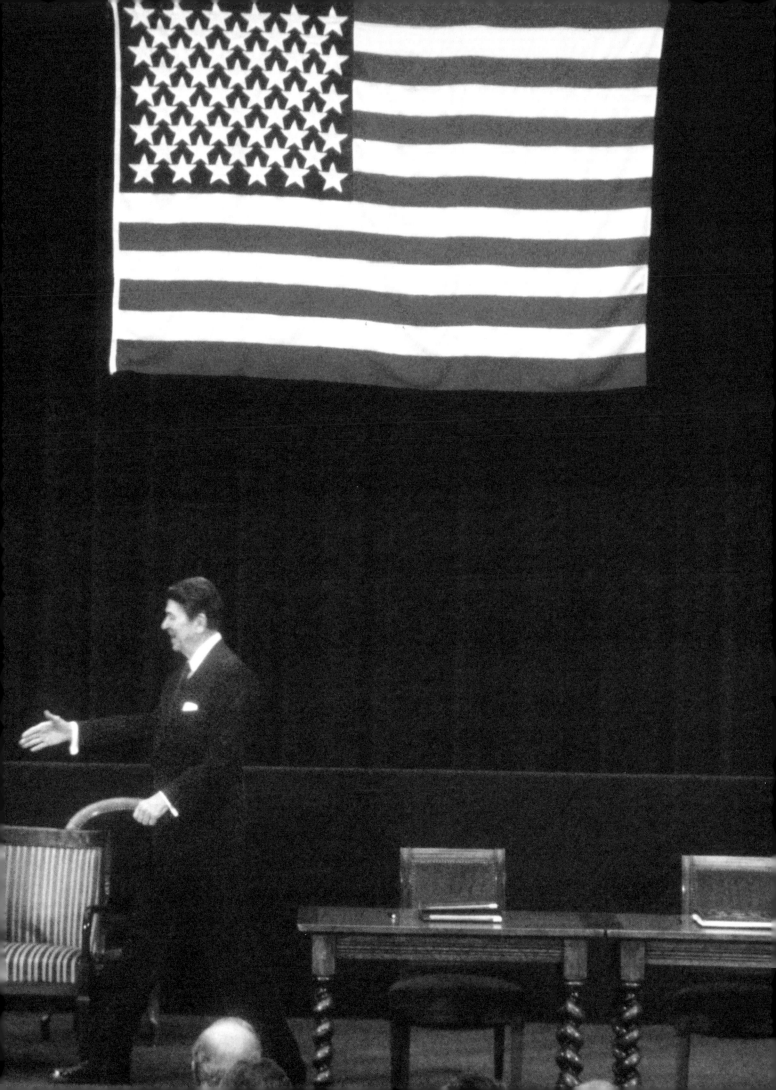

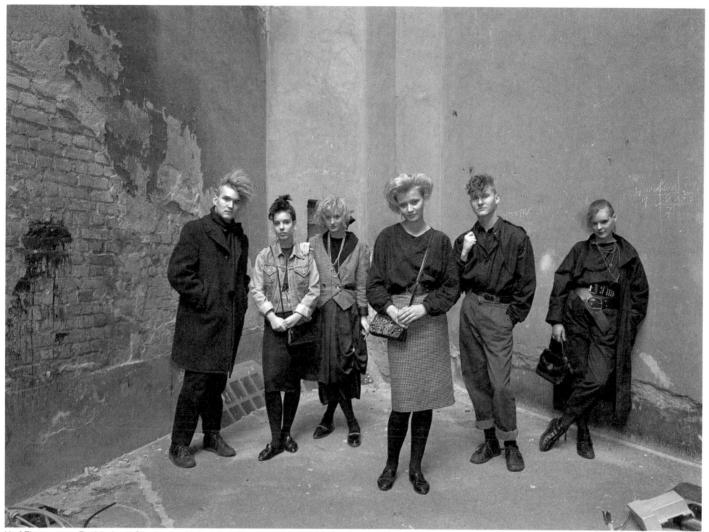

Harf Zimmermann, Tomi (trainee), Silvy (student), Manuela (trainee), her sister Beatrix, known as Trixi (student), Uwe, known as Wembley (trainee), and Tatjana, known as Schnüdel (student), from *Hufelandstrasse, 1055 Berlin*, **1986**

In the tightly controlled German Democratic Republic (East Germany), where teenagers had a limited number of fashion choices, punk became a popular sartorial style. Jeans could be ripped, slogans could be handwritten on t-shirts and accessories like handcuffs were not all that hard to come by. Magazines were smuggled in, giving glimpses of what was going on in the West, and the GDR had its own magazines such as *Sibylle*, which featured female fashion from communist countries. *Sibylle* avoided the strictest censorship, but female models were rarely – if ever – seen in blue jeans or miniskirts. It was hardly surprising, then, that as the West culturally blossomed under capitalism, and the GDR's economy floundered, a growing desire for reform increased among the population. Yet in the mid-80s, the Berlin Wall that separated West Berlin from surrounding East Germany still felt permanent. It remained a global symbol of division, an increasing political pressure point right in the heart of Europe.

Two Sides

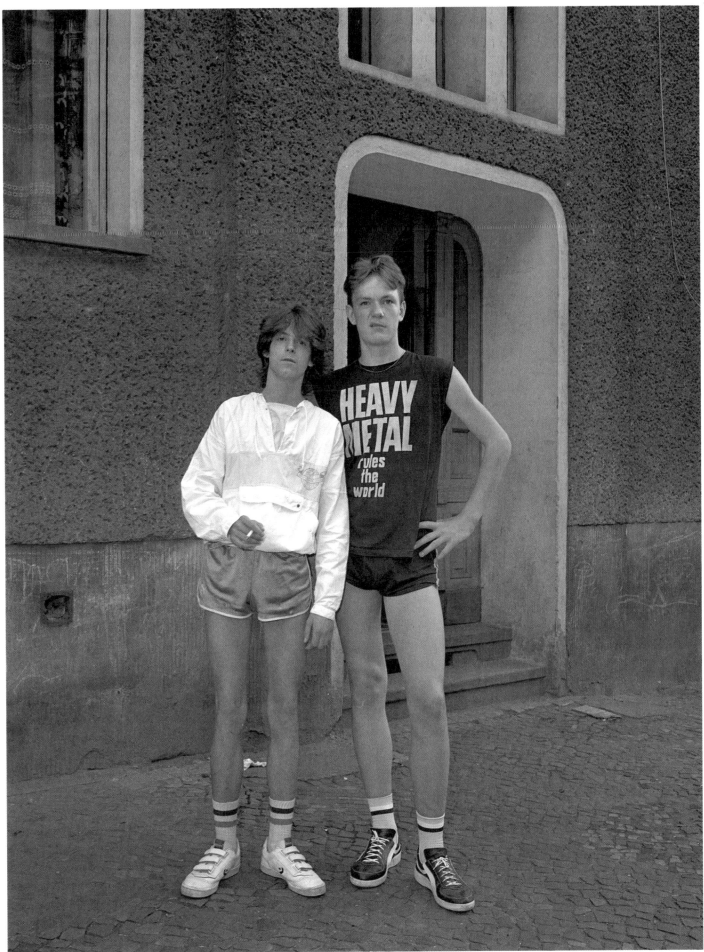

Harf Zimmermann, Two students in the 8th Grade, from *Hufelandstrasse, 1055 Berlin*, **1986**

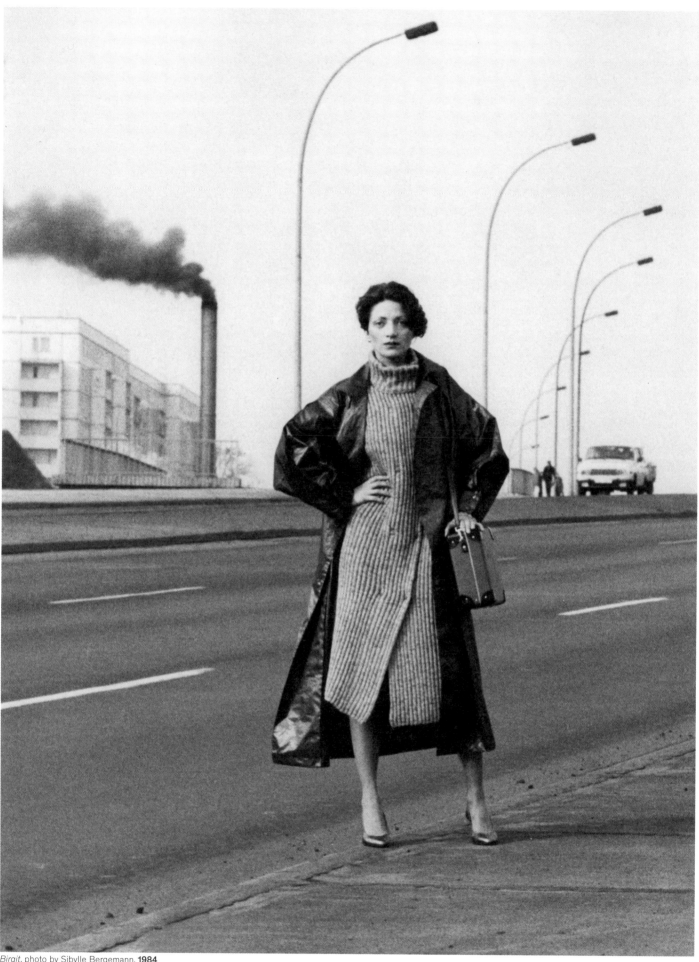

Birgit, photo by Sibylle Bergemann, **1984**

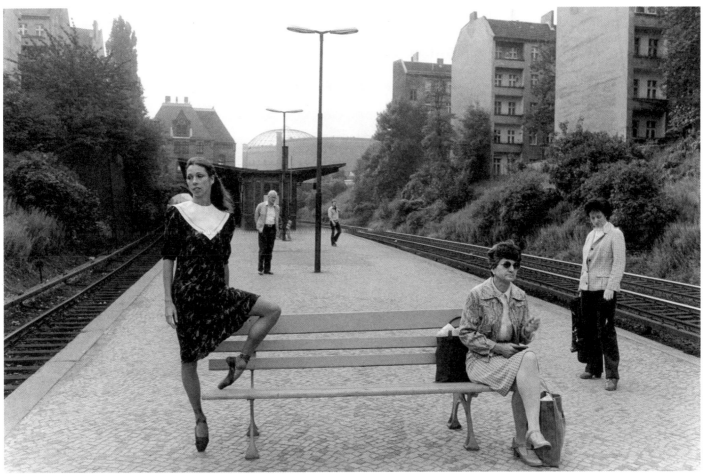

Prima ballerina Jutta Deutschland, Berlin-Prenzlauer Berg, photo by Ute Mahler, **1981**

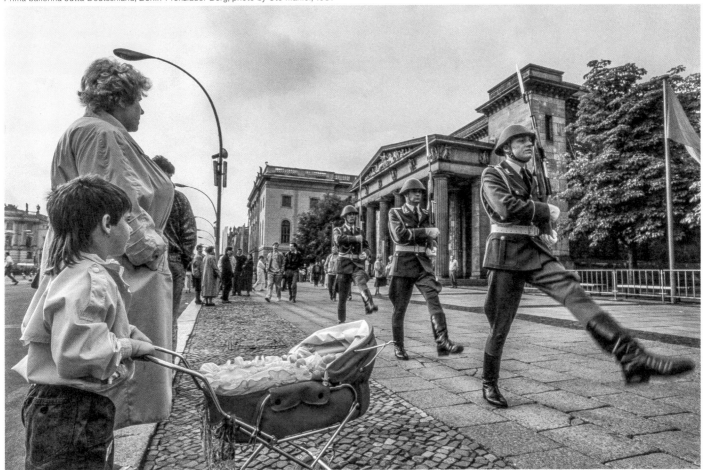

Spectators watching a parade of the Friedrich Engels guard regiment of the National People's Army, East Germany, **1989**

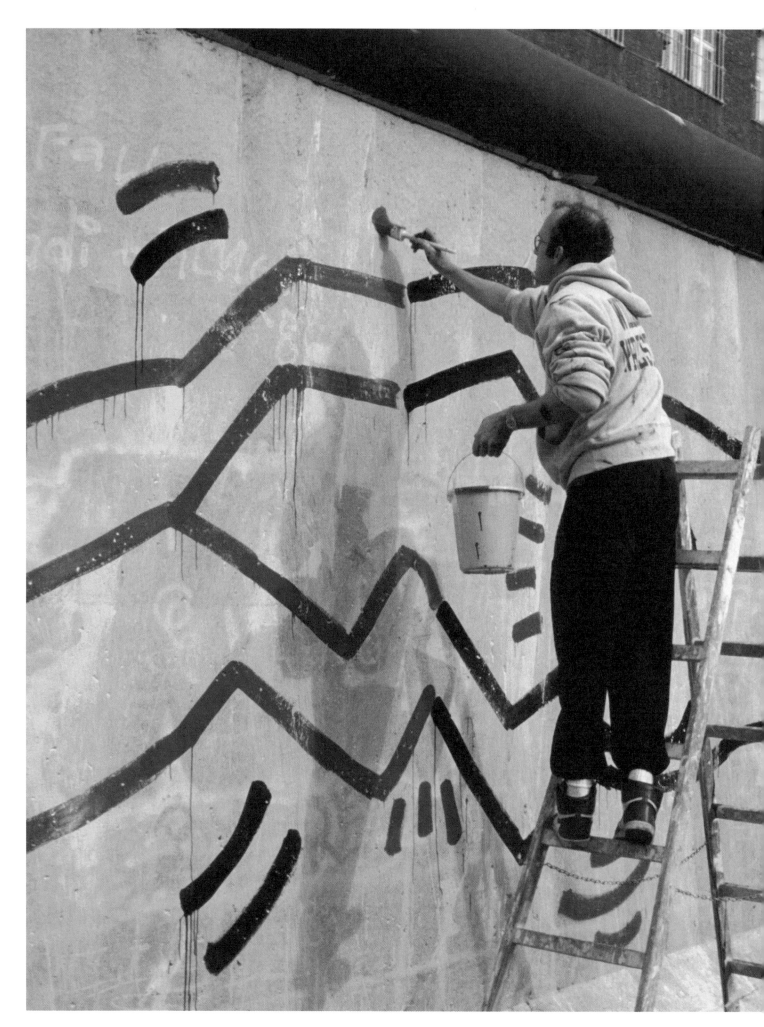

Keith Haring painting the Berlin Wall, **1986**

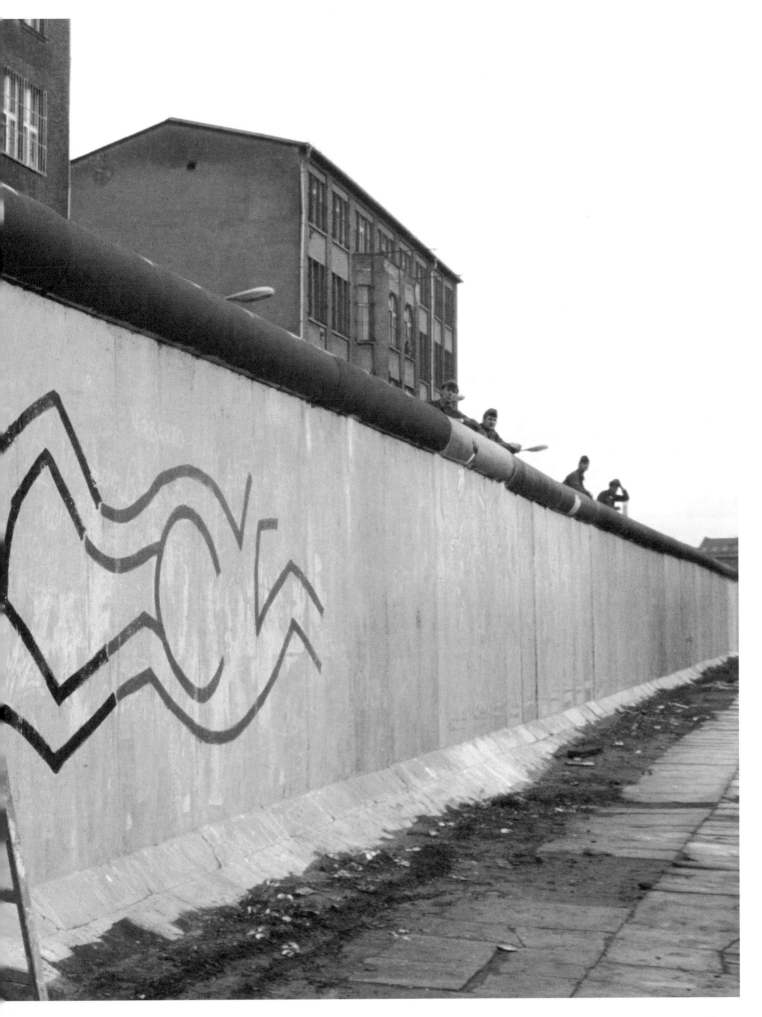

Kenny Scharf, *When The Worlds Collide*, **1984**

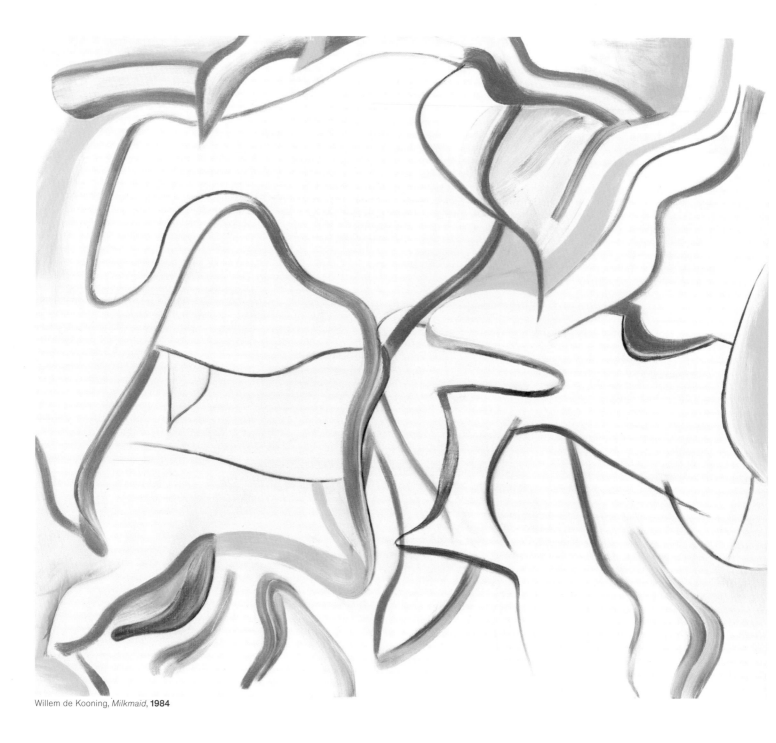

Willem de Kooning, *Milkmaid*, **1984**

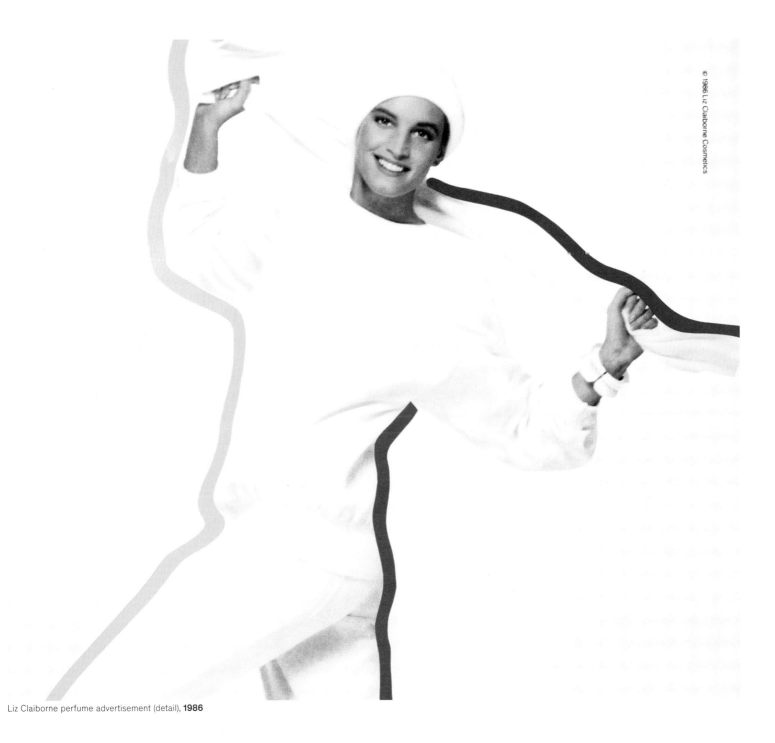

© 1986 Liz Claiborne Cosmetics

Liz Claiborne perfume advertisement (detail), **1986**

Serious Fun

Guerrilla Girls Review the Whitney, from 'Guerrilla Girls Talk Back', **1987**

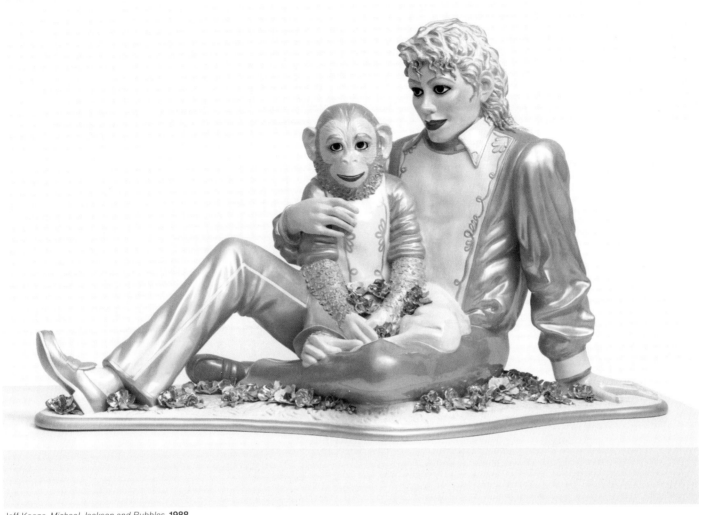

Jeff Koons, *Michael Jackson and Bubbles*, **1988**

The art market, especially in New York, was booming. Owning art was a flashy emblem of wealth and big, bright and brash works changed hands like baseball cards. Dealers like Larry Gagosian, a.k.a. 'Go-Go', started buying works for unheard-of prices for his exclusive list of collectors. Record-breaking sales at high-profile auctions added a touch of theatre to buying art, most notably when Van Gogh's *Sunflowers* sold to a Japanese collector for $40 million (87). Jeff Koons emerged with shiny, attention-grabbing sculptures resembling balloon animals and depicting pop culture icons such as Michael Jackson and his pet monkey, Bubbles. Art infiltrated mainstream politics and fashion like never before, with Keith Haring painting on the Berlin Wall and collaborating with Swatch. Art was fun. Art was sexy. Art was incredibly expensive. The seeds that Andy Warhol planted in the 60s had grown into a bountiful green jungle where money did, indeed, grow on trees.

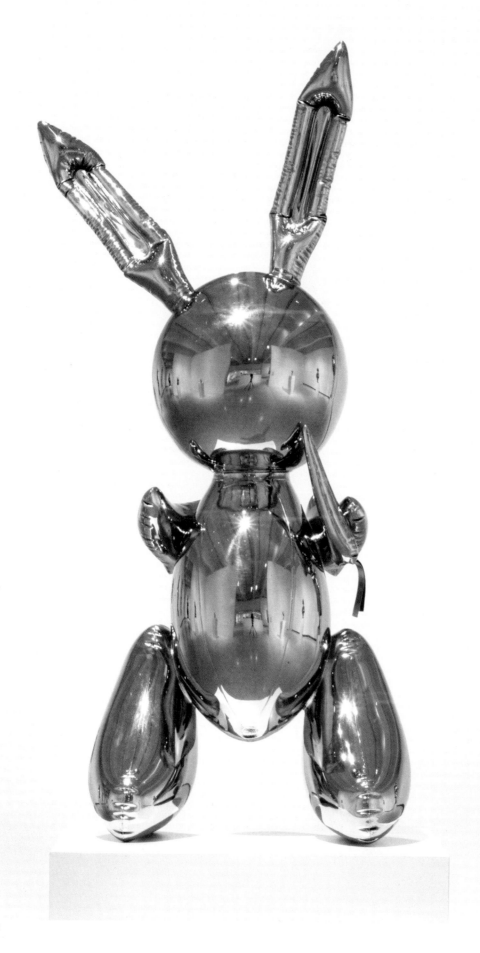

Jeff Koons, *Rabbit*, **1986**

Serious Fun

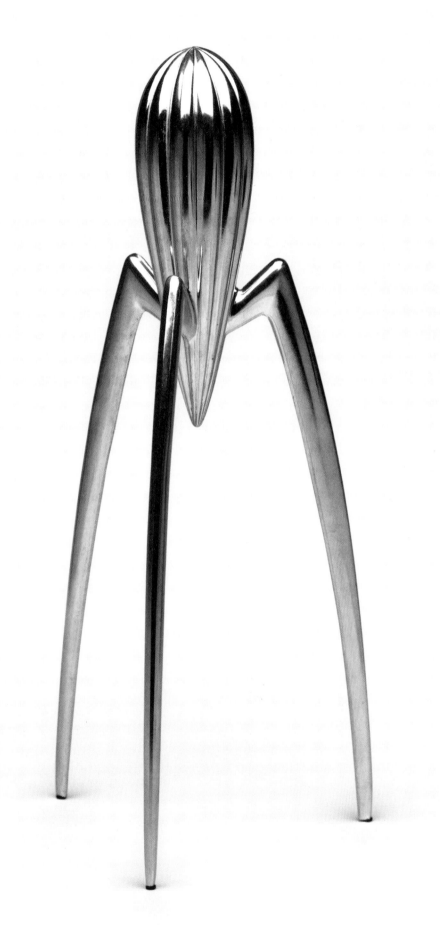

Philippe Starck, *Juicy Salif* lemon squeezer for Alessi, 1988

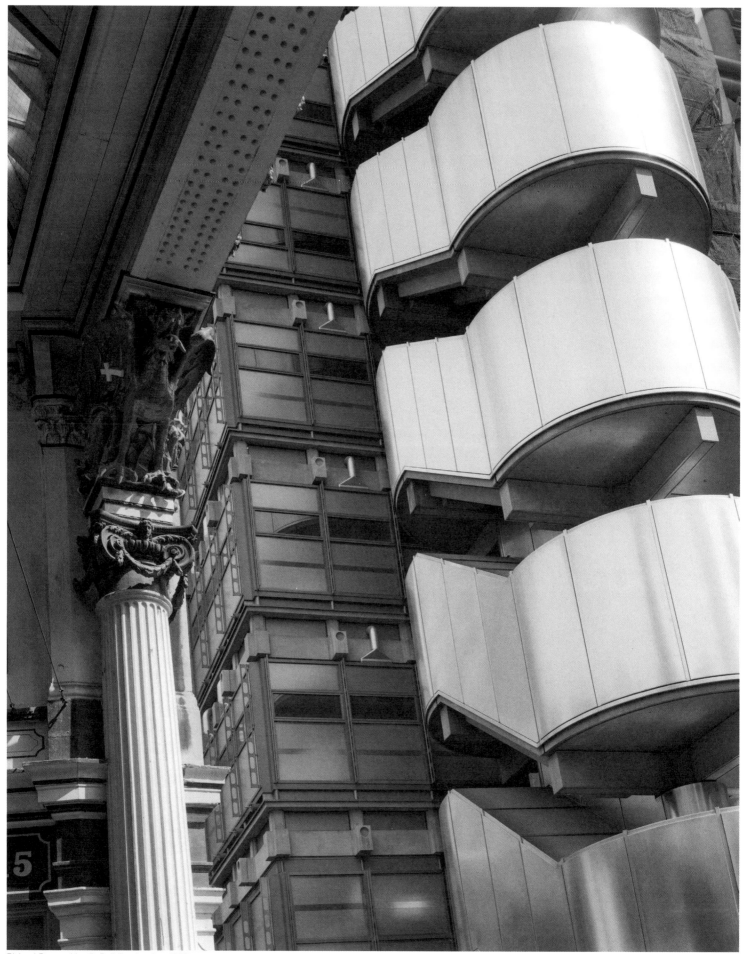
Richard Rogers, Lloyd's Building, London, 1986

Seats of Power

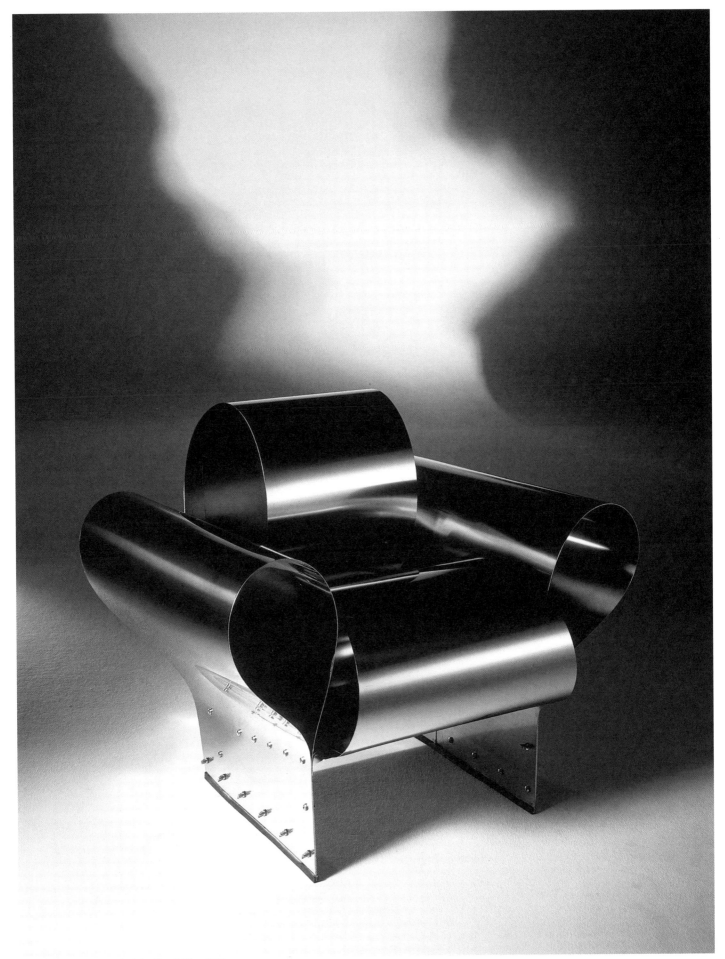

Ron Arad, *Well Tempered Chair* for Vitra Edition, **1986**

(Overleaf) Hands Across America, **1986**

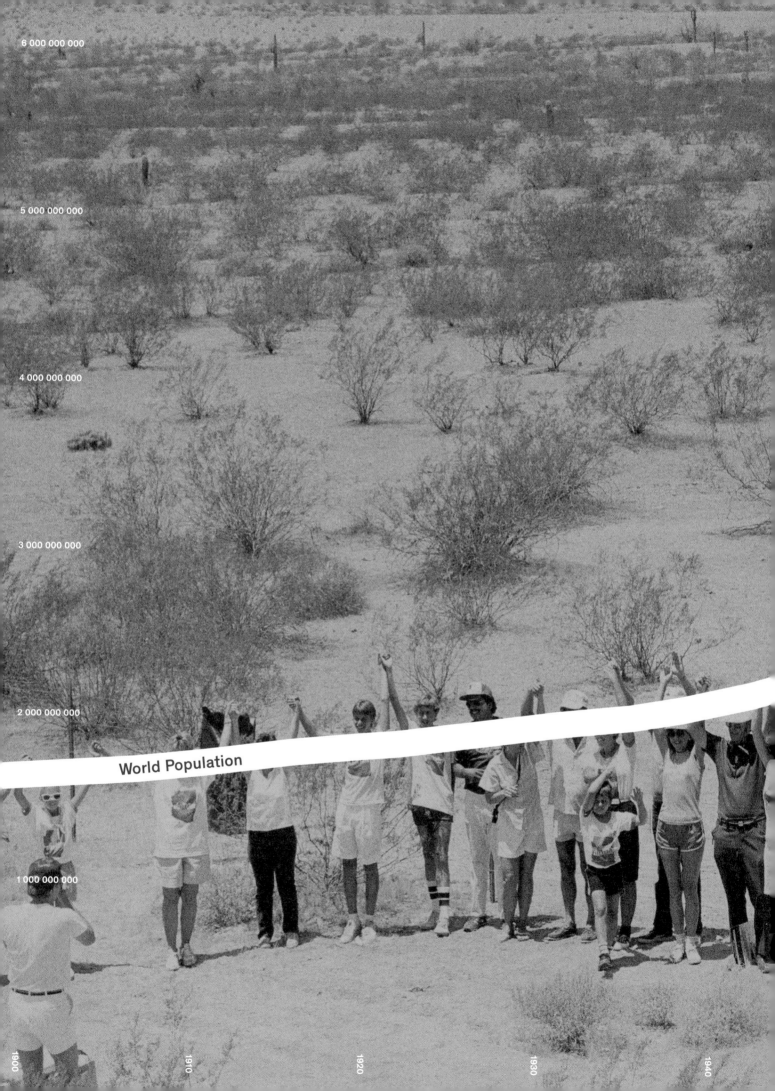

6 000 000 000

5 000 000 000

4 000 000 000

3 000 000 000

2 000 000 000

World Population

1 000 000 000

1900

1910

1920

1930

1940

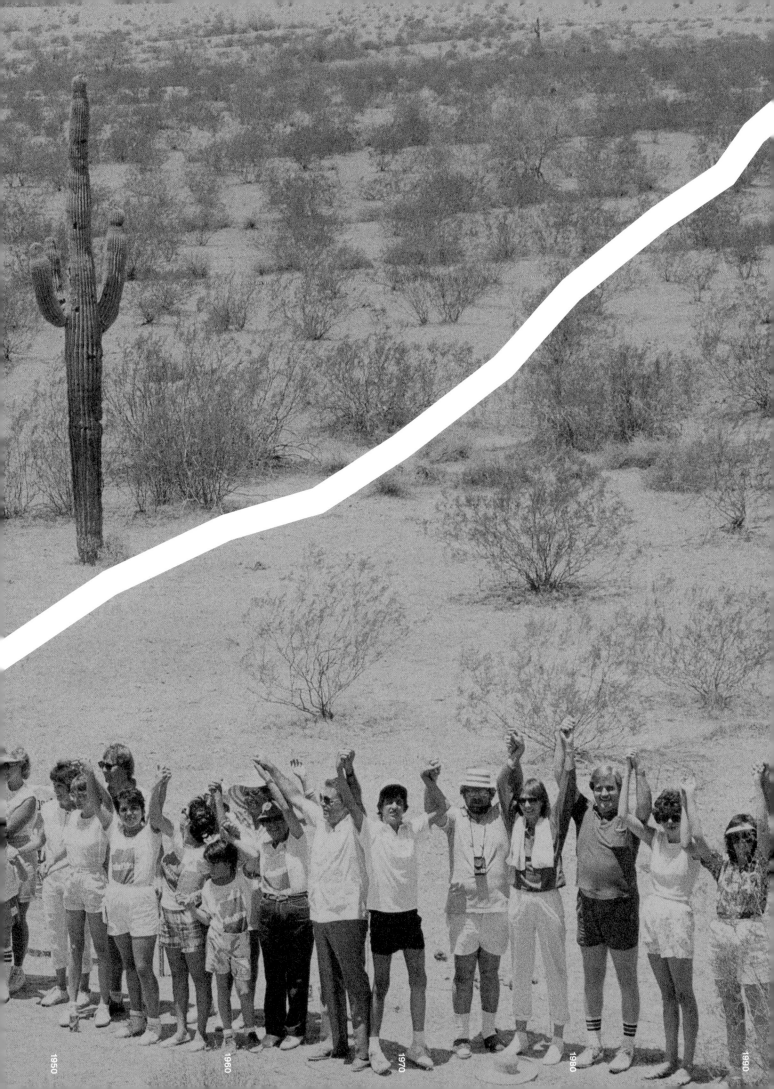

1950　　　　　　　　　　1960　　　　　　　1970　　　　　　　1980　　　　　　　1990

Star Wars: Empire Strikes Back, **1980**

RoboCop, **1987**

Top Heavy

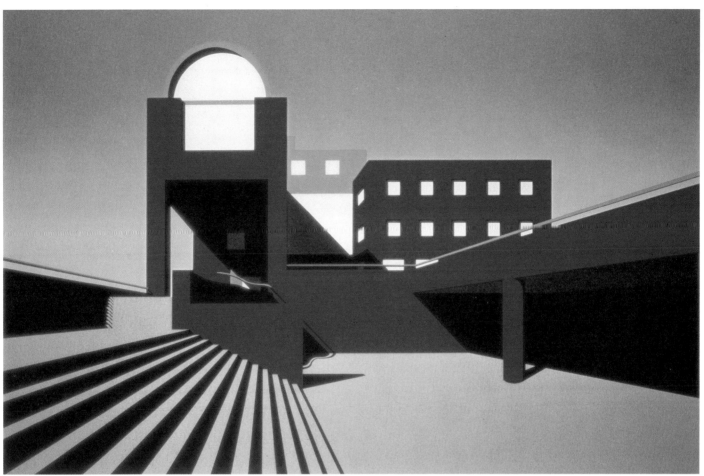

Arata Isozaki, drawing for the Museum of Contemporary Art, Los Angeles, **1983**

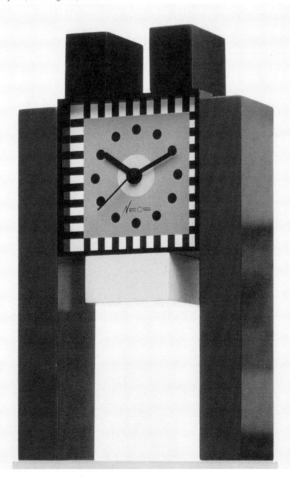

George Sowden for Memphis, *Neos* clock, **1986**

(Overleaf) Margaret Thatcher during the Conservative Party Conference, photo by Chris Steele-Perkins, **1985**
(258–259) Donald Trump in his private helicopter, **1987**

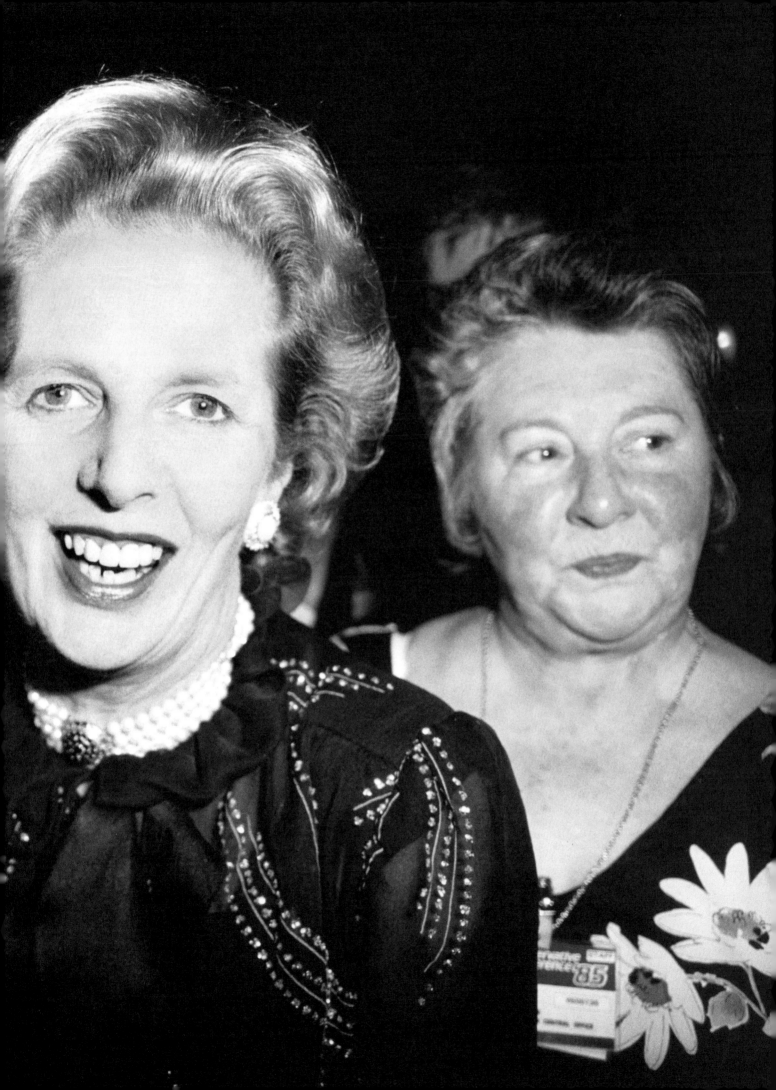

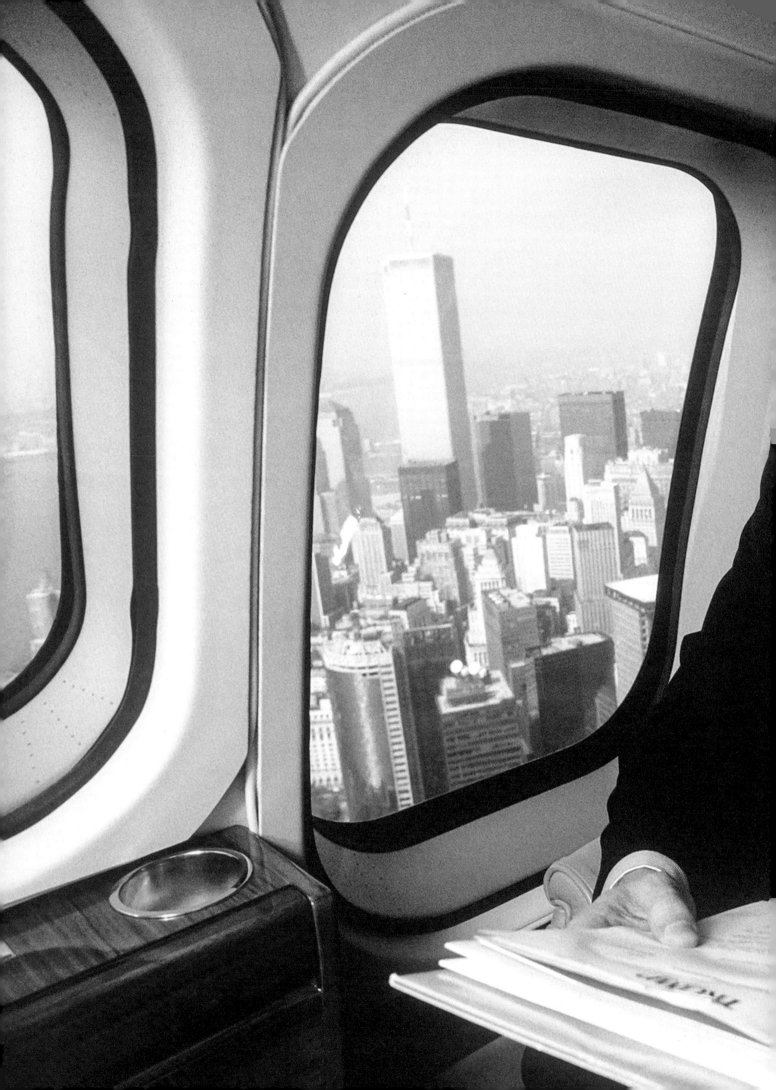

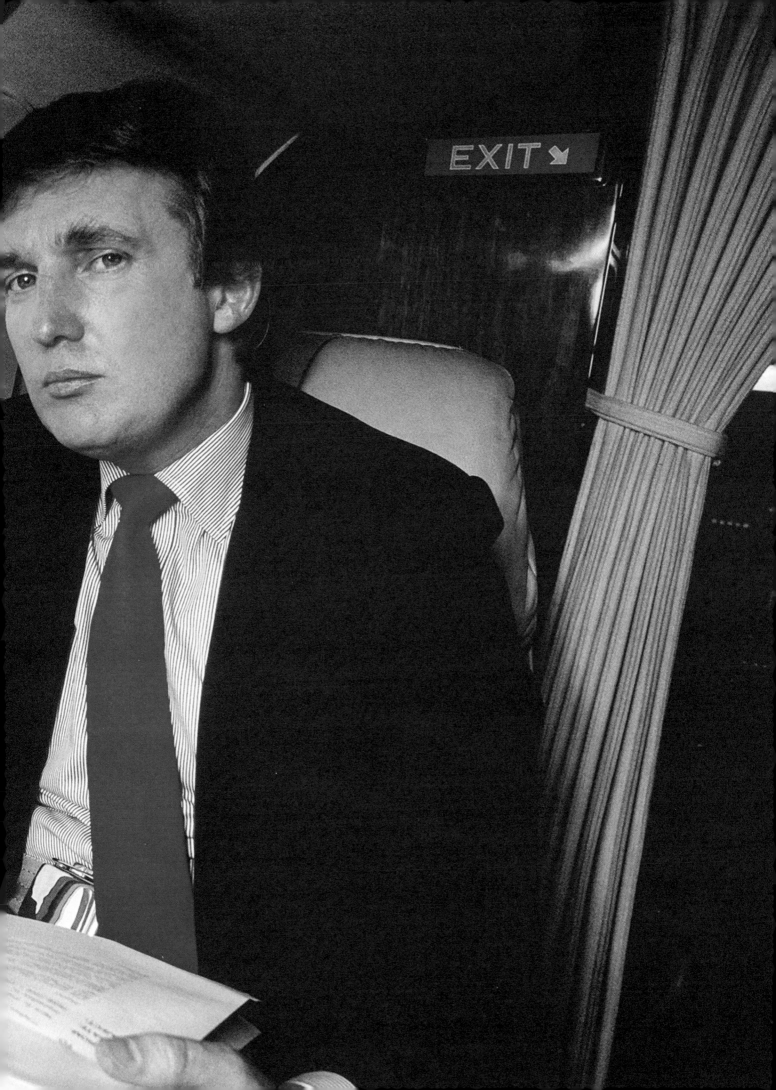
EXIT ↘

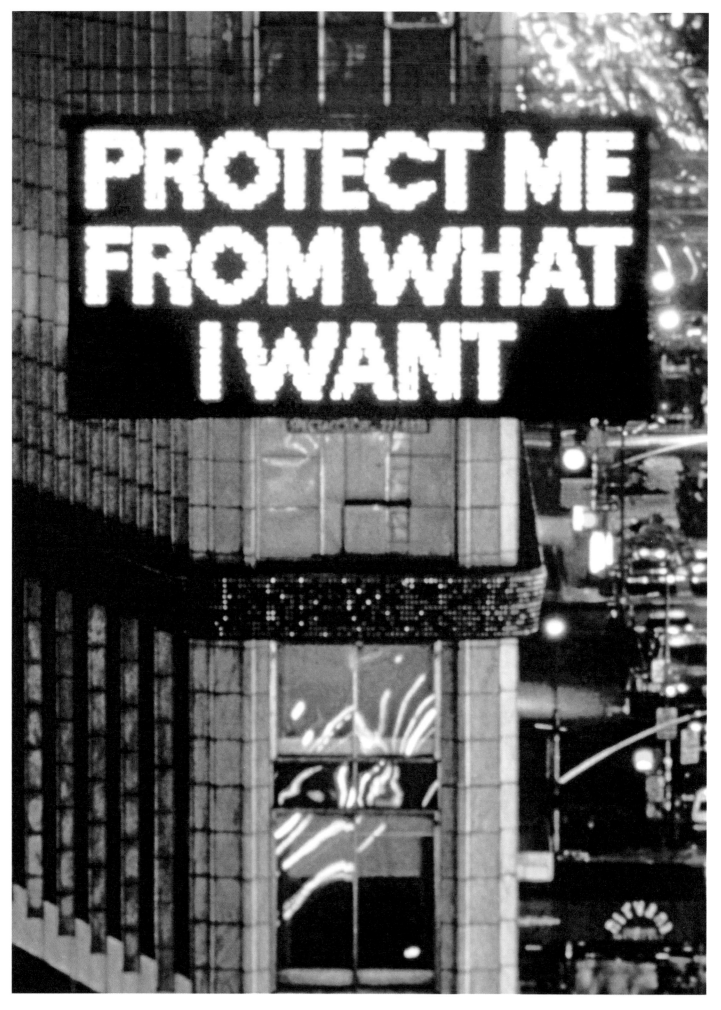

Greed is Good

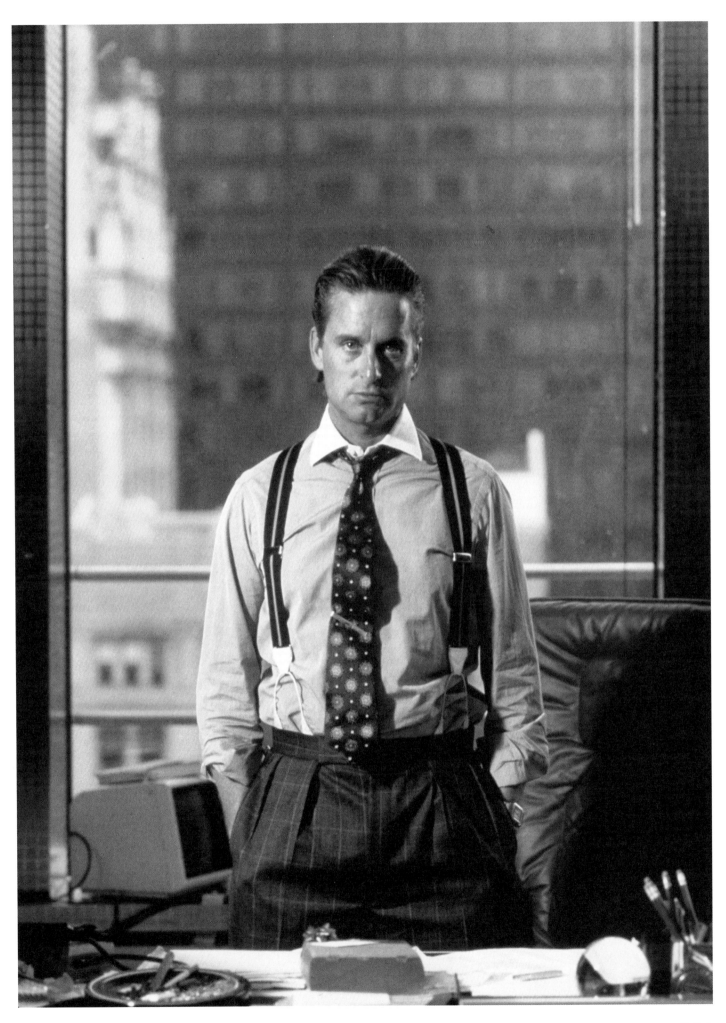

(Opposite) Jenny Holzer, *Protect Me From What I Want*, Times Square, **1985**
(Above) Gordon Gekko in *Wall Street*, **1987**

c.1987–89

As the
decade
came to
a close,
so did
the party.
For some.

In October 1987, the US markets crashed, sparking fears of another global recession. Perfect timing for the pharmaceutical giant Eli Lilly to release Prozac (**88**), a new green and white pill for depression that would, after just three years, become the bestselling antidepressant of all time. Meanwhile two other (illegal) drugs were circulating. There was Ecstasy, the fuel for the rave culture and acid house music that would, in 1988, see a 'second summer of love' explode in the UK and Ibiza. And there was crack, a highly addictive type of cocaine that was tearing low-income Black communities apart in New York City.

While the economy floundered, international politics looked a little rosier. The USSR and the US were engaged in more constructive dialogue, and negotiations between Reagan and Gorbachev set in motion a treaty that required both countries to eliminate all intermediate and short-range nuclear weapons (**87**). In Europe, communism was collapsing. Solidarity, a trade union created in 1980, formed a government in Poland (**89**). In Germany, that long-standing concrete symbol of division, the Berlin Wall, finally came down (**89**). In South Africa, apartheid was looking increasingly fragile as brutal military responses to unrest in Black townships only inflamed anti-apartheid sentiment. By 1988, 155 educational institutions in the US were committed to 'divestment', withdrawing all financial investments in companies that traded with South Africa. In the same year, a Nelson Mandela Tribute Concert took place at Wembley Stadium and was broadcast to 600 million people in sixty-seven countries, further amplifying the demand for immediate action.

As tensions with the USSR eased, Western attention turned to the shifting situation in the Middle East. Ayatollah Ruhollah Musavi Khomeini, the supreme leader of Iran, died after ten years of rule (**89**). Shortly before his death, he issued a fatwa on the author Salman Rushdie for his novel *The Satanic Verses* (**86**). When Iran's eight-year war with Iraq ended with a dissatisfactory ceasefire (**88**), the Iraqi leader, Saddam Hussein, escalated tensions with oil-rich Kuwait, refusing to repay a $14 billion loan used to finance the war. In terms of world leaders, it was out with the old, in with the old. Reagan's Vice President, George H.W. Bush, came to power in the US (**89**). In South Africa, P.W. Botha was succeeded by F.W. De Klerk (**89**), another supporter of apartheid, albeit a slightly less hardline one. In the UK, the Iron Lady was getting rusty and would soon be replaced by her Chancellor, John Major (**90**).

As music fell on more politically engaged ears the lubby dubby lyrics of the New Romantics started to feel a bit ... *80s.*

On the streets of New York and Los Angeles artists like N.W.A., Salt-N-Pepa and Run-D.M.C. kicked off the golden

age of hip-hop, rapping about police brutality and the racial injustices of the Reagan era. A related shift was happening in Hollywood. After years in which the all-powerful blockbuster formula dominated, low-budget indie films like Steven Soderbergh's *Sex, Lies, and Videotape* (**89**) started to see respectable returns at the box-office. But it was Black New Wave directors like Spike Lee who charted the most significant new course. Lee's 1989 comedic drama *Do The Right Thing* set in a pre-gentrified Brooklyn neighbourhood, and accompanied by the soundtrack of Public Enemy's *Fight the Power*, engaged mainstream audiences with an insider's perspective on racial tension in modern America.

Tragedy dogged the decade right to the very end. In the skies over Scotland, a bomb exploded on Pan Am flight 103 (**88**), killing all on board as well as eleven residents of the town of Lockerbie. Off the coast of Alaska, the Exxon Valdez spilt 10 million gallons of crude oil that killed 250,000 seabirds, 2,800 sea otters, 300 harbour seals, 250 bald eagles, and up to twenty-two killer whales (**89**). In northern England, a human crush at the Hillsborough football stadium resulted in the deaths of ninety-seven people and hundreds more injured (**89**). In China, the communist government massacred thousands of students protesting for reforms in Tiananmen Square (**89**). In Uganda's capital, Kampala, almost 30 per cent of pregnant women were found to have HIV by the end of the decade. In New York, Los Angeles and London, the death toll from AIDS surpassed 100,000 by 1990. In Washington D.C., politicians were given a wake-up call when NASA scientist James Hansen showed the US Senate a disturbing line graph that projected temperature rise over the coming decades, caused by human activity (**88**). Meanwhile, every single country on Earth signed the rapidly agreed Montreal Protocol (**87**), banning the use of ozone-depleting gasses.

This rare instance of unanimous global cooperation did, quite literally, save the world.

In the midst of spiralling fear and uncertainty about AIDS, terrorism, climate change, systemic racism, drug addiction and a crumbling global economy, an object was gliding silently through the vastness of space. It wasn't an asteroid on a collision course with Earth – although that certainly would have been fitting end to a tumultuous decade – rather it was heading in exactly the opposite direction. On Valentine's Day, 1990, the Voyager 1 space probe, the furthest human-made object from home, took one final photograph before powering down its cameras in preparation for its eternal glide into interstellar space, a journey that started in 1977. It showed Earth as a tiny speck from 3.7 billion miles (6 billion km). Earth appears fragile and totally insignificant to the cosmos. Yet not to us. The image was named 'Pale Blue Dot' and inspired the title of a book by Carl Sagan in which he wrote, 'Look again at that dot. That's here. That's home. That's us.'

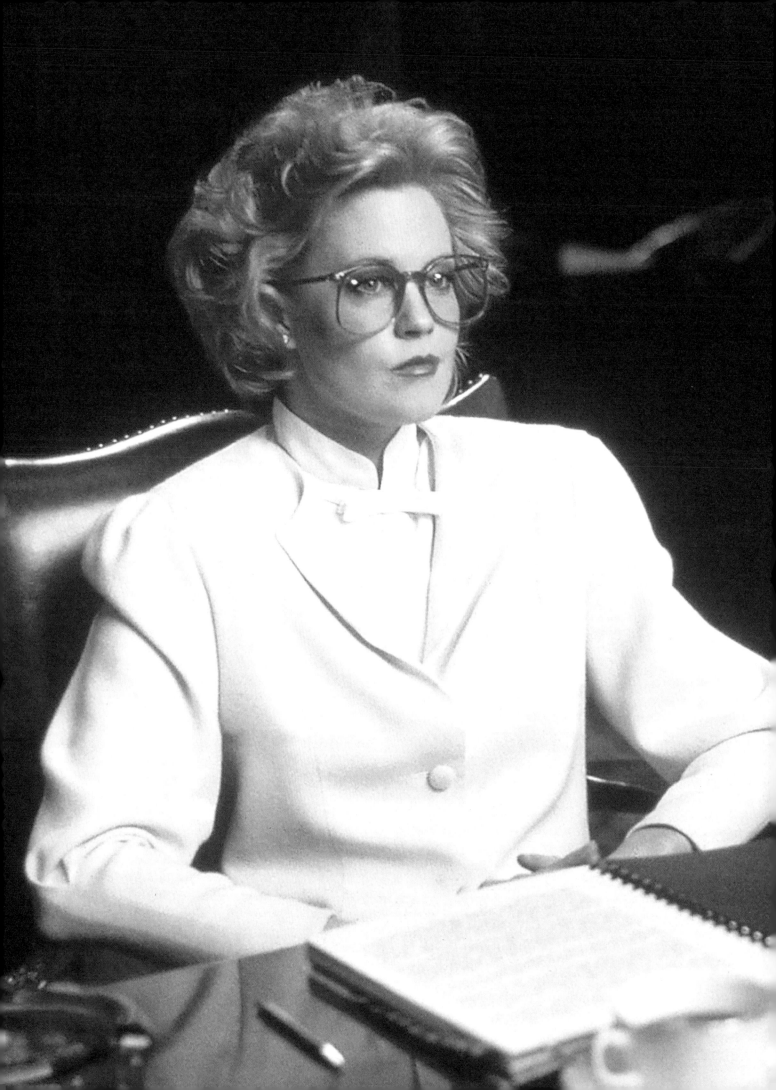

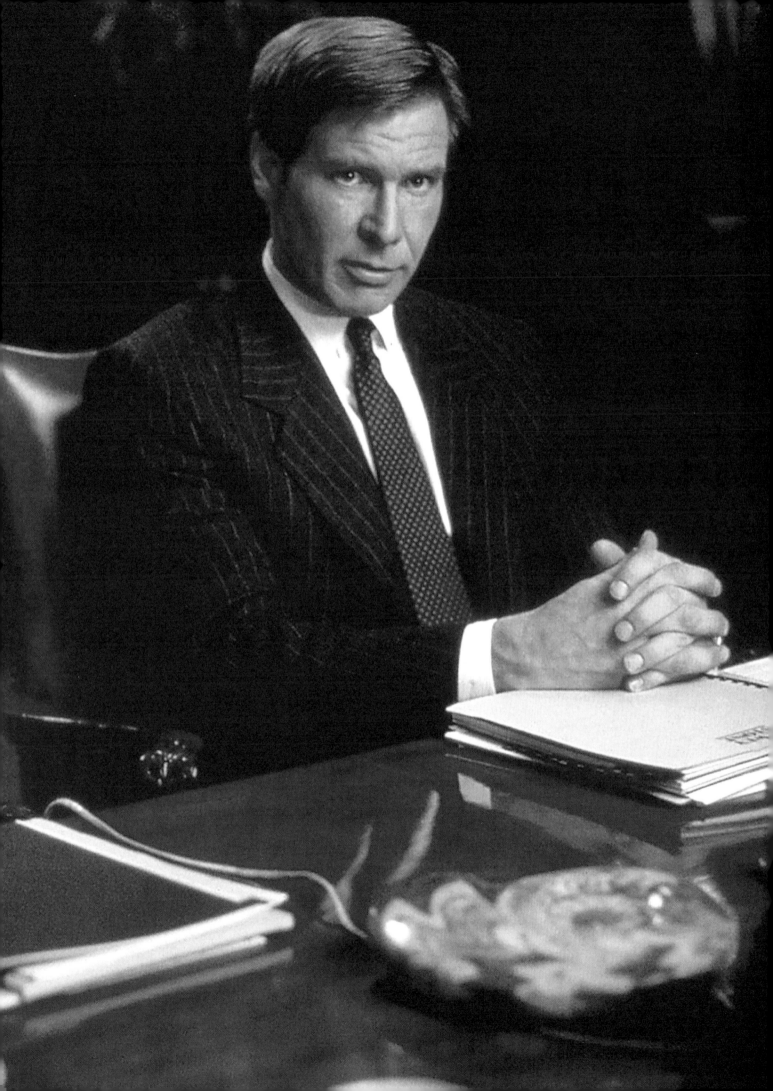

Big, 1988

Men in Crisis

Baby Boom, **1987**

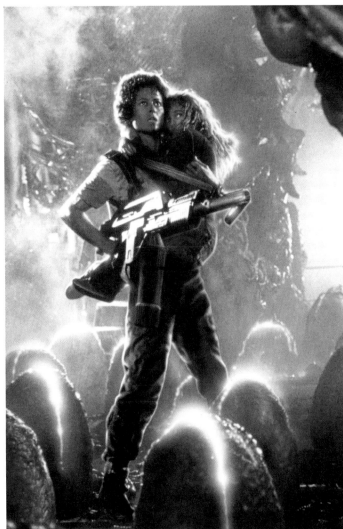

Aliens, **1986**

How many men does it take to change a diaper? Three was the best estimate of both Paris and Hollywood, as the 1985 French comedy, *Trois hommes et un couffin,* was remade as *Three Men and a Baby* (87). This was just one of many films depicting men as struggling caregivers, as women advanced in workplaces – others included *Parenthood* (89), *Look Who's Talking* (89) and *Kindergarten Cop* (90). Pets were another common metaphor for flailing fathers; in both *Turner & Hooch* (89) and *K-9* (89), police detectives struggle to care for their four-legged friends. And then there was *Big* (88), in which Tom Hanks played a literal man child. Another patriarchal response to the rise of assertive women were big men with big guns. The captains of this invincible army were Arnold Schwarzenegger, Dolph Lundgren, Jean-Claude Van Damme and Sylvester Stallone. But it's perhaps Bruce Willis who best summed up this resistance movement, making the leap from romantic comedy lead, in *Moonlighting* (85–89) and *Blind Date* (87), to flawed action hero whose attempt to save his marriage in *Die Hard* (88) is thwarted by terrorists.

Trois hommes et un couffin (remade as *Three Men and a Baby*), **1985**

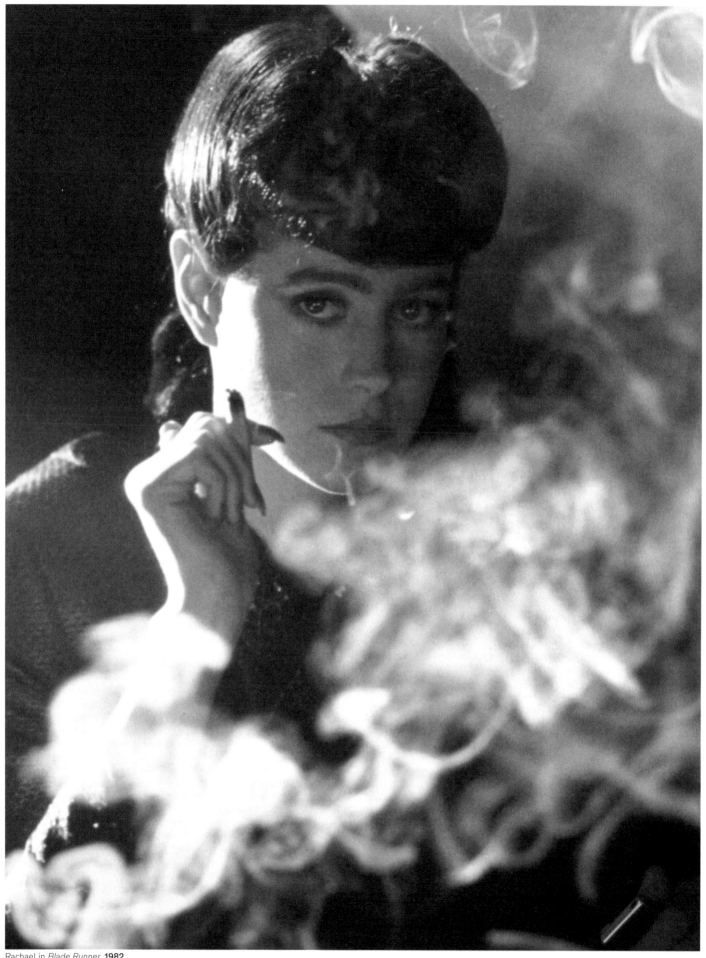

Rachael in *Blade Runner*, **1982**

Smoking Thrills

Silk Cut advertisement, Saatchi and Saatchi, **1984**

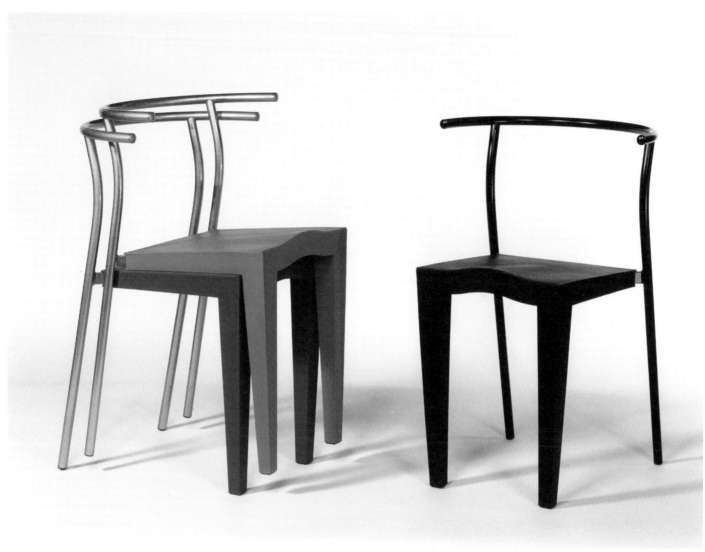

Philippe Starck, *Dr Glob* chairs for Kartell, **1988**

After the Memphis group disbanded in 1987, a new look emerged for a new decade.
A desire grew for something sleeker, less showy and – dare I say – a little more refined.
Extravagance was out. Simplicity was in. Designers like Philippe Starck created elegant
and accessible everyday objects for the home and office, developing and making the
most of the latest mass production techniques and intelligent materials. Designs
were playful, but the work was serious. Chairs and tables favoured acrylic or metal over
wood. Lines were essential, clean and simple. Accent colours faded to pastel. However,
function and affordability no longer meant sacrificing experientiality or quality. In this
more 'democratic' approach to design, as Starck referred to it, something as simple
as a toothbrush should still feel like poetry in the hand.

Philippe Starck, toothbrush and toothbrush holder, **1989**

(Overleaf) *Grandmaster Flash and the Furious Five*, photo by Janette Beckman, **1987**

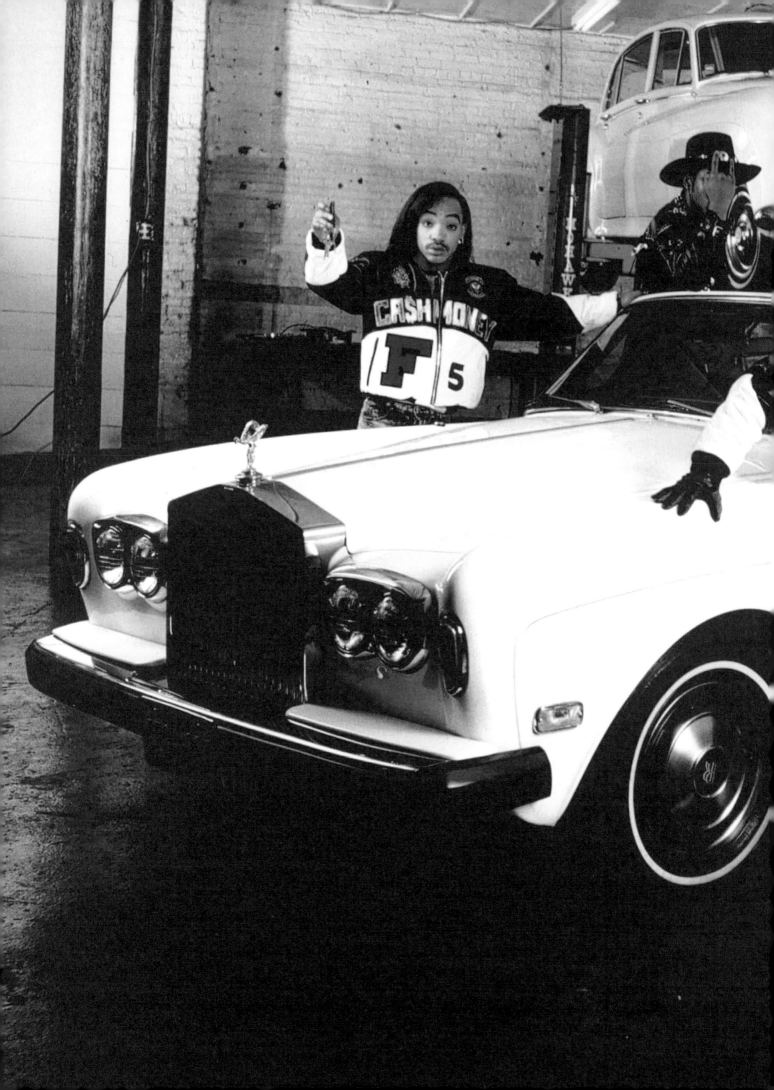

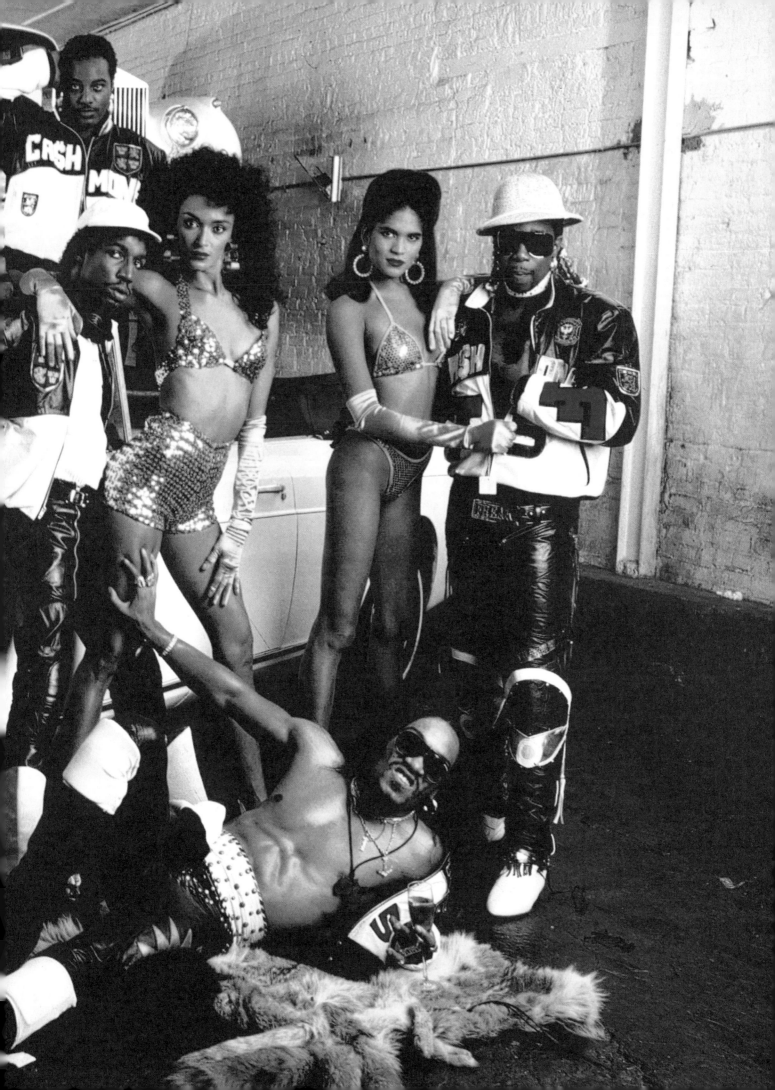

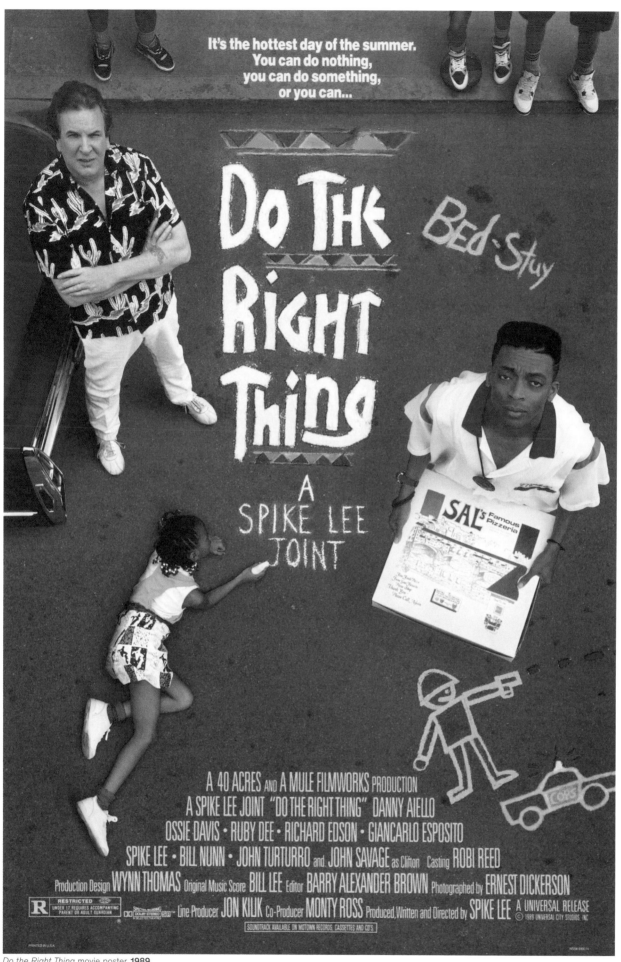

Do the Right Thing movie poster, **1989**

Cover of De La Soul's debut studio album, *3 Feet High and Rising*, **1989**

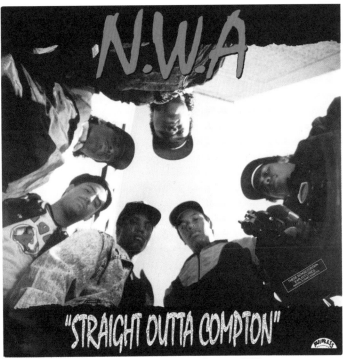

Cover of N.W.A's debut studio album, *Straight Outta Compton*, **1988**

What had been glittering in the shadows for years did, indeed, finally turn to gold. With the release of Run-D.M.C.'s album *Raising Hell* (86), hip-hop smashed its way into the mainstream. Artists like LL Cool J, Public Enemy, the Beastie Boys, and Ice-T basked in the genre's golden age. Pop sounded soppy and manufactured compared to the humorous, pithy, and overtly political lyrics and sledgehammer beats of hip-hop. The unashamed brashness of the music was reflected in a distinctive and original sartorial style. Hip-hop artists dripped in gold and elevated sports and streetwear into high fashion. Many outfits were designed by the Harlem couturier, Dapper Dan, who essentially redesigned European designer clothes. His 'knock-offs', which plastered large unmissable logos over everything, were overt declarations of wealth and success and became high fashion in their own right.

Hip-Hop Has Landed

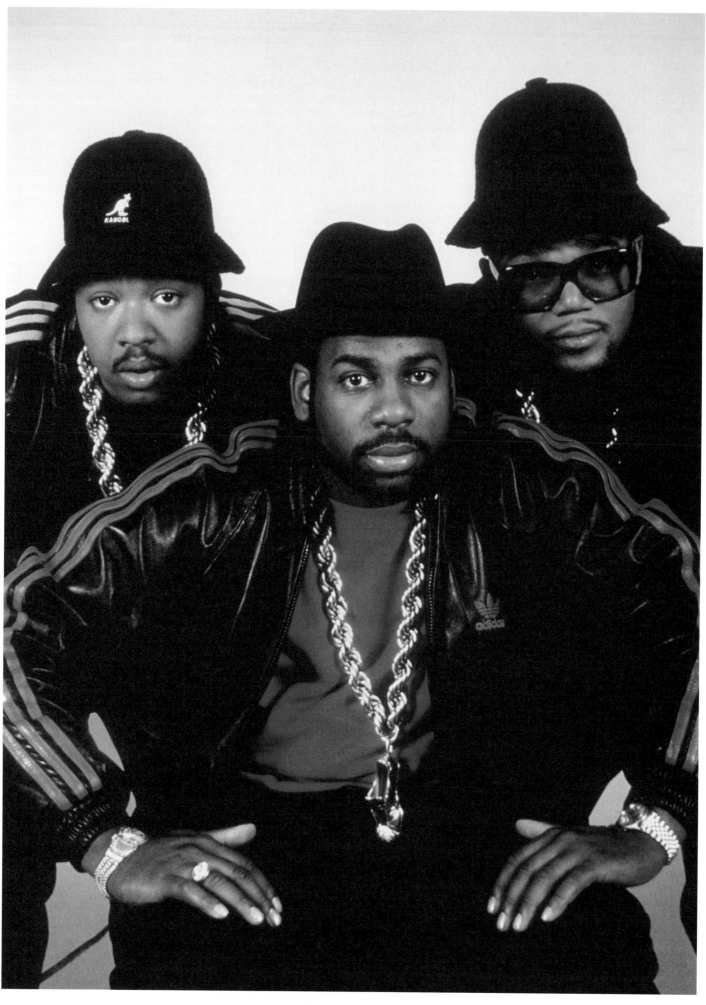

Run-D.M.C., c. 1985

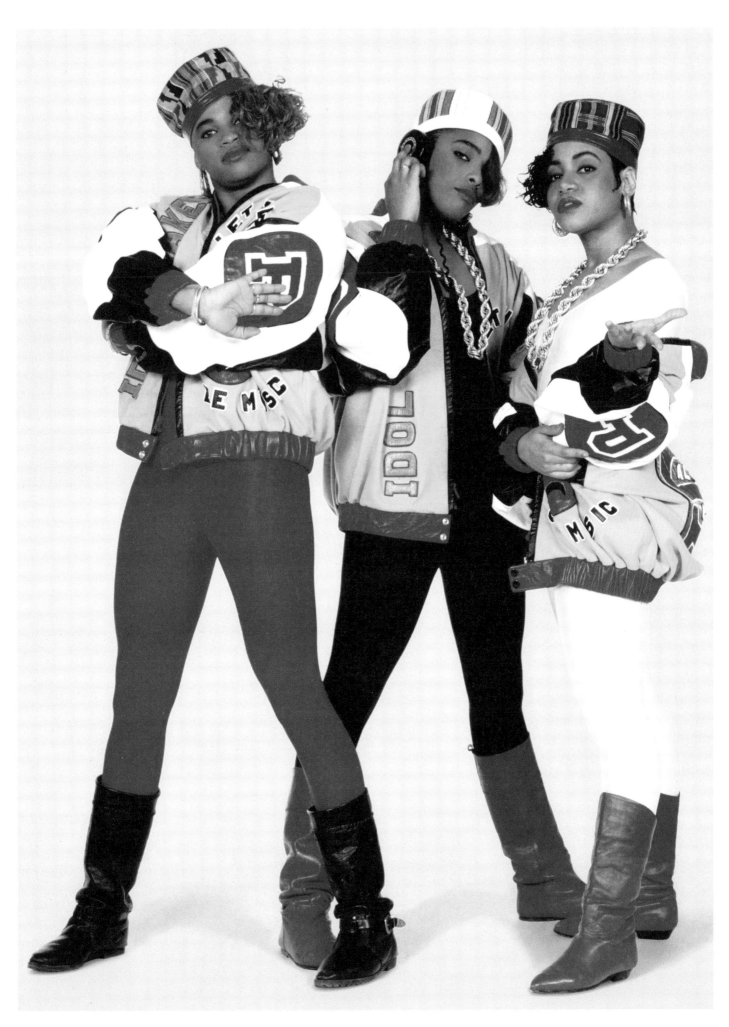

(Above) Salt-N-Pepa, photo by Janette Beckman, **1987**
(Overleaf) Group portrait of female hip-hop artists, photo by Janette Beckman, **1988**

281

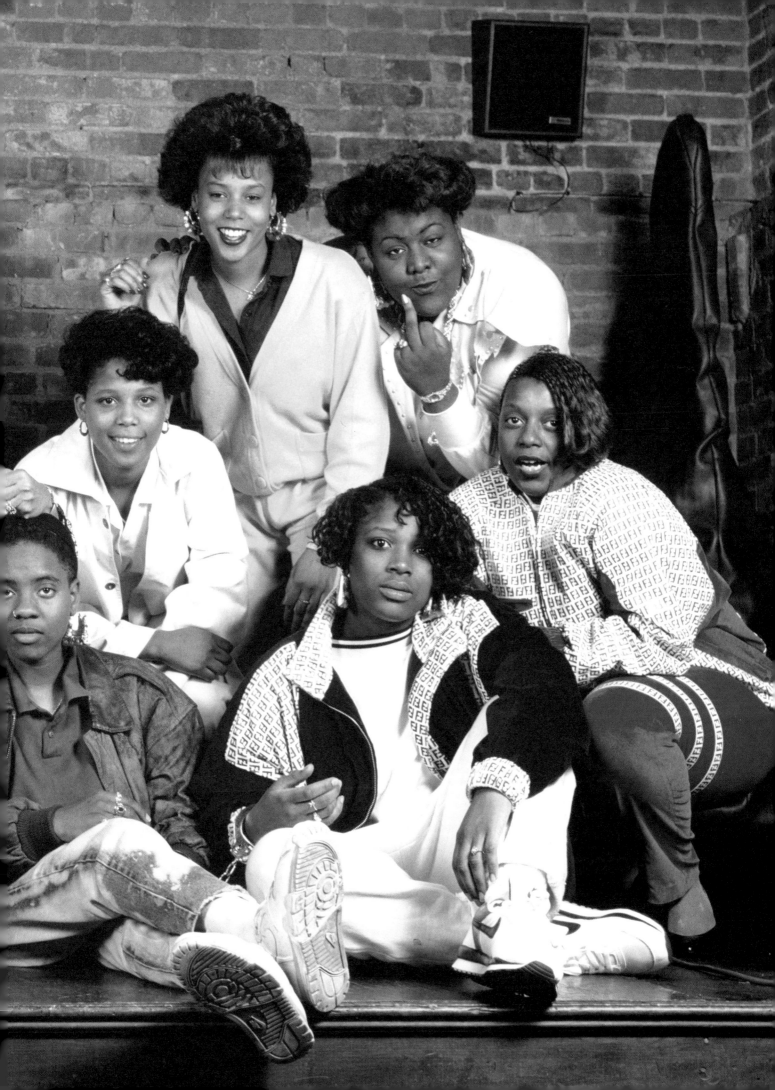

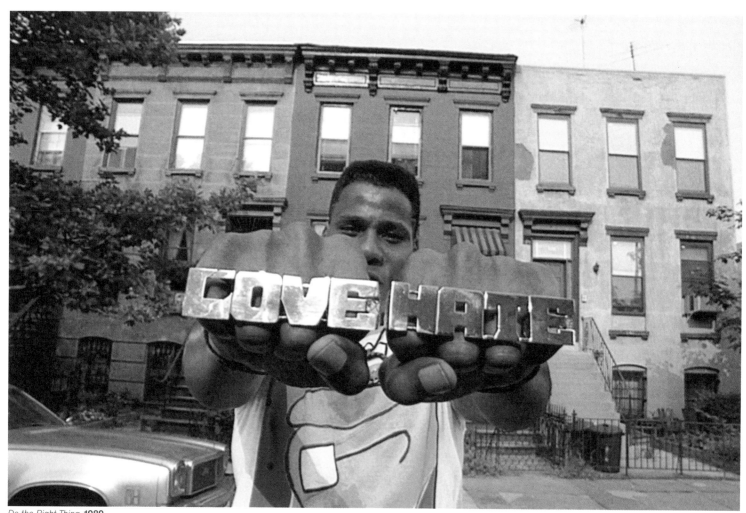

Do the Right Thing, **1989**

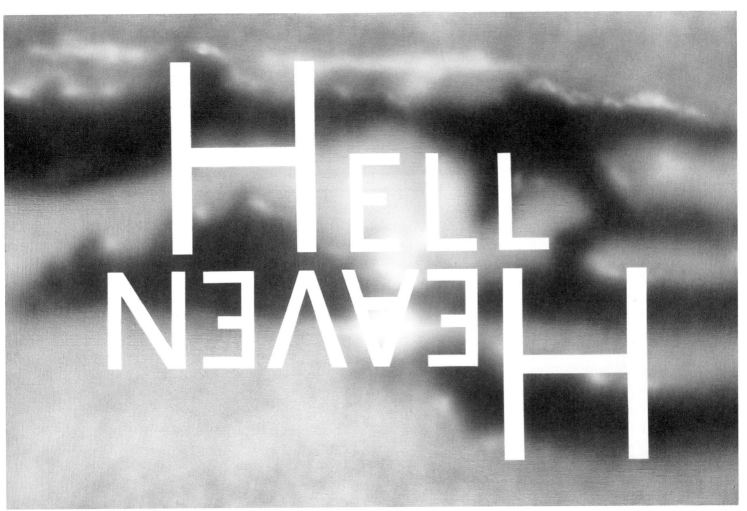

Ed Ruscha, *Hell Heaven*, **1988**

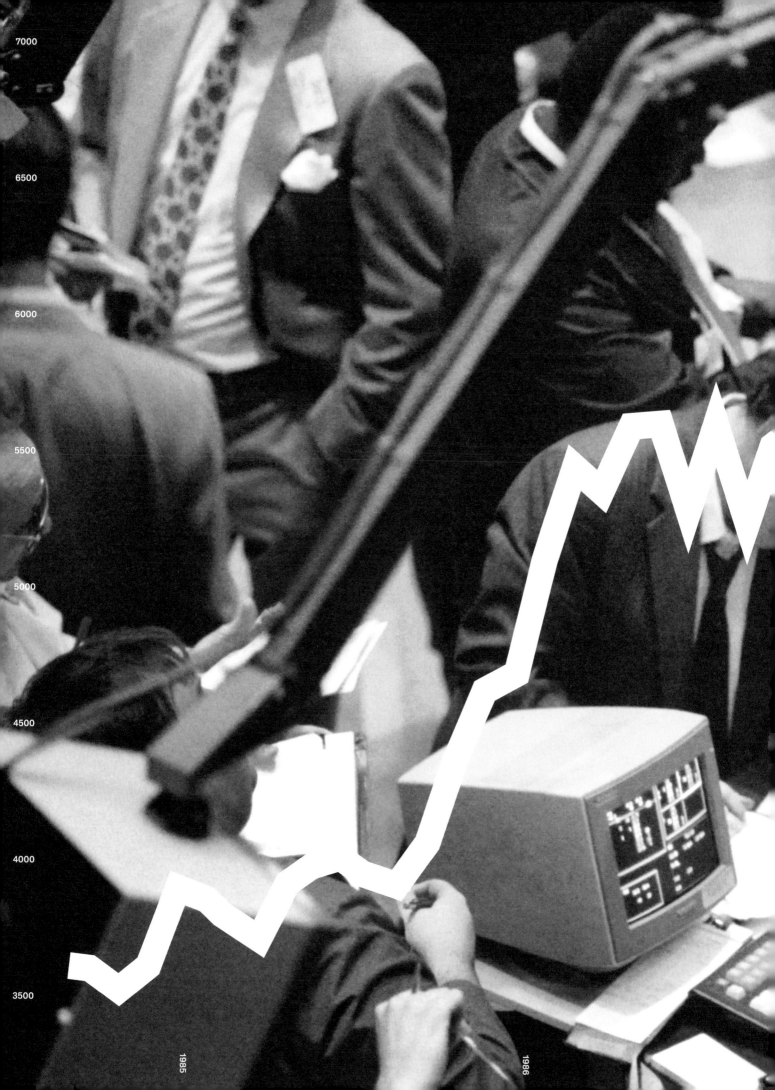

7000

6500

6000

5500

5000

4500

4000

3500

1985

1986

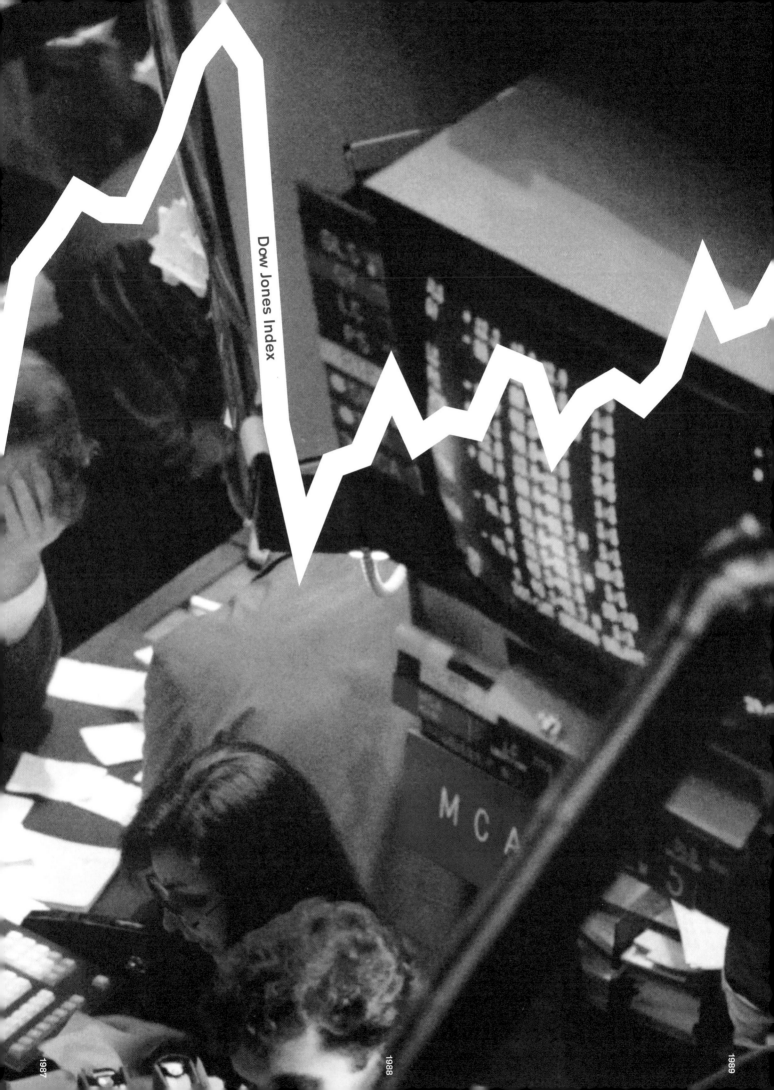

Dow Jones Index

1987

1988

1989

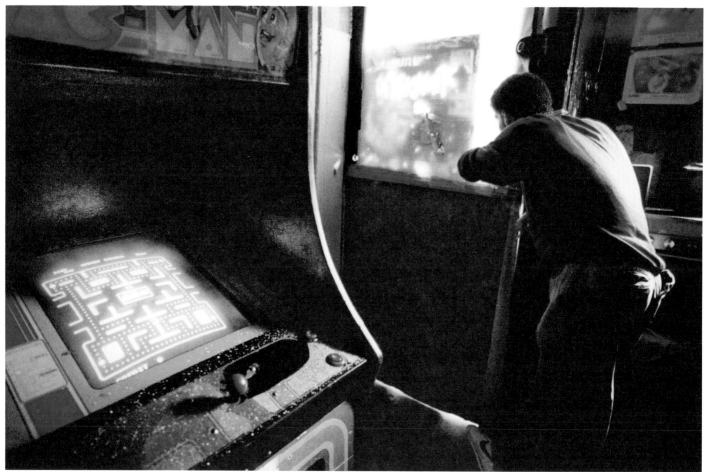

Susan Meiselas, *Primo watches the crackhouse door for a customer or undercover cop*, East Harlem, New York, **1989**

The razzle dazzle of Wall Street had been drowning out the quiet crackling that could be heard in darker, less affluent New York neighbourhoods. The influx of crack, a highly addictive and more affordable type of cocaine, combined with a lack of jobs in low-income Black communities, resulted in spiralling addiction, drug-related violence and an increase in AIDS infections due to shared needles. By the end of the decade, the crack epidemic had torn Black lives apart and increased the number of incarcerated to breaking point due to Reagan's 'War on Drugs', a policy that didn't seem to affect those who snorted their cocaine through a $50 bill.

Susan Meiselas, *Cezar snorting cocaine in a housing project courtyard*, East Harlem, New York, **1989**

Susan Meiselas, *A man smokes crack in a housing project stairwell*, East Harlem, New York, **1989**

Crack is Wack

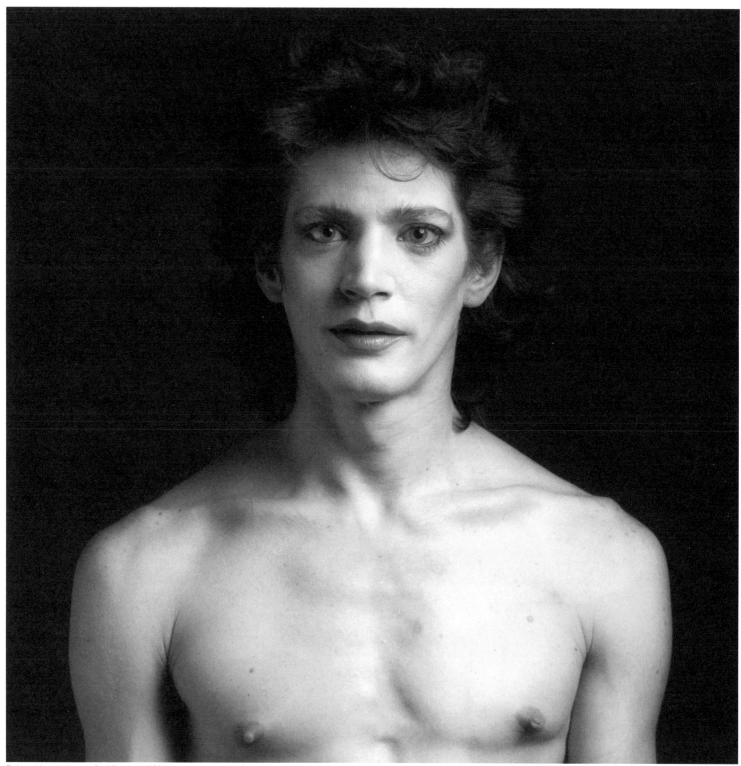

Robert Mapplethorpe, *Self Portrait*, **1980**

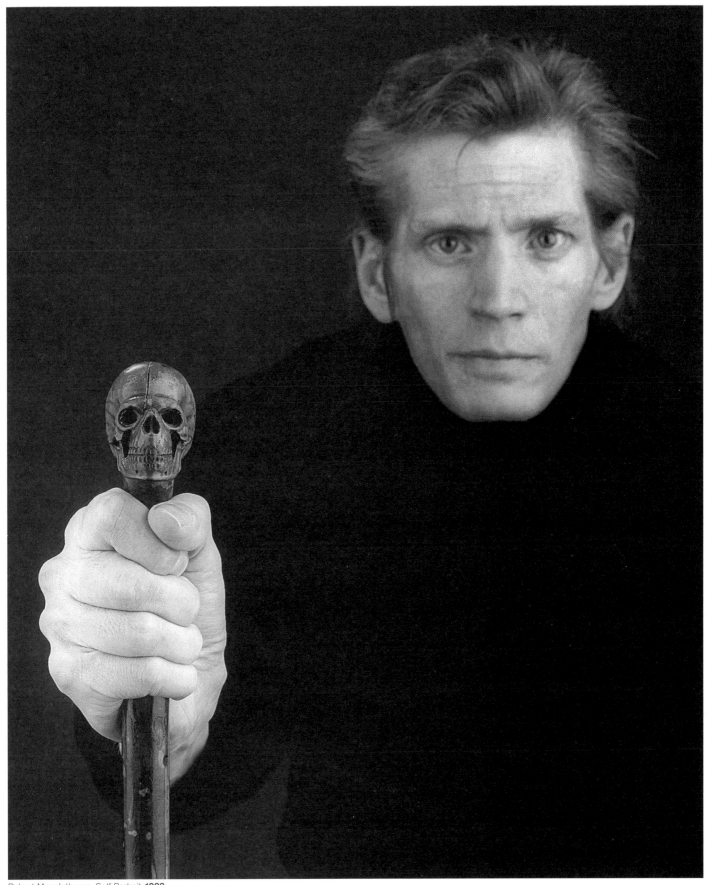

Robert Mapplethorpe, *Self Portrait*, **1988**

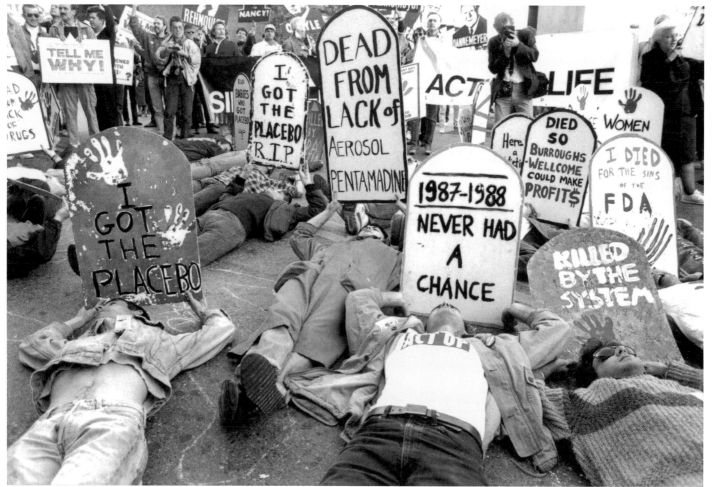

ACT UP protesters blocking the Federal Drug Administration headquarters to demand the release of experimental medication for HIV/AIDS, Maryland, **1988**

The response to HIV and AIDS finally started to pick up pace in the latter half of the 80s, due to the efforts of medical professionals, activists, artists and high-profile figures such as old Hollywood's leading man Rock Hudson, the first celebrity to announce he had the disease (85). Campaign groups such as ACT UP in the US and Body Positive in the UK were formed, and the Silence=Death Project pasted awareness posters around New York. The poster featured a pink triangle that referenced Nazi persecution of gay people in the 1930s, and became the central symbol for AIDS activists in the US. As the list of dead continued to grow and grow, it started to include famous names. Rock Hudson died (85), as did Liberace (87) and Robert Mapplethorpe (89). But as the end of the decade drew closer, an antiviral drug, AZT, went into circulation and campaigners like Princess Diana, who very publicly shook the hand of a man suffering with AIDS, helped lessen misconceptions about how you contracted the virus.

Silence=Death

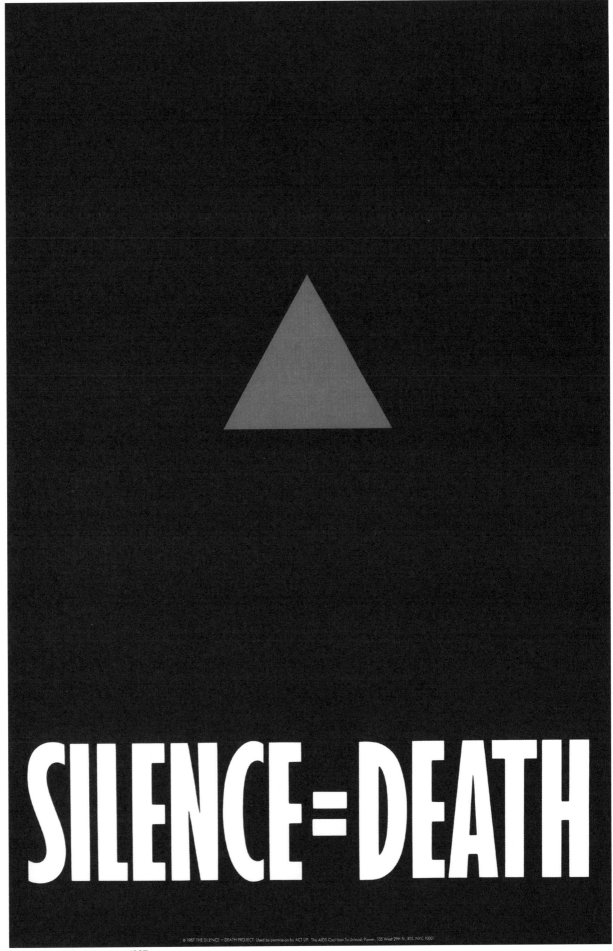

Silence=Death Project poster, **1987**

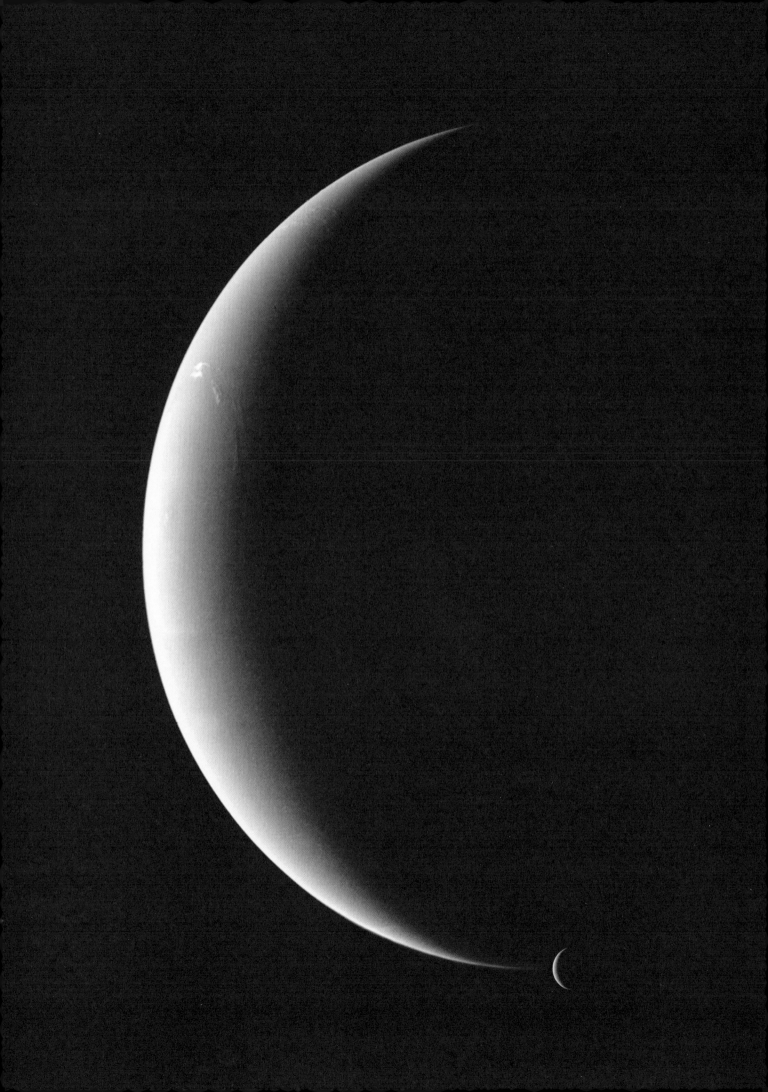

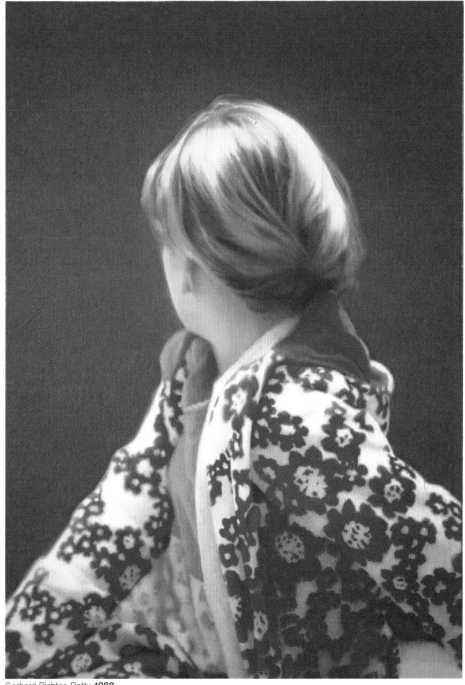

Gerhard Richter, *Betty*, **1988**

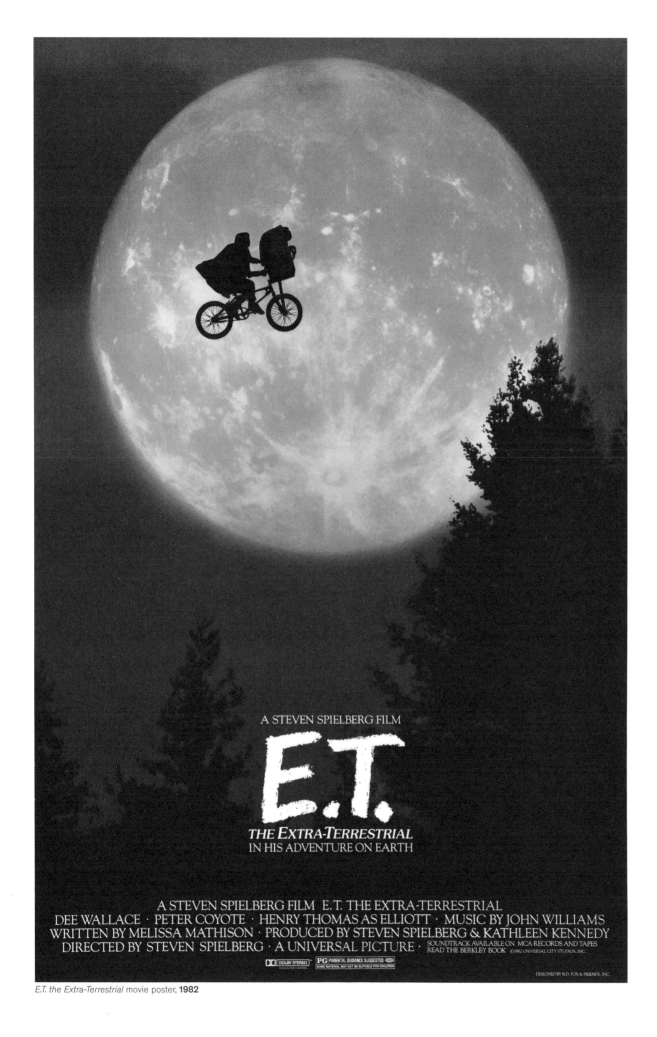

E.T. the Extra-Terrestrial movie poster, **1982**

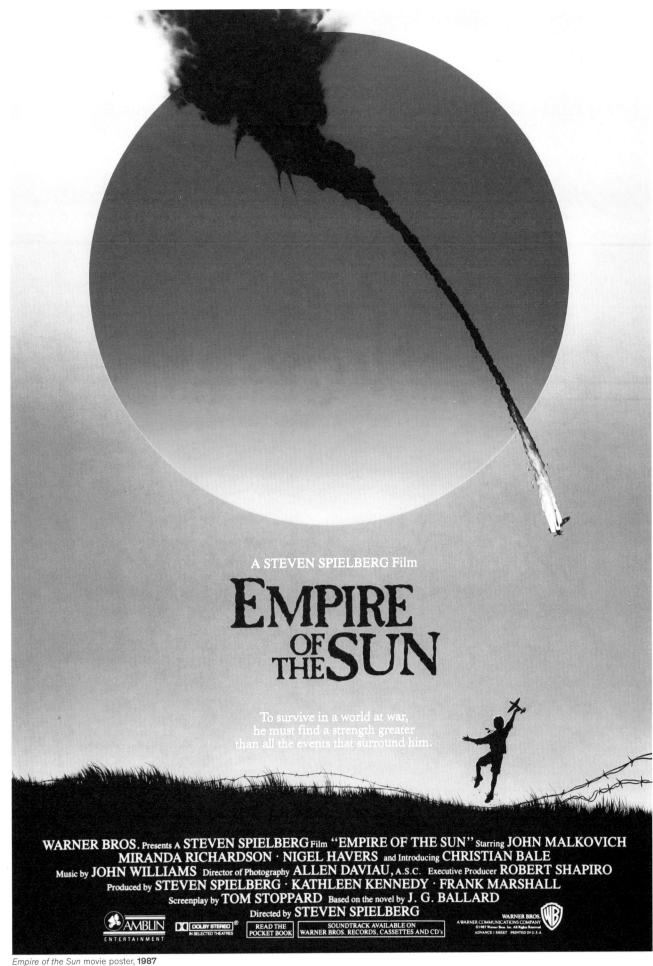

Empire of the Sun movie poster, **1987**

Miss Saigon, **1989**

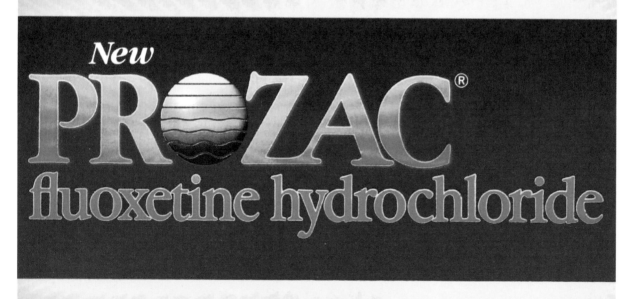

Prozac advertisement (detail), **1988**

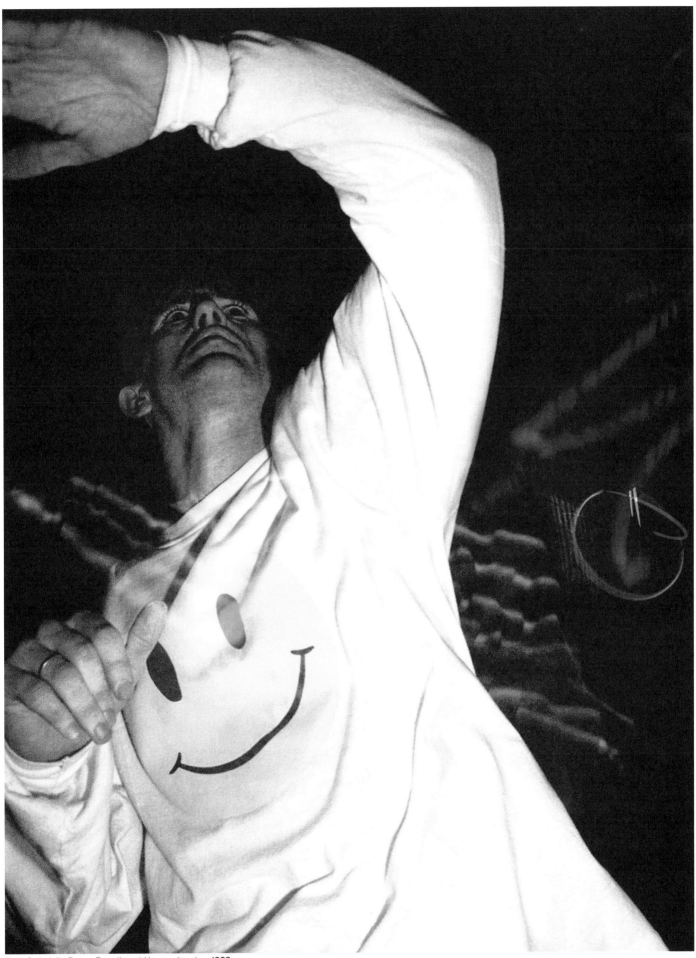
Dave Swindells, Danny Rampling at Heaven, London, **1988**

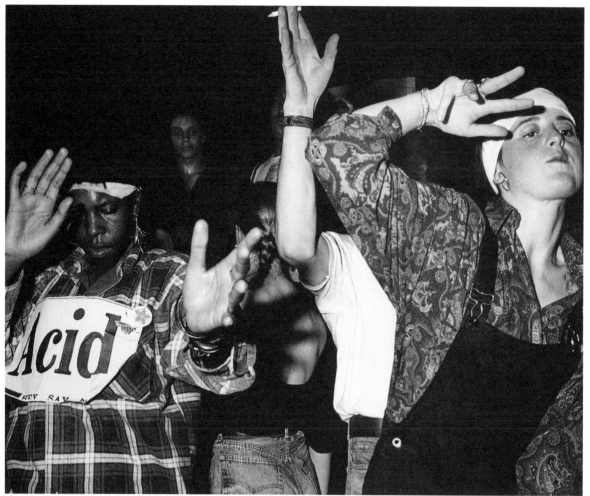

Dave Swindells, Acid Otis dancing at Trip, the Astoria, London, **1988**

The repetitive bass and electronic 'squelches' of Acid house were the soundtrack to the second summer of love in 1988 (the first being in 1967). Illegal raves, fuelled by Ecstasy, the new drug *du jour*, sprung up in abandoned warehouses and fields across England and the beaches of Ibiza, as did a smiley face first used by DJ Danny Rampling in his London club Shoom. The smiley perfectly encapsulated the mental state of rave culture: happy but unresponsive, with no actual feeling behind the wide eyes and broad smile. It was big and round and yellow like the sun, but it wasn't warm or nourishing. It was, for a new generation coming of age in the UK and Europe, a symbol of disillusionment. It represented an exhaustion with Conservative governments and an overwhelming feeling of being ignored. What else was there to do than take drugs and drown out the world with music the establishment was guaranteed to hate :)

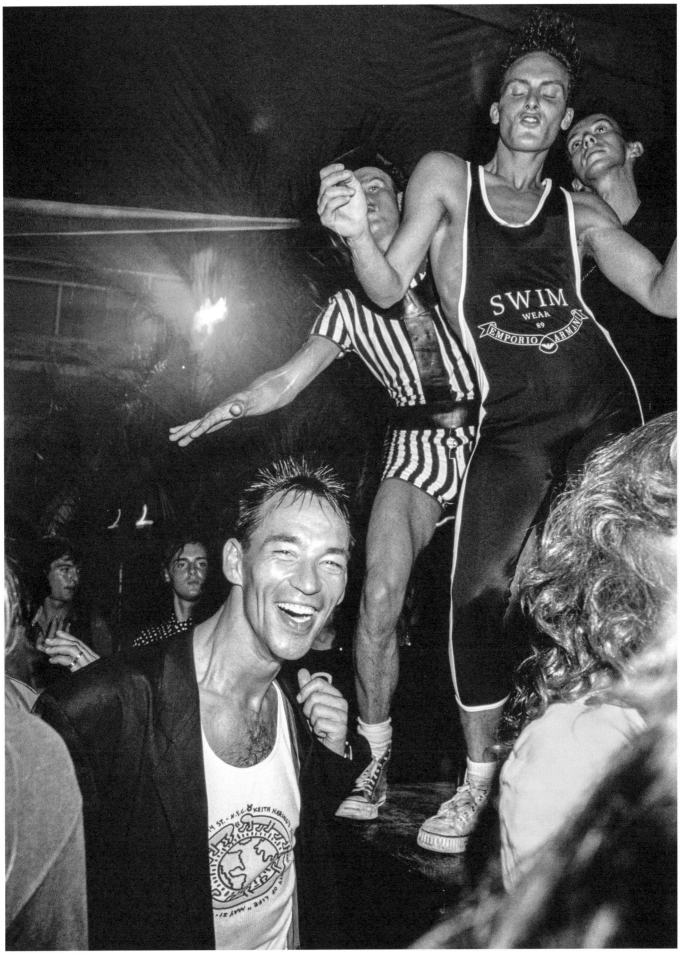

Dave Swindells, Alix Sharkey and go-go boys at Pacha, Ibiza, **1989**

Le Grand Bleu (The Big Blue), **1988**

304

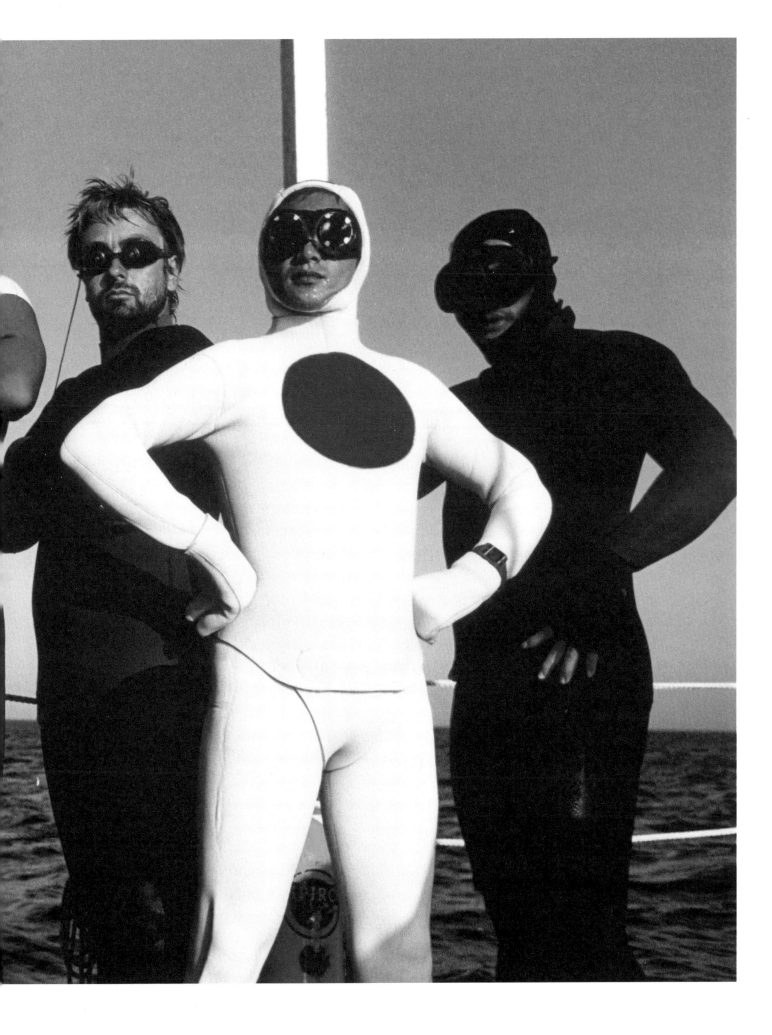

305

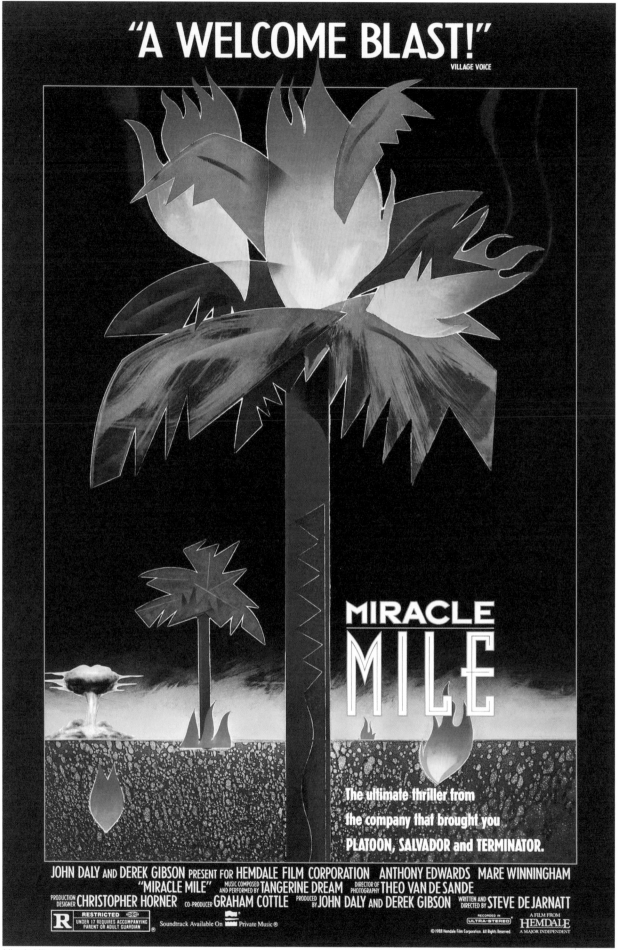

Miracle Mile movie poster, **1988**

The Fire

Billy Joel, 'We Didn't Start the Fire', **1989**

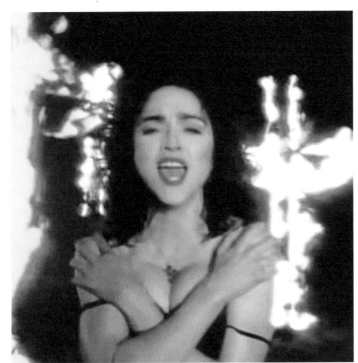

Madonna, 'Like a Prayer', **1989**

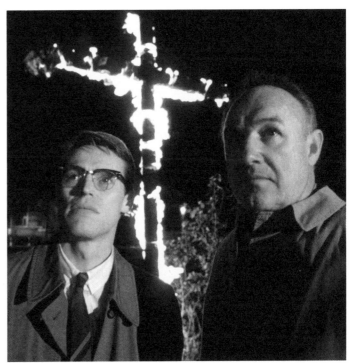

Mississippi Burning, **1988**

(Overleaf) NASA scientist James Hansen addressing the US Senate on his predictions for a rise in global temperatures due to human causes, Washington, **1988**

307

1.0°C

0.8°C

0.6°C

0.4°C

0.2°C

0.0°C

Hansen projection of global temperature rise

1988

1993

1998

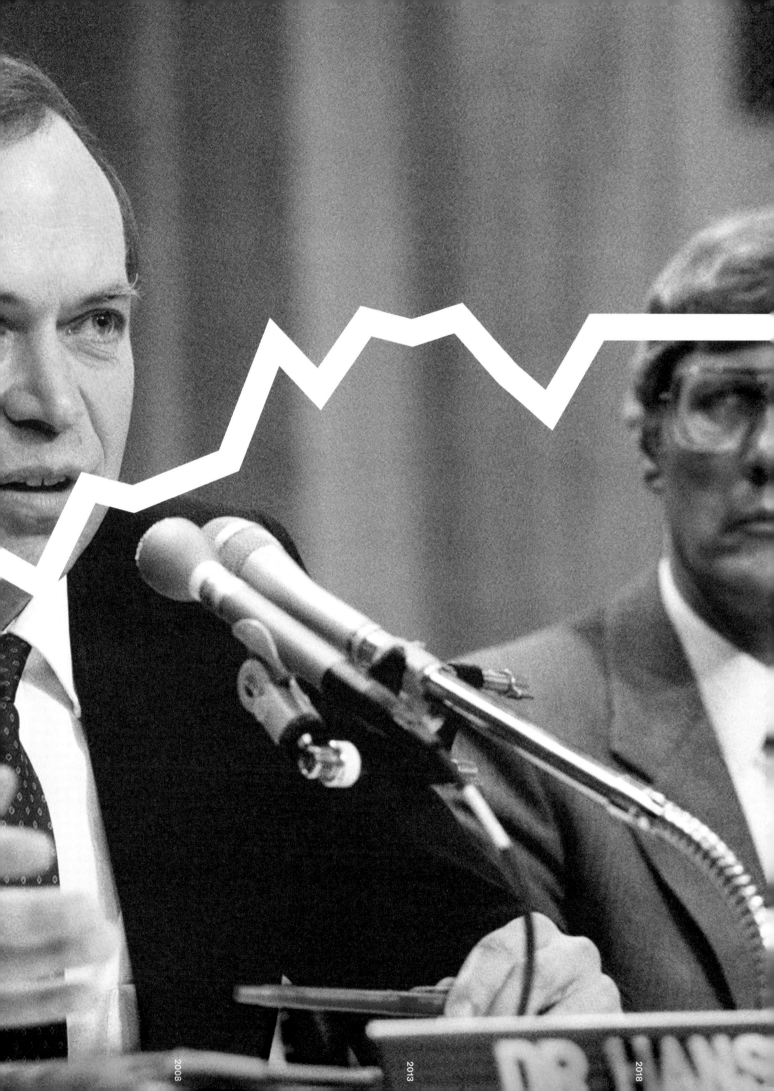

2008
2013
2018

Die Hard, **1988**

The Fire

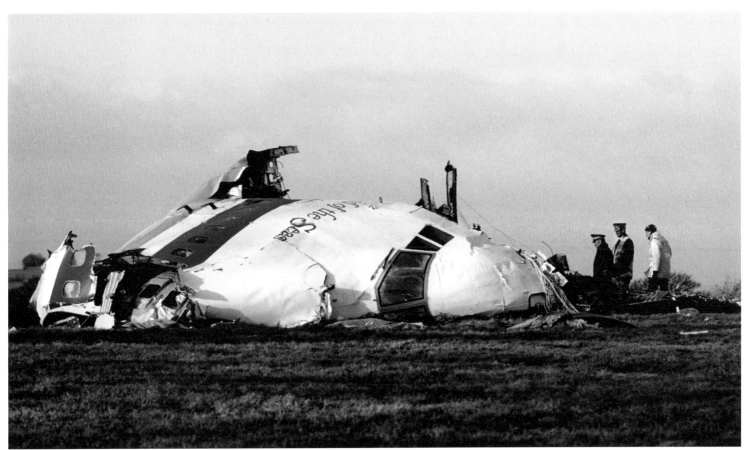

The wreckage of bombed Pam Am flight 103 in Lockerbie, Scotland, **1988**

When NASA scientist James Hansen presented his projections for global temperature rise to the US Senate (88) a collective gulp echoed around the world. This was the second time in less than a decade that humanity had been faced with the realities of mass extinction by its own doing. Global warming was, in a twisted way, the perfect metaphor for a world accelerating out of control. In the last three years of the 1980s AIDS-related deaths were devastatingly exponential and terrorism reached new levels of shock with the bombing of Pan Am flight 103 over the Scottish town of Lockerbie (88). There was the massacre of students in China's Tiananmen Square (89) and the catastrophic Exxon Valdez oil spill (89). If Billy Joel's 'We Didn't Start the Fire' (89) had another verse it might well have been: *Global Warming / Oil spills / Free Mandela / Happy pills. Dead composer / Cold War over / Tank Man / Supernova. Tetris on your Game Boy / Yuppies shout in wireless toys. Hip-hop / Bush on top / Homer Simpson make it stop!*

(Overleaf) *Paris Is Burning*, 1990

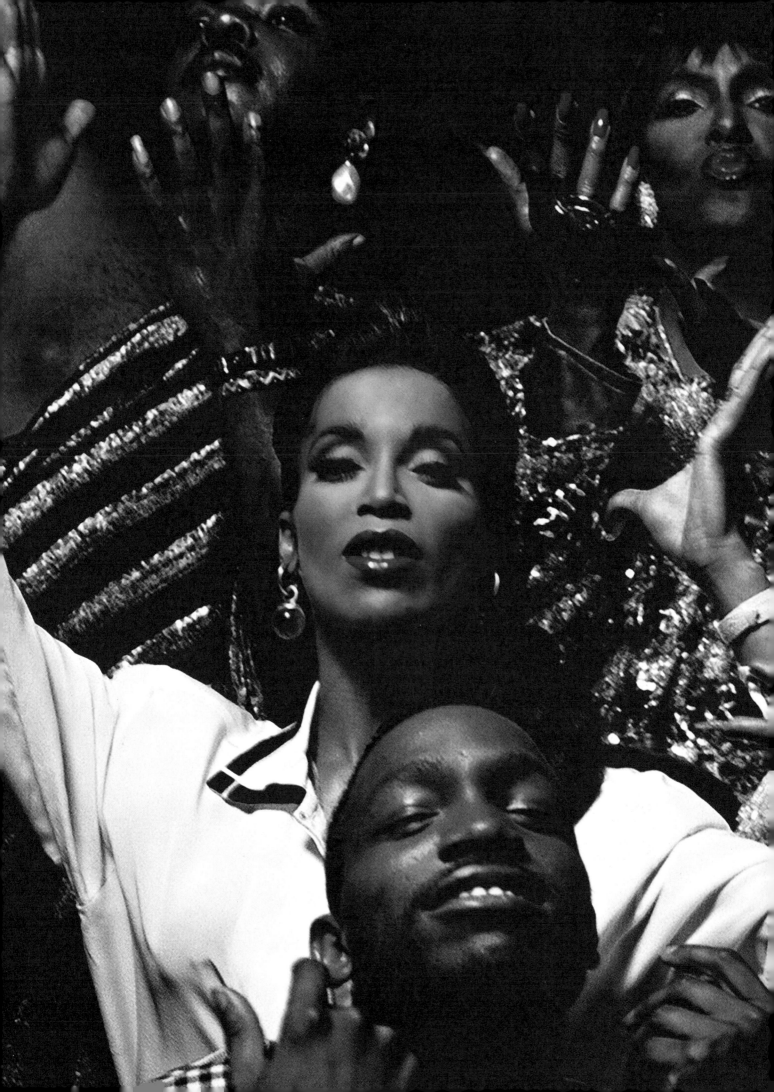

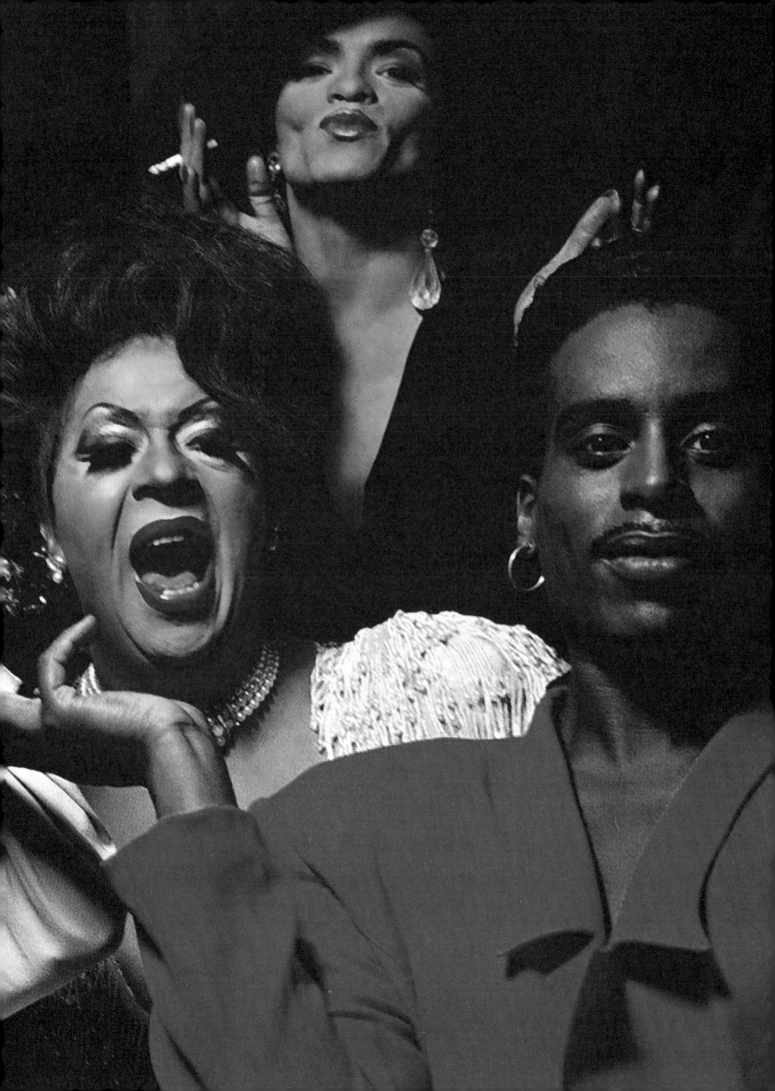

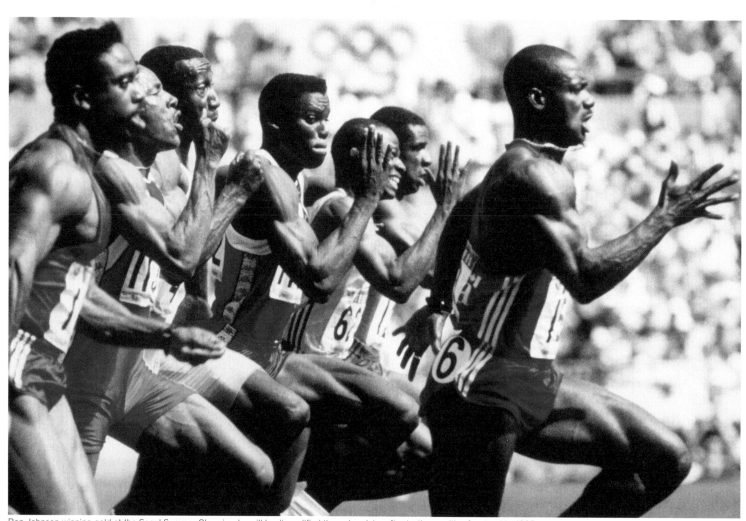

Ben Johnson winning gold at the Seoul Summer Olympics; he will be disqualified three days later after testing positive for steroids, **1988**

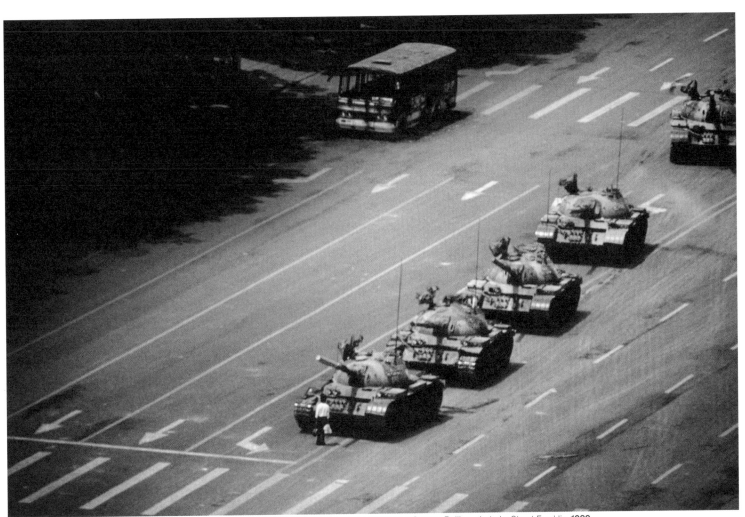

An unidentified individual known as the 'Tank Man' standing before a column of T59 tanks in Tiananmen Square, Beijing, photo by Stuart Franklin, **1989**

(Overleaf) Tom Fox dying of AIDS at the Sacred Heart Hospital, Oregon, photo by Michael A. Schwarz, **1989**

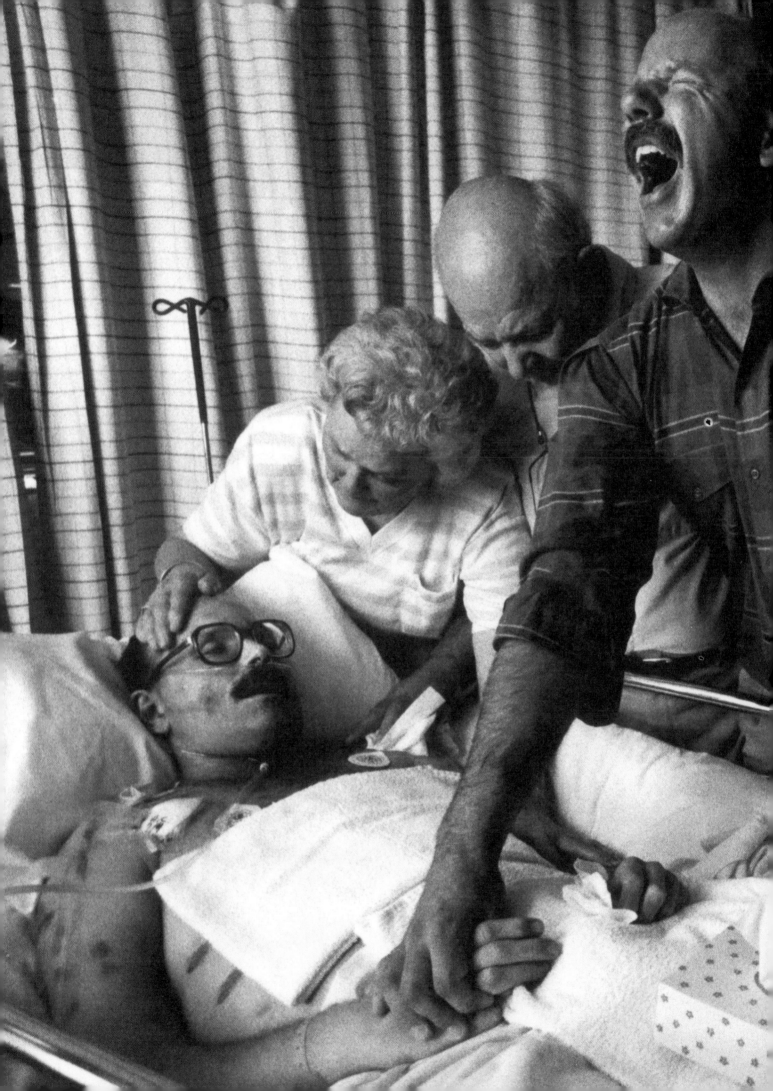

Francesco Clemente, *Earth*, **1983**

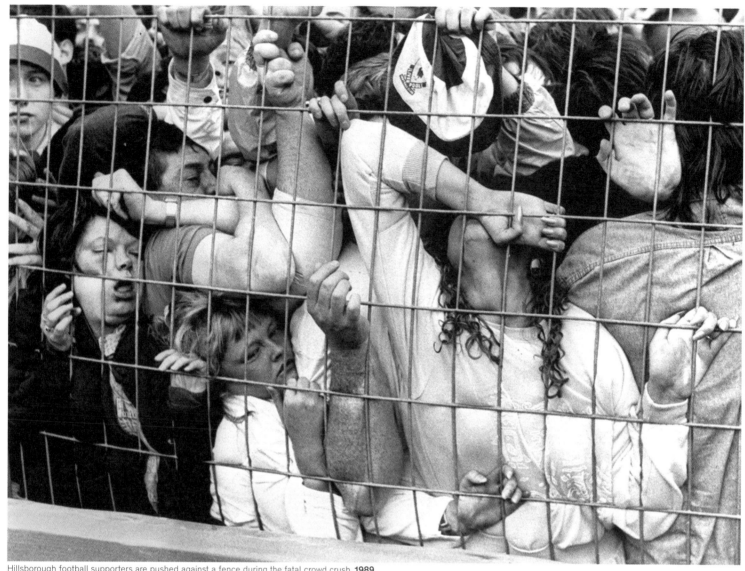

Hillsborough football supporters are pushed against a fence during the fatal crowd crush, **1989**

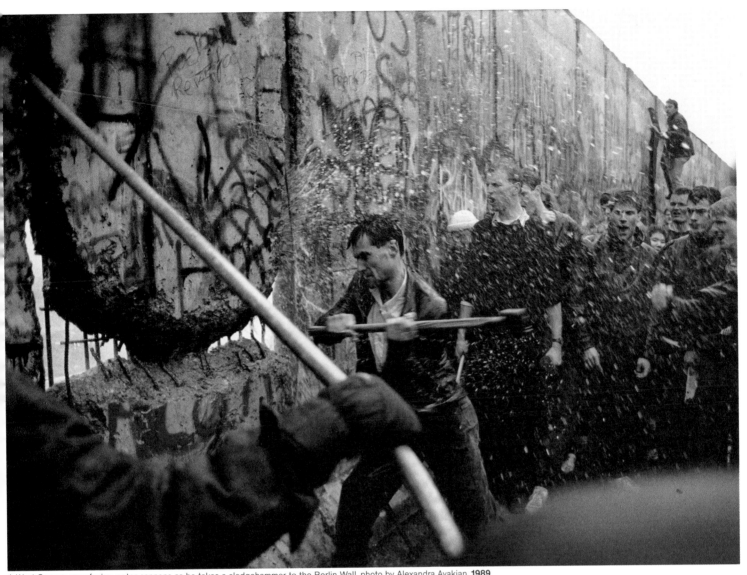

A West German man facing water cannons as he takes a sledgehammer to the Berlin Wall, photo by Alexandra Avakian, **1989**

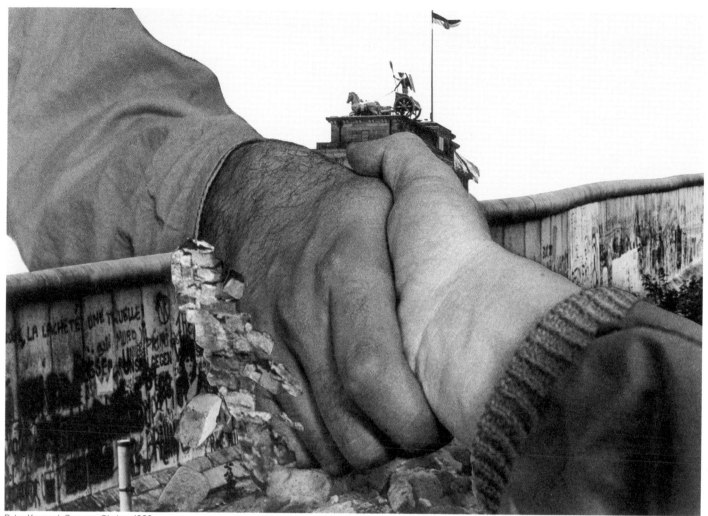

Peter Kennard, *Germany Shakes*, **1989**

There was still much to figure out: many wrongs to right, lives to be saved and economic and environmental issues to overcome. Yet, as the world entered the final decade of the 20th century, humanity was – more or less – heading in a positive direction. The Cold War was over, action was being taken to fix the hole in the ozone, medical and social advances were tackling the spread of AIDS, the starving millions in less affluent countries were being seen and heard, and in South Africa apartheid was about to crumble. In the face of all this triumph and tragedy – perhaps even because of it – new creative voices were emerging, different stories were being told, new images being looked at and music being listened to. Advances in technology and communication had placed us on the brink of a faster, more globalized world that would, in theory, bring us all closer together. The future is always uncertain, and never more so than at the end of the 1980s. One thing, however, was patently clear: *We can't rewind, we've gone too far.* Times they were a-changin', whether you liked it or not.

Solidarity

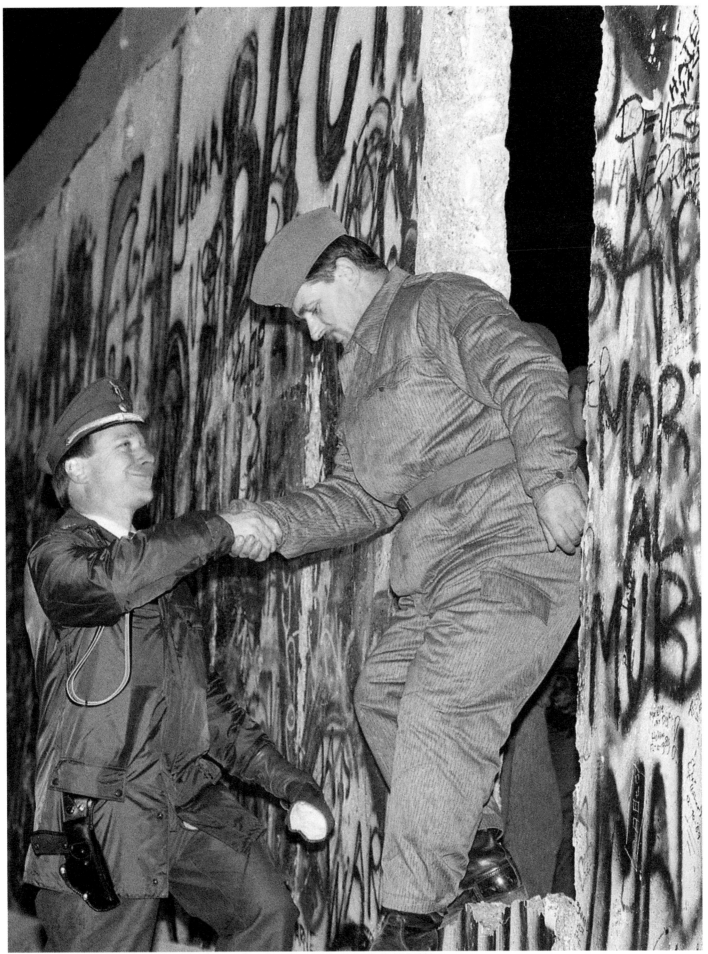

East German border guard is welcomed by a West German officer through an opening in the Berlin Wall, **1989**

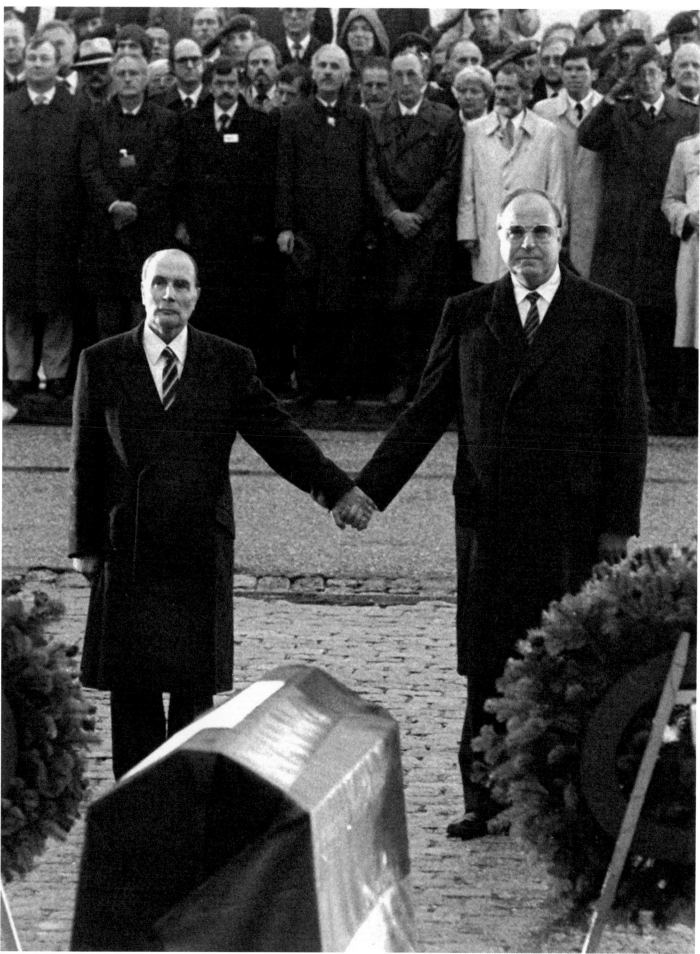

President of France François Mitterrand and Chancellor of Germany Helmut Kohl holding hands at the Douaumont Ossuary memorial, Verdun, **1984**

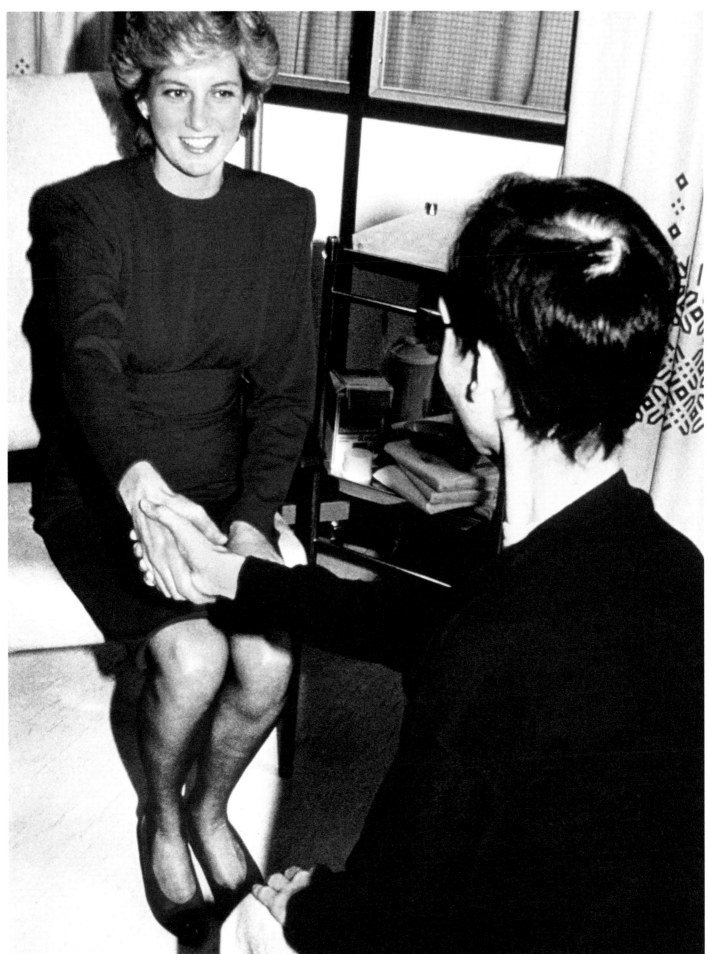

Princess Diana shaking hands with an AIDS patient as she opens a new AIDS ward at the Middlesex hospital, London, **1987**

(Overleaf) Newly elected President H.W. Bush showing support for Solidarity leader Lech Walesa one week before the party
forms a coalition government ending communism in Poland, **1989**
(328–329) *The Simpsons* season one series premier, 'Simpsons Roasting on an Open Fire', also titled 'The Simpsons Christmas Special', **1989**
(330–331) Nelson Mandela's 70th Birthday Tribute Concert, Wembley, London, **1988**
(335) Chris Steele-Perkins, *At a Night Club, London*, **1989**

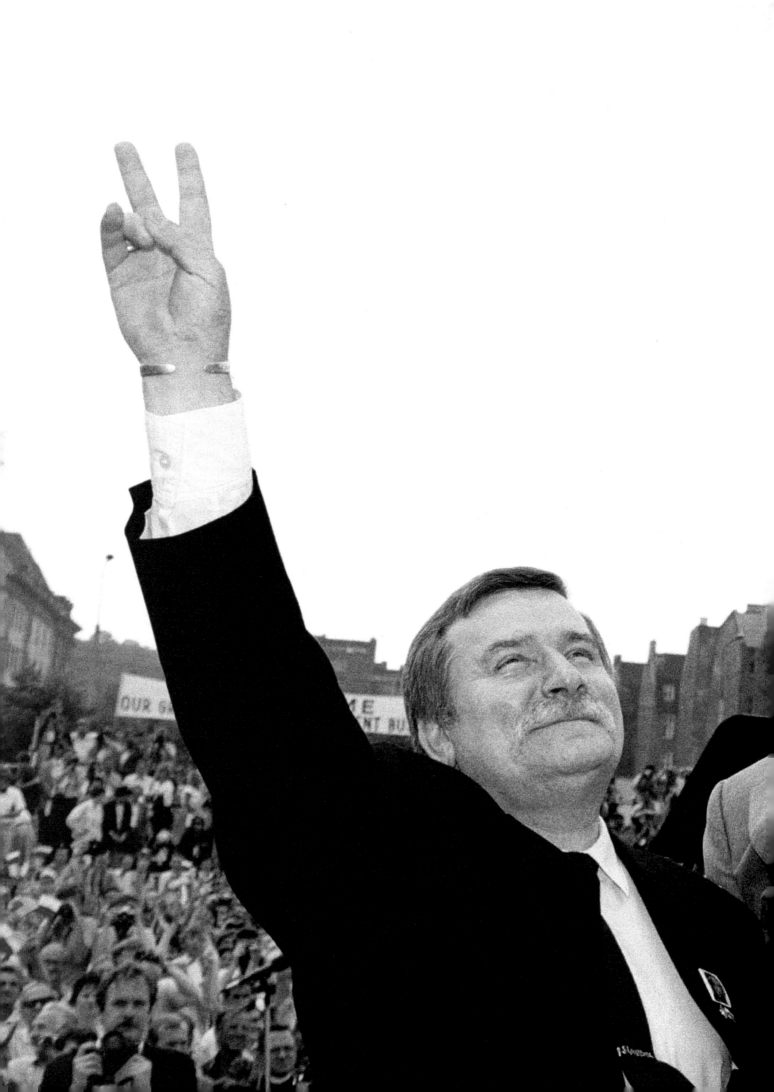

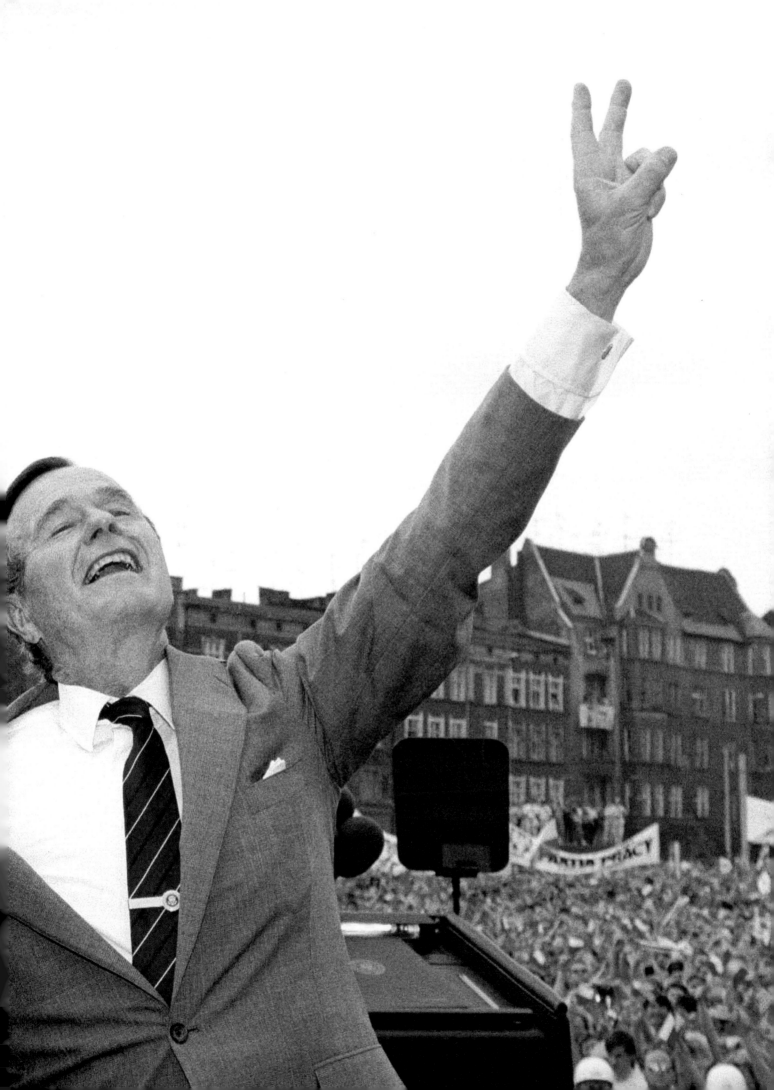

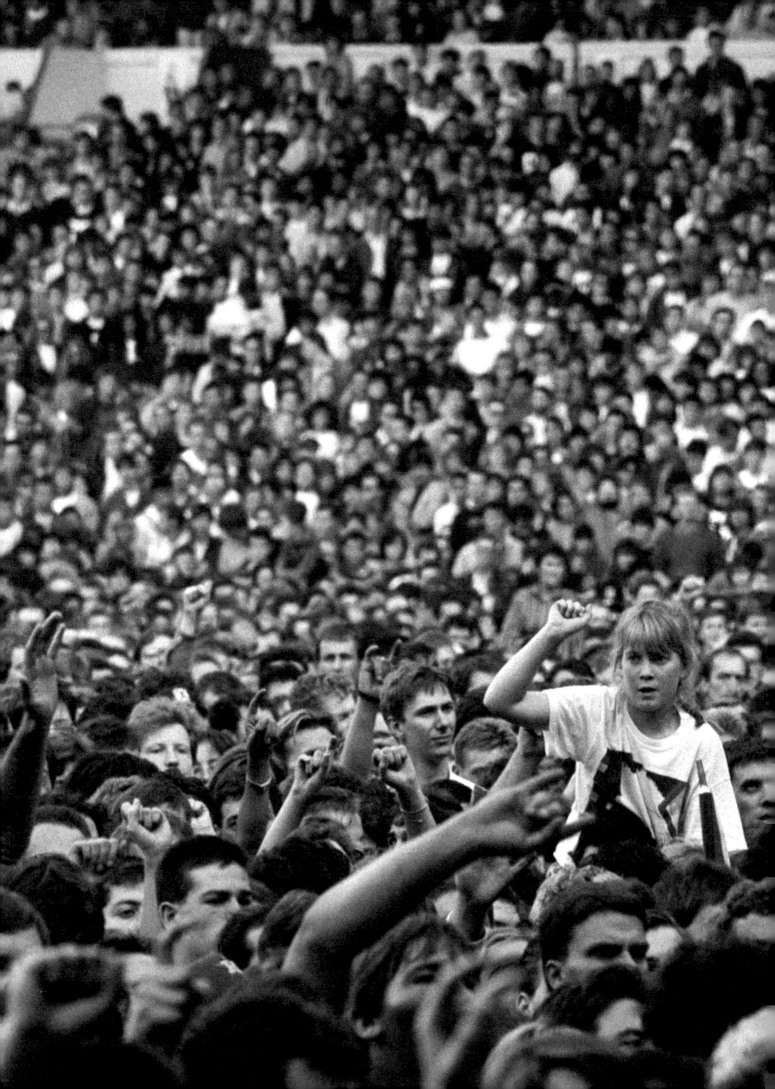

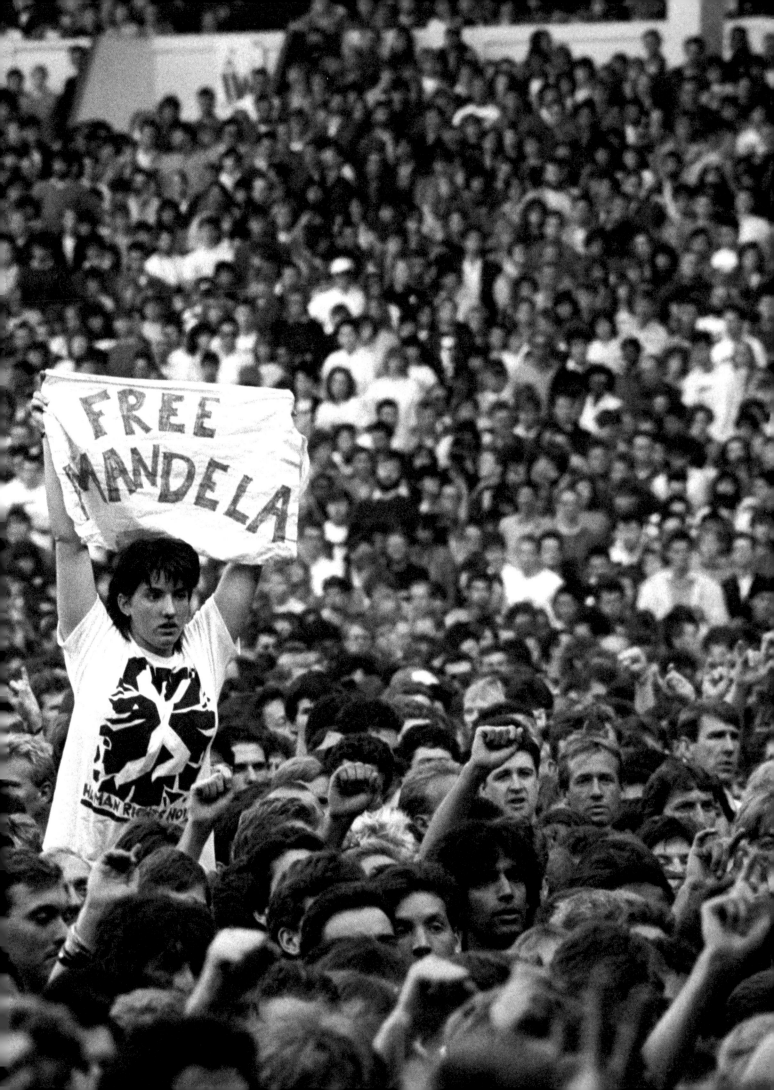

Sources of illustrations

333

Index of characters and events

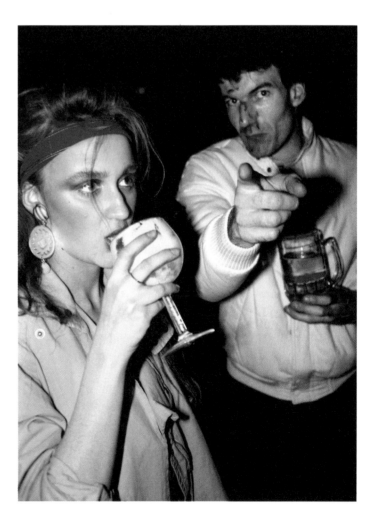

Acknowledgments

Thank you to Marc Valli at Thames & Hudson who backed my initial concept from the start even though I'd answer most questions with, 'I'm not sure, but I think I can make it work'. Huge thanks to designer Daniel Streat, Creative Director Tristan de Lancey and Head of Design Matt Watson-Young. I cannot thank enough Sally Nicholls, Giulia Hetherington and Domniki Papadimitriou for their dogged persistence finding images and clearing permissions, and thank you to the artists and galleries who granted us permission to feature works. Without a doubt the most deserving slice of gratitude goes to editor Sara Goldsmith who tweaked my writing so thoughtfully and made such valuable contributions to the image selection. A final thank you goes to the following for their involvement in various capacities: Francesca Anderson, Jane Cutter, Carlos De Spinola, Frazer Douglas, Richard Ellis, Andrew Fairclough, Sarah Farzam, Dan Golden, Benjamin Goodman, David Goodman, Matt Grubb, Melina Hamilton, Alex Hardcastle, Nicole Herman, Nigel Howlett, Adrian Jones, Nikolai Lafuge, Selwyn Leamy, Christy Lemire, Nigel Lopez-McBean, Danielle Mourning, Simone Rosenbauer, Quinn Singer, Terry Squadrito, Kimberly Stanford, Janet Urban, Elizabeth Weiss.

First published in the United Kingdom in 2024 by Thames & Hudson Ltd, 181A High Holborn, London WC1V 7QX

First published in the United States of America in 2024 by Thames & Hudson Inc., 500 Fifth Avenue, New York, New York 10110

The 1980s: Image of a Decade
© 2024 Thames & Hudson Ltd, London

Text © 2024 Henry Carroll
For Picture Credits see pages 332–333

All Rights Reserved. No part of this publication may be reproduced or transmitted in any form or by any means, electronic or mechanical, including photocopy, recording or any other information storage and retrieval system, without prior permission in writing from the publisher.

British Library Cataloguing-in-Publication Data
A catalogue record for this book is available from the British Library

ISBN 978-0-500-02722-6

Printed in Malaysia by Papercraft

FSC
www.fsc.org

MIX
Paper | Supporting responsible forestry
FSC® C016973

Be the first to know about our new releases, exclusive content and author events by visiting
thamesandhudson.com
thamesandhudsonusa.com
thamesandhudson.com.au